Digital Photography
Expert Techniques

Digital Photography
Expert Techniques

Ken Milburn

O'REILLY®

BEIJING • CAMBRIDGE • FARNHAM • KÖLN • PARIS • SEBASTOPOL • TAIPEI • TOKYO

Digital Photography: Expert Techniques

by Ken Milburn

Published by O'Reilly Media, Inc., 1005 Gravenstein Highway North, Sebastopol, CA 95472.

O'Reilly & Associates books may be purchased for educational, business, or sales promotional use. Online editions are also available for most titles (*safari.oreilly.com*). For more information, contact our corporate/institutional sales department: 800-998-9938 or *corporate@oreilly.com*.

Print History:

March 2004: First edition.

Editor: Robert Eckstein

Production Editor: Emily Quill

Cover Designer: Emma Colby

Interior Designers: David Futato and Melanie Wang

 This book uses RepKover™, a durable and flexible lay-flat binding.

0-596-00547-4
[C]

Contents

Introduction

If you've picked up this book, you're obviously interested in digital photography. And there is a wide variety of digital photography books available these days. However, if you've ever dreamed of being a *serious* digital photographer, then *Digital Photography: Expert Techniques* is the place to start.

This book serves three purposes:

- It helps serious photographers who are either crossing over to digital or who want to make their digital workflow more efficient.

- It's all about solving the problems that come up most frequently during the day-to-day tasks of digital photography. In other words, it helps to improve your digital photography workflow.

- And finally, it takes you way beyond Photoshop solutions. Now, don't get me wrong—whenever a solution is available in Photoshop, we'll cover that method first. (After all, more of you are working with Photoshop than with any other image-editing program—so much so that it has become the de facto image-editing standard.) However, if there's a more time-efficient, technologically advanced, or easier solution available via a third-party program or plug-in, I'll show you that as well.

Organization of This Book

This book consists of thirteen chapters. At the beginning of most chapters is a section entitled Getting Started, which gives you the basics you'll need to get the job done. After that, I provide a number of Tips that address common issues that you're likely to face as you move further into that domain. As the title of this book suggests, the combination of these form a set of "expert techniques" that you can use to successfully master that task.

Chapter 1, The Digital Photographer, discusses the essential elements of the digital camera, including the CCD sensor and memory. This chapter also makes recommendations for various camera accessories you should consider purchasing, as well as tips for both computer and printer hardware.

Chapter 2, Be Prepared, introduces several workflow hints that digital photographers learn sooner or later. This includes a list of accessories that you should have for both indoor and outdoor shoots, as well as various tips to help you get the best shot possible and keep you from pulling your hair out.

Chapter 3, Bringing Out the Best Picture, talks about how to extract your photos (including RAW files) from your camera and perform the necessary exposure corrections to make your shot look its best. This chapter also contains several tips to help you organize, manage, and protect your photographs once you discover that you have several thousand to choose from.

Chapter 4, Panoramas, discusses an area of photography that has grown tremendously in the past few years. This chapter discusses in detail the do's and dont's of making your digital camera display the world all around it.

Chapter 5, Photoshop Selections, Masks, and Paths, covers the most important Photoshop skills you can have: selecting discrete areas of an image for modification. I also discuss some third-party solutions for making "knockouts" that can make your life much easier.

Chapter 6, Basic Digital Photo Corrections, introduces an arsenal of digital photograph manipulation strategies that any digital photographer should be aware of: everything from color correction to image noise, distortion to enlargement. This is the information that you'll use time and time again when perfecting your digital photographs.

Chapter 7, Converting Photos to Paintings, provides you with an increasingly popular set of tips to make those digital photographs look like works of Picasso—all without ever opening a tube of paint!

Chapter 8, Special Photographic Effects, provides a number of techniques that you can use to turn your ordinary digital photograph into something quite extraordinary.

Chapter 9, Retouching and Rescuing Photos, arms you with the information you need to clean up those photographs that just didn't turn out the way you wanted them to. This chapter covers everything from coffee stains on your scanned images to drawing attention to various areas of your pictures.

Chapter 10, Creating Fictitious Photos, is every tabloid photographer's dream chapter (although I certainly don't endorse these techniques in any fact-finding organizations). This chapter shows you how you can increase your self-expression by compositing elements of one photograph into another.

Chapter 11, Color Printing, provides an in-depth look at issues that digital photographers will face whenever they need to print out a photograph using today's color photo printers.

Chapter 12, Use Pictures to Sell Yourself, gives you an introduction into the world of exhibiting digital photographs, including creating archival-quality photographs, mats, and frames that will stand the test of time.

Chapter 13, Sell It on the Web, continues the theme of Chapter 12 by focusing entirely on creating online portfolios for everyone from professional clients to relatives.

Who This Book Is For

Because there were so many solutions and techniques to cover, I faced a conundrum: should I try to make it easy for everyone to understand, or take it for granted that readers have at least a little familiarity with Photoshop? I opted for the latter. For example, I assume that you know how to use common commands and tools (e.g., the Magic Wand, the Move tool), and I also save a lot of time, words, and pictures by making liberal use of keyboard shortcuts or by simply putting the command in brackets.

Does this mean that Photoshop novices shouldn't buy this book? Not at all. It just means that you may need a beginning Photoshop book as a quick tutorial. If you're looking for a good place to start, consider Deke McClelland's *Adobe Photoshop CS: One on One* (O'Reilly). This book is a great introduction to the basics of Photoshop CS in the context of digital photography, and has something most other Photoshop books don't: a CD-ROM of 2-hour tutorial video that you can play again and again.

The other tough choice was deciding what classes of camera to base this book on. Almost all the current books on digital photography—even those that claim to be aimed at professionals—concentrate on cameras that cost less than $500. At the time of this printing, that price range is just beginning to include the type of cameras used by most professional and serious photographers: the interchangeable-lens single-lens reflex (SLR). This book focuses on digital true SLR cameras that have higher megapixels of non-interpolated resolution—in other words, professional-quality cameras that let you clearly see exactly what the lens sees. Because these cameras are all capable of producing high-quality RAW files, we also explore how to get the most out of RAW files.

This book is more about workflow than it is about procedures in a specific program. Because the majority of serious digital photographers use Photoshop, that's the program used in most of the examples in this book. Having said that, you're certainly welcome to use any program you like—after all, most image editors have derived their interface and command structure from Photoshop, so chances are good that you'll be able to see what I'm getting at and do the same thing in your own program.

So does this book contain all the information you'll ever need as a professional digital photographer? Of course not. Hundreds of books have been written on the subject of digital photography and digital image editing. If anyone could have fit all that information between the covers of one or two books, it would have been done a long time ago and there would be far fewer publishers in the business today. But hopefully, this book will provide the solutions to a serious photographer's most nagging problems. Be sure to let me and the folks at O'Reilly know if we've missed any that are especially dear to your heart. We'll try to squeeze them into the next edition.

About Photoshop versions

Adobe Photoshop CS is the eighth iteration of Adobe's world-famous image editing program; CS first appeared in the fall of 2003. I'll gleefully point out new features in Photoshop CS that solve particularly annoying professional problems. However, if you have an earlier version of Photoshop, don't worry. You should be able to master almost all of the examples inside this book with Photoshop 7 (and probably in any version newer than 5.5) without incident. In fact, you'll likely be able to accomplish these tasks using Photoshop's sibling program, Photoshop Elements 2.0, or any other image editor that supports layers and Photoshop-compatible plug-ins.

Conventions Used in This Book

This book is meant to be equally useful to both Mac and Windows aficionados. There is virtually no difference in the operation of Photoshop and the other programs mentioned herein.

Menu commands are exactly the same unless followed by a parenthetical remark that points out a difference or distinction. Menu commands are given in hierarchical order, with a → preceding each new appearance of a cascading menu, like this: Image → Adjustments → Levels. If a menu appears from a palette or dialog menu, the name of the menu or dialog will precede the naming of the command hierarchy.

Macs and PCs use different but equivalent keys for keyboard shortcuts, so I'll give you both commands in one breath. Because Photoshop first appeared on the Mac, the Mac command abbreviation is given first, followed by the Windows command abbreviation. So a keyboard shortcut is given like this: Cmd/Ctrl-Opt/Alt-D (that is, Cmd-Opt-D on the Mac, and Ctrl-Alt-D on the PC).

The following typographical conventions are used in this book:

Plain text
> Indicates menu titles, menu options, menu buttons, and keyboard accelerators (such as Alt and Ctrl).

Italic
> Indicates URLs, email addresses, filenames, file extensions, pathnames, and directories.

About the Digital Studio Series

This book is part of O'Reilly's *Digital Studio* series, a new set of books geared toward turning high-end users into authoritative experts, whatever their area of expertise may be. At O'Reilly, we forever strive to raise the bar with this series—and with our other books as well—offering you a volume that not only gives you a tremendous amount of value for your money, but also relieves your "information pain." In other words, we want to answer not only your tough questions, but also address those arcane and annoying problems that you'll face as you mature in your field of study. These are the problems that others tend to think of as "outside the scope of this book."

Comments and Questions

Please address comments and questions concerning this book to the publisher:

> O'Reilly Media, Inc.
> 1005 Gravenstein Highway North
> Sebastopol, CA 95472
> (800) 998-9938 (in the United States or Canada)
> (707) 829-0515 (international or local)
> (707) 829-0104 (fax)

We have a web page for this book, where we list errata, examples, and any additional information. You can access this page at:

> *www.oreilly.com/catalog/dphotohdbk*

To comment or ask technical questions about this book, send email to:

> *bookquestions@oreilly.com*

For more information about our books, conferences, Resource Centers, and the O'Reilly Network, see our web site at:

> *www.oreilly.com*

Acknowledgments

Robert Eckstein has been a pioneer, a mentor, someone who's always there when I needed him, and a lot of fun to talk to. Besides, he lives in the same part of Texas where I grew up—he knows what's important. Derrick Story and Susan Lake were the technical reviewers for this book, providing insight and helpful comments every step of the way. And I also have to express my admiration and gratitude to and for the entire production team at O'Reilly, including Emily Quill, my production editor, whose tireless hours of copy-editing go well beyond that of mere mortals; David Futato, who did a fantastic job with the new Digital Studio layout (hey, just look at it!); and Rob Romano, technical illustrator, whose careful attention to color and detail shows in every printed photograph in this book.

Also, many thanks to Margot Maley Hutchinson, my agent at Waterside Productions. She is simply the cream of the crop: honest, loyal, brainy, hard-working, and a great mom.

Many of the best lessons in life are taught to us by our families. My son, Lane, has been a great teacher, and the directions his life is taking today are just downright inspiring. I also owe a lot to my extended family: Bob Cowart, Janine Warner, Nancy Miller, Jane Lindsay, Marina Tate, Roger Mulkey, Keehn Gray, Rick White, and a host of other friends and neighbors.

Finally, this book couldn't have happened without support and help from every manufacturer or publisher whose products are mentioned or featured.

The Digital Photographer

1

Recently, the world has seen a resurgence in still photography. Gone are the days of darkrooms, negatives, and harmful chemicals. Replacing it is the simplicity of digital cameras, computers, and photo-quality printers. And now, digital photographers have the ability to perform an infinite number of corrections and enhancements to their images before showing them to the world. Frankly speaking, the fun of taking pictures has returned.

And why not? The digital photographer can do far more now with their photographs than they ever could with film, and in less time and at a fraction of the cost! Even better, professional digital cameras that previously cost several thousand dollars are tumbling in cost, some even falling below the all-important $1,000 barrier. So, if you've shelved all those chemicals and turned your basement darkroom into a den, well...there's never been a better time to come back. Or if you've exhausted the possibilities of that first-generation digital camera and you're ready to start exploring the more serious digital photographer's world, this is the place to be.

This first chapter explores the three items that are essential to any serious digital photographer: the camera, the computer, and the printer. It ends with a quick overview of a typical digital photographer's workflow. If you already have each of these components, and you're happy with them, you may want to just skim this chapter and move on to the last section on workflow. However, if you're looking to purchase some new equipment, this is place you want to start.

In this chapter

The camera

The computer

The printer

The workflow

The Digital Camera

The most essential element in digital photography is, of course, the digital camera. These days, digital cameras are so popular that there are several hundred to choose from. So, if you're looking to purchase a new one, the issue is not which camera is best overall, but rather which camera is the best fit for you and your needs. Two excellent cameras are shown in Figure 1-1 and Figure 1-2.

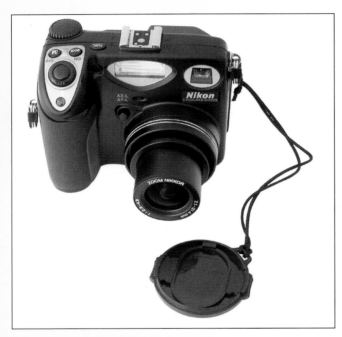

Figure 1-1. The 5MP Nikon Coolpix 5000 is a "prosumer" camera (a high-end consumer camera for serious amateurs and part-time pros). There are many others in this category.

Figure 1-2. A professional SLR, the Fujifilm S2 Pro.

> **NOTE**
>
> SLR stands for Single-Lens Reflex, a type of camera used by professionals which has an accurate viewfinder, interchangeable lenses, and many automatic functions including auto-exposure and auto-focus.

We've come a long way in just a few years. In 2002, digital cameras that were considered suitable for professional photographers cost between $8,000 and $25,000. Sadly, one of the reasons for this hefty price tag was simply the *look* of the camera—after all, a pro has to look...well, like a pro! If you arrive at a shoot with nothing more than a digital pocket camera, your subject might conclude that you don't know your stuff or that you can't afford the right equipment. Neither makes a very good impression.

Since then, prices have fallen. As I write this, there are several choices in professional SLR cameras for less than $1,500, and all but the least expensive of these have interchangeable lenses. (In fact, many of these cameras can reuse lenses from older 35mm SLR film cameras.) In addition, there are even some $3,000 cameras (e.g., the Kodak 14n) that have just as much resolution as older $25,000 medium-format single-shot digital camera backs.

So the good news is, if you're a serious photographer, you can now afford a digital camera that actually makes you *look* like a professional. For less than $1,000, you can find one good enough to replace that 35mm SLR film

camera that set you back several thousand dollars a few years ago. (You may even be able to reuse some of your old lenses.) I even know of some highly reputable professionals who see no reason why a professional's first choice shouldn't be a digital camera. As I mentioned earlier, film is quickly becoming antiquated.

The sensor and image quality

Before we go any further, however, let's take a closer look how a digital camera captures an image. We're all familiar with how a 35mm film camera works: when you press the shutter release, the camera opens its shutter for a set amount of time, and the light coming through the lens is then captured on photo-sensitive film. After the shutter closes, the film quickly advances so that the camera is ready for the next shot.

Digital cameras work in much the same way, except that they don't use film. The power behind any digital camera lies in its sensor, which is what the camera uses to "see" and capture incoming light. There are currently two types of sensors on the market for digital cameras, CMOS and CCD.

CMOS (complementary metal oxide semiconductor). CMOS chips are used in a variety of computing devices. Hence, these sensors tend to be less expensive because the same facility that generates a CMOS light sensor can generate a number of other CMOS products as well. So, the good news is that these sensor chips are inexpensive. The bad news? Until recently, they typically yielded poor image quality. Today, however, they are featured in several high-end digital SLRs. Some of these, such as those used in the Canon 10D and 300D, are highly regarded for their ability to produce very low-noise images compared to their CCD counterparts.

CCD (charge-coupled diode). A charge-coupled diode is the most commonly used sensor in both prosumer and professional digital cameras. Even though they are more expensive to produce, and often consume more power, many cameras still use these sensors to obtain a much higher image quality than older CMOS sensors.

So, how does a sensor work? Well, a digital camera CCD sensor is really a two-dimensional array of pinpoint "light collectors" called photoreceptors. The number of photoreceptors on a sensor determines the maximum resolution of the pictures that can be taken. Individual photoreceptors measure specific colors in the incoming light. For example, one type of receptor may measure the amount of blue in the incoming light, another may measure the amount of red, and a third may measure the amount of green. Or the camera may use a different color scheme, with receptors measuring cyan, magenta, and yellow.

Typically, a large number of photoreceptors for each color are laid out across a digital camera sensor in an alternating "mosaic" (i.e., checkerboard) fashion.

What Is Film?

To quote Vincent Versace, one of the most famous digital photographers: "Film is that stuff that gets on your teeth when you don't brush them."

Changing Times

On January 13, 2004, while this book was in production, the Eastman Kodak company announced that it would stop selling traditional film cameras in the U.S., Canada, and Western Europe. Instead, the company would focus on digital solutions for these expanding markets.

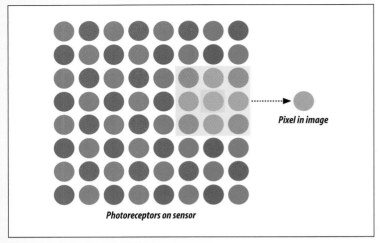

Pixel in image

Photoreceptors on sensor

Figure 1-3. De-mosaicing a CCD sensor's photoreceptor involves taking data from the center photoreceptor, as well as the photoreceptors around it (in this case, the eight immediately surrounding it) to generate the final pixel value for the digital image.

When the shutter is opened, incoming light strikes the photoreceptors, and each receptor measures the brightness of the base color that strikes it. An onboard chip inside the camera then uses an analog-to-digital conversion process to quantify the base color of the receptor, and then interpolates it with the value of adjacent receptors (of different base colors) to calculate an absolute color value for that receptor's picture element, or pixel. This entire process involves a number of mathematical equations, and is often referred to as de-mosaicing. See Figure 1-3.

Let's assume that a camera uses this process to generate an image comprised of 1000 pixels horizontally by 1000 pixels vertically. This means that the image has a total of 1 million pixels, or a megapixel (MP). You may think that's impressive, but today's digital cameras can do far better. The general rule of thumb is this: the higher the megapixel value, the better quality images the camera will generate.

So let's say it's time to look for a new digital camera that can meet the standards required by professionals. What should you look for? Well, you want to be equipped with at least the following:

- A 35mm format SLR camera

- An image sensor at least 2/3 the size of a standard 35mm film frame

- Enough resolution for the size of prints you'll be generating

The amount of resolution needed for various prints is shown in Table 1-1. Note that this table assumes a 200 pixel-per-inch (ppi) resolution, which is considered "acceptable" for quality prints. If you're doing professional work, you should consider using 240 to 360 pixels-per-inch for your prints.

Table 1-1. Digital camera resolution (at 200 ppi)

Print size	Image resolution (in pixels)	Megapixels needed (raw CCD)
3 × 5	600 × 1000	.6
5 × 7	1000 × 1400	1.4
8 × 10	1600 × 2000	3.2
11 × 14	2200 × 2800	6.2
16 × 20	3200 × 4000	12.8

So does this mean that you must have a 12.8 MP camera to generate 16 × 20 prints? Not really. Cameras often use interpolation techniques at the pixel level to "enlarge" images to a resolution that is greater than what the camera's sensors are capable of registering.

TIP

The Latest Innovations

There are also some proprietary variations on the standard "row and column" pixel matrix that complicate this formula. For instance, Fujifilm's sensors are hexagonal rather than rectangular, and are arranged in a staggered matrix that actually increases the perceived resolution of the image when the camera interpolates it for final output. Sigma's sensors, on the other hand, are arranged in three color layers—so, although the resolution count is much lower, only one pixel needs to be used to record all colors.

Taking the picture

So, now that we know about the sensor, what exactly happens once you take a picture? First, the CPU receives a signal from the shutter release button, which in turn tells the onboard computer to both focus and clear out the CCD memory. After that, the shutter opens and the pixel data is computed from the CCD photoreceptors as described above.

After the picture is taken, a camera may perform other processing on the resulting picture and its pixels, such as noise reduction, sharpening, enlarging, and white balance—each according to the camera's settings. For example, the onboard microprocessors may attempt to adjust the white balance of the picture or it may attempt to enlarge and sharpen it. As a user, you may or may not have control over this process. Better cameras will allow you more freedom of choice.

Let's digress for a moment. Does that mean that you don't want the camera to perform any corrections? Not necessarily. The good news is that most digital cameras have a healthy amount of intelligence in them. Ten years ago, for example, a photographer had to consider white balance well before taking the shot. This meant buying different types of film depending on whether you were shooting outdoors in the sun, or indoors under normal tungsten lighting. Many digital cameras, however, can adjust the white balance automatically. They can also use menu presets, or even allow the user to hold up something "white" in front of the lens and force the camera to reconfigure its settings. So, there may be times you want to manually correct white balance, and there may be other times where you want the camera to make the changes itself. As you take more pictures with your digital camera, you'll get more comfortable with its internal settings.

EXPERT ADVICE

Ken's Recommendations

If you're a professional photographer, I would recommend a digital camera with at least 6 megapixels of memory. Why? If a digital image contains at least 6 MP, it has roughly the same resolution as an ISO 200 negative 35mm film frame. In addition, you can use all sorts of post-production interpolation tricks with your computer (which are often much better than what the camera can perform internally) to enlarge the resulting image without any noticeable loss of detail.

After any in-camera corrections take place, the camera will either write the picture data out to flash memory, or it may store the image data inside of a local cache so that it is instantaneously ready for the next shot. Again, this depends on the camera.

This entire process is shown graphically in Figure 1-4.

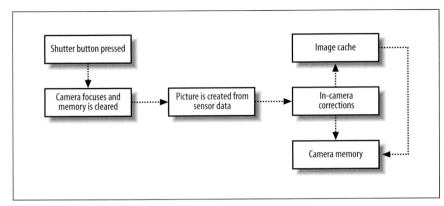

Figure 1-4. The process of taking a digital picture.

You can continue to shoot images with your digital camera until you've exhausted the flash memory that you have in your camera. At that point, reloading is again much easier than a film camera: simply turn off the camera, take out your memory card (or equivalent), and insert a new one.

Features you want in a digital camera

As I mentioned earlier, you should start with a 35mm format SLR camera with enough memory for the size prints you'll be generating. However, you don't want to stop there. Here are some other features to strongly consider when searching for the right digital camera.

Minimal shutter lag. This is a big one. Shutter lag is the time gap between the instant that the shutter is fully depressed and the click—in other words, the time between when you fully press the button and when the picture is actually taken. With a film camera, the shutter-release process is mechanical, so there really isn't any shutter lag that you need to worry about. With a digital camera, however, the CPU has to process the signal from the shutter release button, which tells the camera to focus and clear out the CCD memory. A total absence of shutter lag is your only assurance of capturing the exact moment you intended to. Most professional digital cameras have little to no perceptible shutter lag (i.e., less than .01 seconds). Prosumer cameras, however, vary quite a bit here. Caveat emptor.

Minimal write time. The amount of time it takes for a camera to record an image from the camera sensor to the memory card is called write time. A professional camera will have a memory cache that holds several images until they're all written to the memory card. When this cache is full, it may be several minutes before you can take another picture. If you're going to be shooting action, fashion, weddings, and the like, make sure the camera can fire 5–10 shots without any write delay. Also, buy a camera that turns on instantly the moment you flip the switch (or, if it's gone to sleep, when you partially depress the shutter button).

RAW files. RAW is a relatively new image format that contains an incredible amount of photographic data. The best advice I can give any digital photographer who is serious about getting the best quality image is this: *shoot in RAW mode.* Why are RAW files so important? Because they record everything that the image sensor sees, which includes (and I'm not exaggerating) about a billion colors! Using that, RAW files let you decide *after the fact* what color balance you want to use, what highlights and shadows you want to adjust, the level of sharpening and noise reduction, and other choice factors without ever damaging or compromising any of the original data. You can even create multiple "interpretations" of the same photo.

The most popular pro and prosumer cameras have the ability to capture RAW files to a format that can be read by the Adobe Photoshop CS Camera RAW plug-in. Until the Adobe RAW plug-in (see Figure 1-5) came along, it was very troublesome to open and deal with the RAW files—you had to use the proprietary software that shipped with the camera and that often didn't work as a plug-in. Consequently, most digital photographers shot JPEGs.

—NOTE—
You can download the Adobe Digital Camera RAW plug-in from the Adobe web site (www.adobe.com/products/photoshop/cameraraw.html) for Photoshop CS. The latest version as of this printing is Version 2.1, which supports a number of new digital cameras. See Chapter 3 for more details.

Going Beyond Compact Flash Cards

A Microdrive (which fits into a CF II slot) is several times faster in my Fujifilm S2 Pro than the fastest solid-state CF II card. (This may not be the case with all digital cameras, however.) At the time of this writing, you could buy a 1 GB Microdrive that fits into a Type II CF card slot for about $200. IBM, which invented the Microdrive technology, has just merged its hard-drive making operations with Hitachi, and Hitachi promises that by the time you read this there will be 4 GB Microdrives available.

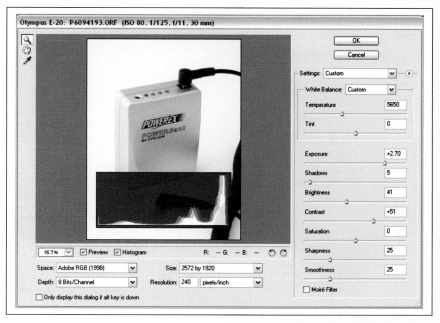

Figure 1-5. You can determine just what information to keep by using the Adobe Photoshop CS Camera RAW plug-in.

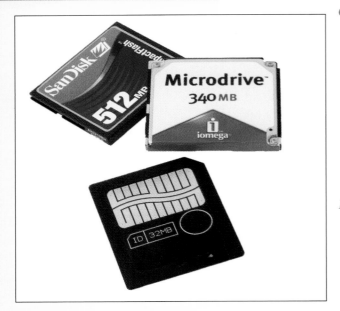

Figure 1-6. A standard CompactFlash card, a Microdrive that fits a CF II slot, and the xD Picture Media (formerly SmartMedia) card used as an alternative by some pro and many prosumer digital cameras.

CompactFlash memory cards. Standards change quickly in the digital-photography industry, but for now the most common flash memory card format for digital cameras is known as CompactFlash (Types I and II), shown in Figure 1-6. The capacity of these cards is currently up to 4 gigabytes and continues to climb steadily. Great strides have also been made in the speeds at which images can be written to these cards. For the foreseeable future, CF cards offer the lowest cost per megabyte and the best assurance of an upgrade path when you buy a new pro camera.

External flash. The use of supplementary lighting, especially for brightening detail in shadows, is even more important in digital photography than in conventional photography. This is because *there's always more noise in the darker areas of a digital image*. Supplementary lighting is also useful when you're working with large areas of delicately graduated tones, such as sky and human skin.

Built-in flash units are okay for filling in shadows in outdoor portraits and other close-ups, but they are generally too close to the lens to provide flattering shadows. In addition, they're too weak to light objects that are more than 8 to 12 feet from the flash source. So, consider a camera that at least has a standard "hot shoe" that takes both proprietary and third-party flash attachments (see Figure 1-7), and that can host an adapter for a standard PC connector for firing a studio or off-camera flash.

Spot, center-weighted, and matrix metering. Spot, center-weighted, and matrix metering are methods for reading specific portions of the image, as shown in Figure 1-8. The more versatility you have in metering, the quicker you can adapt to different shooting situations. This is especially important when working with an unfamiliar subject.

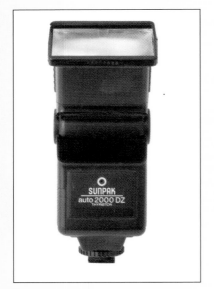

Figure 1-7. A third-party exterior flash unit that will slide into a hot shoe. Such units can also be adapted with a cord so that they can be positioned at a distance from the camera.

- Spot metering is useful for reading small areas of the image that may be the center of interest, such as the skin tones of a face or the brightness of the light reflecting from a small subject against a dark background. It is also useful for individually measuring small areas of brightness within the picture (whether they're the center of interest or not).

- Center-weighted metering measures a circular area in the center of the picture and is the best choice for close-up portraiture and small objects.

- Matrix metering divides the image into several sections and then "weighs" the brightness of those sections to determine overall exposure.

The Digital Camera

It's helpful to choose a camera that lets you move the "hot spot" within the viewfinder so that it is positioned close to (or atop) the most critical area of brightness. That way, you don't have to pan the camera after taking a meter reading.

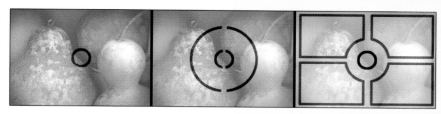

Figure 1-8. Simulated meter patterns showing the area covered for (left to right): spot, center-weighted, and matrix metering. The specific areas covered for matrix metering vary greatly from camera to camera, as does the number of areas that comprise the matrix.

Lens-mount versatility. I'd recommend choosing a camera that either accepts a standard Leica C-mount or that can use Nikon, Canon, or Pentax (in order of number of lens choices) automatic lenses. You'll then be able to mount all the standard automatic lenses made by that manufacturer, as well as third-party lenses made by such manufacturers as Tamron, Sigma, Tokina, and Vivitar.

Ability to use remote control. An electronic remote control allows you to fire the camera without touching it; for example, while you're standing in front of it or hiding in a blind some distance away (the latter is a great advantage when photographing wildlife). Virtually the entire line of Olympus prosumer cameras ships with a tiny remote that gives you full control over zooming, focusing, and firing the camera; for other cameras, you may need to purchase a remote control separately.

Sequence shooting. Sequence shooting, shown in Figure 1-9, allows your camera to take a number of shots rapidly (perhaps several each second). Sequence shots ensure that you will capture the best part of any action shot.

Interval sequence shooting. Some cameras or remote controls can be set to fire at intervals of several minutes or even hours between shots. This is called interval sequence shooting, and it makes it possible to capture such things as changes in weather or traffic over time. With a digital

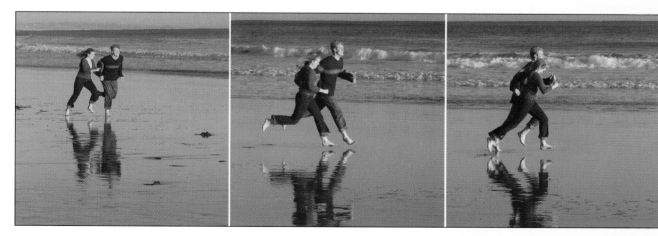

Figure 1-9. A sequence shot at 2 fps with the Fujifilm S2 Pro.

camera, you can also layer photographs to show the same objects shot at different intervals (such as people, animals, or clouds) to appear in the image as if they had all been present at the same time.

Maximum range of ISO settings. ISO settings determine the sensitivity of the camera sensor to light. With a lower ISO setting, there's likely to be less noise in the image. With a higher ISO setting, you'll be able to use a faster shutter speed to eliminate image blurring due to camera movement. Hence, a wide range of ISO settings will enable you to take photographs in varying conditions. The Canon D10 is outstanding in this respect, offering a choice of ISO settings from 80 to 3600 in one-stop increments.

Maximum range of shutter-speed choices. On the same note, the wider the available range of shutter-speed choices, the more interpretive choices you will have in deciding how to explore your image. However, exceptionally long exposures create additional image noise, and camera manufacturers do not like to offer settings that will make their equipment look bad. So, by increasing your shutter-speed choices, you'll be able to take good photographs in a wider range of lighting conditions, and will have the choice of either using extremely slow shutter speeds to shoot at night or blur action or using wider f-stops to decrease depth of field.

Full range of mode settings. All the professional and prosumer cameras that I know of allow you to choose between a fully programmed "point and shoot" mode, full manual mode, aperture-priority mode, and shutter-priority mode. A good prosumer camera should also feature auto-bracketing of both exposure and color balance, a rapid-sequence mode, and a movie mode.

Adaptability. Using accessories that you already own is a great advantage. For instance, if you have been a user of Canon film cameras and you buy a Canon digital SLR, you will still be able to use all of your existing lenses, filters, close-up attachments, and external flash units. You can also reuse your existing camera bags.

I also like cameras that let you use standard digital-camera accessories, such as memory cards and rechargeable batteries. That way, you don't have to spend several hundred extra dollars on new accessories when you trade up to a new camera. Furthermore, if you own several cameras, you can use the same batteries and memory cards in all of them; this means that there's less stuff to maintain, organize, and remember when you're rushing out the door for a shoot.

Intuitive ergonomics. Intelligent placement of controls, command buttons, and LCD menus ensures that you'll have as little learning to do as possible in order to operate the camera. This is also a good reason to consider any camera that has the same (or nearly the same) body as a camera you may already own. For instance, Nikon film-camera owners can choose

camera bodies from at least two other manufacturers besides Nikon (Kodak and Fujifilm) when it comes to picking out a professional digital SLR. Canon users can choose from several cameras made by Canon. Some older Kodak pro digital cameras also use Canon bodies.

Other useful features

Here are some other features that you may find useful when working with a digital camera. You may not find these on all the cameras you look at, but they're a definite plus to have.

Ability to write to RAW and JPEG simultaneously. JPEG images are compact and can be transmitted easily and quickly. RAW images, on the other hand, contain brightness information far beyond what the human eye can see, thus giving you much more control over the appearance of the image in final production. If the camera records the image in both formats simultaneously, you can choose which format to keep after the shoot.

Ability to write JPEG 2000. JPEG 2000 is a new image file format that uses an advanced technology called wavelet compression. Wavelet compression allows files to be compressed at ratios of more than 10:1 with no apparent loss in image quality. Also, unlike standard JPEG files, JPEG 2000 files can have layers and transparency. It is also (at least theoretically) possible for RAW files to be saved to JPEG 2000 format, which would save you a ton of bucks in storage media purchase—especially when shooting on location. At the time of this writing, no pro digital cameras offer this format, but you can bet that it will be the "killer feature" on new cameras very soon.

Cable release. A cable release may be an old-fashioned way to prevent the camera from jiggling when you fire the shutter (see Figure 1-10), but you can always count on it to work at exactly the instant you tell it to. Although most digital cameras use electronic IR remotes or dedicated remote releases now, cable releases are a much less expensive option (currently about $6 instead of $100). Besides, one size fits all, and they're available almost everywhere that professional-quality cameras are sold.

Figure 1-10. A cable release. The small threaded end screws into the camera's shutter-release button.

Video output. If your camera has video output, you can use the TV screen as a monitor, which is useful when shooting in the studio. This makes

it much easier to let your subject preview the way the camera and lights react to each change in his or her pose.

FireWire (IEEE 1394) or USB 2.0 interface. Many cameras now support the USB 1.1 interface. However, the presence of either FireWire or USB 2.0 connector types will greatly speed the downloading of images directly from the camera, especially if you're shooting RAW files. However, many professionals prefer using an external card reader so that an assistant can download files to the computer while the photographer is occupied with something else.

Best Shot Sequence. Best Shot Sequence is Nikon's name for a process that lets you shoot several images in sequence by keeping the shutter button fully depressed. When you release the button, the sequence stops and the camera discards all but the image with the sharpest edges. Best-shot sequencing is a tremendous aid when shooting at shutter speeds below 1/60 of a second, especially if the subject stays relatively still for the duration of the sequence. (In other cases, what the camera thinks is the best shot could turn out to be the worst. So as long as the camera has a regular sequence mode, you can shoot a sequence and choose among the images yourself.)

Auto-bracketing. Bracketing is the practice of taking several shots of the same image at different exposures (see Figure 1-11). This lets you choose the best exposure for a given subject by judging the results visually. It can also be a great way to extend the overall range of brightness values in

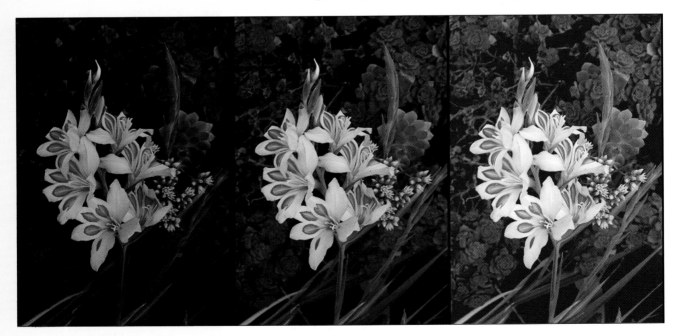

Figure 1-11. A series of three exposures, bracketed one full stop apart.

the image. Auto-bracketing allows the camera to auto-matically change each exposure in a sequence. This is much faster and easier than manually changing the camera's settings after each shot in the sequence. It also helps to minimize camera movement between shots.

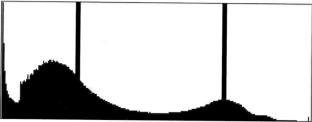

Histogram of captured image. Most professional cameras let you view a miniature histogram (see Figure 1-12) on your preview monitor when you are viewing the picture you just took. This histogram tells you if the image is exposed correctly by showing you how many pixels are occupying each level of brightness. Typically, you want to shoot for a histogram that distributes its pixels all across the brightness range. This ensures that you have the greatest amount of leeway working with the image in post-production.

Figure 1-12. A histogram shown by a digital camera representing the distribution of pixels in the image. This image appears slightly underexposed, as the histogram shows a much greater concentration of dark pixels on the left side and very few bright or white pixels on the right side.

Ability to record sound and make voice annotations. If the camera has a built-in microphone, you can record comments while you shoot. You may also be able to record sound with movies. However, most movies

Professional vs. Prosumer Cameras

I keep mentioning the word prosumer, which is a combination of the words "professional" and "consumer," to describe a halfway point in digital cameras between amateur and professional. So, what separates the professional cameras from the prosumer cameras? So far, the biggest difference is lens interchangeability, followed closely by image quality. Professional cameras typically have sensors that are only about 2/3 the size of a 35mm film frame. In addition, they are built on bodies adapted from 35mm SLR film cameras.

My advice to a digital photographer is this: if image quality is paramount and you can afford a professional camera, go ahead and get one. Professional cameras built on 35mm film SLR bodies can reuse the full range of existing 35mm accessories, such as external flash units, lenses, and filters. Also, a professional digital camera will feel very familiar to anyone who has spent time working with 35mm film SLRs. In addition, it allows the camera manufacturer to incorporate quite a bit of new technology, including larger film sensors than those seen in consumer cameras. The larger sensor size in the professional camera results in significantly less crosstalk (color interference) between the individual sensors that comprise the image, so even though nominal resolution isn't all that much higher than that of a 5 megapixel pocket camera, image definition is startlingly

better. Finally, the professional SLR camera's heavier weight and larger hand grip make it possible to get a steadier shot, resulting in a sharper image at slower shutter speeds.

Does this mean that lower-cost prosumer cameras have no place in the serious photographer's kit? Absolutely not. Prosumer models can be life-savers should the primary camera fail. Smaller cameras are also excellent for visual note-taking and location scouting. And remember, a great photograph isn't judged on the merits of the camera that took the picture, but on the emotional impact that the picture has on its audience.

So what if you want to go prosumer? Well, a good prosumer camera should have at least a 3:1 zoom lens and 5MP or better resolution. Also, make sure that the camera has a "hot shoe" or PC connector that lets you use external flash and studio strobes, as well as some means of attaching a cable release or remote control. If the camera has a rotating LCD, you will be able to shoot arms-length photos with the camera held overhead or close to the ground. In addition, I'd recommend a camera that can capture RAW image files and has the ability to use CF II (CompactFlash, Type II) cards. If you go with these features, this will ensure maximum image quality and the flexibility to interpret that image in as many creative ways as possible.

made by still cameras are restricted to low frame rates that are best suited to short, attention-getting sequences for use on a web site or in an email. So the voice annotation capabilities are much more important than recording a "movie" soundtrack—use a prosumer camcorder for that.

Availability of underwater housing. If your camera uses the same or nearly the same body as a major brand camera (especially Canon or Nikon), you can obtain an underwater housing for it. Underwater housings offer excellent protection when shooting in stormy weather and dust storms, as well as when taking pictures underwater.

The focal length difference

If you already have lenses for your film SLR, you need to be aware of an unfortunate problem: a professional DSLR (digital single-lens reflex) typically uses a sensor that is about 2/3 the size of that of a 35mm frame. As a result, an interchangeable lens of a given focal length will have a narrower field of view on most digital cameras than on the film version of the same camera. Compare Figure 1-13 and Figure 1-14 to see an example of how the focal length of a lens differs between a 35mm camera and a pro DSLR. This is not the sort of thing you want to suddenly discover when you're taking pictures in the field!

Hopefully it won't be long before costs fall and all pro DSLRs have full-size sensors, but in the meantime, you should acquire an instinct for what a given

Converters as an Option

For a fraction of the cost of equipping yourself with a 14mm zoom lens (most are in the $1,500 price range) so that you can have a 21mm wide-angle equivalent, you can get a supplementary wide-angle conversion lens that has a 1.5X focal-length factor. However, there are some drawbacks. These converters vary in quality—it's fair to say that only the most expensive will retain an acceptable level of sharpness at the outer edges of the frame. Also, barrel distortion (i.e., curving of otherwise straight edges at the edge of the picture) can be noticeable, so you'll have to choose between effect and accuracy.

> **NOTE**
>
> *At the time of this writing, however, the Kodak 14n and the Canon D1 both contained image sensors that were exactly the same size as a 35mm film frame, meaning that there is in fact no difference in the effective focal length of the lens. In addition, the image in the viewfinder is just as large as what you'd see in the same camera's 35mm viewfinder. At present, however, these cameras are more than double the price of a typical DSLR.*

focal-length lens will translate to on a pro DSLR. An easy way to recalculate it is to add about 50% to the focal length of the lens you're considering. Thus, a 20mm lens becomes a 30mm lens, a 35mm lens becomes a 55mm lens, and so on. These equivalencies vary slightly from camera to camera, but most photographers will find them close enough. Table 1-2 shows some of the more common focal lengths and their equivalents on a pro DSLR.

Figure 1-13. An image as seen by a 100mm lens on a 35mm film camera.

Figure 1-14. The same image as seen by a 100mm lens on a typical pro DSLR.

Table 1-2. Focal lengths of 35mm lenses on DSLRs

Nominal focal length	Equivalent focal length on pro DSLRs
14mm	21mm
21mm	32mm
24mm	36mm
50mm	75mm
105mm	152mm
200mm	300mm
300mm	450mm

EXPERT ADVICE

Depth of Field

Here's another thing to remember: even though a given focal length of lens has a different field of view on a pro DSLR, the depth of field is still the same. However, you can decrease the apparent depth of field in your digital darkroom. There are several other ways to do this, too, and they're discussed in Chapters 6 and 8.

The 4/3ds format—a joint effort between Olympus, Kodak, and Fujifilm—creates a series of lenses for a camera sensor of a specific size. Each of these manufacturers intends to make a range of digital cameras that use an identical size (i.e., ideal format, rather than a 35mm proportion) sensor, as well as lenses that are made specifically to work with that sensor. There are two advantages to this:

1. When you are used to working with a sensor of a specific size, you'll quickly gain an instinct for the angle of view and depth of field for a lens of a given focal length.

2. You get a much wider choice in how you can "grow" your system, since you can buy new camera bodies from any manufacturer who's following this new standard and use them with lenses you already own.

The Computer

The second component that every digital photographer needs is a computer to do post-processing on the images. Of course, any system will work as long as it can download images from your camera and can print them to your printer. And as far as operating systems, it doesn't really matter whether you use Windows or Macintosh; each platform has its own strengths and weaknesses. Just use whichever OS feels more comfortable to you.

EXPERT ADVICE

Ken's Recommendations

If you are considering buying a new system, I would recommend a system with at least the following specifications:

- 2.4 GHz processor or better
- 1 gigabyte of RAM or more
- At least a 17-inch CRT monitor
- A CD-ROM or DVD-ROM burner
- Two or more USB 2.0 connections
- Two or more FireWire (IEEE 1394) ports

As noted above, I would highly recommend both a FireWire and a USB 2.0 port. If your computer is relatively new, it probably already has a FireWire port; if it doesn't, you can buy an expansion card for around $40. If you have neither FireWire nor USB 2.0, you can buy a combination PCI card from Keyspan, Adaptec, SIIG, or D-Link that will give you both types of output in one slot—and all for little more than the price of a single adapter by itself. Most of these cards also work in Mac towers.

Disk storage

You probably noticed that I didn't specify a storage capacity in my recommendations above. Well, if you are serious about the quality of your photos, you'll want to keep them at the highest resolutions possible. You'll probably discover as you go through this book that you want to keep several versions at hand; at a minimum, the original photograph, the exposure-corrected Photoshop file, the version that includes composites and special effects, a finished and flattened version that's saved as a TIFF file, and different sizes that have been optimized for different-sized prints and proofs. If you add all that up, various versions of a single picture could easily consume 500 MB of disk space! If you take several hundred photographs, that can add up to a lot of hard-drive space and hundreds of CDs (as shown in Figure 1-15)!

The obvious solution is to bite the bullet and purchase a ton of hard drive space. And the good news is that hard drives are getting simultaneously faster, more capacious, and cheaper by the week. But before you purchase an internal IDE or SCSI drive, consider some of the other options that are available to the digital photographer:

Figure 1-15. A large stack of CDs holding image files.

Docking stations for internal hard drives. These will let you back up data to a drive, label it, and remove it from the docking station. Whenever you need it again, just insert the drive that holds the files you want. The most convenient docking stations I've found are WeibeTech's FireWire and SuperDrive docking stations, which are all FireWire (IEEE 1394) based. You can get more information at *www.weibetech.com*.

External hard drives. Preformatted hard drives (see Figure 1-16) are now available in either IEEE 1394 (FireWire) or USB flavors from numerous manufacturers. I've come to rely on Maxtor drives, as they are reasonably priced and readily available, and because the company has bent over backward every time I've had a problem. I also like the fact that their latest drives have both FireWire and USB ports and that they just look good when stacked up in my studio.

Adding an external drive is hardly rocket science—just plug it in and you're ready to go. Try to find drives that are preformatted to FAT32 standard, which is the one standard that both accepts long filenames and is compatible with both Macs and PCs. There is a catch, however: you can rarely format the drive on a Mac and have XP recognize it. If you format the drive yourself, use a machine running Windows 98 or XP to assure cross-platform compatibility. (Most of the time, however, you don't have to format a new drive yourself; they are already formatted correctly for cross-platform compatibility when you purchase them.)

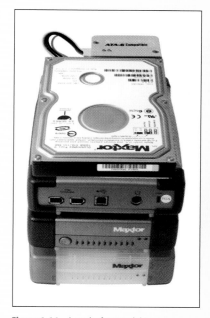

Figure 1-16. A stack of external drives.

If you're a Macintosh-only user, and you're going to create a library of external drives (that need formatting and reformatting) that are meant to plug into a WeibeTech-type dock or generic drive case, I suggest keeping an older PC around that runs Windows 98. You should have no trouble finding such a machine for well under $300.

Software

You should strongly consider purchasing at least one of the following:

Adobe Photoshop CS. Long considered the holy grail of digital photography, Photoshop CS (Creative Studio) is the name of Version 8.0 of this popular software package. With Photoshop, you can do an unimaginable amount of processing to your digital images to get them looking fantastic. Of course, with power comes price. Adobe Photoshop CS currently retails around $650, or around $150 for the upgrade. But trust me, you *really* want this software.

Photoshop Elements

Photoshop Elements 2.0 has close to 90 percent of Photoshop's features but does not interpret RAW files, can't write Actions, will not handle 16-bit or CMYK images (for printing), and has no Curves command.

Adobe Photoshop Elements 2.0. Photoshop Elements is a less-expensive photo manipulation tool from Adobe that is geared primarily towards amateur to intermediate digital photography. Put succinctly, it's a subset of Photoshop. In several cases (but not all) throughout the book, you can use Photoshop Elements to achieve a similar effect. If you can't, I'll let you know.

Throughout the book, I'll recommend other software packages or plug-ins that can make your life easier. In some cases, the same effect can be achieved in Photoshop or Photoshop Elements, and if that's true, I'll discuss the Adobe approach first. In other cases, where it's nearly impossible to achieve the same quality result, I'll recommend one or more third-party tools and discuss their strengths and weaknesses.

Image management software

Organization is another key to being a successful digital photographer. These days, you can do quite a bit of image management using the latest operating systems, Windows XP and Mac OS X (Jaguar or Panther). However, you should be aware of what you can do with programs such as iPhoto 2 and Adobe Photoshop Album, as well as dedicated image management programs such as Canto Cumulus 5.5. There are also numerous third-party programs for image management, such as Picasa, Photo Mechanic, and ACDsee, that we won't cover here but are worth investigating.

iPhoto. iPhoto is one of the coolest tools of all time for managing images. I could probably start some real ego battles over whether it's superior to Adobe Photoshop Album, but that's a moot point—which product you'll use is dictated by which platform you happen to be using to visually organize your image files.

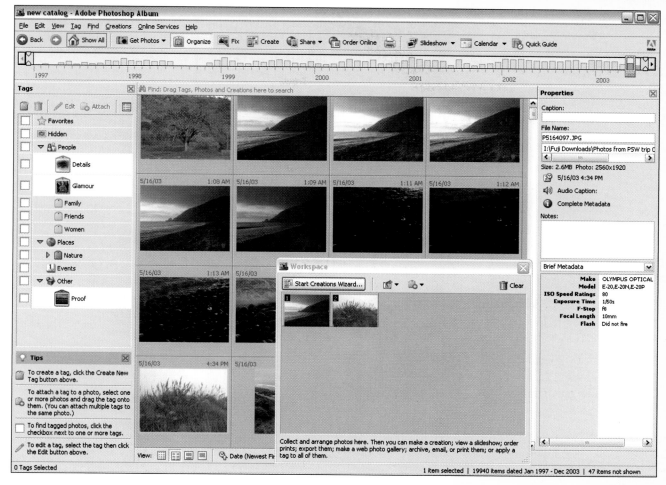

Figure 1-17. Screenshot of Adobe Photoshop Album.

iPhoto is an easy-to-use application that allows you to import and organize your digital photos. Because it interfaces with iMovie and iDVD, Apple users love using it to import and export images from both applications, as well as exporting slides to iTunes. However, the most important feature for the digital photographer the ability to catalog and archive each of your images, which saves information for each photo including date, album, film roll, and a variable number of keywords and comments. iPhoto '04 currently works only on Macs, and is bundled with new OS X machines. If you have an older machine or want to upgrade to the latest version, you can buy the iLife '04 suite from Apple for around $40.

Adobe Photoshop Album. Adobe Photoshop Album is a standalone application that runs only on Windows. Much like iPhoto, you can use Adobe Photoshop Album to catalog photos from your digital camera, CDs, a scanner, or your hard drive. At that point, you can locate any photo by the date it was taken, or by cross-referencing keyword tags that describe each photo. Adobe Photoshop Album is shown in Figure 1-17.

Canto Cumulus 5.5. All in all, I've found Canto Cumulus to be the archetype of professional multimedia asset management programs—even better than iPhoto 2 or Adobe Photoshop Album. First, Cumulus is much faster than Photoshop Album at cataloging, it can search out images by many more criteria, and is more flexible at letting you categorize and search for images. (One of the reasons it's so much more powerful than Photoshop Album is its ability to find images by searching for any piece of information in its very extensive and extensible database.) However, the price for the software is much higher. It starts at $99 for the home version, and moves up from there. Canto Cumulus is shown in Figure 1-18.

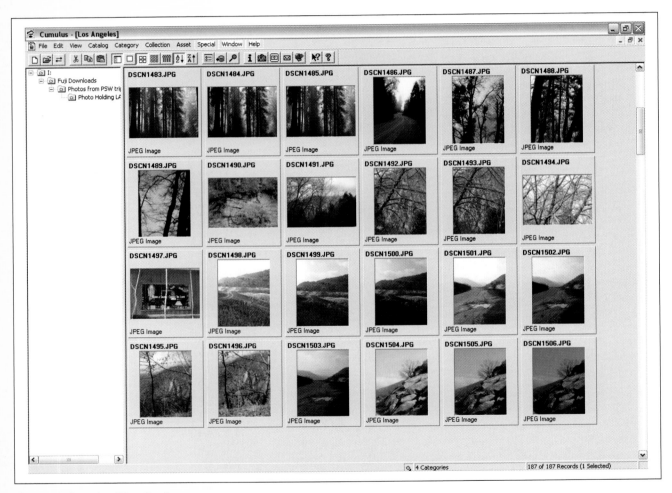

Figure 1-18. Screenshot of Canto Cumulus.

Pressure-sensitive pen pads

After working with digital photos for a while, you'll soon discover that the mouse is not the ideal tool for drawing curvy lines or for doing delicate alteration. It's like trying to write with a bar of soap—possible, but far from ideal. Just look at Figure 1-19.

Many serious digital photographers go the extra mile and purchase a pressure-sensitive pen and tablet. In addition to handling like a pencil on paper or a brush on canvas, the pressure sensitivity means that you can control the width, opacity, and brightness of any stroke (see Figure 1-20) you make in a photo or paint program. For some brushes, it will even consider the tilt of the stroke—making it possible to have calligraphic script that narrows in the curves and widens in the straightaway. Another important characteristic of pressure-sensitive digitizing tablets is absolute positioning, which means that the position of the pen on the tablet corresponds to the same position on the screen.

If you spend much time editing photos, there will be no going back once you have a pressure-sensitive pad. Using a mouse will begin to feel like an unnatural act. And a pressure-sensitive pad is essential when working with photopaintings, which we cover in Chapter 7.

Figure 1-19. A painted line drawn with a mouse.

Figure 1-20. A painted line drawn with a pressure-sensitive pen.

Ken's Recommendations

By far the most popular pressure-sensitive digitizing tablets are from Wacom. Adobe Photoshop CS and Adobe Photoshop Elements 2.0 are both compatible with the Wacom series of pressure-sensitive pads by default. (Most competitors are compatible with Wacom's protocols as well, but it's a good idea to check the literature.)

In my experience, however, no other manufacturer comes close to providing the level of support that Wacom does. At $99, the Graphire2, pictured in Figure 1-21, is Wacom's least expensive tablet, and it does its job very well. If you spend a lot of time painting with applications such as Corel Painter, or you're doing technical drafting, you'll probably want the even greater accuracy of Wacom's Intuos2 line of tablets. The latter range in size from 4 x 5 to 12 x 18 inches, are programmable, offer twice the resolution of the Graphire2 (2540 lpi versus 1015 lpi), and (best of all) have a sexier pen.

If money is a big issue, you may be able to find a used Wacom pad that is compatible with your computer. Models with USB connections are compatible with most modern computers, but even those with older serial interfaces can often be modified to work.

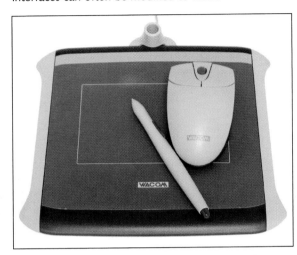

Figure 1-21. The $99 Wacom Graphire2 comes with a mouse, Adobe Photoshop Elements, Painter Classic, and nik multimedias penPalette LE

The Photo Printer

Recently, a number of printers on the market have started advertising themselves as photo printers. So, what exactly is a photo printer? And how does it differ from a regular printer? Well, to understand this, we need to cut through the corporate speak and look at how photo printers work.

First, the two most popular types of digital photo printers are:

Inkjet printers. Inkjet photo printers blend a number of base colors together (typically 6 to 8, instead of 4) to spray a dithered pattern of microscopic ink dots on paper. This results in an image that approximates the color range of a photograph. Inkjet photo printers are essentially the same printers that we've been using for the past ten years, except that the color quality is much better and they are capable of producing prints that can last a long time when using archival inks and papers. So if you plan on exhibiting and selling your digital photographs, you should strongly consider an inkjet photo printer.

Dye-sublimation printers. Dye-sublimation printers use ribbons instead of inks. These colors are then applied to a special form of paper and then heated to blend the colors that are needed. The result is exceptional

quality prints with no perceptible dot pattern. The upside of dye-sublimation printers is that the results are smoother than what can be created by an inkjet printer. The downside is that these printers are much more expensive, and are really geared only towards making photographs (i.e., not text).

Paper and ink

Photo printers require a special type of paper. This is extremely important. You can't use regular inkjet or copier paper while printing a photograph; if you do, the paper will absorb too much ink and it will end up looking like a smeared, wrinkled mess. There are two types of photo paper that you should consider:

Coated letter-weight paper. This is, as you might guess, paper you normally use for the office, but it's coated on one side with a special kind of compound (often consisting of clay) that reduces its absorbency. This results in less color contamination as the inks are sprayed onto the paper from the printer. This paper prints photo illustrations in text documents quite well, but can't handle the intensity of color and doesn't have the traditional feel of photo papers.

Photo paper. Photo paper contains a much heavier coating, and comes in three surfaces typical for traditional photos: glossy, semigloss, and matte. Photo papers can also be bought in a number of art surfaces, such as watercolor, canvas, or silk. When inkjet colors are sprayed onto the surface of photo paper, there is little (if any) color contamination due to the coating, and the result is a much better-looking photo. Photo paper also comes in two different flavors: regular and premium. Premium photo paper is generally available in a heavier stock and is more stable, and prints made on it tend to look the most like real photos. The downside, of course, is that the more "premium" your photo paper, the more green it takes from your pocketbook.

As far as getting the correct ink, you should always start with whatever ink is recommended by the manufacturer of your printer. (This makes more of a difference than you may think, as ink cartridges of a specific color are not necessarily the same from one manufacturer to the next.) As you expand your experience, you may want to experiment with special archival inks.

There are a number of great printers on the market, and calibrating your hardware and software to work with them can take some time. Chapter 11 is dedicated to working with color printers.

The Digital Photographer's Workflow

So, let's start by talking about the workflow that I use as a professional digital photographer. The remaining chapters of this book go into much broader detail for each of these elements, but it's important to get the workflow right at the beginning.

1. *Get your equipment in order and shoot.* This is the focus of Chapter 2. However, I can't emphasize enough how important it is to be prepared for whatever unexpected events may occur during your shoot.

2. *Download the images to your computer, rename them, make simple corrections as necessary, and delete the bad ones.* This step is the focus of Chapter 3. I suggest you start deleting the photos you don't want using your thumbnail image management program. For Windows folk, I recommend Adobe Photoshop Album. Corporate users and those who store their images on multiple servers or across a network may prefer Canto Cumulus. Mac users will benefit from the astounding speed and new features in iPhoto '04.

3. *Rotate the verticals.* Immediately after deleting the bad pictures, select the images that need to be vertically oriented using the Photoshop File Browser, and rotate them. If some need to be rotated left and others need to be rotated right, you will have to repeat the operation for each of those orientations. In order to minimize image deterioration, particularly if you plan to keep files stored as lossy JPEGs, it is best to rotate images to the correct orientation as soon as they are downloaded. See Chapter 3 for more information.

4. *Match the exposure and contrast of sequence shots.* If there are groups of pictures of the same scene and that use the same camera angle and lighting conditions, make sure that they are all of uniform brightness, contrast, and color balance. We'll look at how to do this in Chapter 3.

5. *Archive the keepers.* Once you've eliminated the duds and done your basic corrections, it's essential to archive these items offline. Don't wait until later: you'll never have time to do archiving of huge libraries all at once. Once the basic editing has been done, copy the new files to another hard drive and to a CD or DVD. CDs are easier to distribute because more users have the drives installed and because they only cost about 20 cents each. DVDs, on the other hand, will hold a lot more information.

6. *Make a project or job folder for sharing and communication.* Once your images are basically presentable, make sure that similar frames are uniformly adjusted and that all frames are adjusted to show an acceptable amount of detail and contrast. Again, the easiest way to do this is by

using Album or iPhoto. Collect the photos you want to use in your communications (perhaps to discuss with an assistant, client, or friend before you proceed with additional editing, interpretation, or special effects.)

7. *Sketch out where you're going to do image editing.* Once you've communicated with clients or friends, you'll probably have a short list of preferred photos and a long list of editing suggestions. Ask each of the people you communicate with to add their notes to either a copy of the image or by using an opaque, brightly colored marker on a proof print.

8. *Do the required cropping first.* If your editing sketch has crop marks, do your cropping first. It will save you having to do retouching and editing on details that you're not going to use later anyway.

9. *Tweak specific brightness values with the Curves dialog.* You have already made the basic brightness and contrast corrections earlier. There will undoubtedly be specific areas of tonalities in the image that can benefit from some brightening and darkening while using the Curves command. The easy way to brighten or darken all the objects that fall within a specific tonal range is to use the Curves dialog. We discuss this in more detail in Chapter 6.

10. *Adjust color saturation.* Often, it's not so much the overall color balance of the image but the intensity of the colors that really makes or breaks the impact of the image. This is also discussed in Chapter 6.

11. *Make all physical changes to parts of the image.* Operations that involve actually changing a specific part of the image include burning and dodging, all sorts of retouching, red-eye correction, and cloning to remove undesirable objects in the image such as power lines and lawn trash. These are discussed in Chapters 8 and 9.

12. *Apply any filters you want to use for image adjustments.* If you want to use plug-ins and special effects that will affect the overall image (or any selected part of it), now's the time to do it. Do any filter effects that affect image quality, and perform any local area focus control (blurring and sharpening). All the work you've done to this point will be affected equally, and you won't have to do specialized retouching that takes the effects into consideration.

13. *Apply any filters you want to use for special effects.* If you want to texturize the image, use photo-painting filters, or create colorization special effects, now's the time. Since these effects completely change (and therefore destroy) the original image's data, it's a very good idea to archive the version of the file that exists immediately prior to your applying these effects. See Chapters 7, 10, and 11 for more details.

14. *Copy all the finished images to a new folder and burn it to CD-ROM.* If you have worked on a number of images during your editing process, it's a good idea to back up the entire session to CD-ROM or DVD. It's then much easier to find and repurpose images made for that given session, if needed. Remember, CDs are inexpensive these days, and backups made on them in the course of your work will pay for themselves many times over in time saved, not to mention their value as insurance against losing all that work.

Are You Ready?

At this point, you're probably ready to start taking pictures. Well, you'll quickly discover that the workflow above forms a sort of natural process that most digital photographers follow when they take those prize-winning photographs. That's what the rest of this book is dedicated to teaching you. So, now that you've entered the digital world and have your digital camera and computer and photo printer ready, turn the page and let's start discussing how you can always be prepared to capture that perfect photograph when you're out in the field.

Be Prepared

2

It's probably happened to you. It can happen at any time, and at any place: you just weren't prepared for a shot when you saw it, and it passed you by. Well, the bad news is that with digital photography, you'll still encounter these situations. The good news is that digital cameras help you minimize the chances of missing that all-important moment. And even better, this chapter contains a number of techniques for making sure that this doesn't happen at all. Many digital photographers already know these tips, but even professionals can forget them in the excitement of a shoot.

Getting Started

The first step to being prepared is having the right accessories. In fact, having the right accessory on hand can make a bigger difference in getting a great photo than any choice of digital camera. Look carefully at the difference between Figure 2-1 and Figure 2-2, which shows what a simple tripod can do.

Before you go out

Before you go out, get your gear organized. The following checklists can help you be prepared at all times. Feel free to make copies of these checklists to keep in all your camera bags, and modify it to suit your own needs.

You probably won't need all of these items for each shoot. Note that there are two areas for checkmarks next to each line item. Here's how I do it: if you need an item on a particular shoot, check the box closest to the item. When the item is ready to go, check the outside box.

Figure 2-1. Slight blurring in hand-held shots is especially noticeable in sharp-edged subjects, such as architecture.

Figure 2-2. Using a tripod keeps the shot razor-sharp.

On-Location Accessory Checklist

___ ___ Extra memory (digital-film) cards

___ ___ Batteries fully charged before departure

___ ___ Extra camera batteries

___ ___ Extra flash batteries

___ ___ Car power inverter

___ ___ Chargers for all gear that might require a battery recharge

___ ___ Laptop computer

___ ___ Portable hard drive

___ ___ LCD hood (or anything that shades the LCD in bright sunlight)

___ ___ Cable release

___ ___ Remote control

___ ___ Monopod

___ ___ Tripod

___ ___ Lens shade(s)

___ ___ Polarizing filter(s)

___ ___ UV filter

___ ___ Carrying case or bag

___ ___ Remote-controlled external flash units

___ ___ Air blower

___ ___ Lens brush

___ ___ Extra lenses

___ ___ Underwater housing or camera raincoat

___ ___ Close-up lenses

___ ___ Lens cleaners

___ ___ Voice recorder

___ ___ 2-way radios

___ ___ Reflectors

Studio Accessory Checklist

___ ___ Three strobe-lamp heads

___ ___ Strobe power pack

___ ___ Umbrella reflectors

___ ___ Stepladder

___ ___ Light table

___ ___ Light tent

___ ___ Soft box(es)

___ ___ Backdrop holder for people photography

___ ___ Backdrop holder for still-lifes

___ ___ Fan

___ ___ Music system

___ ___ Video monitor

___ ___ Power supply for camera

___ ___ Three incandescent lamps

___ ___ Copy stand

___ ___ Boom arm for the tripod

Let's quickly go over some hints and common "gotchas" for each of the items in these checklists. We'll start with the on-location accessory checklist.

Extra digital-film memory cards. You should have at least 256 MB if you're shooting RAW files. Remember that having more cards is better than having larger capacity cards: if one card fails, you won't lose as much.

Make sure rechargable batteries are fully charged before departure. However, make sure that you don't leave them in a constant charger for much longer than the required time. Overcharging can actually weaken a battery. (Nickel Cadmium batteries, or NiCads, are well known for this.) A charger that turns itself off when the batteries are fully charged is a wise investment.

Extra camera batteries. I recommend using NiMH (nickel-metal hydride) batteries with a rating of at least XX mAh (milliampere hour). The higher the mAh rating, the better. See Figure 2-3.

Extra flash batteries. Use whatever type your flash requires. Note that if you have several flashes, you may need different battery types for each.

A power inverter. A power inverter plugs into your vehicle's cigarette lighter or into a battery pack and lets you recharge batteries, cell phones, and laptops. You can even run your camera off AC (its wall plug) with the aid of one of these inverters. See Figure 2-4.

Figure 2-3. AA batteries are readily available should your batteries wear out or if you need affordable spares. I recommend using only one brand at a time. Note that I've oriented my batteries in the same way as they're loaded into the camera to remind me that they're fully charged.

Figure 2-4. This inverter allows you to run or charge two devices at a time while you're driving.

Chargers. This includes the entire range of battery chargers, including those for your camera's batteries, laptops, and portable hard drives. Add them to this list as appropriate.

Laptop computer. It helps to bring a laptop along so you can download, review, and do preliminary editing on photos before returning to the studio. This is especially important when traveling.

Portable hard drive. This is a drive that is battery powered or can plug into a power inverter. It either has built-in CF card slots, or can connect to the camera for direct image downloading.

LCD hood. A hood is anything that shades the LCD in bright sunlight; see Figure 2-5 for an example. A square yard of black felt is an inexpensive and useful alternative (and if you sew white or aluminum fabric to one side, you can also use it as a reflector to bounce light where you might need it). If you'd rather purchase one, Hoodman (*www.hoodmanusa.com*) and several other companies make inexpensive portable hoods that attach to the back of your camera.

Figure 2-5. LCD hoods come from several manufacturers to fit a variety of cameras and preferences. This one is from Hoodman. The magnifier slides out if you want to view the LCD at arm's length.

Monopod. Use a monopod when you just don't have the time or energy to carry a tripod. Monopods can be indispensable in keeping telephoto shots and low-light shots steady.

Tripod. For any serious attempts at macro or static-subject photography—or in any situation in which you might want to have both hands free (e.g., you need to shade the lens with a magazine or hold a reflector in your hands)—be sure to bring a tripod.

Lens shade. A lens shade can help reduce flare. Lens flare (a flaring of direct light due to secondary reflections on the lens) is seldom attractive when encountered; if you do want it, it can be added in post-production.

Polarizing filters. Polarizing filters are the best way to control the darkness of the sky and to eliminate glaring reflections. Be sure you use a circular polarizer; others can foul up the camera's light-metering system.

UV filter. UV filters help to darken the sky in outdoor photography without requiring a wider lens aperture for shooting. They can also protect the front lens element.

Carrying case or bag. Make sure your carrying case is big enough to hold everything in this list, plus the camera and at least two lenses. It should have enough padding so that your equipment will be safe if the bag gets bumped, yet it should also be light enough and small enough that you can carry it on the plane with you or hide it under the car seat. Consider color carefully. Black bags are harder to see at night—especially if they're placed on the floor of an unguarded car. On the other hand, highly reflective bags are less likely to transfer the outside temperatures to their contents.

Remote-controlled external flash units. If your external flash units have built-in infrared sensors, they can be fired wirelessly by the camera's built-in flash.

Figure 2-6. The larger bulb is for blowing on the image sensor and larger areas around the camera. The bulb with the brush is usually used for cleaning lenses and viewfinders.

Air blower. If you're using an interchangeable lens camera, you'll need to clean your image sensor from time to time. A big airbulb-type blower (see Figure 2-6) is one of the safest ways to do this. Also, if you can blow dirt and dust away, there's no chance of scratching the lens or eyepiece in the process. (Blower bulbs can occasionally suck in dust and then blow it back out again, which is never good.) The best device I've seen for this is a blower that uses a CO_2 cartridge. With a CO_2 cartridge, the intensity of the air blast can be controlled by the amount of pressure on the trigger. I found mine at American Recorder Technologies, Inc. (*www.american-recorder.com*), but there are many other sources.

---WARNING---

Do not use the aerosol-type air blowers on your camera, as they may spray a liquid residue that will remain on the sensor's photoreceptor cells. That's bad news.

Extra lenses. Be prepared to shoot both wide-angle and telephoto shots. If you use zoom lenses, try to cover the entire range of 24–300mm (35mm equivalency) with a maximum of three lenses. If you do a lot of macro photography, you should also carry a macro lens.

Close-up lenses. These can be used in lieu of a dedicated macro lens, and can be screwed on to the front of your lenses.

Lens brush and cleaners. Be sure the lens brush has soft bristles and is free of oils or solvents. Use cleaners that will not dissolve the coating on your lenses and a microfiber cloth that won't scratch the lens (see Figure 2-7). Kits are available through eyeglass and camera stores.

EXPERT ADVICE

Good Multi-Function Cloths

EIKO, Ltd. (*www.eiko-ltd.com*) makes a microfiber cleaning cloth that is the same color as a Kodak 18% gray card, so it can double for setting color balance. I'll show you how to use this in Chapter 3.

Figure 2-7. Lens spray and a microfiber lens cloth. The cloth happens to be 18% gray (50% light-reflective and color-neutral) so that it can also be used for setting the camera's color balance and for getting an average exposure in scenes that are primarily lighter or darker than average.

Underwater housing or camera raincoat. Use whatever will protect the camera in the various weather conditions you're likely to encounter. If the weather is severe, an underwater housing is your best bet. Ewa Marine housings, sold through B&H Photo (*www.bhphotovideo.com*), are a good choice.

Voice recorder. Small digital voice recorders (see Figure 2-8) will easily fit into a pocket and are very handy for making notes in the field without wasting precious memory on your film cards.

2-way radios. 2-way radios are useful when working with assistants who are cuing distant models, cars, or aiming reflectors during a shoot. They are also useful when having others scout a nearby location, or even when shopping at large trade shows!

Reflectors. Reflectors are a more natural-looking means of brightening shadows than using fill flash. Car windshield reflectors that have a bright metallic side and a white side are both portable and inexpensive—a great choice.

Figure 2-8. Digital recorders are perfect for taking notes and easily fit into a pocket.

Here are some additional explanations for the in-studio accessories.

Strobe-lamp heads. These are a minimum for good lighting control. The heads generally come with a parabolic reflector for general-purpose lighting.

Strobe power pack. The power pack should be at least 1200 watts for a studio that plans to shoot fashion. Much higher power is required for shooting architectural interiors, automobiles, and theatrical sets.

Umbrella reflectors. Umbrella reflectors are the most versatile general-purpose soft-light source.

Stepladder. A stepladder is handy for shooting from an elevated position.

Light table. A light table is useful for under-lighting glass and shooting shadowless still lifes.

Light tent. A light tent can be used to ensure that lighting is uniformly soft all around the subject. This is especially useful for small product shots.

Light domes. A 24 × 36-inch light dome sends out evenly diffuse light over a wide area, approximating a "northlight" coming through a living-room window.

Backdrop holder for people photography. These are useful to hold nine-foot-wide background paper. The most versatile ones will hold several rolls.

Backdrop holder for still lifes. This is usually a rod that fits over a pair of heavy-duty lightstands so that a four-foot roll of seamless paper can be suspended from it.

Fan. A fan can bring long hair to life or propel fog from a fog machine. The fan should be variable speed so that you can control its effect. The more powerful the fan, the wider the range of wind effects you can achieve.

Music system. A music system can help set a mood and atmosphere when photographing people.

Video monitor. A small TV set can be very useful when you want to be able to see your composition without having to peer through the viewfinder, or when you want to confer with others over what the camera sees.

Power supply for camera. Obviously, this keeps the camera from dying in the midst of a long studio shoot.

Three incandescent lamps. Better than strobes for shooting products, still lifes, and 2D art because you can see the exact effect of repositioning the lights.

Copy stand. A copy stand is useful for photographing 2D objects such as artwork and printed pages.

Boom arm for the tripod. A boom arm allows the camera to hang directly over the subject when the camera must be positioned over a tabletop, or when shooting someone lying on the floor.

After you come back

You can waste a lot of time gearing up because you forgot to put things away after your last shoot, or because your batteries are dead and your film cards are full. In order to make sure this doesn't happen, set up what I call a "return routine" and follow it as soon as you get back.

1. Recharge all the batteries you've depleted, or have replacements ready. If the rechargeable batteries in your camera are only partially depleted, recharge them so that the next time you venture forth, you'll have a full charge. Again, be sure not to overcharge.

2. If your flash units use batteries, make sure that you have replacements ready if they're low, or recharge them if they're rechargeable.

3. Immediately download any images to your main computer. Also, transfer any images that are on your laptop and/or portable hard drive to your main computer.

4. Open all the files in the Adobe Photoshop CS or Adobe Photoshop Elements 2.0 browser. Rotate any vertical images that are lying on their sides (Cmd/Ctrl-click each of them, and then press Opt/Alt while clicking the Rotate icon at the bottom of the browser).

5. Cmd/Ctrl-click each image that belongs in a general category (e.g., trees, landscapes, sand), and batch-rename the whole group by the name of its category and a serial number. All of those meaningless code names assigned to the files by your camera now have names that will help you relocate them with your computer's Find/Search command. We'll discuss this more in Chapter 3.

6. Remove all the equipment from your camera bags and blow each piece clean with an air compressor or canned compressed air.

7. Clean all your lenses with an optician's lens-cleaning fluid and a microfiber cleaning cloth.

8. Check your packing list and make sure you have everything you originally brought.

9. Repack your equipment bags for the next shoot.

Again, this is just what I do. Feel free to modify this to suit your needs. However, no matter what you do, it's important to set routines for yourself, especially if getting a job done is critical.

Tip 1: Plan Ahead If Using RAW Files

In Chapter 1, we only brushed on RAW files; let's discuss them further here. Any camera that is capable of shooting RAW files captures more bits of data (10–16 bits of color, depending on the camera) in the image. Translated to English, this means that you are getting billions of shades of color rather than millions.

But our eyes can't even see the million colors that an 8-bit file contains, so why should you care whether you've got billions of shades in your file? Because you can choose precisely which ranges of colors you want to see during post-production image editing. To put it another way: RAW files give you total freedom of interpretation. Look carefully at the difference between Figure 2-9, which is a JPEG, and Figure 2-10, which is a RAW file. If you want to be a professional photographer, you really can't afford to not use RAW files.

Figure 2-9. This JPEG is a nice picture, but what you see is pretty close to what you're going to get.

Figure 2-10. Here's the same image, shot at the same exposure in a RAW file. Look at all the range and detail this image offers! Not only can you see the background in all its glory, but also the bush (5 o'clock position) retains its color clarity.

In Chapter 1, we discussed how a camera uses a grid of photoreceptors on its sensor to measure incoming light. For capturing RAW files, the process is actually a little easier: the camera simply takes the raw data from the CCD, without performing any color interpolation or sharpening, and writes it into its memory. It's then up to the processing software on the computer, and not the camera, to download and interpret the data to the best of its ability.

If you do choose to use RAW files, I highly recommend the speed and accuracy of the Adobe Photoshop CS Camera RAW plug-in to interpret that data. Try to avoid using the RAW file interpreters provided by camera manufacturers unless you absolutely have to—in my experience, they don't offer the amount of creative latitude afforded by the Photoshop CS Camera RAW plug-in. We'll discuss using this plug-in in more detail in Chapter 3.

Space considerations for RAW files

At around 9 to 14 MB per picture, it takes far longer for the camera to write a RAW file to a flash card than it does to write a 2 MB JPEG file. How can you eliminate write time so that you don't miss the opportunity to capture a precious moment? Well, you can't eliminate it completely, but try following these suggestions:

Figure 2-11. The Sandisk Ultra card operates more than twice as fast as Sandisk standard cards, provided your camera or card reader is wired to support the higher speeds.

Speed up camera writing with fast compact flash cards. Most companies that make flash memory cards for digital cameras make versions with a higher speed rating than the 150 KB-per-second transfer rate of ordinary data cards (Figure 2-11). Just as with CD-ROM and recordable drives, the speed rating is measured by a multiplication factor— the number of times faster these cards can transfer data from the camera. But here's the catch: very few cameras can take full advantage of these speeds! The speeds of the data bus and processor in some cameras simply haven't caught up with the speeds of these faster flash cards. Still, these cards are worth testing on your camera. Even a 10 to 20% improvement can make a big difference when you're on the spot. Investigate the specs on your camera and check the company's web site to see if they recommend any specific flash cards.

Get many high-capacity flash cards. Compact flash memory cards now come in capacities as high as 4 GB. Personally, I feel more comfortable with about 512 MB, which holds about the same number of RAW images as a roll of 35mm film. And sometimes memory cards fail *after* you've filled them with pictures and the opportunity to reshoot them has passed. If that ever happens to you, you'll be glad you didn't have all your pictures on one card.

1 GB microdrives may be faster and cheaper in some cameras. One alternative to CF cards is the microdrive, which fits in a CF II card slot. Many experts claim that microdrives are more susceptible to damage than solid-state memory cards, which makes sense because they use very high-speed, highly miniaturized moving parts. (On the other hand, I've had one for over a year that hasn't given me a speck of trouble, and my Fuji S2 actually writes to it faster than to any of the high-speed cards I've tested so far.)

Immediately delete everything you don't want to keep. Whenever there's a break in the shooting, review the images in your camera and delete any obvious mistakes: any image where the lighting, facial expression, composition, or exposure just doesn't work. There are three good reasons why. First, you don't want to show these things to anyone you hope to impress.

Second, they won't be crowding your workflow as you move through the various processes. Finally, they won't be taking up precious memory on your memory cards.

Carry a battery-powered portable hard drive or a laptop. If your shoot takes you away from the studio, it's a good idea to bring along some mechanism to download your photos to. A laptop computer is one option. Of course, you'll want to make sure that you have a fully-charged battery or a power inverter than you can run it off of.

Another option is a pocket-sized, self-powered, rechargeable hard drives marketed mostly to photographers who need to download files while they're in the field. These are sometimes called photo drives. Don't confuse these drives with external desktop USB or FireWire hard drives—those may be a useful way to expand your storage capacity, but they still require a computer (such as a laptop) to function.

Yet another option is a portable CD-R/RW drive from Apacer (*www.apacer.com/apacer_english/product_html/disc_stone_cp100.asp*). This drive interfaces to USB 2.0 (which is backward-compatible with USB 1.1 ports), so transferring data to your computer can be very fast indeed. (If your computer only has USB 1.1 ports, transfer will be pokey—but much less so than using a card reader attached to a 1.1 port and having to download each card separately!) One nice thing about portable CD-R/RW drives is their virtually unlimited capacity. Even though a single disk can hold only 700 MB, you can take along all the disks you want for about 20 cents each...and you can make copies to send home, to a lab, or to a client. However, they're not nearly as compact as portable pocket drives.

EXPERT ADVICE

Portable Photo Drives

Battery-powered portable photo drives come with a variety of feature sets, capacities, and interfaces. The best feature of these drives is that they're small enough to fit into your pocket, thanks to the fact that they're based on the 2-inch laptop drives rather than the 3-inch desktop hard drive.

At the time of this writing, these portable drives range in price from $250 to $600. The more expensive drives have built-in LCD monitors so that you can preview and edit your files after you've downloaded them. This isn't really necessary and tends to double the price of the drive, but it can be handy if you're willing to spend the extra $200–$300. The X'S drives from Vosonic (*www.vosonic.co.uk*) feature slots for all six types of flash cards—good insurance for the future, and handy if you're using it to store data from your MP3 player or Pocket PC. All you have to do to download from the card after insertion in a slot is push a button and wait until the lights stop blinking. You can also use the drive as a card reader when you're back in the studio.

It's also useful to have a drive that features both FireWire and USB ports so you can connect to virtually any computer. Whenever you want to transfer the files to your computer, you just insert a cable between the drive and the computer and it instantly becomes an external drive for that machine. Then, all you have to do is copy the files to the appropriate folders on the main computer.

EXPERT ADVICE

Using Your Car... Efficiently

If you have enough flash memory to keep your camera going until you get back to the car, you can plug your camera's AC adapter into a DC-to-AC power inverter, then delete all your unwanted photos before you write the card to the portable drive or computer. Depending on how you shoot, this can sometimes effectively double or triple the capacity of your portable drive. Also, powering the drive from your car battery eliminates the possibility that the drive will run out of juice before you finish downloading your images. Some pocket drives even come with a car-battery adapter.

Tip 2: Always Return Your Camera to Program Mode

Many times, a great shot can pass in the blink of an eye. Advances in technology continue to make it easier for digital cameras to calculate exposure, color balance, bracketing, sequence shooting, sharpness, and many other factors that can improve the quality of the shot. However, these settings vary from shot to shot, and if you accidentally reuse the camera settings from the previous shot, you may miss the next one. Figures 2-12 and 2-13 provide an excellent example of a moderate shot followed by an unexpectedly great shot. And these shots were only a few seconds apart!

So, here's an easy tip: get in the habit of returning your camera to program mode so that you can just point and shoot, and you'll always be ready for that unexpected shot. (On most digital cameras, program mode is indicated by the letter "P" on the main settings dial, just above the right-hand grip and just behind the shutter button.) In addition, it's a good idea to completely reset the camera to its defaults so that you don't find yourself using the previous settings for bracketing, sharpening, or shooting at an unfaithful color balance.

Figure 2-12. Model feeling a bit intimidated.

Figure 2-13. Same model, a split second later, fun and spontaneous.

If you consistently return your camera to program mode before you begin a new shooting situation, you're more likely to capture the moment you intend to. As soon as you get a break, review the images and adjust the exposure according to your preferences.

If you expect to shoot a series of photos of the same subject in the same location, then you may want to consider switching to a manual exposure, which will ensure that the camera won't change its exposure due to the sudden introduction of a brighter or darker object or light source in part of the picture. You'll also be able to choose equivalent settings that could give you a faster shutter speed for stopping action, a wider aperture in order to blur the background or overexpose for a more high-key (brighter) effect, and so forth. But this should be the exception and not the rule.

Tip 3: Know Your Camera's Shutter Lag and Write Time

It's impossible to predict the exact moment that will tell the story you want your photograph to tell, and you rarely get a second chance to capture it. Even if you're lucky enough to have a shoot full of such moments, you want to make sure you don't miss even one. Consider Figures 2-14 and 2-15.

The difference here is shutter lag, which was mentioned briefly in Chapter 1. If you own an up-to-date professional digital SLR, you probably have no significant shutter lag. If you have a prosumer camera that does have shutter lag, however, be sure it allows you to use external flash and to turn off the LCD preview monitor any time you can do without it. Ditto for autofocus, especially continuous autofocus that changes every time you or the subject makes a slight movement. Why all these things? It's important to have control over these features because built-in flash, preview monitors, continuous autofocus, and special shooting modes force the camera's computer to do calculations before the camera can take the picture, increasing the camera's shutter lag.

Shutter lag isn't the only factor that can keep you from taking the picture at the intended moment. Even experienced digital photographers confuse shutter lag with write time

Figure 2-14. By knowing your shutter lag and anticipating your shot ahead of time, you can capture a great shot like this.

Figure 2-15. However, if you're not aware of your shutter lag and your camera keeps shooting late, you may only get the aftermath.

between exposures. The more resolution your camera has and the higher definition the file type (especially RAW and TIFF files), the more time it takes the camera to write them to the memory card. Most pro SLRs will let you shoot at least 5 shots at the rate of 2–3 frames per second (when shooting high-definition lossless stills) before making you wait for those files to write to the card. At that point, the typical write time will be between 6 and 10 seconds per image. Some of the more expensive SLRs favored by news and sports photographers (who are often willing to sacrifice resolution and definition for timing) use both lower-resolution images (which require less write time) and more expensive, state-of-the-art circuitry that writes much faster. If high-volume, rapid shooting is your style, be sure to check the write time stats for any camera you consider buying. You can almost always find very professional feature-by-feature comparative reviews at *www.dpreview.com*.

Camera write time aside, here are some tricks the pros use to capture that perfect 1/1000th of a second, even if they have to fight digital camera shutter lag in order to do it.

- As we mentioned in Chapter 1, buy a camera that turns on instantly the moment you flip the switch (or, if it's gone to sleep, when you partially depress the shutter button). It's very easy to check this out for yourself in the camera store before you plunk down your cash.

- Keep your camera hanging around your neck with your favorite lens already mounted and the lens cap off.

- If you're shooting in conditions that may require a flash, turn off the internal flash and attach an external unit that runs on its own battery power. Also, consider putting a diffuser over the flash so that you minimize red-eye and maximize the softness and spread of the light.

- If you're shooting a subject, do some test shots before your subject arrives. Instant feedback is the greatest gift a digital camera has to offer, so take full advantage of it before it's time to get serious about capturing a precious moment.

> **TIP**
>
> ## Reducing Resolution to Make Sequences Faster
>
> Some cameras will shoot frames faster if you reduce the resolution. Check your owner's manual to see if this is the case for your camera. If lowering the resolution permits you to shoot frames faster, you'll have to decide whether the moment or the image quality is of paramount importance. If you're shooting for a magazine, newspaper, slide show, or scrapbook, then timing will almost always take precedence.
>
> If resolution is really unimportant and if your camera will shoot videos, you might want to consider that option. Resolution will usually be limited to a mere 320 × 240 pixels, but you will be shooting about 15 frames per second. Later, you can use the enhancing techniques described in Chapter 6.

Now I know it can be difficult to make all the decisions involved in taking a perfect picture in the excitement of the moment. Consider the sea gulls in Figure 2-16. If you wait until the moment has passed, you're not likely to recapture that same intensity.

In those cases, keep the camera hanging around your neck and put the camera into sequence mode. Then, you can press the shutter button an instant ahead of time and shoot the full range of allowable frames. As we mentioned earlier, if you're using RAW files, you'll want to check how quickly those files can be written out to flash; many times, sequence mode isn't the best time to use RAW files.

Figure 2-16. You won't get a second chance to shoot these gulls flying in such perfect composition.

Even if you make mistakes with exposure, color balance, and the correct shutter speed, the godsend is that you're shooting digitally. This means that the first time you have a break in the action, you can take a look at the results and take the time to adjust the camera settings to flatter the specific subject or scene. Shooting digitally also means that you can make corrections after the fact, as you'll see throughout the remainder of this book. Of course, you'll be spending more time in the digital darkroom and you might hate showing someone the unfinished product, but both these inconveniences are worth it if you ultimately get a better result.

> ── **NOTE** ──────────
>
> *Some cameras that shoot RAW give you the option to simultaneously capture a JPEG. This speeds your ability to make contact sheets or to send the images electronically. However, it also increases write time because two versions of the file must be written to the cache and to the card.*

Tip 4: Frame the Picture Properly

Let's assume that a magazine calls you up and begs to print your picture. If you are using a 35mm type SLR digital camera, your image probably has about the same proportions as a 35mm film slide, just a little too tall on its longest side for most page layouts. You can always crop a photo after you've taken it, but you don't want to rely on this too much—you'll end up throwing away a great deal of resolution in the process. The trick here, as demonstrated in Figures 2-17 and 2-18, is to be prepared to frame a picture so that it will look as good as possible with minimal cropping. Compose your picture so that it at least fills as much of the width or length of the frame as appropriate for the intended final layout proportions of the picture, thus ensuring a minimal need for cropping.

Figure 2-17. In this shot, cropping the bottom isn't an option; the subject is too near the edge.

Figure 2-18. However, if we move him up a little (and magically move the windsailor in the background, which you'll see how to do in Chapter 10), we can easily crop to get a properly framed shot that looks great.

A zoom lens makes it much easier to crop the image in the camera without having to move so much that you lose your spontaneity. Don't like something at the edge of your picture? Zoom in slightly and remove it. Zoom lenses are especially helpful when you have to react quickly, whether your subject matter is sports, wildlife, or people on the go. Having said that, however, be as mobile and agile as your physique will permit. Remember, if you maintain a constant distance and position between yourself and the subject, your perspective will be static throughout all of your shots. So, be sure to move around as well. Don't depend entirely on your zoom lenses to do all the cropping for you.

I'd also recommend creating well-composed long, medium, and close-up shots. Too often, you get back to the studio only to discover that you've failed to anchor your story in time and space. Worse, you didn't capture enough information about the subject's surroundings. See Figures 2-19 and 2-20.

Use the following routine:

- Take a long shot to capture the atmosphere surrounding the subject and situation

- Take a medium shot to capture the action in context

- Take a close-up to capture all the details

This routine works best for photojournalism (and other types of assignments that are meant to tell a story), but it's a good idea to keep in mind for any shoot. Remember that when you're shooting digitally, there is no film to waste, so take the time to cover the story from all points of view.

Figure 2-19. Pastries at the San Rafael Farmer's Market.

Figure 2-20. A story of the San Rafael Farmer's Market, including a long shot of the area, a child eating some of the market's delicious food, and a shot of the pastries.

Tip 5: Emphasize the Center of Interest

Compare Figures 2-21 and 2-22. Every time you take a picture, you are trying to convey a message to your audience. So how do you "slap them in the face" with that particular message?

Here are some ways to use lighting, focus, and point of view to direct the viewer's attention to things you don't want to escape unnoticed:

- Use dramatic lighting focused on the subject. If you're shooting in natural light, try using a reflector to block the light in areas outside the center of interest. (You can do this in Photoshop as well.)

- Keep the focus on the subject by keeping the depth of field shallow.

- Contrast the subject with the background by using differences in brightness, color, or pattern.

- Use an unusual point of view to catch the viewer's attention. Spend a little time not keeping the camera at eye level. Look for especially high or low vantage points, such as stairwells, ladders, cherrypickers, or aircraft.

- Let a path in the composition lead you to the subject. Find ways to use other objects in the frame to "point" toward the subject.

It pays to spend some time thinking about what is most likely to distract your viewers from what you want them to focus on. For instance, keep an eye on the edges of the frame. Some very distracting things tend to appear there just when you're ready to press the shutter button. Remember, don't let the supporting cast outshine the star!

Figure 2-21. This is a nice shot…

Figure 2-22. …but the flow of water past the hiker is emphasized with this point of view.

Tip 6: Focus On the Eyes

This is a common tip: sometimes we look at a portrait and just don't feel "connected" to the subject. This is especially true when the model is supposed to be conveying a message directly to the viewer. A great public speaker always makes eye contact with the audience, allowing the audience to feel as if they're being spoken to on a one-to-one basis. Compare Figures 2-23 and 2-24, and you'll understand why the old adage says that the eyes are the windows to the soul. When you're directing your subjects, be sure to advise them that the camera is the audience—not the photographer or anyone else hanging around the set. For your part, learn to lock critical focus on the eyes.

Of course, if you're shooting candids or reportage, it's much more important to shoot your subjects without posing them. There will be many times when it just isn't appropriate reporting to have the subject staring into the camera. Still, once your subjects are comfortable and they've started talking to you, having them communicate their ideas directly to the camera can be a very effective technique.

Figure 2-23. It's a dramatic shot, but look what happens when the cellist actually looks at us…

Figure 2-24. Eye contact instigates one-on-one communication between viewer and model.

Tip 7: Use Fill Flash (Carefully) in Bright Sunlight

Bright, hard lights—such as sunlight—almost always costs you shadow detail if you are exposing for the highlights (as you should when working with digital cameras). See Figures 2-25 and 2-27.

A common solution to this problem is to use your camera flash to fill in the shadow areas with more light. This is called fill flash, and is shown in Figures 2-26 and 2-28. Looks good, right? Well, unfortunately, fill flash can create its own set of problems. It often causes red-eye or creates a sharp shadow under the nose (I call it a *nose moustache*), neither of which is particularly flattering to the subject.

Let's tackle the red-eye problem. Remember that red-eye is caused by bright light that bounces off the back of the eyeballs to an individual's retinas. It's certain death for a portrait. So, what about using your camera's red-eye reduction mode? Well, that's almost always a bad idea, as it fires a pre-flash that can cause all sorts of problems. Your subject may be unconsciously blinking or moving to avoid the oncoming and even brighter flash that's to follow. Also, if you have slave strobes on the set, they can go off too early when the pre-flash fires. Another idea to combat red-eye is to use an external flash that is positioned far enough away from the lens that the bright light doesn't reflect off the back of the subject's retinas. However, the problem with that approach is that it can cast shadows that look even more out of place. The best option is to use a camera's fill-flash mode (*not* the camera's red-eye reduction mode), if it is available. This mode reduces the intensity of the flash so that it doesn't overpower the existing available light.

If your camera doesn't have a fill-flash mode, be sure to take a test shot of your subject first. If the flash overpowers the natural light, try using a longer lens (or zooming in) and moving as far away from the subject as necessary to balance the light. As an alternative to backing away from the subject, you can also try taping a small piece of facial tissue over the flash lens (be careful that it doesn't overlap the viewfinder or focusing sensor). Add layers of facial tissue until you get the flash intensity you want. This has the added benefit of diffusing the fill flash so that its effect isn't as harsh and there's less chance of a nose shadow.

If none of these solutions work, try using a reflector. Reflectors often make your subject squint, but at least the light is constant. With constant light, you can see exactly what effect the reflector is having and can move it accordingly; it also gives your subject a chance to get used to it. I find two types of reflectors to be cheap and handy in almost all circumstances. One is the sort of reflector that you put in the windshield of a car to keep your camera and memory cards from being boiled to death. You can find these reflectors silvered on one side and white on the other; the white side produces a softer

Figure 2-25. Shot in the middle of the day in direct sunlight.

Figure 2-26. Using fill flash to open the shadows paid off substantially.

Figure 2-27. Once again, bright sunlight is rarely flattering.

Figure 2-28. If you have no other choice for time and location, and time is of the essence, fill flash is your best use for on-camera flash.

light, while the silvered side provides a more intense, spotlight-like fill. You can also use the silvered side at a much greater distance from the subject. If you need softer light over a wider area, full-size pieces of white matte illustration board or foam-core board work very well.

Figure 2-29. I've seen busier backgrounds, but there's no question that this one detracts from the subject.

Figure 2-30. The model was knocked out from the background and placed in front of a textured wall (photographed on a separate occasion).

Tip 8: Keep the Background Simple

Objects and shapes in the background often compete with the objects you intended to focus on. This is rarely a good thing. So do your best to keep backgrounds simple. There are many ways to simplify a busy background. For example, note how I "knocked out" the model from Figure 2-29 and inserted her into the plainer background in Figure 2-30 to focus more attention on her.

Here are several methods for keeping a background simple.

- Move the subject in front of a plain wall or sky.

- Use a wide lens opening and a long lens. Focus carefully to keep the subject in sharp focus while the background goes softly out of focus.

- If the subject is moving across the sensor plane (that is, parallel to the picture), use a slow shutter speed and pan (rotate) the camera at the same speed that the subject is moving. Use the spot meter mark in the center of the viewfinder to track your lead on the subject. The result will be a reasonably sharp subject against a motion-blurred background.

- Use a slow shutter speed, place the camera on a tripod, and zoom the lens quickly while you take the shot. This will cause the outer edges of the image to blur radially while the center stays relatively sharp.

- Place the subject in lighting that contrasts strongly with the lighting of the background. If the background is substantially lighter or darker than the subject, the subject will stand out.

Of course, a detailed background is sometimes called for if the objective of the photo is to show the subject relating to the environment, or if you want to create a complicated tableau by making both the subject and its surroundings equally important. As with almost all the other aspects of photography, there are times when violating the rules is the very thing that draws attention to the photograph.

Tip 9: Know How to Keep a Shot Steady

Without steady nerves and a *lot* of practice, it is very hard to hand-hold the camera absolutely motionless. To make matters worse, the longer you keep that shutter open, the more likely you are to quiver just a bit. See Figures 2-31 and 2-32 for an example of how a slight movement (such as breathing) can blur a shot.

So, how do you steady your shot? Well, raising the shutter speed above 1/250th of a second can be a big help. But, there's a downside to this approach: it means that you'll have to use light that is bright enough to support such a shutter speed. That's seldom flattering to your subject.

A far better option is to get a good tripod. This advice may seem obvious, but note that I say *good*. You want to use a sturdy, portable, and easily adjusted tripod. Remember, tripods can be shaken by winds and fast-moving traffic, so don't bother with a unit that's flimsy. Also, make sure you can lock down the pan, tilt, and make height adjustments; many low-cost tripods just aren't very reliable in that regard. You also want to get a tripod that can be adjusted to whatever height you need. Most professional tripods can be lowered so that the camera is only a couple of feet off the ground

The advantages of using a tripod are many: the picture will be sharper, you won't drop the camera, and your hands will be free. That being said, however, tripods can get in the way if you have to move and react rapidly. If that's the case, here are three alternatives.

Figure 2-31. A picture shot at 1/125th of a second. I picked the tripod up slightly from the ground in this shot and didn't bother to be careful with my breathing.

Figure 2-32. I put the tripod back down, screwed in a cable release, and took the same picture. Nice difference in the apparent sparkle of the landscape, but it's not immediately apparent why.

Monopods. These were mentioned briefly in Chapter 1 and are like one leg of an adjustable-height tripod. If you have to stay mobile but also want to use long lenses (which greatly exaggerate the effect of camera movement when the shutter goes off), a monopod will steady the camera enough that you can probably drop the shutter speed by a couple of settings (say, from $1/100^{th}$ to $1/25^{th}$ of a second).

Camera clamps. For railings, doorjambs, and table-tops, you can buy a small clamp that has a miniature pan head welded to it. Simply attach the camera to the pan-head screw and then clamp the clamp onto something rigid; your camera will stay right where you put it.

Table-top tripods. These are nearly as handy: if you want to shoot at a different height than table-top height, you can always hold the small tripod against a wall or place it on any reasonably flat surface (such as a car hood) that happens to be handy.

Using Best Shot Sequence

Sometimes you have to shoot in dim light that calls for a slow shutter speed, and you don't have a tripod. That's never good. However, there's still hope. Nikon and a few other manufacturers feature a shooting mode in some of their cameras that Nikon calls the Best Shot Sequence (BSS). If you set the camera to this mode, it will automatically take the shot at several exposures and use a computer algorithm to compare them while they're still in the image cache. The algorithm throws out all but the image with the sharpest edges, which is usually (but not always) the shot you want. (If you have this feature you'll be amazed at what you can do, even at very slow shutter speeds like 1/2 a second.) Figure 2-33 shows the most unsteady shot in a sequence that I took, and Figure 2-34 shows the steadiest shot.

Figure 2-33. The most unsteady shot in a sequence. **Figure 2-34.** The steadiest shot in the same sequence.

If your camera doesn't have BSS, don't despair. Use your camera's regular sequence shooting mode (if you don't have that, then just shoot several shots manually), preview the sequence on your LCD monitor, and throw out all the shots that are too blurry. It's not as automatic, but you'll often find that there's good reason to keep more than one shot in the sequence—after all, sometimes a blurry shot just adds to the drama.

The amount of camera shake that can be tolerated varies according to your personal style and photo type. For instance, it is generally expected that landscapes and studio product shots will be sharp and absolutely noise-less, while more impressionistic subject matter can tolerate a great deal of blurring. There are even photographers who specialize in blurring nearly everything—the technique can be very effective, especially when the point is motion. However, you're generally better off getting the original as sharp as you can in terms of keeping the camera steady. If you decide you want it blurred later, Photoshop and numerous plug-ins give you endless methods for doing so.

Tip 10: Be Ready to Find a New Point of View

If you're shooting a popular subject and you use a clichéd point of view, the photo will not feel very original or creative. It will give the viewer a "been there, done that" feeling, which is the last emotion you want commercial or art photos to evoke. See Figure 2-35.

You don't have to do much preparation to get an unusual point of view. You could just tilt the camera, lie or squat on the ground (as was done in Figure 2-36), look for a manhole, or carry a portable aluminum stepladder. If you have a prosumer digital camera with a swiveling LCD monitor, you can even hold the camera over your head or set it on the ground.

However, just imagine the fresh point of view you can get by rigging your camera to a more portable object. For example, have you thought of:

- A balloon
- A remote-controlled airplane or helicopter

Figure 2-35. Nice scene, nice feeling of depth, but not very fresh or commanding.

Figure 2-36. Now we're involved in the scene; we can almost feel ourselves walking up the creek bed.

- Kite-based aerial photography
- A remote-controlled model car with a camera

These ideas may seem extreme, but they can actually be a great, inexpensive solution! If you decide to explore some of these options, you'll probably want to use a prosumer camera that can shoot RAW files, as these cameras are lighter and often come with remote controls (e.g., most of the Olympus models).

Remote-controlled helicopters are the most versatile of these solutions. If you want to use this method to get that aerial shot of the mountains, visit your local hobby store—but be prepared to spend several thousand dollars learning to build and fly the right system. (So unless you really enjoy this as a hobby, you might look for someone in your area who already uses a remote-controlled model for aerial photography who'd be willing to rent his time and equipment to you.) You'll also need a fair amount of practice to figure out what camera angles correspond to the position of the model and its distance from the subject. Finally, check with the local police department to find out the local ordinances concerning model airplanes.

Here are some good resources for learning about camera-capable models:

Remote controlled airplanes:
 www.hobby-lobby.com
 www.towerhobbies.com/rcwairclub.html
 www.mrrobot.com

Kite-based aerial photography:
 www.arch.ced.berkeley.edu/kap/equip/equip.html

Remote–controlled model car with a camera:
 www.media.mit.edu/~tlackner/play99/vt.html

You'll find dozens more resources if you search on Google or any other search engine for a combination of words containing "remote control" "model" and "camera."

A less dramatic way to get an aerial photograph is to hire a construction crane called a "cherry picker," as shown in Figure 2-37. Cherry pickers are often used in the movie industry, and can lift you and your camera as high as several stories. Cherry pickers vary in size and maneuverability. If you don't have experience with this type of machinery, you'll probably want to rent an operator as well. Check with your local yellow pages for construction equipment rentals.

Of course, one thing you have to keep in mind when seeking unusual points of view is safety. If you're going to use a remote-controlled model or a construction crane, be sure you know the local laws governing their use, get all the necessary permits, and have an experienced operator. And even if you're doing something as simple as lying on the ground, try to avoid getting run over by a car or trampled by a team of soccer players.

Figure 2-37. One of many types of construction cherry pickers. Some models have boom arms that swing and tilt.

Tip 11: Bring Digital Props

Figure 2-38. Small animals, fruit, electronic gear, and other small items can be excellent for "accessorizing" background photos.

Adding small details or accessories can enhance almost any picture. In fact, small props (for instance, a briefcase or tennis racket in a portrait, or some apples and oranges in a still life) often add considerable character to the message you're trying to convey. For example, look at how the cat in Figure 2-38 was placed on the table in Figure 2-39.

If you have time to anticipate what you are going to be shooting in advance, you can bring some objects that might help to tell the story. However, in the digital age, you can also collect photos of objects that might make good "digital props" (and I use the word "props" in the broadest sense here). For example, you might want to digitally add a car to the driveway of a house, a pet waiting on a doorstep, or even include hats for your portraits.

Digital props can be quite a bit of fun. I often photograph these digital props in the studio so that I can shoot them in both hard and soft light, with the key light positioned at several different angles approximately 30-degrees apart. This makes it much easier to match the prop image with the existing lighting in the main photograph. Another advantage of shooting props in the studio is that you can place them on a plain background of a contrasting color (dark blue or dark green usually works best). You can then easily extract the prop from its background using a number of software tools.

You can also use licensed stock photographs of objects as digital props in your own photographs. (In fact, if you don't have time to go out and take a photo yourself or if you can't find the exact prop you want, stock photos may be your only option.) Stock props are relatively inexpensive and are available on CDs from such vendors as Corbis (*www.corbis.com*), iStockphoto (*www.istockphoto.com*), The Stock Solution (*www.tssphoto.com*), and many others. The downside is that you'll have a tough time getting the lighting and the atmosphere of the prop just right, and it may be difficult to give it the feel of your own authorship.

In order to digitally insert objects, however, you should also become an expert at "knocking out" objects from their original backgrounds. A bit of practice with the knockout and compositing techniques described later in this book should easily qualify you in that regard.

Figure 2-39. I inserted the cat onto the tabletop and generated a shadow. It's passable, but we'll discuss techniques to make knockouts like this look far better in Chapters 9 and 10.

Tip 12: Collect Backgrounds

There are times when the subject is doing something spontaneous that you just *have* to photograph and there's no opportunity to direct them to stand against the ideal background. Or perhaps you want to substitute a background that detracts from the subject, as we mentioned earlier in this chapter.

Fortunately, modern digital darkroom techniques and software allow you to substitute a new background fairly easily. See Figures 2-40 and 2-41. As with the previous tip, it's a really good idea to make a collection of photographs of any interesting doorway, interior, wall texture, window, or pattern of natural foliage that you happen to encounter while you're out shooting other things. When you get back, drop all of these shots into folders that describe the different types of backgrounds.

I *always shoot backgrounds in RAW mode* when possible. The reason is that it is *much* easier to change the color temperature and contrast of the background later to match the color temperature and overall tint of the subject photo. Of course, if the subject photo is also shot in RAW mode, I have better

Question: Why Are Knockouts So Hard to Get Right?

We'll get into this later in the book, but for one thing, most objects have "transitional" rather than razor-sharp edges. That is, in order to look natural, the edges have to blend or merge with the surroundings. The most demanding examples are objects that are reflective or transparent (because the original surroundings can be seen within the object), objects that have very complex edges (such as hair, fur, or foliage), and objects that cast a strong shadow.

Figure 2-40. This tree root in South Florida was beautiful.

Figure 2-41. So is my friend Sonita. So I put them together.

color, exposure, and contrast-matching options all the way around. Be sure to keep that in mind.

Speaking of matching backgrounds, another nice trick is to use lighting effect filters to make the lighting in the background seem to match the general direction of the lighting in the foreground. That brings to mind another important tip: if you shoot your subject on a solid color background in the studio, you can then make your knockout using tools such as Ultimatte AdvantEdge, Corel Knockout, or the Adobe Photoshop Extract filter.

These filters (plug-ins, actually, but they're found on the Filter menu in Photoshop) quickly drop out the background while maintaining nice transitional edges. This brings up another tip: if you choose your background photo *before* you shoot, you'll be able to set up your studio lighting so that the main light source comes from the same direction as the light source in the background. We'll discuss these techniques later in the book.

Tip 13: Protect Your Memory Cards

Heat, dust, and opening the camera too soon can damage film, but you rarely lose the pictures altogether. So you'll be shocked when, after a two-week assignment in the Sahara, you go to download your images and your computer or portable hard drive says that the memory card is damaged or that there are no files. Or maybe you simply pushed the wrong menu button at the wrong time and *zap*! All those amazing shots you took at sunset of that lovely couple from Miami have just evaporated. Now what?

Well, the best solution is not allowing that sort of thing to happen in the first place. If the damage was due to heat or humidity, you should remember to carry your film (flash memory) cards in a sealed container with some silica gel dehumidifier. Get one of those small plastic soup thermoses from a camping store and put your cards in there to protect them from extreme heat.

The self-contained portable hard drives discussed earlier are a very good idea, as they allow you to save and back up your files immediately after you've shot them. Most have their own rechargeable built-in batteries, and there are usually slots for Compact Flash and Smart Media. The CF slot is most commonly a Type II slot, and you can usually buy adapters for SD and Memory Stick flash memory cards from the manufacturer of the drive. Some of the more expensive drives, such as the Smart Disc FlashTrax, also have LCD monitors that allow you to preview images without wasting your camera's batteries.

> **TIP**
>
> ### Recovering from Disaster
>
> If you've already lost your pictures, there's still hope. Try PhotoRescue (*www.datarescue.com/photorescue/*), a file recovery utility made especially for recovering photos from both disk and flash memory sources. I have tried several recovery utilities, but PhotoRescue seems to succeed for more different media types and situations than any other. It even comes in a Macintosh version!

Bringing Out the Best Picture

3

So you've taken the shot. Is that it? Certainly not. In the world of digital photography, you can use a wide variety of techniques to "bring out" the best picture possible from the shot you've taken. You might be wondering, "How is that possible?" Well, in order to explain that, we should provide some background on how cameras differ from our own brains.

The human brain can process more color range at any given instant than a computer monitor or a digital print can display. Our eyes don't actually see more range than film or digital sensors; rather, our brain instructs our eyes to composite different areas of the image into a single whole. The brain does this "multiple-exposure" blending so quickly that we think we are looking at only one image.

The camera, on the other hand, doesn't have our brain inside. It records only one instant in time, which is why we are often so disappointed when we look at a base picture. ("That's not how I remember the color and the details!") And it gets worse: cameras are notorious for losing all the little details in the highlights and shadows of a shot. Thankfully, we can use the camera and the computer to minimize these deficiencies, and bring out a wider range of brightness and colors in each of our digital photographs.

For example, compare the differences between Figures 3-1, 3-2, and 3-3. Figure 3-1 shows a landscape shot using the color range that you would expect from a camera that saves to JPEG. As we mentioned in the previous chapter, RAW files capture a far greater range of colors—you can see an immediate difference in the color range of Figure 3-2. Figure 3-3 shows what the same photograph looks like after applying several of the techniques in this chapter to bring out more detail.

Figure 3-1. A landscape photo as a JPEG image sees it.

Figure 3-2. The same image as a RAW file sees it. Again, look to the darkest and lightest areas to see more detail.

Digital Photography: Expert Techniques

Figure 3-3. The same image after applying some of the exposure techniques below. This picture has a tremendous amount of detail.

Getting Started

Here are two tips that will get you the best results in any situation:

1. If you use RAW files (and I hope you do), get in the habit of slightly underexposing your shot. Then, adjust the RAW image using computer-based software to show the widest range of brightness possible.

2. No matter what file format you use, make Photoshop exposure corrections before any other image modifications.

Let's look at these tips one at a time.

Underexposing and adjusting RAW images

If you shoot in RAW mode, *you always want to underexpose the shot*. This may seem counterintuitive, but when you set the camera for slight under-exposure, you minimize the chances that important details—such as the highlights in backlit hair or the brightest clouds in the sky—will be washed out to solid white. See Figures 3-4 and 3-5 for a nice example of this. In that case, I set my camera to underexpose by a half-stop. With this underexposed shot, I can then bring up details in the shadows by using either the Levels (Adobe Photoshop and Adobe Photoshop Elements) or the Curves (Adobe Photoshop only) tool when first opening an image.

Super CCDs

The "Super CCD" sensor, pioneered by Fuji and featured in several of their latest prosumer cameras and the new S3 Pro, uses two sensor cells for each pixel position—one to record highlights and the other for shadows. These two "exposures" are then blended by the camera to automatically produce dynamic range similar to that described in the procedures on these pages.

Figure 3-4. An image shot using the cameras recommended exposure. Note the lack of detail in the whitest petals.

Figure 3-5. An image shot at -.5 exposure compensation. Although the shot may appear a bit dark, the RAW file converter can correct the overall exposure without losing detail in the highlights.

Figure 3-6. An image saved from the RAW file converter with no adjustments.

Figure 3-7. The same image after choosing settings in the Photoshop Camera RAW plug-in.

Figures 3-6 and 3-7 show another example of a RAW file image as it came from the camera, and how it can be corrected using the Photoshop CS Camera RAW plug-in. As you may recall, I talked about the Camera RAW plug-in just briefly in the previous chapter. Now it's time to use it to bring out the best in your RAW shots.

The Adobe Photoshop CS Camera RAW plug-in is by far the most widely used application to interpret RAW images. Yet another example of the power of this plug-in is shown in Figures 3-8 and 3-9. If you're not using it, I'd give serious consideration to getting your hands on it (it's built into Photoshop CS). Here's why:

1. It handles RAW files in a more versatile and friendly manner than any other interpreter I've seen. It's also much faster than the run-of-the-mill RAW file interpreter.

2. It handles RAW files from a variety of cameras, so if you have multiple cameras (even from different manufacturers), you won't be forced to use different RAW interpreters for each of them.

Different Standards

Unfortunately, RAW files differ from one camera manufacturer to the next. Unlike JPEG and TIFF, the file format that the data is stored in is not yet standardized. Hopefully, this will change soon.

Figure 3-8. This image, shot in a Berkeley bar, as a preadjusted RAW file.

Figure 3-9. The same image after making the adjustments recommended in this section.

The cameras currently supported by the Adobe Photoshop CS RAW plug-in are shown in Table 3-1.

Before You Go Further...

You may want to make sure that your monitor is properly calibrated. See the beginning of Chapter 11 for more details.

Table 3-1. Cameras recognized by the Adobe Photoshop CS RAW plug-in

Canon	Fujifilm	Nikon
EOS-1D	FinePix F700	D1
EOS-1Ds	FinePix S5000 Z	D1H
EOS 10D	FinePix S7000 Z	D1X
EOS-D30	FinePix S2 Pro0	D100
EOS-D60		D2H
EOS 300D (Digital	**Kodak**	Coolpix 5700
Rebel/Kiss Digital)	DCS 14n	Coolpix 5000 (with firm-
PowerShot 600	DCS720x	ware version 1.7)
PowerShot A5	DCS760	
PowerShot A50		**Olympus**
PowerShot S30	**Konica Minolta**	E-10
PowerShot S40	DiIMAGE A1	E-1
PowerShot S45	DiMAGE 5	E-20
PowerShot S50	DiMAGE 7	C-5050 Zoom
PowerShot G1	DiMAGE 7i	C-5060 Zoom
PowerShot G2	DiMAGE 7Hi	
PowerShot G3		**Panasonic**
PowerShot G5	**Leaf**	DMC-LC1
PowerShot Pro70	Valeo 6	
PowerShot Pro90 IS	Valeo 11	**Pentax**
	Valeo 22	*ist D
	Leica	**Sony**
	Digilux 2	DSC-F828

Figure 3-10. The Photoshop CS File Browser.

Using the Adobe Camera RAW plug-in

Here are step-by-step instructions using the Camera RAW plug-in:

1. Open the Adobe Photoshop CS File Browser (File → Browse) and navigate to the folder to which you've downloaded your RAW files. Wait a moment (these files are about 10 times larger than JPEGs) and the thumbnail images for those files will start appearing. See Figure 3-10.

2. Rotate any vertical images to their proper position. (This doesn't affect the file itself, but it makes it a lot easier to judge the photograph without having to lie on your side.) To rotate 90 degrees, click the Rotate Left or Rotate Right icon.

3. Right-click on any image you want to delete, then choose Delete from the in-context menu. RAW files are very large; it's a good idea to get rid of losers before the task of finding the image you want turns into a lifetime project.

4. Use Batch Rename (Automate → Batch Rename) to rename all the images with meaningful, abbreviated filenames that describe the subject by category, name, and an alpha character for each different point of view on the same subject. The Batch Rename dialog is shown in Figure 3-11.

5. Double-click a RAW image, or just drag it into the Adobe Photoshop CS workspace. The Camera RAW plug-in dialog will open. Older versions of the plug-in will appear similar to Figure 3-12, while the Photoshop CS version looks like Figure 3-13.

Figure 3-11. The Batch Rename dialog. You can see some renamed files in the background.

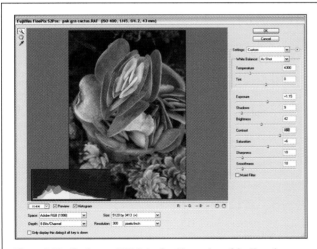

Figure 3-12. The Camera RAW dialog for older versions of the Photoshop Camera RAW plug-in.

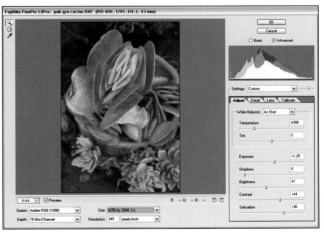

Figure 3-13. The Camera RAW dialog for Photoshop CS.

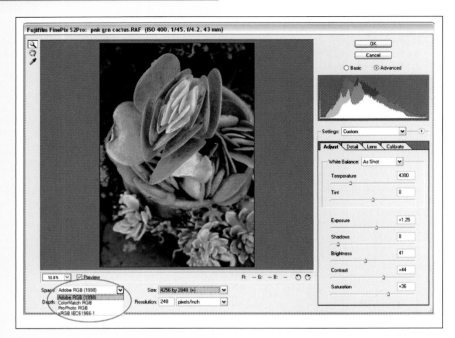

Figure 3-14. The Space Menu.

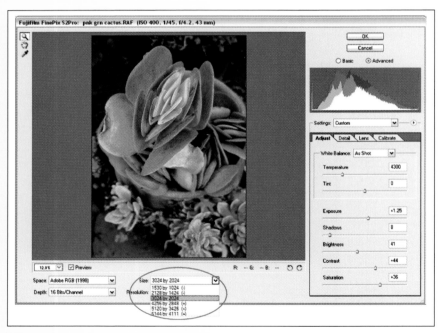

Figure 3-15. The Size menu.

6. Choose 16-bit from the Bit Depth pull-down menu. This will allow the image to open in Adobe Photoshop in 16-bit color mode so that you can do your exposure corrections *before* you have to throw out all that data.

7. Check the Histogram box at the lower right of the Preview window. (In the Photoshop CS version of Camera RAW, the histogram is permanently visible.) The histogram shows the image's distribution of pixels over the full range of brightness. This is a great aid in "scientifically" judging the brightness levels in the image you will export from the RAW file.

8. From the Space pull-down menu, choose the Adobe RGB (1998) color space, as shown in Figure 3-14.

9. From the Size pull-down menu, choose the largest image size the program permits for your camera (see Figure 3-15). I recommend you do this because any adjustments or retouching you do is less obvious if you start with a large image. You'll also be less likely to destroy image information by repeatedly having to enlarge and reduce (resample) the image.

10. Set the resolution to 300 dpi if most of your images go to print, or 240 dpi if they go to a color inkjet printer for display. (If you also create web images, don't worry about size right now; you'll be drastically resampling and optimizing them at a later stage.) See Figure 3-16.

Figure 3-16. The Space, Depth, Size, and Resolution fields.

11. Set the brightness of the brightest significant highlight area by pressing Opt/Alt and dragging the Exposure slider until a light spot appears on the background. The smaller the light spot, the better. The preview image becomes much brighter at this stage.

12. Set the darkness of the area that you want to see as a solid (or near solid) black by pressing Opt/Alt and dragging the Shadows slider until the areas you want to turn dark start appearing against the white background.

13. Drag the Brightness slider to adjust the midtones until you like what you see. There is no scientific "must" for this setting; it's a matter of personal taste.

14. Play with the Contrast and Saturation sliders. They give you a lot of interpretative leeway.

15. Sharpness and Smoothness default to a setting of 25, but I prefer to reduce them to about 10. On the other hand, I have a talented friend who is happier with a setting of 5, so you may want to experiment a bit to find what you like. The idea is to lower these settings so that you can better control edge sharpness and noise (smoothness) using more sophisticated tools, which we'll talk about later.

16. Finally, zoom in to 100% using the Zoom pull-down menu at the bottom left of the Preview window.

And that's it! Click OK to export the image as you see it in the Preview window. Or, if you want to start all over again, press Opt/Alt and click the Cancel button when its label changes to Reset.

> **NOTE**
>
> *Note that the suggestions above for setting lightness and darkness simply give you the best possible starting point to ensure that you have maximum detail in both highlights and shadows. If you later decide that you want deeper shadows or washed-out highlights, you can always change these settings. However, I recommend making these "interpretative" adjustments after you've made all the others as suggested here.*

Do your Photoshop exposure corrections first

The second step is very important: *always do your exposure corrections in Photoshop first*, before any of the other corrections or effects you'll find later in this book. If you don't, you'll find that correcting exposure is extremely hard (if not impossible) to do. For example, look at the difference that exposure correction makes between Figures 3-17 and 3-18.

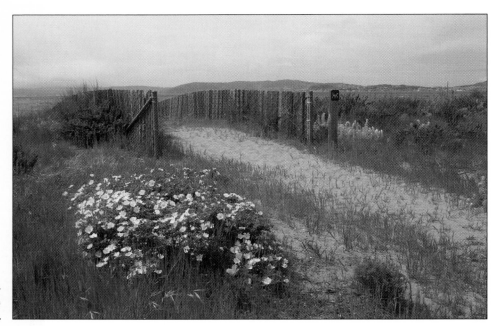

Figure 3-17. An image after corrected export from the Camera RAW plug-in.

Figure 3-18. The same image after further exposure corrections in Adobe Photoshop.

Here's how to do exposure corrections in Photoshop. If you're not using the Adobe Camera RAW support, make sure your camera's RAW file conversion software saves in 16-bit format. Next, open Photoshop, load your image, and use the following routine.

1. As soon as you've opened a new file in Photoshop, choose Image → Duplicate. In the Duplicate Image dialog, add "-cor" (short for "exposure corrected") to the filename (see Figure 3-19). Then click OK.

Figure 3-19. The Duplicate Image dialog.

2. When the duplicate file window appears, select the original file window and click the Close button. You'll be asked if you want to save the file. Since the purpose of this workflow is to keep the original undisturbed, click No. This is especially true if the image is a JPEG that may deteriorate each time it's saved due to repeated image compression.

3. Press Cmd/Ctrl-L (or do it slowly and painfully by choosing Image → Adjustments → Levels). The Levels dialog appears, as shown in Figure 3-20.

4. The first thing you should do is spread the histogram across the visible spectrum of brightness values. If you do this for each color channel independently, you will simultaneously perform a color correction to the image that can be adjusted to suit your preferences with minimum hassle and maximum chances for success. So, press Cmd/Ctrl-1 to first isolate the histogram to the Red channel.

Figure 3-20. The Levels dialog as properly adjusted for the Red channel.

5. Drag the shadow slider at the left of the histogram (for the Input Levels, not the Output Levels) to the first point that shows pixels in the histogram. Some image's histograms will show quite a rise at the very end. If there is no empty space at the shadow (black slider) or highlight (white slider) end of the histogram, don't move the slider for that end. *Do not* move the midtone (gray) slider for any of the color channels at this time.

6. Repeat this for the other color channels (i.e., green and blue). When you have adjusted all of the channels according to the instructions in Step 5, press Cmd/Ctrl-~. You will see the histogram for the composite RGB channel. In the rare case that there is still a gap between the shadow or highlight end of the histogram and the histogram window, adjust the slider for that end of the histogram. See Figure 3-21.

Figure 3-21. The Levels dialog after properly adjusting the composite (RGB) channel.

Figure 3-22. The Levels dialog after adjusting for brighter midtones.

EXPERT ADVICE

Using Autocolor...or Not

You could perform essentially the same operation by choosing Image → Adjust → Autocolor. However, if you perform the process manually, you'll learn how to adjust an image according to your own interpretative preferences. Of course, if you're in a big rush, the Autocolor command is a viable shortcut.

Figure 3-23. The Curves dialog before making any adjustments.

7. Now you can adjust the midtone brightness of the image using the gray slider. If you want to force higher contrast in the image, move the highlight and shadow sliders in toward the center until you get the effect you are looking for. See Figure 3-22.

8. Lastly, you may need to change the overall color balance using the Levels command, even though your adjustments up to this point have made the color balance "theoretically correct." Perhaps you shot the image too far off-balance to achieve correct color balance without forcing it. Or you may want to create a certain mood by giving the image a cooler or warmer color-cast. You can do this by doing what I told you not to do before: move the midtone of the primary color(s) that are most likely to shift the color in your preferred direction. Dragging any color channel's midtone slider to the right will intensify that primary color, while dragging it to the left will intensify its opposite (in the Red channel, dragging the slider to the left will add Cyan; in the Green channel, it will add Magenta). So if you want a cooler (bluer) image, press Cmd/Ctrl-3 to access the histogram for the Blue channel and then drag the midtone slider to the right. If you want a warmer tone, drag the midtone slider to the left. About 85% of the time, you can get the color balance you want by adjusting only one primary; if you don't, there's no law to prevent you from tweaking the other two.

You now have an image with almost perfect exposure correction. But "almost perfect" isn't quite perfect enough. So there are a couple more things you can do using the Curves and Hue/Saturation commands. First, press Cmd/Ctrl-M to bring up the Curves command, shown in Figure 3-23. (Note that this command is not available in Adobe Photoshop Elements 2.0.)

9. Use the Zoom tool (or enter a Zoom Level in the small box at the left end of the Status bar) to make the image small enough so that you can see the entire image in addition to the Curves dialog.

10. Move the cursor over the image (notice that the cursor turns into an eyedropper). Find a specific tone that you want to lighten or darken (perhaps you want to darken the shadow side of a face or brighten the leaves on a tree), and Cmd/Ctrl-click directly over that area.

A black dot will appears on the curve line at the point that precisely represents the area you want to brighten. See Figure 3-24.

Overdoing It

Occasionally, you'll overdo placing and dragging curve points and come up with a surprisingly ugly result. The easy cure is to start over by pressing the Opt/Alt key and clicking the Reset button (before you pressed Opt/Alt it was the Cancel button).

Figure 3-24. The circle on the diagonal line shows the exact level of brightness under the point of the cursor (eyedropper) in the image.

11. Place a point on either side of the dot. This will anchor the curve line so that it doesn't move when you adjust the area that you highlighted above.

12. To brighten the chosen area, drag its dot up; to darken it, drag its dot down. For example, in Figure 3-25, the dot was dragged down slightly.

You're done! Save the file and, if you're curious, compare the original with the corrected version to see what you've done.

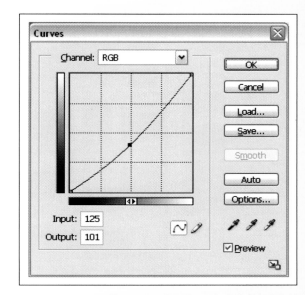

Figure 3-25. Dragging up the dark dot in the center brightens the shades between the dots that were placed on either side. You can manually control specific areas of brightness by adding and dragging more dots.

Tip 1: Get to Know the Photoshop File Browser

Figure 3-26. The Windows Explorer file browser for XP.

We used the Photoshop File Browser earlier to load our RAW files. However, there's so much more that you can do with this File Browser that using it is our number one tip for this chapter.

The file browsers native to the latest Windows and Mac operating systems have been updated to make them a bit more useful for managing image files. (The Windows Explorer file browser for XP is shown in Figure 3-26.) You can now see images as thumbnails, instead of as simply filenames and types. However, neither Windows nor Mac OS X does much to help you rename cryptic camera filenames efficiently, you can't rotate thumbnails without rotating the image, you can't sort by rank so that you can see all the good shots at the top of the browser, and you can't see any file info alongside an image.

This is where the Adobe Photoshop File Browser, which comes with Photoshop and Photoshop Elements, comes in. Here are some of the common problems that the Photoshop File Browser (shown in Figure 3-27) will help you to solve. Each task is named in the order in which you should perform it.

Batch renaming. One of the most powerful features of the File Browser is Batch Rename. If you want to change the entire contents of a folder to have a common filename, you can simply select all the files in that folder, enter the part of the filename that the files will have in common in the first field, leave a space after that name, ask for a

Figure 3-27. The Adobe Photoshop File Browser.

serial number to be added in the next field and the file type extension in the last field, then click OK. All the files will be uniquely named with the same starting filename almost instantly. (As mentioned in Chapter 1, you should do this as soon as you open a new folder of recently downloaded images.)

Ranking images. By choosing Large with Rank from the View By pull-down menu at the bottom of the File Browser palette, you will see the word Rank under each thumbnail. If you haven't assigned a rank, Rank will be followed by an underline (____). Click the underline, and an entry field will automatically appear. You can enter up to 15 alphanumeric characters, but I suggest you just enter one of the first four or five letters in the alphabet, like school grades. Then, when you sort by ranking, you'll see the images that you like best at the top of the browser instead of having to poke around through dozens of thumbnails.

Rotating images. After renaming, the first thing you should do when you download images is open the File Browser and rotate all vertical images to the proper orientation (unless your camera rotates them automatically). The File Browser doesn't actually rotate the image, just the thumbnail. It also inserts an instruction into the file header telling Photoshop to rotate the image as indicated every time it is opened. This is such a valuable data-saving feature that I wonder why Photoshop Album doesn't do exactly the same thing.

Viewing details. If you turn on the Expanded View portion of the File Browser, you can size that view to see a greatly enlarged version of the currently chosen thumbnail. I leave it on by default. Above it, you will see the browser path to show where in the directory the file is located. The File Info will appear immediately below the image preview.

Seeing the file info. You can see all the pertinent information about the photograph by clicking the Expanded View icon at the bottom of the File Browser. Choose All from the pull-down menu that appears when you click on the arrow just under the image info. Scroll down, and you'll see all the information you entered for the image. See Figure 3-28.

Figure 3-28. The File Browser, showing all the image information (see lower left).

Tip 2: Use Your Image Management Program Wisely

TIP

Create Individual Folders for Shoots

If you've just returned from a shoot where all images were shot with the same digital camera, download all the files into the same folder. This makes it easier to both locate and rename all the files with the greatest efficiency with the Photoshop File Browser.

Three image management programs were introduced in Chapter 1: iPhoto, Adobe Photoshop Album, and Canto Cumulus. No matter which application you like, there's a certain process that you should always follow when you start to use these programs.

If you have either Adobe Photoshop Album or iPhoto 2, be sure to do the following to avoid headaches:

1. *Eliminate duplicates.* It is a good idea to rid yourself of all duplicate files on your system before you create your first catalog. Otherwise, you'll have many more files to manage, which can suck up all the time you should be spending hiking, going to movies, or getting quality time with the family.

2. *Create a catalog.* In the terminology of these two programs, a catalog is a database of image thumbnails, as well as user-supplied information such as captions, notes, and tags. You can have the program catalog all the image files on your system, or you can specify that only certain drives or folders be included. For example, I create one catalog for all my screen shots, book illustrations, and business graphics and another exclusively for photographs. This makes it much easier to sort and find what I am specifically looking for. Unfortunately, catalogs only *reference* images throughout the system. Both programs will lose track of files if you delete them or move them to a different location, or inadvertently change a drive letter.

3. *Tag files by category and subcategory.* The idea behind tagging is to get all your images, regardless of their location, organized by category and subcategory. Only Photoshop Album specifically uses tags, but you can accomplish the same thing with iPhoto 2. Each tag is simply a descriptive reference to that file—it does not alter the file itself. Photoshop Album has a fixed set of category tags, but you're allowed to create subcategories and new categories. You can also assign multiple category tags to a photo. For example, you can have a category called Women, and subcategories called Women in Business, Glamour, Girls, etc. Then, when you want to create a project that will involve only certain images within a limited number of categories, you can display only the images with that tag by simply clicking on the tag. This becomes extremely powerful when it comes time to create projects (see Chapter 14) because you can quickly

find just the photos that are best suited to that project and drop them into the Workspace window. Album 2.0 also has Catalogue tags that allow you to place files from any number of tag categories into any special-purpose collection of images.

4. *Add captions and titles.* Both programs allow you to add captions and titles. You can also do this inside the Adobe Photoshop File Browser. If you're using iPhoto, you need to add captions at this stage so that you can find and display files by category.

5. *Archive the files by tag.* At this point, you will find it good organizational practice to use the program's archiving capability to move all the files with a given tag to a dedicated folder. In Photoshop Album, you do this by displaying the items with a given tag and choosing File → Export. In the Export dialog, create the file folder you want to export to after clicking the Browse button. Leave all the other settings at their defaults and click OK. When the operation is complete, close the dialog; the tagged items you selected will still be displayed. Choose Edit → Select All and then press Delete. Be sure to check the "Also delete selected items from the hard disk?" box before clicking OK in the Confirm Deletion from Catalog box. Now, immediately delete the original files and their thumbnails and create a new catalog. It may take a few hours to create the new catalog, so I'd suggest you do it before leaving the studio for the day.

6. *Use the Workspace to create projects.* If you select a few files, you can drag them into a project window. In Photoshop Album, this window is called the Workspace. It's where you can gather files from a variety of tags or other search criteria, do minor editing on them such as one-click exposure and red-eye correction, and then incorporate them into a project.

7. *Archive the projects.* Since you might want to reuse or repurpose a contact sheet or slide show by putting it on a web site or submitting it as a portfolio, it's a good idea to simply store everything you need on a well-labeled CD-ROM. We'll discuss that later in this chapter.

Table 3-2 shows suggested subcategories for tags or titles. Suggested abbreviations for these categories are handy if you want to incorporate them in filenames. iPhoto doesn't have predefined categories, but you can still use these as guidelines. I strongly suggest that you make a similar chart, add every category and subcategory you can think of, then print it out and keep copies in all the places where you might add names to files (e.g., with your laptop, by your computer, etc.). This will ensure consistency and greatly ease all your other file-management chores.

iPhoto Albums

In iPhoto, the equivalent of *tags* is *albums*. Instead of assigning tags to images, you drag thumbnails from the main catalog into albums, which can be named for categories.

The default categories are Favorites, Hidden, People, Places, Events, and Other. See Table 3-2 for some quick suggestions to speed you along.

Table 3-2. Suggested file categories and abbreviations

Category	Notes	Abbreviation
Favorites	Use for anything that pertains to a particular job or personal interest.	Invent your own
Hidden	I use this category for things that are so job-specific that I'm unlikely to use them as stock photos or for any other purpose.	hd
	Camera	cm
	Photo Accessories	paccs
	Screen Shots	ss
	Book Illustrations	bi
People		ppl
	Candids	cndd
	Friends	fnd
	Family	fam
	Glamour	glm
	Kids	kdz
	Babies	bab
	Executives	exc
	Workers	wkr
Places	This is for anything that has more to do with location than population. I duplicate tags when categories overlap, such as People and Russia.	plc
	If I've photographed a particular place (Country, state, city, neighborhood) extensively, I add a specific tag for it.	
	Urban Landscape	ulnd
	Suburban Landscape	slnd
	Urban Detail	udt
	Suburban Detail	sdt
	Mountains	mtn
	Creeks	crk
	Beaches	bch
	Water	wtr
	Nature (also subdivided into plants, flowers, animals, scenes...)	nat
Events		evt
	Nightlife	nte
	Public Gatherings	gth
	Festivals	fst
	Party	pty
	Opening	opn
	Trade Show	tdsw
Other		otr
	Clouds	cld
	Surf	srf
	Backgrounds	bkg
	Textures	ttr
	Objects	obj

Classification Abbreviations

You may want to add classification abbreviations to the ends of filenames while you're working in your album application. The tags or titles help you to keep these filename additions consistent with one another and with their tag names, and they help others to identify specific files, especially if you have to send them to a publisher or client.

Canto Cumulus 5.5

As I mentioned in Chapter 1, I really like using Canto Cumulus 5.5. So why not just forget Photoshop Album and its competitors and jump straight to Canto Cumulus? Well, it's mostly about cost. Photoshop Album costs $50, and some of its competitors cost even less. Canto Cumulus 5.5 Single User Edition sells for $100. The Workgroup Edition sells for closer to a thousand dollars, and each additional seat is $295. In my experience, however, even a low-volume professional photographer will find that the Single User version pays for itself several times over in time saved.

Here are some of its advantages:

- One big advantage of Cumulus is the way it puts albums ("collections") together. Instead of just asking you what files and drives you want to include, Canto actually shows you thumbnails of any directory, and you can either ask for all the files in that directory or simply drag and drop the files you want to catalog into the collection. There is an immense amount of flexibility in how you can put the collection together, too.

- Cumulus uses categories instead of tags. You can create categories and subcategories, then just drag files into them from directories in the Cumulus browser. There's no limit to the number of primary categories you can have or how you name them, and you can establish subcategories any way you want. You can also assign multiple categories to any image. Canto suggests assigning them by Image Type, Project, and Subject as the root categories. Not a bad idea.

- You can drag and drop categories, either by dragging the image file to the category or by dragging the category to the image, much as you do in Photoshop Album. You can search for an image by anything you type into its record fields. Record fields are automatically filled in with any data that is already in the file, such as EXIF data or the data you entered in Album or in the Photoshop File Info interface. You can then add additional fields in Cumulus if you wish.

- You can create collections of files by searching for any piece of information that exists in an image's data fields. This is one of the most amazing things about Canto Cumulus. For example, say you wanted to put together a collection of finished versions of red flower images photographed in the springtime. No problem—just search the right fields for the right data and you'll have your collection in an instant.

> **EXPERT ADVICE**
>
> ## Creating Web Portfolios Easily
>
> Canto Cumulus can automatically create a web portfolio from a preselected collection of on-disk photos. This is, in my opinion, well worth the money alone. Files are sized and optimized automatically in a matter of minutes. Many of these programs will also create frames and automatically title the images. Of the programs mentioned in this chapter, Cumulus and Photoshop Album are best at this because they allow you to add meaningful titles to the file data and therefore don't have to depend on cryptic filenames. It's then very easy to individualize the style of the gallery by going into the HTML and changing things such as type fonts, background colors, and even the positioning of the individual files.

- Like Photoshop Album, Cumulus can also create slide shows and HTML web pages that catalog your photo collections. Cumulus creates a QuickTime slide show instead of a PDF slide show, regardless of the platform you're working on. You can move assets from one disk or directory to another, something you can only dream about in Album. You can also move assets to an FTP site if you need to share files with others.

When it comes to image management, it may seem as though you might do okay to use the file-browsing capabilities built into your operating system. However, these don't give you nearly the power and flexibility of a full-featured image management program. It's more difficult to change the size of thumbnails, and you certainly couldn't undertake the archiving operations mentioned later.

Given the power of Cumulus, you might be wondering whether there's any point in using Photoshop Album. I feel there is. Album excels in building projects such as slide shows, web galleries, books, CDs, and gifts, thanks to the ease with which you can tag files, view them visually, and drop them into the workspace window where they can be ordered for use in a project.

Tip 3: Use a Gray Card to Make Instant Accurate Corrections

If you are shooting in a shaded area next to an intensely colored wall, shooting with mixed lighting, or using fluorescent tubes that vary in color from their stated color balance (a maddeningly common occurrence), you may have a hard time adjusting color balance using some of the techniques described at the beginning of the chapter. This is because you have to guess at the proper changes in more than one color channel.

Figure 3-29. The subject has a bluish cast. An 18% gray lens-cleaning cloth has been placed in the frame.

One way to help is to start by taking a test shot that includes an 18% gray card (or other item that is 18% gray), as shown in Figure 3-29. These cards reflect 50% of the light cast on to them. Kodak's 18% gray card is very popular and can be found at most pro camera stores. Microstar's 18% gray lens cleaning cloth is compact, inexpensive, and serves multiple purposes. Personally, I like to order several cards at a time (they're easy to lose) and it's a good idea to have one in every camera's carrying case so that you don't forget it when you venture out to shoot.

If you place your camera in spot-meter mode and set the white balance to automatic, you increase your chances of getting the proper color balance in the image when you take the shot. Unfortunately, the camera will probably pick another color balance as soon as you move the gray card or cloth from the picture. The best way around this is to keep the shutter button half depressed to lock in the settings, have someone else remove the gray card, then press the button all the way to take the shot.

If you can't do that, the gray card still serves a purpose, as it can be used by Photoshop as a basis to balance the overall color and exposure, yielding a photo such as Figure 3-30. Here's how you do it.

1. When you get the image with the gray card/cloth into Photoshop or Photoshop Elements, open either the Levels or Curves dialog. (The Curves dialog is shown in Figure 3-31.) At the lower-right side of the dialog, you will see three eyedroppers: black (shadow), gray (midtone), and white (highlight). Choose the gray eyedropper, click on the gray card in the photo, and presto! The color balance in that image is instantly perfect, yet your overall exposure doesn't change.

2. In the dialog, click the Save button. This will save the settings used to correct the image. When the Save dialog appears, give the *.acv* file a category name that describes all the images you want to correct according to the same setting. Save and close the gray card file.

3. Drag all the other files you want to color-correct into the workspace so that they're all open at the same time. Click each in turn to make it active, then press Cmd/Ctrl-M to open the Curves dialog. Click the Load button (it brings up a standard "File Open"-type dialog) to load the *.acv* file you saved for the gray card exposure. When the file loads, the color balance will automatically correct. If this is the last curves adjustment you need to make for this image, just click OK and then Save As, and add "clr corr" to the filename just before the final serial number.

4. Repeat Step 3 for all the other images in the series. If you have created an action, just highlight it in the Actions palette and click Play to do everything in this exercise with a couple of mouse clicks.

Figure 3-30. This image has been color-corrected with the same settings used to correct Figure 3-29. The color corrections were made in the Curves dialog, and the exposure corrections were made at the same time.

EXPERT ADVICE

Using Actions

The gray-card routine works even faster if you create a Photoshop action for it. All you have to do is create a new action. Name the action in the resulting dialog and click OK to start recording. Then perform these steps and click the Stop icon at the bottom of the Actions palette when you've completed the routine.

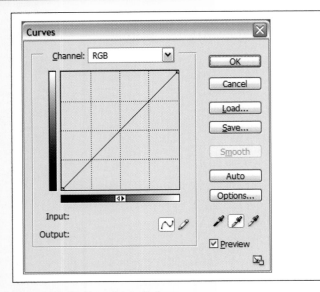

Figure 3-31. The Curves dialog with the gray eyedropper tool highlighted.

Experimenting with Eyedroppers

The black and white eyedroppers can also correct color balance if you can find an absolutely black or white object in the picture, but they will also likely change the overall exposure. It's worth experimenting with these options at least once, as there may be times when they are useful. However, they should be used only as a last resort or an intentional deviation meant to create a "mood."

Sadly, it's not practical to stick a gray card into every shooting situation. All too often, you simply need to shoot first and ask questions later. Thankfully, Photoshop lets you correct color balance in numerous ways, so with a little bit of effort you'll likely produce a perfectly acceptable result. For instance, you can use the technique described earlier when setting levels; you can color-correct specific areas of brightness by using the Curves dialog on one or more color channels; and you can even break down and use the Image → Color Balance, Image → Hue/Saturation, or Image → Variations dialog to change the color balance. If you've shot RAW files, you can also make adjustments with the Temperature and Tint sliders in the Adobe Photoshop Camera RAW plug-in dialog.

EXPERT ADVICE

Don't Forget Photoshop Adjustment Layers!

If you use the Levels or Curves command as an adjustment layer, you can instantly adjust other images shot in the same conditions. To do this, open the original image and its Layers palette and link all the adjustment layers. Next, open any image in which you want to make identical adjustments. Make the first image active and then drag the linked adjustment layers to the image you just opened. The original adjustment layers instantly appear in the Layers palette of the new image, and the layers are automatically adjusted.

Tip 4: Keep the Original Image Intact When You Start Making Modifications

One of the great things about digital photography is that it accelerates your ability to meet your deadlines. In a rush, however, it's easy to forget that once you've modified an image—particularly if it's an already-compromised JPEG—you have lost image quality data that you can *never* retrieve.

There's an easy solution: *never make modifications to the original file*. I always add the abbreviation "orig" to the original interpretation of any file, especially if that interpretation is a JPEG image. Most originals, such as Figure 3-32, are destroyed simply because the photographer or the assistant forgot that a

Figure 3-32. The original photo.

Figure 3-33. One of many interpretations that has the same file size.

duplicate should be made before making modifications to the image (such as the zoom and color correction in Figure 3-33).

As I hinted at earlier, you can also protect the original by rotating the thumbnail representation of the file in the Adobe Photoshop CS File Browser before you open it inside of Photoshop. This saves a rotated proxy of the image and leaves the original completely unscathed. It also tells Photoshop how to rotate the image as soon as the file is opened. As long as you save the file with a new name when you're done working with it in Photoshop, it never needs to be rotated again. To rotate the image in the File Browser, click the Rotate icon in the bottom left margin of the File Browser. (Click Opt/Alt simultaneously to rotate counterclockwise.)

Because many of their browsing functions overlap, it's difficult to know when to use the File Browser versus the OS browser versus applications such as iPhoto, Photoshop Album, or Canto Cumulus. Here's what I do: use the Photoshop File Browser with the Camera RAW plug-in to open your RAW files, to name images as soon as they're downloaded from the camera, and to rotate images. Once you've done that, it's easier to keep your ducks in a row if you start working in iPhoto, Photoshop Album, or Cumulus.

> **EXPERT ADVICE**
>
> ## Immediate Duplication
>
> It's a good idea to get in the habit of choosing Image → Duplicate the *minute* you open an image (you probably noticed that we did that earlier). A dialog will appear asking you to name the duplicate; you can substitute the "orig" suffix for one that describes how you'll be interpreting the image. Then close the original file (you don't need to save it) before you've done anything more to it.

Tip 5: Keep Layers 'Til the End

Once the layers in an image have been flattened and the file has been closed, you can't make a change to one of the layers without starting over from scratch. This is true when it comes to correcting exposure as well as the effects used on objects. The problem is, the more layers you have, the larger the file size (with the exception of adjustment layers, which add virtually nothing to file size). In fact, each layer can increase file size by as much as 100% of the size of the background layer. Compare Figure 3-34 with Figure 3-35 to see all the layers that were added to the original photograph. Figure 3-36 shows the actual layers in the Layers palette.

This brings me to another valuable tip: *keep those layers*. There is a wealth of advantages to keeping layers for as long as possible before flattening the image. You should flatten or merge layers only when you're sure that you'll no longer need them, or when the file size is so large that every little edit takes minutes instead of seconds.

Figure 3-34. Starting from scratch.

Figure 3-35. There are six layers in this image, including correction layers, the helicopter, the birds in the foreground, and the birds shadows.

When you are ready to send the file elsewhere and *don't want it to be altered*, choose Image → Duplicate. Then flatten and rename the duplicate to reflect the purpose for which it will be used. I recommend saving it as a TIFF file.

Many people are too miserly when it comes to saving hard drive space, a hangover from the days when it wasn't affordable or easy to add drive space to an existing computer. Today, FireWire and USB 2.0 ports allow you to daisy-chain numerous drives together for about $1 per gigabyte. Since those drives are also hot-pluggable, they can be stored offline when they're used to hold older projects or to archive images. In other words, there's no practical limit to how much hard drive space you can easily attach to one computer. Don't sell yourself short.

Figure 3-36. The Layers palette for the photo in Figure 3-35.

Tip 6: Keep Duplicate Files to a Minimum

Earlier, I mentioned that you should use an image management program to keep down the amount of duplicate files on your system. That's a good idea no matter what.

As cameras increase their sensor size, resolution, and RAW file bit-depth, image files get larger. On top of that, digital photography makes it easier to interpret the same image in many different ways in order to create different moods, meet different layout specs, or match different color schemes. The more prolific you are in digital photography, the worse this problem can become. Before you know it, you can end up with duplicate files everywhere on your data drives. The results of a Windows XP Search command on one of my drives, shown in Figure 3-37, illustrates how bad it can get.

Figure 3-37. A typical search for files using the Windows XP Search command.

To remedy this problem, you need to employ both of the following solutions:

1. Create good habits for naming, tagging, and storing files as you create them.

2. Immediately get rid of all the useless duplicates on your system before you start using file-organizing software such as Adobe Photoshop Album.

Note that getting rid of duplicate files is not a repeat of the advice to delete all the mistakes from your camera cards before you download them. The problem here is that it's too easy to create numerous copies of the same file *after* you've downloaded it. You may create various versions because you've exported them to different computers within your office system. Or you may just forget where you stored the file and end up saving it again. I once found myself with 45,000 photographs on my main computer when I tried to consolidate all my image files and about four-fifths of them turned out to be duplicates. Trust me: getting rid of all those duplicates is one of the most tedious, boring, and time-consuming jobs on the planet!

The traditional way to get rid of duplicate files is to search for all the image files with a given filename using the search facilities built into the operating system. Some image management software, such as Adobe Photoshop Album, Canto Cumulus 5.5 (the traditional pro favorite), Picasa, and even the Adobe Photoshop and Photoshop Elements File Browsers can help in getting rid of duplicates because you can see the images. However, this just takes *way* too long if you've been collecting digital images for a year or more and haven't carefully managed your accumulation of dupes.

What you really need is a "de-duplication utility." My personal favorite is a $24 program appropriately called DeDupe (see Figure 3-38). If you're a Mac user, you can run DeDupe with the aid of VirtualPC. If you want, download the full version from *www.technopundits.com/dedupe.htm* and put it to work right away.

When you set up DeDupe, you can specify which drives and directories you want to search, as well as what file types you want to search for. Then, just click the Run icon and the program does a thorough search. On my system, which contains over a terabyte of files, this can take over an hour, but when the search is finished all the files are sorted alphabetically by name. DeDupe automatically makes the first file with a given name the "primary" file, codes it with a gray bar, and then lists all the duplicate files beneath it. (Files with different filename extensions are not treated as duplicates.)

> **WARNING**
>
> *Exercise extreme caution when trying to de-dupe files that have the original serial numbers given to them by the camera. It is entirely possible that multiple files have exactly the same name and are exactly the same size. Be sure to rename these files as soon as you download them so that you can avoid this problem (see Tip 1 for more on using the File Browser for batch renaming). If you already have hundreds of serialized files downloaded, ita wouldn't be a bad idea to use the File Browser to batch-rename them all before de-duping.*

Figure 3-38. The DeDupe file duplicate search interface.

Here's the most efficient routine I've found for eliminating unnecessary files using DeDupe:

1. Scroll down until you have an entire screen of real duplicates.

2. Mark the primary file for each list of duplicates. Use the Return/Enter key to fly through the cautionary dialogs.

3. Shift-click to highlight the entire list.

4. Ctrl-click to deselect the primary files.

5. Double-check to make sure that all the highlighted files are actually duplicates (with the same file size and date). Deselect any that aren't.

6. Right-click to choose Delete Duplicate, then press Return/Enter twice to fly through warning dialogs.

7. Scroll up until you have a whole new page of duplicates.

Columns can be narrowed or widened by dragging the vertical table line. Do this to ensure that you can see all the data you need to see to determine if the file is actually a duplicate.

If you follow the suggestions in Tip 2: Use Your Image Management Program Wisely, you should never need to use DeDupe. However, if and when you do need it, DeDupe can be a lifesaver. However, DeDupe does lack some capability that I'd like to see added: the ability to preview a thumbnail, the option to delete all files of a given name, and the option to rename files on the spot in case a duplicate isn't really a duplicate (e.g., a web, proof, or small version of the file, or a version that has been edited but hasn't been cropped or resized).

As noted earlier, if you're a Mac user, you won't be able to use DeDupe unless you own the version of Virtual PC that's appropriate to your operating system.

Tip 7: Use Special Names

Adobe Photoshop and Photoshop Elements give you an impressive list of file formats that you can save to. They then complicate matters by adding a variety of options as to what to include with a file when you save it. If you don't pay attention to how you name your files when you're choosing those options, you'll either needlessly increase the number of duplicate files on your system or you'll start deleting files that you spent hours editing. Compare Figure 3-39 and Figure 3-40 to see examples of a magnified JPEG and a magnified TIF, based on various settings that we've given the files when we save it. (These are two separate images, each magnified to 400%.)

Figure 3-39. Detail of a JPEG file with moderate compression (magnified to 400% of original image). Note the blockiness.

Figure 3-40. Detail of a TIF file (magnified to 400% of original image). Note how much better the image quality is compared to a JPEG.

Figure 3-41. Note the abbreviation that has been inserted at the end of the filename.

The solution to this problem lies in doing two things:

1. Choose your save options carefully and purposefully.

2. Add information to the filename that lets you know how and why the file differs from the original enhanced file.

Naming files so that you know how and why they differ from other versions of the same photo makes it much easier to distinguish different versions of the same files from others that are simply duplicates. As mentioned previously, this is best done by adding a short abbreviation as the very last element of the filename when the Save or Save As dialog appears. Photoshop always shows the current name of the file in the File Name field. Place your cursor just ahead of the dot that precedes the file extension and then type in the abbreviation. Table 3-3 shows a list of abbreviations that I use to show the important characteristics of a file; these should be added to the abbreviations that designate the file's purpose. I also add a serial number to the original in order to track different versions of these operations.

Table 3-3. Helpful Photoshop abbreviations

Abbreviation	Meaning
cor01	The primary exposure-corrected file; nothing else has been done to this image. You will want to go back to this file if you decide to explore a whole new route to enhancing the image. The serial number indicates further corrections.
fx01	Special effects have been added to the original.
cmp01	Additional images have been composited into the original.
sm01	This is a small 1024 × 768 version of the file that can be used for presentations, CD albums, project printing, etc. Using smaller images saves time when a prototype project involves numerous images.
wb01	The image is web optimized.
pub01	The image is sized and profiled for offset printed publication.
lg01	The image is flattened and sized for an exhibit print.

See Figure 3-41 for a practical application.

There are literally dozens of image file formats, so it's a good idea to limit your formats to those you're most likely to use. Unless you have an application that requires a peculiar format in order for you to do a job, you should convert all of these weird formats to the four that are most universally accepted across the various computer platforms. Doing so will save a lot of confusion later on. Table 3-4 shows the most common Photoshop extensions, and some recommendations on using them.

Table 3-4. Common Photoshop extensions

Extension	Purpose
.psd	The Adobe Photoshop multilayer file format, which can also be read by most other image-editing and paint applications. Always use this format for works in progress, including those that you may want to further alter at some later date.
.tif	The most cross-platform and cross-application compatible file format for single-layer lossless images. Use this for anything that you are shipping as a finished file for publication or for service bureau printing.
.jpg	The most widely accepted full-color format for photo-quality web images or for any other application where files must be highly compressed in order to save storage or data transmission space. Do *not* use this format to archive files that must maintain maximum quality.
.gif	The best web format for animations and colored text, drawings, and flat-color illustrations.

The Save As dialog

You may find it helpful to make use of the following features in the Photoshop and Photoshop Elements "Save As" dialogs. Most of these options should already be turned off, unless you have created that entity (e.g., annotations or layers) before saving the file. Some of these options are not available with Photoshop Elements.

As a Copy. This option lets you save a version of an image that you've altered to a different filename. You can also change the filename by adding the distinction codes listed in the preceding section.

Alpha channels. Any time you spend more than 10 minutes making a selection, it's a good idea to save that selection so that you can recall it if you decide to make more changes to an image (choose Select → Save Selection). The saved selection takes the form of an alpha (transparency) channel, which will be bundled with the file if the Alpha Channels checkbox in the Save As dialog is checked. The downside of saving each selection is that it increases the file size by approximately one-third from the original RGB file. So you don't want to save alpha channels if you won't be using them again for a final version of a file or for a file that has to be web-optimized. We'll talk more about this in Chapter 5.

Layers. Each image layer can easily double the file size. However, you should save layers whenever reasonable. If disk space is a worry, you might be better off biting the bullet and buying more drives instead of having to re-create the entire editing process just to make a slight change in exposure or re-create a special effect or composite.

Annotations. Many people don't know that Adobe Photoshop CS lets you add both voice and text annotations to an image. These annotations can be a big help if you're part of a crew that is working on an image, or if you want to collaborate with someone else. They're also useful as notes or reminders of something that you might want to teach or write about later on. On the other hand, annotations can add quite a bit to file size and won't work in all file formats, so don't save annotations if you don't need them. To make an annotation, simply choose the text or voice annotation tool from the Toolbox and click when the cursor is over the part of the image that you want to annotate. You can open and close the annotation at any time. If you make all annotations on a separate layer, you can hide that layer anytime you want to see the image without the annotation markers.

Spot colors. Spot colors are process colors that are printed with a dedicated ink—usually to ensure a perfect match with a client's logo or product color (think Coke red or Master's Tournament green). If you've specified them in a file to be used by the client whose color it is, be sure that the color stays with the file.

Color profile. Be sure to embed the color profile if you want the destination printer to print the file as you envisioned it.

Image Preview options. If you check this box, you will save the thumbnails. I'd recommend doing this unless the file is being sent to an Internet destination where file space is important.

Try to make the Photoshop Save/Save As dialogs the only place where you set and change the options described above—even if other utilities allow you to change them. Keep in mind that if you don't conscientiously stick to the plan, your efforts at effective file management will have a less consistent payoff. You'll start wondering if it's really safe to eliminate what you think is a duplicate, and you'll start designating primary files that really should have been eliminated.

Tip 8: Add and Maintain File Information

You need a way to record the circumstances and feelings that surrounded the taking of the photograph, or the technical information about how the picture was taken (known as EXIF data), or the relevant categories and keywords that might help you locate files that are suited to a particular market.

Photoshop allows you to enter and save various kinds of information with a file any time you open it by using the File Info command (shown in both Figure 3-42 and Figure 3-43). This command is located on the crowded File menu, which makes it very easy to overlook when saving and retrieving information about your image. So make it a habit of choosing File → File Info as soon as you use Photoshop to open a file for the first time.

Figure 3-42. Screenshot of user-entered general file information.

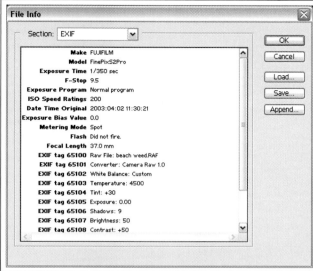

Figure 3-43. Screenshot of EXIF data that comes with a file. This is often provided by the camera.

At a minimum, add a title that relates the file to the shoot it was taken for (e.g., "Telegraph Ave – student bookstore façade"). Later, you can use the search capability of other file management programs to locate all the Telegraph Ave photos. If you're getting paid for the shot, name it after the client and assignment. In any case, be sure the name of the shoot is descriptive enough and standardized enough to help you relate it to other shoots of the same type. Then, create a macro that will open the file and append the information from a saved file to the file info for each image in the folder (you've created a separate folder for each shoot, right?). Now all you have to do is open the file info for each file and add whatever information is unique to that file, such as a caption or certain keywords.

It would be nice if you could use this information to find certain files from within Photoshop and then have them show up in the browser, but unfortunately that can't be done yet. But at least you can use the File Info dialog to see all of a file's information or add more information.

Note that if you maintain the file info, you can use some image management programs, such as Canto Cumulus. See Tip 2: Use Your Image Management Program Wisely for more information.

Tip 9: Archive Regularly to CD or DVD

This may seem obvious, but there are many reasons why you should consider archiving your work. First of all, your photos are extremely valuable—but you probably don't need to be told that. You may also find yourself needing to keep collections of certain types of subject matter on a media that is easy

to duplicate and ship. (Of course, you can simply use either Windows XP or Mac OS X to move image files to a folder, but it's tough to find, edit, and organize photos for a particular purpose when you're in a hurry.) Also, you may want to be able to include some way of presenting the images on the CD, such as a slide show. Finally, hard drive space isn't infinite, even if you have dozens of 250 MB hard drives daisy-chained to your computer.

Once again, the solution for avoiding an organizational mess is to establish a logical workflow using an image management program, such as iPhoto, Adobe Photoshop Album, or Canto Cumulus. The following workflow provides a good starting point that you can customize to your own needs and preferences. Here's a method to offload projects to CDs that you can find easily and ship anywhere at a moment's notice without having to worry about Internet download times.

1. *Use iPhoto 2 or Photoshop Album to select the files.* You really want to use your image management program to do this. If you've already tagged files by category and subcategory, it should be easy to quickly collect all the candidates for a particular project by displaying only images that are tagged with the appropriate categories. Try not to use another program such as the Adobe Photoshop File Browser. You could end up skipping over some files that belong to more than one catagory.

2. *Drop the files into a Workspace window.* Highlight or search for only the tags that suit the project you're working on. You'll probably want to eliminate any apparent duplicates and be sure you've chosen versions that are appropriate to your project (i.e., the final exposure-corrected and layer-composited versions). It's much easier to make these choices when you can see both the image data and notes and the image itself. When you find the exact image you want, simply drop it into the Workspace window. See Figure 3-44.

3. *Export the project images to a CD.* It may be that all you want to do for this project is create a CD that contains only the images you want to work on or send to a team member.

To create a CD of all the files you've placed in the workspace, just use the Export command. (In Photoshop Album, click the Command button in the Taskbar at the top and choose Export from the pull-down menu.) When the Export dialog opens, choose the file type and photo size (be sure to choose Original if you don't want the image resized before exporting), click the Browse button to locate and name the CD or folder you want to export the images to, and then choose whether you want to add a common base name or simply use the original filenames. If you choose a common base name, each file will have a serial number added to it.

Organizing by CD

If I make up a portfolio, I place all the files to be printed into a workspace and then make a CD of those images. Then, any time I want to duplicate the portfolio, book, or presentation, I can just mount the CD, open all the files in Photoshop, and then print them. Be sure to have the printer profile (we'll discuss this in Chapter 11) on the CD, too. That makes it easier to find the correct profile for that particular group of images if you intend them to be printed on a specific printer/paper/ink combination.

You may want to create another CD of slide-show files to preview a project or to create a low-cost portfolio. This can be very useful, as portfolios are often not returned because potential clients want to keep them for future reference, so you likely won't want to spend several hundred dollars on a portfolio case, mounting boards, and custom prints. A CD slide show is much more affordable. It also provides a great way to test the contents of a portfolio before you go to the expense of making up a hard-copy portfolio.

To create a CD slide show from the images in the workspace, click the Start Creations Wizard button and choose Slideshow from the Creations Wizard window (see Figure 3-45). Now all you need to do is follow the instructions in the Wizard. You can choose to create your slide show as hard copy for print, export it to a self-playing CD-ROM, email it to someone, or use it to order prints online. If you want to do more than one of the above, simply go back and continue to push buttons on the fifth page of the Creations Wizard.

4. *Print a contact sheet that can be stored with the CD.* While you're still in the Workspace window, you can also print the images to a contact sheet that contains the captions, filenames, and dates for each photo. I would like to see the individual images be somewhat larger, but you can control that to some extent by the

Figure 3-44. The Photoshop Album Start Creations Wizard. The images you see in the window have been dragged from the album workspace and will be used in whatever creation or export you choose to make.

Figure 3-45. The Creations Wizard.

fact that you can choose any number of columns. You can also choose Individual Prints rather than Contact Sheet in the Print Workspace Window (see Figure 3-46), and the program will automatically fit as many prints as possible on the page, given the size of the print you've chosen. The only problem with this is that there's no identifying filename or caption, so you could lose track of exactly which print the client had chosen. I sometimes present the prints both ways, so that the client can see somewhat larger prints for making final annotations and choices, while using the contact sheets as a reference. You may want to rotate images so that you can view both landscape and portrait images without having to physically rotate the page. That's up to you, but remember that Photoshop Album can't rotate a proxy. It resamples the image and could therefore cause some data loss, which is especially worrisome if you're rotating JPEGs that are already lossy.

Figure 3-46. The Print Workspace dialog in Photoshop Album.

EXPERT ADVICE

Use Glossy Paper for Professional-Looking Shots

I buy 100-sheet packages of Epson or Kodak glossy paper at my local discount or office supply warehouse for about $20 a package. This is not archival paper, but it certainly lasts long enough to present a contact sheet to a client for preprinting markup and image approval. Also, the images look professionally photographic—which is not the case if contact sheets are printed on standard-weight office-size photo papers.

Slide Shows and Email

Photoshop Album and iPhoto also let you create emails and email-able slide shows. The process for doing this is essentially the same as for creating a slide show except that you choose email as a destination. Also, if you're producing a slide show on disk, there's no need for the program to optimize files for the Internet, so your images can be enlarged to fit whatever size screen the viewer has available.

There are, of course, many other programs and methods that let you accomplish all of the tasks in this section. However, I tend to use the workspace in Photoshop Album to organize the images that will be placed in those programs or used in those methods, just because it's the easiest way to keep all the appropriate images in one easy-to-find place—preferably a CD. I just wish there were a way to put multiple CD projects on one disk. This would let you export both the slide show and the files you might want to print or archive.

Panoramas

4

Let's digress for a moment and talk about an area that has grown tremendously in the past few years: panoramas. Many types of web sites and digital kiosks benefit greatly by immersing the viewer in a 360-degree panorama: a tourist spot, the interior of a house, or a potential location for a shoot. There's nothing quite like being able to look all around you, especially when you're not even there in the first place. Panoramas open a whole new world of possibilities in digital photography.

So how do we go about shooting a panorama? One option is to use a dedicated panoramic camera. In fact, several film cameras now on the market are dedicated to making panoramic images. However, it's not the most cost-effective option: those cameras are expensive and require specially processed film or exotic digital equipment.

Another option is to crop a portion of a single, still-camera picture. However, that's not a good option either. By cropping so much off the top and bottom, there won't be enough resolution left to make a full-size panoramic print. In addition, still cameras generally don't show a wide enough view to envelop us in the surroundings. You could try to get around this latter issue with a wide-angle lens, but that brings up yet another problem: photographs that use such a wide-angle lens can make nearby objects seem *too* nearby.

In short, we need to find a quick-and-dirty alternative to buying an expensive panoramic camera or cropping a single picture. Fortunately, there is one: shoot several images with a digital camera that has been rotated about the camera's focal nodal point at precise intervals. These images can then be pieced together (stitched) into a seamless panorama, either by using your image editor's layers and transformations, Photoshop and Photoshop Elements' Photomerge command, or a third-party program dedicated to panorama stitching. For example, we stitched together the independent images in Figure 4-1 to give us the panoramic shot in Figure 4-2 using Photoshop Elements.

In this chapter

Organizing images with the Photoshop File Browser

Stitching the panorama

Creating photomosaics

Nodal Point

You may be wondering what a nodal point is. Put simply, it's the point inside of a camera's lens where the light paths cross before being focused on the film plane. It's important to know this point when shooting panoramas in order to avoid a phenomenon called parallax.

A common way to experience parallax is to hold out your hand, and with one eye closed, place your finger over an object you see in the distance. Next, open the other eye and close the first eye. Note how the finger switches position relative to the distant object. This is due to your point of view shifting a few inches from one eye to the other.

If you rotate a camera on something other than its nodal point, a similar thing will happen: objects closer to the lens will appear to switch positions in respect to more distant objects as the camera is panned. Even though it's very subtle, this parallax effect can ruin a panoramic stitch.

There are several applications to help you stitch together images. So which tools should you use? At the time of this writing, third-party programs are the best alternative. They are more accurate and make the stitching process much easier—as long as you're careful about how you take the pictures. Table 4-1 summarizes some of the better stitching applications.

There are many other choices in stitching programs. For an up-to-the-minute list, as well as up-to-date reviews, volumes of other information on making panoramas, and other helpful hints, check out the *www.panoguide.com* web site. This web site also has a wealth of useful information on shooting, stitching, and printing panoramas.

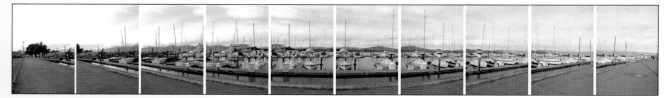

Figure 4-1. The individual photographs that make up a panorama.

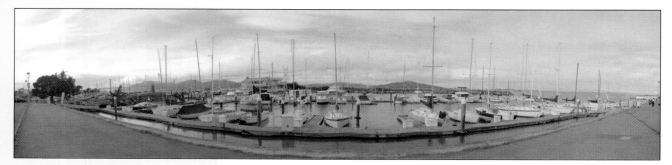

Figure 4-2. A panorama stitched together from a series of independently photographed frames. If you look carefully, you will see what happens as a result of not pivoting precisely on the nodal point and of using primitive stitching software.

Table 4-1. Panoramic stitching applications

Tool	Cost	Trial version?	Web site
Photomerge	Built in to Photoshop CS and Photoshop Elements 2.0	N/A	*www.adobe.com*
Ulead Cool 360	$40	Yes	*www.ulead.com/cool360/*
iSee Media PhotoVista	$60/$190	No	*www.iseemedia.com*
EnRoute QuickStitch	No longer distributed	No	Possibly found on Internet or in discount software bin
PanaVue ImageAssembler	$70	Yes	*www.panavue.com*
RealViz Stitcher	33/500 Euro	Yes	*www.realviz.com*

Getting Started

Follow these workflow steps to shoot panoramas with your digital camera.

1. *Mount the camera vertically on a tripod so that it can be rotated about the nodal point at precise intervals.* This sounds more complex than it is. First, you need a very steady tripod that will keep the camera precisely aligned and level. Second, you will get a consistently better stitch (fewer overlapping artifacts) if you orient the camera *vertically* such that the resulting photographs are taller than they are wide. All other factors being equal, this makes it easier for your panorama-stitching software to minimize mismatching of edges between frames. Figure 4-3 shows a camera properly mounted on a panoramic head (often called pan heads).

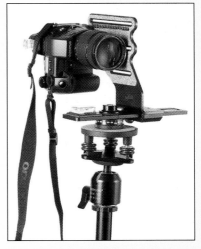

Figure 4-3. A digital camera mounted on a Kaidan panorama head built to be adjustable for all cameras.

You will, however, need a special apparatus to properly mount the camera vertically. Don't try to simply tilt the camera vertically using a standard tripod panorama head: this moves the camera's focal plane away from the nodal point. So what type of apparatus do you need? I recommend buying camera-mounting brackets made for specific digital cameras, or better yet, get adjustable ones that let you adjust the position of any camera so that it is centered over the tripod's rotation point.

EXPERT ADVICE

Using Ball Heads for Panoramas

You may consider using a ball head with your tripod. If you do, note that it's easier to level the camera if you use a ball head *without* a quick-release mechanism. By doing so, all you have to do is make sure the ball head's mounting platform is level and securely tightened. This also minimizes chances of the camera rocking as it is being rotated. Manfrotto (*www.manfrotto.com*) makes excellent and reasonably priced ball heads.

Understanding Panorama Heads

Panoramic heads (sometimes called pan heads) are relatively simple devices. Many universal panoramic heads mount directly on a tripod using a rotating base, and contain adjustable controls that allow a mounted camera both left-to-right and front-to-back movement. This freedom is necessary so that the camera's rotating position can be precisely adjusted to find its nodal point, preventing parallax error.

The best panoramic head is one that is made specifically for your digital camera and lens. These are often sturdier and more rugged than the adjustable types, and they also make it easier to attach the camera, since no adjustments are required in order to keep the camera rotating on the nodal point. The only drawback is that you can't use the same pan head if you trade up to a more advanced digital camera. Choose a model that gives you the option of having the camera click at a 20–30% interval each time you rotate the camera, so that you don't have to second-guess your ability to rotate at precise intervals. Most of the following manufacturers make both universal and camera-specific panorama mounts:

Jasper Engineering (*www. stereoscopy.com/jasper/ panorama.html*)

Kaidan (*www.kaidan.com*)

Manfrotto (*www.manfrotto.com/ products/index.html*)

Peace River Studios (*www. peaceriverstudios.com*)

Now let's discuss camera placement. To determine the proper placement of the camera on the pan head, do the following:

2. *Align the camera over the side-to-side (left-to-right) center point.* In other words, you need to make sure that the camera's rotational axis is directly in the center of the lens. One way to check this (assuming that your camera lens isn't too long) is to point the camera straight down while it is mounted on the panorama bracket and look through the viewfinder or preview LCD at what the camera sees. Next, rotate the camera completely around. Check to be sure that the bolt around which the camera rotates is in the center of the frame at all degrees of rotation (see Figure 4-4). When it is, lock down the left-to-right position of the camera mount.

If your lens is too long to allow your camera to tilt straight down, a less precise way to do this is to move to the front of the camera and look directly into the lens. Make sure the center of the lens is directly over the rotational axis.

Figure 4-4. The straight-down view of this camera's rotational center axis. Remember that it is the center of the image sensor/lens axis that counts—not the apparent physical center of the camera.

3. *Align the camera over the nodal (front-to-back) center point.* Next, place the camera and tripod in front of a pair of tall, vertical objects. One of these should be near the camera's lens, such as a stop sign, lamp post, or light stand; the other should be more distant, such as the vertical wall of a building or the corner of a room. Make sure that the foreground vertical object is within a couple of feet of the lens and that the distant object is as far away as practical (say, 15 to 100 feet). Now, place the camera so that the near vertical object is directly between the camera and the distant vertical object.

Next, rotate the camera so that the near vertical object moves from one side of the frame to the other. If, as you're rotating, the position of the

far vertical object stays directly behind the near vertical object, you have found the exact nodal point. If, however, the far vertical object moves from one side of the near vertical object to the other when you pan, adjust the camera slightly forward or backward (don't let it move from side to side) in respect to the pivot point and repeat the procedure until both objects are aligned no matter what their position within the frame. See Figure 4-5.

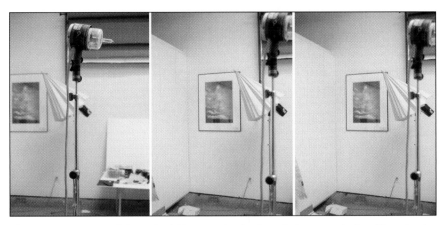

Figure 4-5. The two verticals (original on left) as seen when the pivot point is not properly aligned (center) and when it is (right). Notice that when the focal nodal point is properly aligned, there is no shift in position between the near vertical and the far vertical objects when the camera rotates. In the center image, the near vertical object has shifted slightly to the right.

4. *When you find the right nodal position for your specific camera and lens combo, you're ready to rock—but don't tilt the camera!* Figure 4-6 shows the approximate position of the camera when seen from the front and side.

EXPERT ADVICE

Mark the Positions

Once I align the camera in all positions, I mark its position on the mount. This way, I don't have to run these tests all over again every time I want to use the same camera and lens. If your camera has interchangeable lenses, you'll probably want to standardize on a 28–35mm (35mm equivalent) lens for most of your panoramas.

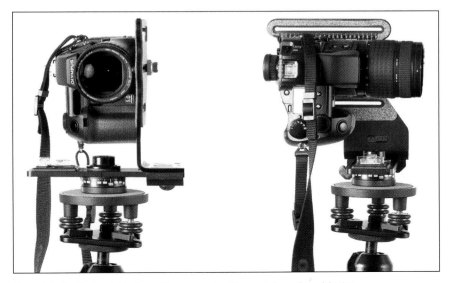

Figure 4-6. The front and side views of the camera when it's mounted over the nodal point.

Getting a Helping Hand

Some non-SLR prosumer digital cameras have a special panorama-shooting mode that lets you align pictures precisely—even if you're hand-holding the camera. Most of the models from Canon, for instance, will move the view of the last frame on the preview LCD so that it overlaps the previous frame by about 20%, and then reduces the opacity of the overlapping image to about 50%. You can then position your next shot so that 20% of it precisely overlaps the previous frame. This is the best (and least cumbersome) way to shoot simple horizontal panoramas of a few frames—especially if the end result doesn't need to appear in a print that's much larger than 20 inches wide.

4. *Make sure the exposure of each frame is the same.* Place the camera in program (automatic) mode, aim the camera at what will be the center of the panorama, then partially depress the shutter button to lock the exposure reading. Next, check the settings LCD to see what exposure the cameras meter recommends, then switch to manual mode and set the camera according to those readings. If you think the shot should be a little darker or lighter than what the built-in meter recommends, use your camera's exposure compensation settings or change the manual settings according to your preferences. If you do make an exposure adjustment, make sure that it's not so severe that other frames in the panorama will be unacceptably light or dark. Again, do not change the exposure from one frame to another or leave the camera in any automatic mode that allows it to change the exposure without your knowledge.

5. *Turn off all "auto" options.* This is especially true for automatic color balancing; otherwise, objects in one or two frames are likely to fool the camera into changing the overall tint or brightness of that frame so that it doesn't match the other frames in the panorama.

6. *Check the lighting contrast.* As a general rule, you want to shoot at times when the lighting is relatively soft and when the main light source is both behind the camera and is lighting the entire scene fairly evenly. Otherwise, parts of the panorama may be underexposed if shaded, or overexposed if there are bright surfaces and few shadows.

7. *Use manual focus.* Again, the last thing you want to happen is the camera to arbitrarily refocus because of some foreground object that appears when you pan the camera. Be sure to focus the camera so that you get the best compromise between the sharpness of foreground and background objects. One of the best techniques is to stop down as far as possible without losing optical sharpness (for most lenses, about 2 stops below minimum aperture). The resulting slow shutter speed won't be much of a problem because you're probably not shooting scenes with moving objects. However, remember that shutter speeds below a quarter of a second are likely to cause objectionable noise in the image.

8. *Center the area of interest.* Rotate the camera and tripod until the most important part of the picture is centered in the frame. Make sure that the panorama frames do not overlap at the area of interest, since the points of overlap are where ghosting and artifacts are likely to occur.

Tip 1: Use the Photoshop File Browser to Organize the Image Files for Stitching

Without careful naming and organization, it can be difficult to get your image files into the proper sequence for a panorama. This is especially true if you have more than one view of the panorama, all with similar-looking frames.

A simple solution is to (again) use the Photoshop CS or Photoshop Elements File Browser to batch-rename all the frames using two-digit serial numbers indicating the proper sequence. (The filename can also include a descriptive abbreviated name for each panorama view.) You can access the File Browser in both Photoshop and Photoshop Elements by selecting the "Browse..." menu item in the File menu. The File Browser is shown in Figure 4-9. The finished panorama is shown in Figure 4-10.

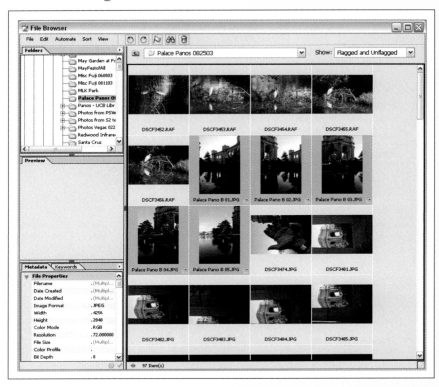

Figure 4-9. The Photoshop CS File Browser with a series of images named and selected for stitching.

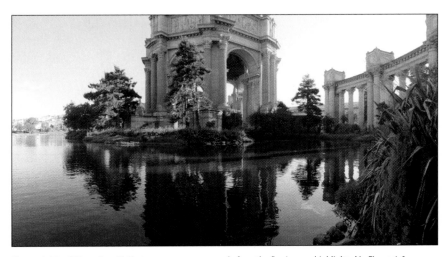

Figure 4-10. A Photoshop CS Photomerge panorama made from the five images highlighted in Figure 4-9.

Here's the routine for treating individual images before stitching to ensure the best possible outcome:

Figure 4-11. The Batch Rename dialog of the Photoshop CS File Browser.

Figure 4-12. The Batch Rename dialog highlighting the use of the "2 Digit Serial Number" for renaming panorama files.

1. Give each panorama a unique name. If there are several panoramas of the same subject, just give each a serial letter (e.g., Pano Library A, Pano Library B, Pano Library C, etc.). To do this, first select the Batch Rename menu item in the Automate menu of the File Browser. The resulting dialog is shown in Figure 4-11.

 In the right-hand text field in the Batch Rename dialog, select the "2 Digit Serial Number" instead of Extension, as shown in Figure 4-12. This ensures that any automatic panorama software will put the images in the right sequence. It is very important that all the files in the series have identical names with the exception of this serial number, which *must* come last—just before the extension.

2. Correct the overall exposure for the center image (or the most visually important image) first. The easiest way to do this is to adjust the Levels and make other exposure corrections in adjustment layers. (Refer back to Chapter 3 for more about Levels and Curves.) You can then adjust all the other frames to exactly the same settings by simultaneously opening the images for all frames and dragging the linked adjustment layers from the first image's Layers palette to the workspace window for each of the other images. Next, activate each of the other files in sequence, open the correction dialog you used, and apply the same settings. This

will ensure that all of the individual images have been corrected to precisely the same degree. *Do not make any regional corrections, such as burning and dodging, at this point—save those for the finished panorama.*

As you correct each file, be sure to save it, adding a "C" to the filename just ahead of the serial number to indicate that it has been corrected. This allows you to go back and start from scratch if you later decide that there is a better way to correct the file.

TIP

Maybe It's Easier Than You Think...

Before making corrections to individual frames in your photo-editing software, you may want to assemble a stitch and run a proof-rendering routine to see how well the stitching program balances the exposure between frames. Some programs do such a good job of this that it's unnecessary to make corrections in the image-editing program.

3. If you do not need as much resolution as your camera has provided, reduce the size of individual frames *before* using the stitcher; this will speed up the stitching procedure and reduce the chance that your computer will crash due to a memory overload. To do the resizing, duplicate each image (Image → Duplicate), resize each duplicate, then Save As to a new filename. In the Save As dialog for each reduced frame, add a short code to indicate the size (S, M, L, and XL often work fine).

The previous recommendations should work well for any image-stitching program you're likely to use, either now or in the future. Just make sure that you leave a sequential series of numbers at the end of the filename and just ahead of the file extension.

Tip 2: Use the Right Tool to Stitch the Panorama Together

Although there's lots of quality software that can stitch together the individual frames in a panorama, you may still encounter some problems, as illustrated in Figure 4-13. A few of the more common stitching problems are:

Cross-platform compatibility. If your program can't run on both Macs and PCs, you may have trouble when other shops work on or modify your images.

Inaccurate stitching. This can occur if you don't adhere strictly to the shooting routine described above, or if the subject matter makes it difficult to follow such rules.

Figure 4-13. This panorama didn't stitch properly because the stitching software couldn't handle the camera's tilt. (Note the dome on top.)

Lack of flexibility in interpreting the stitched image. Some stitching programs do a great job of simple stitching of limited-width panoramas; others excel at stitching full 360-degree panoramas that viewers can move through interactively on a web site or other screen-based media. It can be hard to find a program that's great at everything.

Life would be so easy if I could just recommend one piece of software for all users. Unfortunately, I cannot. A program that works well to fix a simple two-frame panorama (such as the one in Figure 4-14) may not be the best one for a full 360-degree panorama. However, the following suggestions may help you find something that works for you.

- If you generally just need to stitch six or so horizontal frames into a panorama using a program that allows you to easily retouch the blending errors across frames, all you need is a copy of Adobe Photoshop Elements 2.0 or Photoshop CS. The Photoshop CS version is far more sophisticated than Photoshop Elements 2.0; it is capable of both cylindrical and perspective stitching and can also do advanced blending.

- If you create interactive panoramas for the Web and high-resolution panoramas for print or exhibit, you'll need to move up a step to iSeeMedia's PhotoVista 3.0.

- If you want a cross-platform program that does vertical and multiple-row stitching that requires virtually no retouching and allows maximum flexibility in file size and output format, then RealViz's Stitcher is the best (though somewhat pricey) option.

- Finally, if you want a program that can stitch all types of complex panoramas as well as flat row-and-column mosaics (to create a higher-resolution image from a static subject, such as a large oil painting), then you'll need the Windows-only program called PanaVue ImageAssembler. We'll use that program to solve the problem in Tip 3: Make High-Resolution Photo Mosaic Matrices.

Figure 4-14. A simple, hand-held two-frame panorama, after cloning to fix blending anomalies.

The following sections demonstrate the use of these software programs.

Photoshop and Photoshop Elements

If you're just getting into panoramas and are trying to keep the initial outlay and learning curve down, Photoshop Elements 2.0 is a great place to start. The program includes most of the features found in the professional version of Photoshop, but doesn't let you do things like Actions (macros that automate the program) or CMYK prepress work. Photoshop Elements 2.0 does, however, let you do some things that the older Adobe Photoshop 7.0 doesn't, such as automatic panorama stitching using the Photomerge command. (You'll need Photoshop CS to use the Photomerge command in Adobe Photoshop.) Sample results of using Photomerge on the individual frames in Figure 4-15 are shown in Figure 4-16.

Figure 4-15. A series of frames to be stitched.

Figure 4-16. A finished panorama stitched using the Photoshop Elements Photomerge command. (I replaced the sky as well.)

Figure 4-17. The File Browser window in Photoshop Elements with multiple files selected.

Unfortunately, Photomerge does panoramas by simply automating Photoshop's Native Layer, Feathering, and Transformation commands, and it offers no facilities for warping and curving the image. These are necessary for seamlessly matching frames that have straight horizon lines, that were shot more than 45 degrees off-center, or that were shot with a hand-held camera. Photomerge is also incapable of making interactive 360-degree panoramas. However, as long as you keep it simple and are willing to do a little retouching in the blended areas, you should be okay.

Here's how to use the Photomerge tool in Photoshop Elements (the steps are nearly identical for CS):

1. Use the File Browser (File → Browse) to open the folder containing the frame files that you want to stitch. See Figure 4-17.

2. When you locate the images you want to stitch, press the Cmd/Ctrl key to select each image in the left-to-right sequence that you want to stitch them in. For simplicity, this example will merge only two photos.

3. Drag the highlighted images into the Adobe Photoshop Elements workspace. See Figure 4-18.

Figure 4-18. The Photoshop Elements's workspace after dragging highlighted images.

4. Choose File → Create Photomerge (File → Automate → Photomerge in Photoshop CS). The Photomerge Source Files dialog appears, as shown in Figure 4-19.

5. The names of all the files that are open in the workspace will appear. If these are the files you want and they're in the proper order (and if you followed these steps, they should be), just click OK. Then, hurry up and wait. After some automated operations, the main Photomerge dialog will open and occupy the entire screen, as seen in Figure 4-20. If Photomerge was able to do what it considered to be a reasonable blend, it will show you a preview; if not, a warning dialog will appear.

6. Because the frames shown here were shot without a tripod, Photomerge is unable to make a perfect alignment. Instead, we'll have to align the files manually. Check the Snap To Image checkbox on the lower right side of the dialog and drag the two frames into the dialog's workspace. As you drag in the second frame, you will be able to see the first frame through it. Position the second frame so that it is as close to blending as you can make it, then release the mouse button. Photomerge does the best it can; if it's not good enough, try unchecking the Snap To box.

Figure 4-19. The Photomerge Source Files dialog.

Figure 4-20. The main Photomerge dialog.

In this case, there is a noticeable blending error, as shown in Figure 4-21. If you hand-held your shots, you'll likely have the same problem—the camera didn't pan on the nodal point, and you probably didn't keep the camera perfectly level. In this instance (and in most others, if you aren't trying to blend too many frames), it's pretty easy to retouch the blending error with the Clone tool.

If there are a lot of blending errors, try experimenting with the positioning of the images. Choose the arrow at the top of the Photomerge Toolbox to select and move any one of the frames. The selected frame will be outlined in red. If you need to rotate the frame, choose the Rotate tool, which is the circular arrow just below the Arrow tool.

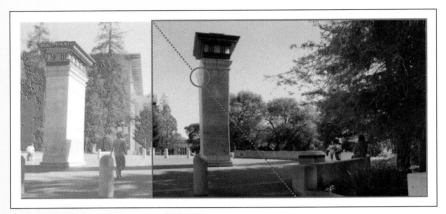

Figure 4-21. The blend error with Photomerge.

If things still aren't right, here's another technique for fixing blending errors. Start back at the Photomerge dialog in Figure 4-20.

1. Before you retouch, Photomerge must render the panorama. Click the Normal radio button at the right side of the dialog under Settings. Note that Photomerge actually does a better job of blending this particular image if you choose Perspective. You may want to experiment, but for this purpose, I prefer the undistorted Normal mode—especially since this image is easy to retouch.

2. Next, check the Advanced Blending box in the Composition Settings options. This may help to minimize any blending anomalies.

3. Make whatever corrections you need to each individual frame. When you think you've done the best you can, click the OK button to render the panorama. Wait a few moments, and the stitched and flattened image will appear back in the main workspace.

4. Now we can do our retouching to hide the seams (and fix any other problems). In Figure 4-21, two problems needed correcting.

 • First, I wasn't careful enough about turning off automatic exposure when I took the shots, so the shot on the right is a bit darker than the one on the left. We need to blend the diagonal line from the upper left corner to the lower right corner of the blending area better. This can be done with the Blur tool.

 • Second, there's some ghosting at the top of the tower where Elements was unable to blend the two images. Overlap ghosting can usually be cloned away with the Clone Stamp tool (see the sidebar).

The Clone Stamp Tool

The Clone Stamp tool is easy to use. Simply move the cursor over a "source" area that you wish to clone (in this case, the sky), then hold down the Opt/Alt key and click. Next, move the cursor over the area you wish to clean up (e.g., the ghosting) and click and drag to remove it. Note that the crosshairs follow your movements as you paint, changing the source pixels. Be sure to give yourself enough sky to work with!

5. After finishing the retouching with the clone brush, crop away the rough edges with the Crop tool.

iSeeMedia's Photovista

If you want to make interactive panoramas—that is, those that the viewer can pan across in a smaller window—you'll have to go beyond the Photomerge command.

One of the most time-tested and affordable cross-platform stitching programs is iSeeMedia's Photovista (see Figures 4-22 and 4-23 for the before and after). iSeeMedia is the third company to sell Photovista, having taken it over from MGI after MGI sold out to Roxio. Before that, MGI had acquired the program from Live Picture. For the examples in this book, I used Photovista 3.0, which was in beta at the time of testing, so there could be slight changes to the program's full release version.

Figure 4-22. The individual shots of the library interior.

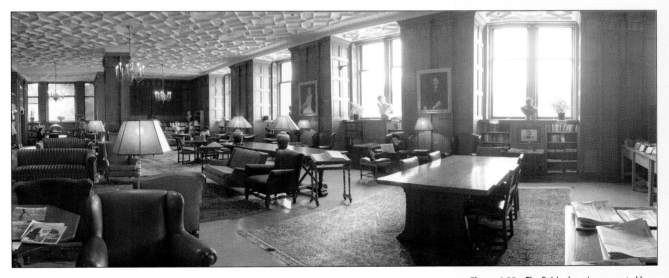

Figure 4-23. The finished version as created by Photovista.

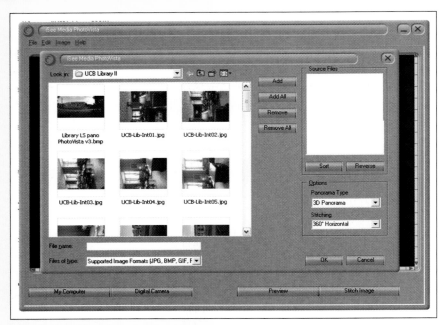

Figure 4-24. The Photovista Open Source Images dialog.

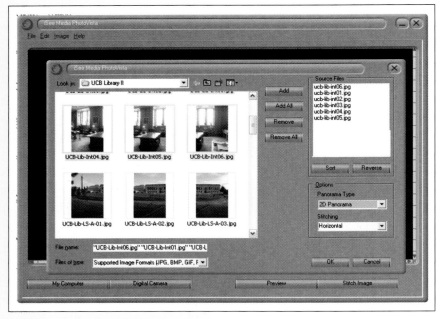

Figure 4-25. The Photovista Open dialog after selecting files.

The most impressive features of Photovista are price (at press time, less than $50), ease of use, and stitching speed—it's by far the fastest of the products I am suggesting here. Its only limitations are that it has no capability for multiple-row stitching or mosaic stitching, it outputs to only one lossless image format (BMP for the Windows version), and it does not save to QuickTime format. However, it does save to a JavaScript format that can be read by most browsers.

The example used here is only five vertical frames wide, but the methodology is the same as if you were putting together a full 360-degree panorama. Here's how it's done:

1. If your images aren't already JPEGs, be sure to convert them before you start. If you want the panorama to have different dimensions than what is indicated by the present size of the files, be sure to duplicate and resize them in your image editor before you start.

2. Choose File → New Workspace.

3. Choose File → Open Source Images (Cmd/Ctrl-O). The Open Source Images dialog appears, as seen in Figure 4-24.

4. Cmd/Ctrl-click to highlight each of the images you want to add to your panorama (see Figure 4-25). If you have named and numbered them according to the suggestions earlier in this chapter, they will be listed in the proper order for stitching when you drag them into the dialog's Source File window. If an image is out of order, you can change

its position in the list by dragging it to the correct position. If you goofed and numbered the files in right-to-left order, click the Reverse button. If the panorama is for print and is not 360 degrees, choose 2D panorama from the Panorama Type drop-down menu; otherwise, choose 3D panorama. (This example is a 2D panorama.) For this example, choose Horizontal stitching; if you want to stitch vertically, as we did for the UC bell tower, then choose Vertical. Then press OK.

5. You will see the images line up from left to right in Photovista's workspace window, as shown in Figure 4-26. If you shot the images vertically and haven't yet rotated them in Photoshop, they will be lying on their side; choose Images → Rotate Images (Cmd/Ctrl-R) to rotate them to the right orientation. If you want to get goofy, you can also flip the images from left to right, but it's not usually a good idea.

6. Choose Image → Select Lens, which will open the dialog shown in Figure 4-27. Pick the focal length that is nearest to the 35mm equivalent of the lens you used. If you're using a professional SLR built on a 35mm body, use the multiplication factor suggested in your camera's literature (typically 1:1.50) to get this equivalent. The easy way to do this is to add the decimal percentage to the actual focal length of the lens: so if the multiplication factor is 1.50, a 24mm lens becomes a 32mm lens.

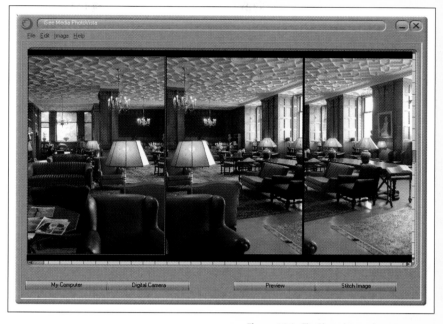

Figure 4-26. The Photovista workspace.

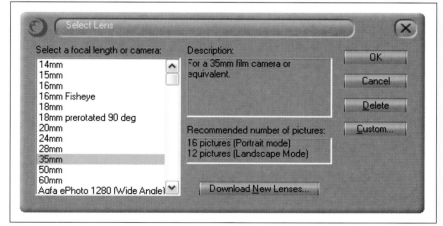

Figure 4-27. The Select Lens dialog.

This next part is optional. If you think automatic stitching is likely to be inaccurate (perhaps you tried to hand-hold the panorama shoot or you didn't calculate the nodal point properly), you might want to turn off automatic positioning of the individual frames. You can then preview the stitch (this will take some time) and then try to manually reposition the frames. In my experience, however, this doesn't help all that much; you'll be better off retouching any anomalies in your image editor after the stitching has taken place.

7. Once you're satisfied with the sequential registration of the frames, it's time to render the final product. Click the Stitch Image button and take a break. When you return, you'll see a 1:1 version of the final image. Pan around it to check for errors in stitching; if the errors are minor, you can probably retouch them in your image editor. In this case, the final (non-retouched) result is shown back in Figure 4-23.

PanaVue ImageAssembler

The first thing to note about PanaVue ImageAssembler is that you'll need a Windows machine (or the latest version of Virtual PC with Windows XP for your Mac) to run it.

Despite its cross-platform issues, ImageAssembler is the most versatile of all the stitching solutions that I've found to date. It can create both mosaic and panorama stitches, and can stitch multiple-row panoramas. It has no limits on file size (other than what your computer can handle), can save to just about every accepted image file format, and output and save panoramas to QuickTime VRs. Like Photovista, you can also publish directly to a web site. Finally, you have a number of options as to how you position and equalize individual frames. In short, the program is exceptionally well equipped for the tough jobs.

When you put together a panorama with ImageAssembler, you have the option to do it automatically. Alternatively, you can manually designate the stitching points by placing "stitching flags" in each frame in the panorama, which can be valuable if you've had to hand-hold the shoot. When it stitches images, ImageAssembler warps, color-adjusts, and blends, with results that produce a minimum of blending artifacts. The program claims to work well when it has to stitch images from a tilted camera and can automatically figure out the focal length of the lens you used. It even works with fisheye lenses.

We'll use ImageAssembler to stitch a mosaic later in this chapter.

TIP

If you use a Mac, you can buy both PanaVue ImageAssembler (under $70) and Virtual PC for Windows XP ($205) for about $100 less than the option discussed next, RealViz Stitcher. Of course, you'll get higher performance from a native program than if you have to run it through an emulator such as Virtual PC. However, if producing panoramas isn't a steady part of your business, this may make the emulator approach a more effective solution because it will also allow you to run other

RealViz Stitcher

RealViz Stitcher, demonstrated in Figures 4-28 and 4-29, comes in a single package that can be installed on either a Windows or Mac computer, and is fully compatible with the latest versions of both operating systems. This highly competent program is the only cross-platform application that does automatic stitching as well as giving you a high level of control over the positioning of frames. This manual control is a must if you want accurate stitching with minimum post-stitch retouching even when you're forced to hand-hold the shooting of the panorama.

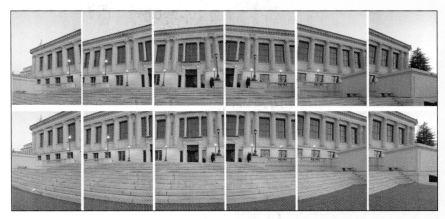

Figure 4-28. The images that comprised the final RealViz two-tier stitched image.

Your panorama stitch can take as many rows and columns as you'd like. Since you can export to QuickTime, you can create a 360 × 180-degree panorama that will allow you to navigate to any point of view. However, there are some tricks to this. Imagine horizontally wallpapering the inside of a globe. The top and bottom "rows" (the ones at the poles) must consist of a single photo that is taken straight up (north pole) and straight down (south pole). Taking a straight-up photo is no problem. But it can be a bit tricky to take a straight-down photo without showing such undesirable items as your own shadow, the tripod legs, or your feet. You may be able to retouch these items out, but it will save you a lot of time if you shoot with a camera that is mounted on a long boom so that these unwanted items will be out of the way to begin with.

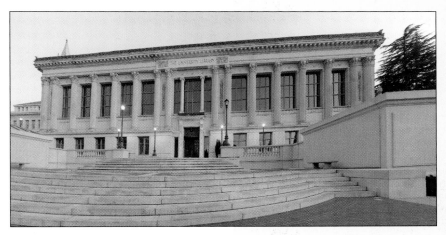

Figure 4-29. The final RealViz rendering.

Here's how to put together a multiple-row panorama stitch in RealViz Stitcher.

1. Choose File → Load Images. In the browser dialog that appears, navigate to the folder that contains your images and highlight the series that will constitute your panorama. For this example, I loaded images for a two-row panorama. Click Open, and the images will appear in the Image Strip window at the bottom of the workspace (see Figure 4-30).

 If you've shot the panorama vertically (as recommended), the images in the strip will be lying on their sides. To correct this, highlight each image by Cmd/Ctrl-clicking it, then choose Edit → Rotate → 90 degrees CW or CCW (counterclockwise), as appropriate.

NOTE

If you check the Display Image Info and Preview box, Stitcher will show you each image you select. Of course, that shouldn't be necessary if you've already done naming and numbering as per the earlier tip, but it's still a useful capability.

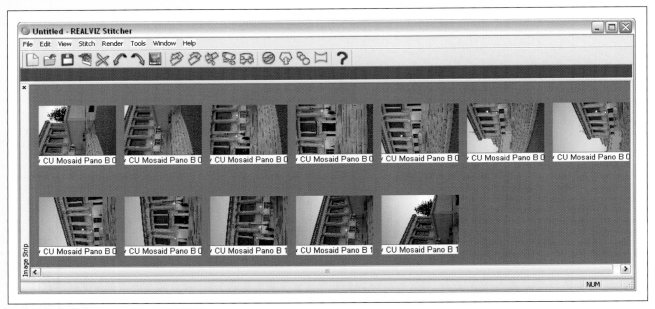

Figure 4-30. The Stitcher interface with the images for this panorama displayed in the Image Strip window.

2. Click outside the images to deselect them and drag the first image into the workspace window. You can stitch from right to left or vice versa; in this example, I am stitching the bottom row from right to left.

3. Drag the next image into the workspace. Place it at the point where it matches closely and click the Stitch button in the toolbar just above the workspace. Stitcher does the most precise positioning it is able to do before it stitches the two images. Make sure your workspace occupies the full screen so that you can judge how well the two images have been stitched together. If it's not to your liking, Stitcher lets you place flags manually to tell it exactly how you want the program to stitch the two images together. Each time you stitch an image, the square at the top right of the Image Strip image that was last stitched will turn green.

4. Repeat the previous process until you have completed the entire first row. If necessary, you can drag the Image Strip's top frame to enlarge the image in the workspace, making it easier to check (and if necessary, correct) the program's stitching as you go along. Stitcher isn't terribly fast, so be prepared to wait a few minutes for each frame to stitch.

5. Now you want to put together the next-highest row (in this case, the top row). Cmd/Ctrl-drag to pan the workspace image so that you can see the top row. (You'll want to continue this panning and dragging as you put together the images so that you can keep your orientation and make room for the next image in the sequence.)

 Drag the rest of the images into the top row. Because you had to tilt the camera up in order to shoot the top row, you'll have to rotate each image so that it matches the image below as closely as possible. To do that, place the cursor on the axis around which you want the image to rotate. Press Shift and right-drag (Control-drag on the Mac) to one side of the pivot axis (you'll see an icon for the pivot axis in the center of the frame). Don't release the right mouse button (Control key on the Mac) until the drag line is long enough to rotate the image slowly and precisely. Make sure that all the elements in the image match up as closely as possible. Once you've rotated the image to the best possible position, use the arrow keys to precisely position the image from left to right and top to bottom.

6. When you're as close to getting the images in register as possible, click the Stitch icon. About 99% of the time, the program will stitch the images to near perfection.

7. At this point, even though you've been careful to use the same exposure and image correction settings for each image, you'll see a slight difference in exposure values in different parts of the image. Click the Equalize icon (the three circles) in the Toolbar and, once again, hurry up and wait. You can see the pre-rendered panorama in Figure 4-31.

8. If you're satisfied with the way the image looks in the workspace, click the Render button in the Toolbar. In the Render Setup dialog that appears, choose the type of rendering you want for this image: Cylindrical QTVR, Cubic QTVR, Shockwave 3D, VRML, Planar, Cubical, Spherical, or Cylindrical. I've chosen Planar, which is the best type if the destination is a printed page rather than an interactive panning window. I recommend you experiment with the different renderings.

9. From the Format pull-down menu, choose the file format you want to save the file to. JPEG is the best choice for web publication and TIFF is the best choice for print publication.

TIP

Using Rotations

Rotating the images also helps when you've hand-held a panorama and haven't been able to keep the camera perfectly level.

EXPERT ADVICE

Shooting with a Tilted Camera

If you have to tilt the camera to make rows above or below the horizon line, be sure to have enough overlap between the individual shots and between the top and bottom rows so that when you have to rotate the pictures to match up seams, you don't end up with unphotographed gaps between frames.

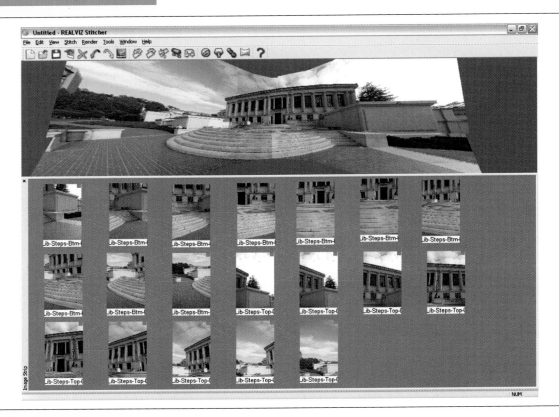

Figure 4-31. The Stitcher workspace showing our image just before rendering. The green lines between images in the Image Strip indicate their stitching order. We can still make positioning corrections by selecting an image, clicking the Unstitch button, and repositioning the image or setting the flags.

10. In the Mixing and Sharpen pull-down menus, I usually select Mixing Method 1 and Normal. Then click the button that's marked with three dots (ellipse), which brings up a file navigation dialog so that you can indicate the directory (folder) in which you want to place the saved file. Enter the filename you want to use in the Filename field and then check the Add Extension box (this makes it easier to read your files on any platform). Finally, drag the resolution bar to create as large an image as you want given the maximum resolution of the current render. Click the Render button and then...call your significant other. Trust me, you can have a deep conversation while you're waiting for the image to render.

In short, if you want a cross-platform program that's suitable for both web and print and will do almost everything (even some really challenging stitches), you should bite the bullet and buy RealViz Stitcher. If you don't need to do QuickTime, you're willing to do some retouching in Photoshop, and you can pay close attention to keeping the camera level and rotating on the nodal point, you can get away with one of the other options. If you're a dedicated Windows user, I would certainly recommend using PanaVue ImageAssembler, which gives you the added benefit of being able to create mosaic photo montages.

Tip 3: Make High-Resolution Photo Mosaic Matrices

The most popular and affordable digital cameras don't provide enough resolution for extremely large prints or art reproductions of large 2D works. Suppose you have to create a print of a piece of artwork that matches the size and visual quality of the original (see Figure 4-32), or an aerial landscape that shows more than you were able to capture in a single shot. Or perhaps you simply need to create a picture of a storefront, but there are trees and parked cars in front. All of these problems can be solved with photo mosaics.

With a photo mosaic, you take several pictures of the subject and then assemble them together, as shown in Figure 4-33. However, this differs from a panorama in that you don't rotate the camera around a single nodal point. This is because you want the end result to be a normal view directly in front of the subject. Consequently, you have to use a different technique for taking the photos as well as for stitching the images together.

To take the photos, use a normal to long lens—so you don't get angle distortion near the edges of the frame—and move parallel to the face of the subject. This technique works best with subjects that are flat (e.g., a painting) or nearly flat (e.g., a building façade). To make sure I'm moving on a perfectly parallel line, I first put the camera on a tripod and position it at the desired distance from the subject. I use a tape measure to measure the distance from the front of the lens to the subject; then, making sure the tape stays at a 90-degree angle

Figure 4-32. The individual photos of Nienke Sjaardemas painting.

Figure 4-33. The result of stitching the photos in PanaVue ImageAssembler.

(perpendicular) to the subject, I measure that same distance from each end of the subject. I mark the two end points and then use chalk to draw a straight line between them. Next, I tie a weighted cord (a plumb) to the tripod's center post so that it nearly touches the chalk line as I move the camera from left to right. I start shooting at one end of the line, then move the camera down the line just far enough so that the next frame overlaps the previous frame. If the plumb line is centered over the chalk line when each frame is shot, I know that the camera is at a uniform distance from the subject. Check any parallel lines in the subject to make sure that the camera's film plane is perfectly parallel to the subject. Use the tripod to move the camera up and down. Figure 4-34 shows the chalk line with a weighted camera.

Figure 4-34. The chalk line with a "plumbed" camera tripod

Adobe Photoshop

Provided you have kept the camera perfectly aligned to the subject, as described above, it's very easy to stitch the frames together in Photoshop, Photoshop Elements, or any other image editor that supports layers and layer transparency. Figures 4-35 and 4-36 show a stitch using Photoshop.

1. Locate the files you want to stitch together in Photoshop's File Browser and drag them into the Photoshop workspace. Each file will open in its own window.

2. Select the image that will be in the upper lefthand corner.

3. Choose Image → Canvas Size to open the Canvas Size dialog (see Figure 4-37).

4. Click to anchor the image in the upper-left corner. Choose "cm" (centimeters) from the width and height pull-down menus, then enter the number of frames to be stitched horizontally multiplied by the present width in the Width field, and the number of

Figure 4-35. Several photos of a painting to be stitched together.

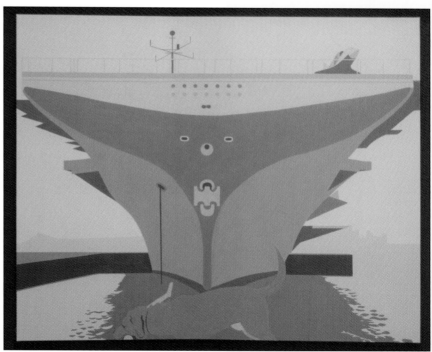

Figure 4-36. The result of manually stitching the photos in Photoshop.

Figure 4-37. The Canvas Size dialog.

> **NOTE**
>
> ## Image Adjustment and Transform
>
> You can use the Image Adjustment commands to adjust shifts in brightness, and the Transform commands to rotate or scale the individual frames so that they match perfectly. If you find this to be tedious and painstaking, it may be well worth the money (time *is* money, remember) to invest in PanaVue ImageAssembler.

frames to be stitched vertically multiplied by the present width in the Height field. Press OK.

5. Choose the Move tool and drag each image onto on the larger canvas. Be sure to zoom in so that you can see the positioning of the images clearly, then zoom out to get an overview. When you have an image positioned pretty close to where you want it, you can use the arrow keys to move the image one pixel at a time so that you get a perfectly invisible seam. When all the images are positioned just right, use the Crop tool to trim the outer dimensions to the proper size.

PanaVue ImageAssembler

If your subject is not a two-dimensional object or if the camera alignment and exposure is not been consistent, then use a stitching program that will do flat mosaics. The best one I've found is the versatile, accurate, and reasonably priced panorama stitcher: ImageAssembler from PanaVue. At about one-fifth the price of RealViz Stitcher, ImageAssembler is a little less intuitive to use, but if you're careful when you shoot, the results will be just as good. The drawback is that it doesn't come in a Mac version, but that may change in the future; check the web site at *www.panavue.com*.

We'll explore two ways to use ImageAssembler: first, we'll put together a high-resolution version of a large oil painting by Nienke Sjaardema; then we'll piece together a composite photo of a storefront that has to be completed in a regular image editing photo.

Here's how to put together the same painting we used in the Photoshop example:

1. Choose File → New Project to bring up the New Project dialog (see Figure 4-38). Select the Image Stitching radio button and click OK.

2. The Project Manager dialog appears. Click the Images tab, then the Add button. In the Open dialog that appears (see Figure 4-39), navigate to the images you want to stitch and select them all by dragging across their filenames.

Figure 4-38. The PanaVue ImageAssembler New Project dialog.

3. Now, here's the somewhat tricky part of the ImageAssembler interface: you have to give your individual frames new frame numbers. Choose the file that will be the first (leftmost) image in the top row and label it number 1—regardless of the number of its filename. Continue opening and renumbering files until you've numbered all the top-row frames with numbers between 1 and 99. Each must make up an uninterrupted sequence. Start the next row down with number 101 and add new numbers in sequence up to 199. The next row would be numbered 201–299, and so forth.

4. When you've numbered all your images, choose the Preview Run button in the Toolbar to see a preview of the stitched images (see Figure 4-40).

5. If you like the way it looks, simply click the Full Run (full resolution image rendering) button in the Toolbar. If you still need to tweak the stitching, click the Arrange Windows button in the Toolbar and arrange the windows side by side. (You may have to spend considerable time zooming in and manually sizing the window so that you can see the full image.) The idea is to see the position of all the flags—shown as X's superimposed on the image—in each frame as they relate to the flags in adjacent frames.

Figure 4-39. The ImageAssembler Project Manager Images tab window and the Open dialog.

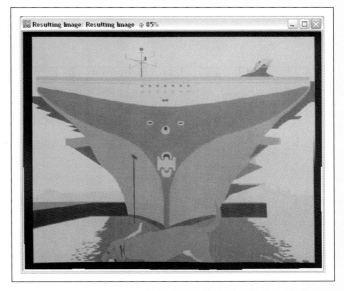

Figure 4-40. The Preview Run image in the Resulting Image window.

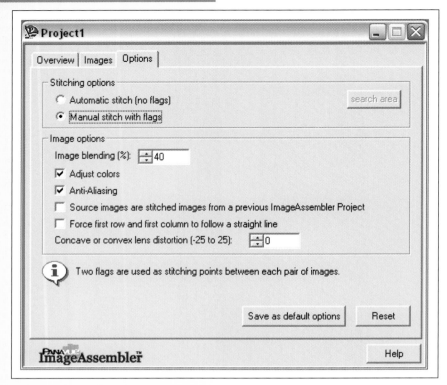

Figure 4-41. The Project Manager Options tab.

6. Click the Project Manager button in the Toolbar to open the Project Manager dialog. Choose the Options tab, select Manual Stitch with Flags, and click the Flag Assistant button (see Figure 4-41). Drag the positions of the flags that have a counterpart in the image immediately to the right to put them in a better position to stitch without mistakes in blending. The Flag Assistant will move the opposite flag in the next frame accordingly. Do this with any flags that need adjusting and then run the Preview. Repeat this step as many times as necessary; when you finally achieve a perfect result, choose the Full Run button. Eventually, if you have patience, you will get a perfect stitch—unless, of course, the original frames are truly beyond help.

Figures 4-42 and 4-43 demonstrate how ImageAssembler can help piece together a composite image of a storefront for a picture postcard. In the original frame, there were some parked cars and a tree in front of the store. For this example, I shot two frames in mosaic style and then stitched them together with ImageAssembler. I then placed the resulting stitched image on a layer in Photoshop, enlarged the canvas, and used some photomontage techniques (see Chapter 10 for more information) to stitch the third image of the store. (It couldn't be stitched in ImageAssembler because the tree confused the program too much. Also, stitching it as a layer in Photoshop allowed me to erase most of the tree so I could see the uninterrupted store wall in the preceding image.)

It was then easy to flatten the file, clone out the rest of the tree, and use the Clone tool to paint out some inconsistencies in the stitching. I also inserted the image of the flowers that was taken as a close-up so that I delete the parking meter. Finally, I placed the proprietress on another layer, used transformations to scale her to the right size, and erased around her to blend the two images.

Figure 4-42. The five shots that make up the finished composite storefront.

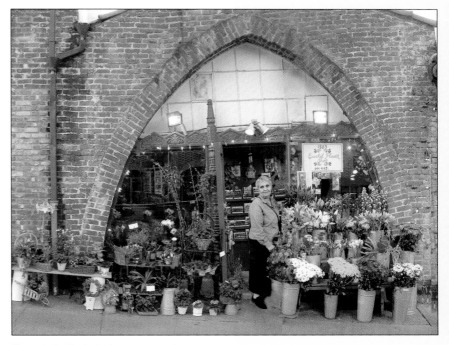

Figure 4-43. The finished composite storefront.

Photoshop Selections, Masks, and Paths

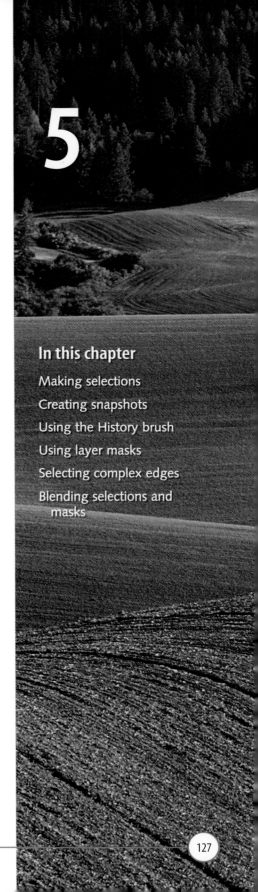

5

As you moved through some of the material in the previous chapters, you may have wondered if there was a way to isolate corrections to certain parts of a digital photograph. For example, you liked how your subject looked in a shot, but the color of the sky was a bit off. Is there a way to just make changes to the sky and not the model? The answer is an unconditional "yes." In fact, that's one of Photoshop's strongest features.

In order to understand how to do this, we first need to review selections, masks, and paths. In Photoshop, selections outline a group of pixels that you wish to have a command applied to. Masks are selections that have been recorded as a grayscale image in a separate channel, and shield areas of the image outside of it from any commands you perform. Paths are contiguous segments of either straight or curved lines. In truth, there's very little functional difference between the three. Any one can easily be converted into another.

Selections in Photoshop are shown with an outline that is frequently described as "marching ants." It's helpful to think of a mask, on the other hand, as a black-and-white silhouette. Black areas fall outside the mask and will not be affected by changes; white areas fall inside the mask and will be affected. Areas that are gray indicate a "halfway" point and will be affected based on the percentage of gray they contain. Paths consist of line segments which can be modified by control points.

Creating accurate selections, masks, or paths can be tricky. However, the precision with which one is drawn and blended will determine how good your isolated change will be and how professional your final photograph will look. In other words, an accurate selection, mask, or path allows you to create natural-looking, believable, and attractive image effects, adjustments, and composites. This chapter teaches you how to do it right.

In this chapter

Making selections

Creating snapshots

Using the History brush

Using layer masks

Selecting complex edges

Blending selections and masks

127

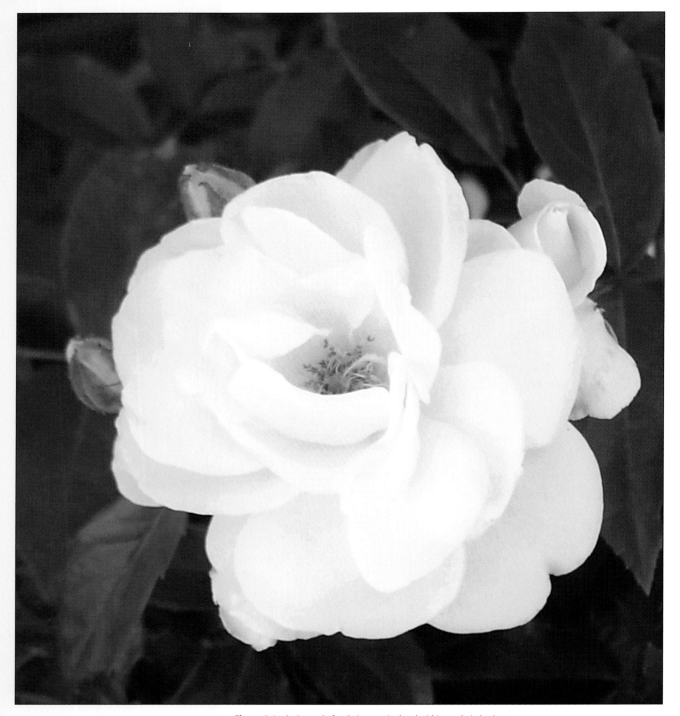

Figure 5-1. An image before being manipulated within masks/selections.

Figure 5-2. The same image after various adjustments. Can you tell what was done where, and what the characteristics of the required selections were? (It's not just the background.)

Learning Photoshop

This chapter isn't a tutorial for learning Photoshop. Instead, it provides techniques for making selections and masks—which are a relatively small but important part of Photoshop. If you need to learn Photoshop, or need to brush up on your skills, I recommend buying Deke McClelland's book.

---N O T E---

You can save considerable hard-drive space by converting masks into paths, then saving the path as a separate vector file. It can then be imported into the same or any other Photoshop file as an Illustrator file. However, you will harden all edges in the process. If the grayscale portions of the mask resulted from a Selection Feather command, it will be easy to re-create the grayscale blending. In other instances, it may not be so practical.

Getting Started

Let's dissect an example RGB image in Photoshop. A typical RGB image contains at least three channels: one for red, one for blue, and one for green. Therefore, each pixel in that image contains a separate value for its red, blue, and green channels. The value represents the intensity level of that color in the channel. If the color depth of the image is 8 bits per channel, the value for each channel is between 0 and 255. If the color depth of the image is 16 bits per channel, the value is between 0 and 65,535. When the intensity levels of these channels are mixed together into a single pixel, they will blend into a unique color. By mixing color channels, we can represent any color in the visible spectrum.

In addition to color channels, a Photoshop image can contain up to 24 alpha channels. An alpha channel is really just a way of storing extra information about each pixel. Remember when we compared a mask to a silhouette? Well, if you create a mask in Photoshop, you can save it as a black and white (grayscale) representation inside one of the image's alpha channels. Each pixel will then contain an extra value from 0 all the way up to the channel's maximum value that describes the pixel's level of "grayness." A pixel's level of grayness decides how much it masks out the pixels below it. Storing masks within alpha channels prevents you from having to recreate the mask or selection each time you edit the image, since alpha channels are saved with the color channels when the Photoshop file is written to disk.

When a mask is converted to a selection, it appears as an outline of "marching ants" that shows the edges of any portion of the image that is darker than 50 percent gray. Masks filter the Photoshop tools and commands to precisely the percentage of gray in any pixel. So masks whose edges graduate from black to white (i.e., the selection is "feathered") will "blend" or "fade" the effect you execute within the mask from no effect to full intensity.

You're probably already familiar with the basics of the various Lasso and Marquee tools, as well as the Magic Wand tool. With these three tools alone, you can select any shape within an image. The real issue is whether we have the patience to make the selection as accurate as we'd like it to be. Luckily, Photoshop is built for people who are short on patience—we just have to know the tricks.

Part of the secret to saving time while improving your selection accuracy is learning some key selection tools and their options—including those not in the menu and whose presence isn't obvious. The reward for learning about these hidden tools is well worth it. For example, flip back and look at the difference between Figures 5-1 and 5-2. Can you tell what was done where, and what the characteristics of the required selections were? Without a trained eye, probably not. But you'll learn as we move through this chapter.

The selection tools

First, let's cover the basics. Any time you choose a selection tool—or any tool for that matter—extra parameters and commands appear in the tool options bar, which is by default at the top of the Photoshop workspace (right below the menus). The options bar changes depending on the currently active tool. However, the selection tools have the same four mutually exclusive buttons just to the right of the tool icon, as shown in Figure 5-3.

Figure 5-3. The selection options.

- The New Selection icon tells Photoshop to drop the previous selection when a new selection is made.

- The Add to Selection icon adds the current selection to any existing selections.

- The Subtract from Selection icon subtracts the current selection from any existing selections.

- The Intersect with Selection icon creates a selection from the mathematical union of a pair of sequential selections.

These options make it easy for you to hand-draw nearly any complex shape. Here is the typical process that I follow:

1. Make a very loose selection that falls entirely *inside* that wiggly-edged thing you want to select.

2. Click the Add to Selection icon, zoom in very tight to the edge, and carefully trace small portions of the edge to add them to the larger selection. Continue until you've added everything you need.

3. Click the third icon, Subtract from Selection, and use the selection tool to carve away any overextended portions (see Figure 5-4).

While you're making selections, be sure to keep the zoom at a *minimum* of 100%. Otherwise, you may end up creating unwanted space near the selection edge, which looks sloppy.

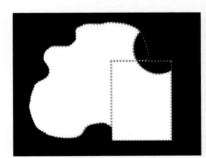

Figure 5-4. The red dotted line represents the first, loose selection; the blue dotted line represents the subtracted selections; and the green dotted line represents the parts that were added.

The marquee tools

There are four different marquee tools in Photoshop: the Rectangular Marquee Tool, the Elliptical Marquee Tool, the Single Row Marquee Tool, and the Single Column Marquee Tool. Each marquee toolbar has some common features that are helpful when making selections.

Fixed-aspect marquees. The rectangular marquee toolbar is shown in Figure 5-5. Holding down the Shift key while dragging a rectangular marquee makes a square selection; holding down the Shift key while dragging an elliptical marquee creates a circle. Alternately, if you need your selection to have a specific aspect ratio, choose Fixed Aspect Ratio in the options bar's Style menu and enter the appropriate numbers in the Width and Height fields. For instance, a 4 × 5 aspect ratio will work for images that need to fill 4 × 5, 8 × 10, or 16 × 20 inch prints. If you now drag the bounding box, the width and height will change but the aspect ratio will remain the same.

Figure 5-5. The options bar for the rectangular marquee showing the settings for a fixed-aspect ratio of 4 × 5. Remember, it's only the number of units that matters, not whether they're pixels, centimeters, or inches.

Using Keyboard Shortcuts to Alter Selections

To save time, use the keyboard to access the selection options.

- To add to the selection, press Shift while making the selection.
- To subtract from the selection, press Opt/Alt.
- To drag a marquee from the center, press Cmd/Ctrl.
- To drop all existing selections, press Cmd/Ctrl-D.

To change selection tools, press the key assigned to that tool. (You will see the assigned keys if you hold the cursor over the tool.)

EXPERT ADVICE

Actions with Pauses

If I need to repeatedly create thumbnails from a series of images, I record a Photoshop action that first creates a fixed-size marquee of the appropriate size, then pauses while I position the marquee exactly where I want it. The action then crops the image, flattens it, and saves it, allowing me to enter or modify the filename.

Fixed-size marquees. Fixed-size marquees allow you to crop or resample images to fit a specific size. You can designate a fixed-size marquee in all the usual units. You can also size the marquee as a percentage (designated "pc" or "%") of the current height or width—a little known secret. This allows you to easily create thumbnails that are a specific and uniform fraction of the full-size image. See Figure 5-6.

Figure 5-6. The options bar for the rectangular marquee showing the settings for a fixed-size marquee.

Feathering. As mentioned earlier, one of the most important things to know about selections is that they can be made to blend with images on underlying layers or with surrounding parts of the current layer. For example, Figure 5-7 shows the flower from Figure 5-2. However, I have intentionally filled the selection with a solid transparent red so that you can see how the color blends with the surrounding image. Feathering has the same effect on anything that's selected. For instance, if you change the brightness of an image selection, the change will have its full effect within the selection borders. However, the effect will gradually taper as it goes across the feathered part of the selection.

The anti-aliasing checkbox. If a selection is not feathered, any effects that are performed can result in edges that have a stair-stepped jaggedness, especially in low-resolution images. So, if you don't want to feather the selection (e.g., if you need to fit an exact edge such as a distant skyline), try checking the anti-alias box. Anti-aliasing causes the selected edge to mix just slightly with the surrounding area, creating the optical illusion of a smoother edge. See Figure 5-8.

Single-row and single-column marquee tools. If you need to draw a straight line that's perfectly vertical or horizontal, you can use one of these selections.

Figure 5-7. A feathered flower. Note that the lighter areas of the magnification are slightly transparent, showing the checkerboard underneath.

Expanding Single-Row or Single-Column Selections

You can also expand the single-row or single-column selection to get a perfectly horizontal or vertical rectangular marquee that remains centered at the starting location. First, choose Select → Modify → Expand and enter the height or width of the marquee in pixels. If you wish, you can then feather the marquee to get a soft-edge bar. I often use this to change the color or density of the image behind a row of type.

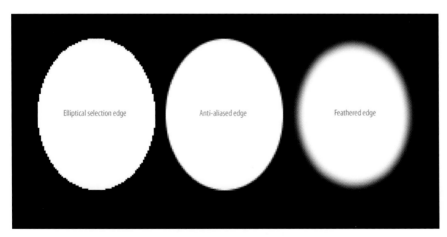

Elliptical selection edge Anti-aliased edge Feathered edge

Figure 5-8. An elliptical selection edge, an anti-aliased edge, and a feathered edge. All three selections were filled with white against a black background.

The Magnetic Lasso

There are three lasso tools in Photoshop: the (regular) Lasso, the Polygonal Lasso, and the Magnetic Lasso. The third tool is the most interesting. The Magnetic Lasso provides an easy way to select the edges of an irregularly shaped object, as shown in Figure 5-9. When you click with this tool inside of an image, a selection path will appear between the first point and the current mouse position, and will "wrap" itself towards areas of high contrast. Selections are easiest, therefore, when the edges of the object and the background contrast sharply—but that's not a necessity.

There are two important options you should be familiar with in the options bar.

Figure 5-9. This flower was selected entirely with the Magnetic Lasso tool. Note the "marching ants" around the selected shape.

Width. The Width field sets the distance from the cursor, in pixels, that the selection path will look for and attach itself to a contrasting edge. Don't make this distance too great (say more than 10 pixels). If the value in the Width field is too large and the background is patchy, the selection path will jump around uncontrollably as you move your cursor.

Edge Contrast. This option sets the amount of contrast that the Magnetic Lasso will look for when moving its selection path. If you have a dark, geometric object against a light background (or the reverse), set Edge Contrast up around 30%. If the edges don't contrast much, set Edge Contrast to a very low number.

EXPERT ADVICE

Making Selections Easier

You can use the Image → Adjustments → Brightness/Contrast… control to make your selections easier. Duplicate the layer you're selecting, boost the contrast so that the Magnetic Lasso can see the edge clearly, and make the selection. Then you can save the selection as a mask and throw away the "contrasty" layer.

The Magnetic Lasso has a couple of quirks you should look out for:

* If you suddenly come across an edge that doesn't have much contrast, the marquee will jump to the nearest edge that does. If you have a lot of these edges, you may want to lower your contrast setting; however, this will slow you down in making the overall selection. Consequently, I often just zoom in to the areas that I missed and make a few quick edits on the small details with the base Lasso tool, pressing Cmd/Ctrl when I want to add to the selection or Opt/Alt when I want to subtract from it.

* The Magnetic Lasso often gets confused when you try to trace the borders of the image—especially if there's a plain background. You can quickly fix that by using the Rectangular Marquee tool to add to the selection along its edges.

TIP

The Magnetic Pen

The Magnetic Pen tool behaves just like the Magnetic Lasso except that it draws a path with control points. That means that you can refine your path by moving the control points exactly where you want them, and then convert the path to a selection (by pressing Cmd/Ctrl-Return/Enter). The Magnetic Pen tool is not the easiest thing to find: you have to first choose the Freeform Pen tool, then check the Magnetic box in the Options bar. Now how's that for obscure?

Figure 5-10. The Color Range dialog, shown here with the sky selected. Note that all other areas of similar brightness are also selected. They can be subtracted with the Lasso tool.

HINT

Common Use

The Color Range command is my tool of choice for removing a boring sky and inserting a more interesting one.

Figure 5-11. The New Guide dialog.

Selecting with Color Range

The Color Range selection command is useful when much of what you want to select is a common color, and there's not much presence of that color elsewhere in the image. To activate this tool, do the following:

1. Choose Select → Color Range. When the dialog opens (see Figure 5-10), drag it to one side so that you can see the color you want to select in the image workspace.

2. Drag the cursor into the workspace and click on the area of color that most represents what you want to select.

3. Drag the slider to broaden or narrow the range of that color to be selected. Keep your eye on the marqueed selection area until you've selected most of what you want without including too many unwanted areas.

4. You can use the eyedroppers to add and subtract other ranges of color, but my advice is to use these sparingly, if at all. If you overcomplicate matters, you'll spend an inordinate amount of time editing the selection.

5. Note that the sky in Figure 5-10 appears as gray, but there are also many selected (white) areas that we don't want to include in the final selection (e.g., the tents). These are easy to eliminate: just use the selection modifiers above to subtract those areas from the current selection. Alternatively, you can use the Quick Mask mode, which we talk about below.

Snappy selections

You can make selections "snap" to the edge of the grid (choose View → Show Grid) or to any guide lines you place. To place a new guide, do one of the following:

* Choose View → New Guide to bring up the dialog shown in Figure 5-11. Choose the Vertical or Horizontal radio button. You can either type in an exact location or drag the guide from the edge of the document window.

* Choose View → Rulers. Rulers marked in the current measurement increments will appear at the top and right sides (Mac) or left sides (PC) of the image. Choose the Move tool and drag from the ruler. The guide will appear, and you can drop it wherever you like. If you have View → Snap turned on, the guide will stop at the nearest ruler increment.

Hiding selections

Usually, it's nice to see the "marching ants" selection marquee so that you can clearly see the boundaries of your selection. However, if you need to carefully watch what happens along a border or you want to see the overall effect of a feathered selection, this marquee can get in the way. To hide the marquee (and the grid, as well as any other extras), press Cmd/Ctrl-H or select View → Extras. Select it again to make the marquee reappear.

Automatically selecting highlights or shadows

There may be times when all you want to do is change the image adjustments for either the highlights or shadows. To select the highlights—everything that's less than 50% gray—press the Load Selection icon in the Channels tab (Layers/Channels/Path palette by default) or press Opt/Alt-Cmd/Ctrl-~. To select the shadows, invert that selection with Select → Inverse or Cmd/Ctrl-Shift-I. Alternatively, you can choose Highlight or Shadow from the Select → Color Range dialog's pull-down menu.

Saving selections

If your selection took more than two minutes to create and there's any chance that you'll need it again later, you should always *save the path!* Choose Select → Save Selection, which brings up the dialog shown in Figure 5-12.

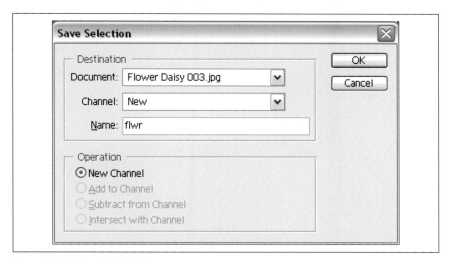

Figure 5-12. The Save Selection dialog.

If this is the first time you've saved any part of a selection, make sure that the New Channel radio button is selected. Next, enter a name for the selection (I usually name it after the shape) in the Name field. If the current selection is meant to modify a selection you've already saved, choose that name instead from the Channel menu. Then click the Add, Subtract, or Intersect radio button to indicate the nature of the interaction between the new selection and the existing channel mask, and finally click OK.

Quick Masks

One of the easiest ways to modify a selection is to click the Quick Mask icon (third row from the bottom in the toolbox) while the selection is active. By default, the image is covered in a reddish mask (you can change this color) except for the selected areas, which remain clear—see Figure 5-13. To modify the mask, paint in black to mask additional parts (the black will turn red) or in white to unmask areas.

If you paint with gray in the Quick Mask mode, the percentage of gray will indicate its transparency. So, if you need a mask feathered along specific portions of the edge, paint with a feathered brush along those edges.

Here are some other hints:

- You can change the opacity of the mask by adjusting the Brightness or Contrast (Image → Adjustments → Brightness and Contrast...).

Did You Know?

Selections in Photoshop are converted to masks when they're saved. They are saved as a bitmap that doesn't interact with the composite (RGB, CMYK, Lab, etc.) image until you use it to either draw a selection marquee or to mask a layer.

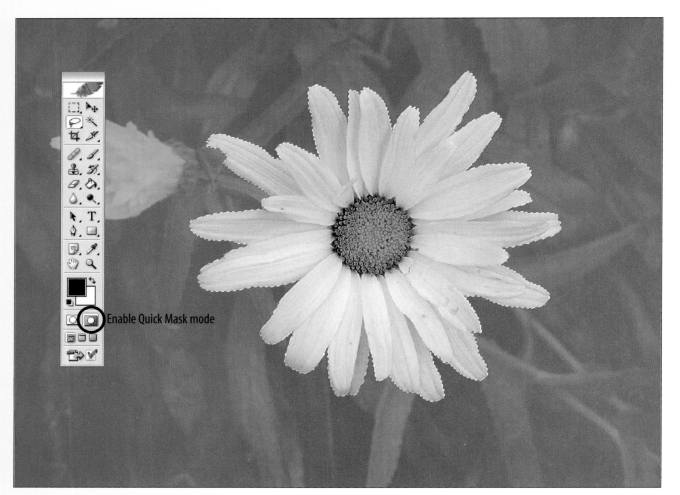

Figure 5-13. The selected daisy from Figure 5-9, shown in Quick Mask mode. The red indicates masked areas; you can add to them with the brush and any shade of gray. Clear areas are unmasked.

- Use the Curves tool (Image → Adjustments → Curves) and its eyedropper to "sample" the amount of masking that is present at any given pixel.

- You can make a selection along a portion of the Quick Mask edge, feather that selection, and then either press Delete/Backspace to remove its contents or fill it using the paintbrush to add masking outside the edge of the mask.

- Another easy way to make feathered selections along portions of an edge is to add to the main selection by drawing loosely with an un-feathered Lasso tool. Then, enter a feather amount in the Lasso tool's Options bar and click the Subtract from Selection icon before precisely tracing the portion of the edge you want to feather. See Figure 5-14.

When you leave Quick Mask mode and return to Standard Editing mode (by pressing the button immediately to the left of the Quick Mask mode button), the mask will be converted back into a selection. The marching ants border will then enclose anything that is greater than 50% masked.

Converting selections and masks

To convert a selection to a mask, open the Channels tab (by default on the Layer/Channels/Paths palette) and click on the "Save selection as channel" icon at the bottom. To convert a mask back to a selection, click on the "Load selection as selection" icon right next to it.

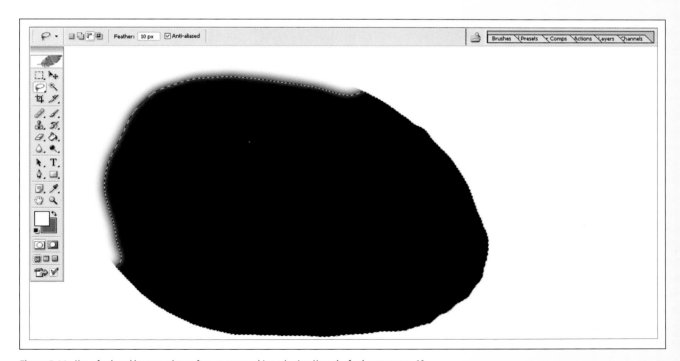

Figure 5-14. Use a feathered lasso to subtract from an overreaching selection. Here, the feather was set to 10 pixels.

The pen tools

Many things in the real world have relatively smooth geometric edges: cars, apples, or the curve of a body are good examples. And you'd think it would be easier to accurately select the edge of a can of soup than the edges of the wrinkles in a model's clothing. The reality, however, is that it's quite difficult to make a perfectly smooth and steady stroke unless you're a calm, trained, and very patient draftsman. If you don't believe me, just look at the freehand selection in Figure 5-15.

Even accomplished draftsmen use some mechanical tools (such as protractors) to keep their edges perfectly straight. The good news is that Photoshop has its own "draftsman's tools," borrowed directly from Adobe Illustrator; the bad news is that using these tools can take a little getting used to.

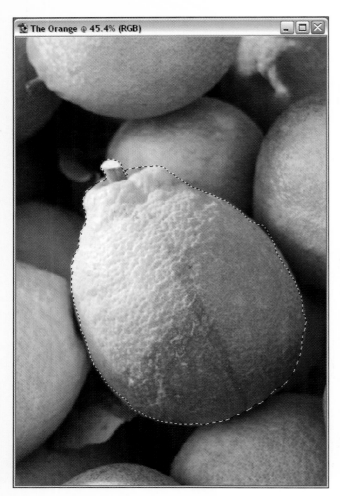

Figure 5-15. A typical freehand selection of this orange using the Lasso tool.

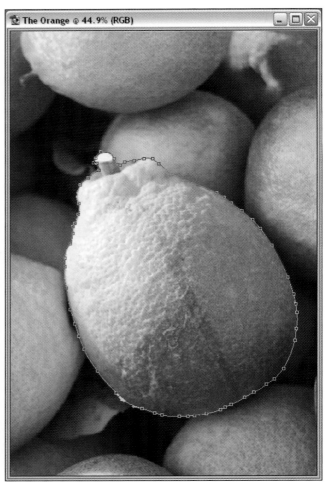

Figure 5-16. The same orange, selected with a vector path.

Now look at the selection in Figure 5-16. This is called a path. The secret to drawing accurate paths is very much like the secret to accurately selecting complex edges with the Lasso tool. First, you draw a path that roughly adheres to the edges of the shape. However, with paths you can then magnify the image and add, subtract, move, and modify control points to bring the path directly into line with the object you're tracing. Finally, you adjust the curve handles on any points that need further refining. See Figures 5-17 through 5-20 for an example of how to do this.

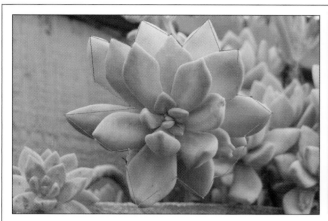

Figure 5-17. First, click to place straight lines at the shapes most prominent points.

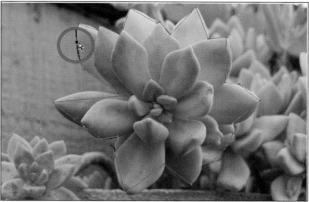

Figure 5-18. Wherever the shape curves away from these points, insert a new curve point and drag it in the direction that makes the curve.

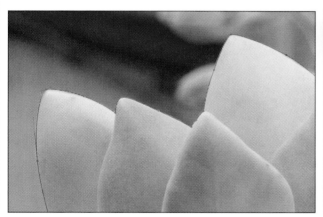

Figure 5-19. After adding and dragging all the major new curve points, zoom in closer and move the curve points so they are exactly in line with the object you want to select.

Figure 5-20. You'll need to convert some of the corner points to curve points, then add new points to properly shape the curve at places where the point was actually a small curve, rather than an angle. To do this, place the Pen cursor over the point and press Opt/Alt. The Change Point tool cursor icon will replace the Pen tool cursor icon; this will change a point to a curve or vice versa. Drag from the new point and a curve handle will appear. If you drag a curve handle with the Change Point tool instead of the Direct Select tool, the handle will affect the curve asymmetrically.

If you don't know how to modify a path, here's a capsule version of the basics:

To reveal all of the path's control points. Choose the Path Selection tool and click the path. To modify any of the control points, you must first switch to the Direct Selection tool by pressing Cmd/Ctrl while the Path Selection tool is active. The arrow will turn solid white, and you can continue to select individual points for modification until you press Cmd/Ctrl again to return to the Direct Selection tool. Of course, you could also switch back and forth in the toolbox, but that's annoyingly slow and tedious.

To add a control point. Place the Pen tool cursor directly over a path where there's no handle (a plus sign will automatically appear alongside the Pen tool), then click on the path to add the point. Alternatively, you can choose the Add Anchor Point Tool from the toolbox.

To remove a point. Place the Pen tool cursor over the point and click. The control point will disappear. Alternatively, you can choose the Subtract Pen tool from the toolbox.

EXPERT ADVICE

Making New Paths

If you can select most of the shape but you really want to make a path, do the following. First, make the selection. Next, open the Paths palette and click the "Make Work Path from Selection" icon. The selection will instantly be converted to a path.

EXPERT ADVICE

Saving Selections

If you have a copy of Adobe Illustrator, I recommend converting your selections to paths, and then saving those paths. It's generally not a good idea to save the selections as masks unless you have an extremely complex path (such as hair or leaves). Here's why: each saved selection actually uses as much space as any other color channel, up to one-fourth (for CMYK color mode) to one-third (for RGB or Lab color mode) of the overall image. When you save paths, on the other hand, they aren't saved with the image, but as a separate vector graphics file.

To save a selection as a path, open the Paths tab (by default in the Layers/Channels/Paths palette) and click the "Make work path from selection" icon at the bottom. Next, choose the Path Selection tool in the toolbox (it looks like a black arrowhead) and use it to select the new path in its entirety. The path will show all its curve points as small black squares. Then choose File → Export → Paths to Illustrator. This will bring up the Export Paths dialog, which is similar to the ordinary Save As dialog. Making sure that Work Path is chosen in the Paths menu, enter a pathname you'll remember and that identifies (or abbreviates) the image it belongs to. Navigate to the folder where you want to save your paths and click OK.

Hopefully, the next version of Adobe Photoshop will let you open vector paths directly in Photoshop, but for now you have to open a drawing program that can open the Illustrator (.AI) file that you just saved. When the path is open in the drawing program, just drag it into Photoshop CS. When a dialog asks you if you want to rasterize the path, say no.

To change a point to a curve (or vice versa). Place the Pen tool cursor over the control point, press Opt/Alt, and drag.

To shape a curve. Place the Pen tool cursor over the control point and hold down Cmd/Ctrl (the Pen cursor will temporarily change to the Direct Selection tool). Then drag the control point handle in the direction you want to path to bend.

To move the entire path. Choose the Path Selection tool and drag.

To duplicate the path. Place the Pen tool cursor over the control point, hold down Cmd/Ctrl, and drag. The cursor will change to the Direct Selection tool with a plus sign, and a copy of the entire path will move.

To move an individual point. Choose the Direct Selection tool, click the control point, and drag.

This section isn't a complete handbook for drawing and modifying paths; rather, it's a quick guide to performing the operations you're most likely to need. Remember, Photoshop usually offers a multitude of ways to accomplish any given task, so you have choices when it comes to establishing personal workflow. It may seem like overkill at first, but you'll almost certainly come to appreciate this versatility.

Tip 1: Make a Selection from an Image

There are times when you want to color-correct, sharpen, or adjust the exposure in portions of an image, but to varying degrees depending on the current brightness. Unfortunately, it's almost impossible to make all those selections accurately by hand. (For example, take the flower in Figure 5-21.) It becomes even worse if you also have to perform feathering that will accurately reflect the brightness in all parts of the image.

Happily, the solution to this problem is simple: use the image itself to make the mask. The workflow is simple, and the results are usually worth it (see Figure 5-22).

1. Duplicate the layer or layers that comprise the image you want to mask.

2. Make one or more changes to that new layer.

3. Copy the layer's contents to the clipboard and paste the clipboard contents into a new Alpha channel.

For example, I used the Channel Mixer (Image → Adjustments → Channel Mixer) to adjust the image in Figure 5-21 to the values shown in Figure 5-23. Note that the Monochrome check box is selected in the dialog so that the output will be a grayscale image.

Figure 5-21. The image as it came from the camera.

Figure 5-22. This image used the Brightness/Contrast control to change the tonal values after the Channel Mixer was used to make a mask from the image. Note that some of the leaves of the cactus are much brighter than others.

After that, select the resulting image (Select → All), create a new alpha channel using the Create New Channel button of the Channel palette, then paste the result inside the new alpha channel. Now we have a mask made from the image. Simply click the "Load channel as selection" button at the bottom of the Channels palette, and you'll have a selection made from the alpha channel values and automatically feathered to reflect the density of the gray values. Remember that the selection will include only those areas that have greater than 50% gray.

You can also make alterations to the image before you convert it to a mask; some useful adjustments are listed here. Note that these can also be combined with one another using layers and blend modes, merged, and turned into yet another mask.

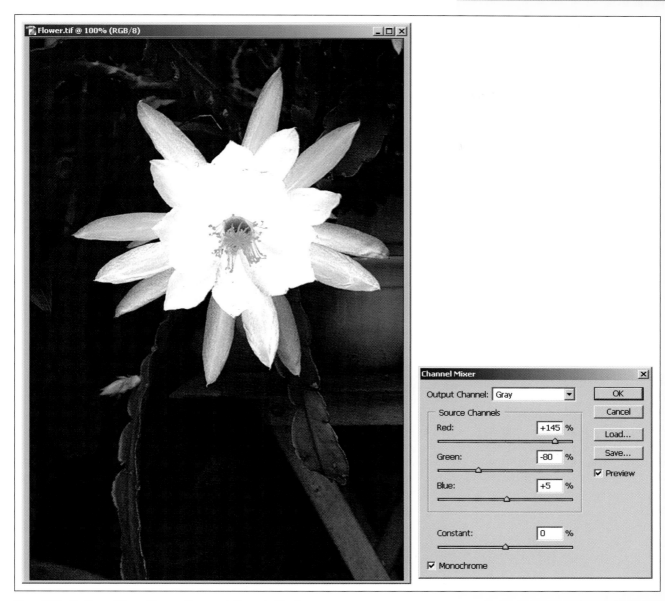

Figure 5-23. The Channel Mixer settings used to generate the mask of the flower.

Find Edges (Filter → Stylize → Find Edges). The Find Edges filter locates all the contrasting edges in the image and substitutes a fine, colored tracing in its place. You may not want to use all of these edges, so try playing with the Brightness/Contrast adjustment to drop out or intensify some of the lighter edges. If you want the edges to be thicker, use the Gaussian Blur filter to spread them out. Or, if you want the edges to form a higher-contrast mask (so that changes are more strictly limited to what's within the

Third-Party Edge Effects

There are also a large number of third-party filter sets that create edge effects. You might want to start by visiting the Adobe site and looking for links to other sites that feature downloadable public domain filters.

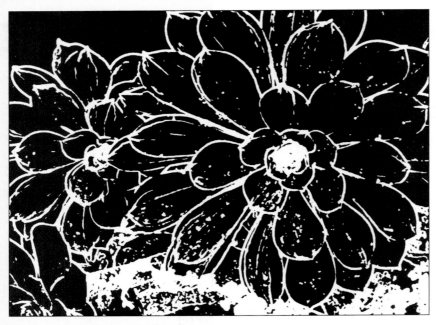

Figure 5-24. A mask made with the Find Edges filter, the Gaussian Blur filter, and the Threshold command.

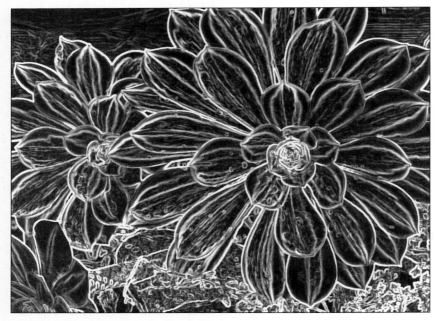

Figure 5-25. A mask made with the Glowing Edges filter. This mask didnt need to be inverted because the "glowing edges" are brighter than the rest of the image after running the filter.

lines), choose Image → Adjust → Threshold, and in dialog that appears, drag the slider until the edges you want to keep are black and the rest are white (i.e., invisible). Figure 5-24 shows a mask that was made using all three of these procedures.

Glowing Edges (Filter → Stylize → Glowing Edges). This is the filter to use when you want to get thick edges, as shown in Figure 5-25. The sliders in the Glowing Edges dialog give you control over Edge Width, Edge Brightness, and Smoothness (see Figure 5-26). Edge brightness is important because you may want to use the Brightness/Contrast and Threshold adjustments to help control what gets left in and out of the mask. Smoothness eliminates jaggedness or spacing in the outline.

Emboss (Filter → Stylize → Emboss). The Emboss filter doesn't make outlined edges; it creates a monochrome version of the image that looks like a three-dimensional stamp in plaster of the original image (see Figure 5-27). This can be a useful mask if you want to create an image that appears three-dimensional. In the Emboss dialog, you can enter a lighting angle or drag the lighting angle dial. You can also adjust the intensity and depth of the highlight and shadow areas by moving the Height and Amount sliders.

Digital Photography: Expert Techniques

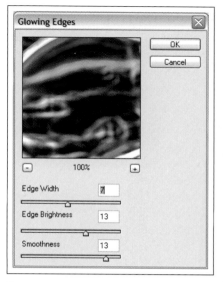

Figure 5-26. The Glowing Edges dialog.

Figure 5-27. Using the Emboss filter.

If you want to use this image to help you impose or exaggerate highlights and shadows, place the layer in an alpha channel, convert it to a mask, and play with the Brightness/Contrast, Threshold, or any of the other image adjustment tools.

Threshold (Image → Adjust → Threshold). In addition to using the Threshold command to create high-contrast edge masks, you can also use it to divide the copied layer strictly into highlights and shadows. Of course, you could also do this by using the Select → Color Range command and then choosing the highlights, shadows, or midtones—but then you couldn't choose the brightness intensity at which the new image transitions from absolute black to absolute white. By using the image itself as

Figure 5-28. A mask made from the areas of the image within 20% of the brightest areas.

Figure 5-29. The left side of the image is the original image. The right side has been brightness-adjusted using the mask in Figure 5-28. This effect has been intentionally exaggerated so that you can plainly see the affected area. You will usually want to make more subtle changes, and feather the mask so that the effect blends more smoothly with its surroundings.

the mask and then converting it to black and white with the Threshold command, you can limit your selections to relatively narrow range of brightness or shadow. See Figures 5-28 and 5-29.

Stroke the selection. You can convert any mask to a selection and then stroke that selection. Stroke is a Photoshop term that means "paint along a selection line or path." This can be done either as a solid line (using Edit → Stroke) or by converting the selection to a path (select "Make path from selection" at the bottom of the Paths palette), choosing a foreground color and a brush tool (including the Eraser, Burn, Dodge, Saturation, Blur, Sharpen, or Smudge tools), and then selecting the "Stroke path with brush" button at the bottom of the Paths palette. See Figure 5-30.

This section only skimmed the surface of how you can use an image to make selections, and of the endless ways you can use those selections to further interpret the image. Later on, you'll see how to use a variety of different image selections stroked with brushes to create an entire painting from a photographic image. Most of the time, however, you'll use these techniques simply to affect the brightness, contrast, and tonal range of specific areas or to focus such operations as sharpening and blurring.

Figure 5-30. This is a stroked path created by using the Threshold (128) filter, selecting by Color Range, creating a path from that selection, selecting the path with the Path Selection tool, and stroking it with a 19-pixel-wide brush.

Tip 2: Make a Snapshot and Use the History Brush

If you're making selections that produce "halos" after you've processed the target effect or put together a composite image, you may need to do a little retouching. The History Brush is a great tool for this.

If you haven't created a snapshot of your image before you started your effects processing, do this first. Backtrack to where you started by repeatedly pressing Cmd/Ctrl-Opt/Alt-Z, choose the History tab (by default in the History/

Actions palette), and press the Create New Snapshot button at the bottom of the palette window. This creates a snapshot of the image at a specific point in time, or state. See Figure 5-31.

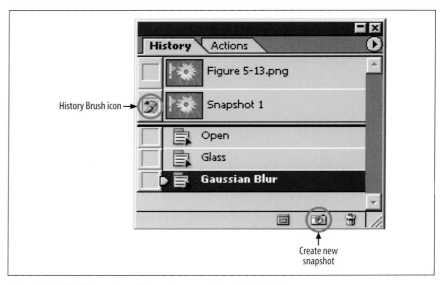

Figure 5-31. The History palette after creating a snapshot and selecting it.

Now, redo back, if needed. Once you've done your best to make the selection and have done your effects processing, drop the selection. Wherever there are halos or other signs of mismatches between the selection edges and the original backgrounds, select the Snapshot that you just created in the History palette (be sure the small History Brush icon is next to it), then choose the History Brush from the Toolbox. Now, wherever you paint, you'll be painting back in the original image state that was stored at the snapshot.

EXPERT ADVICE

Faking It

The History Brush technique described above is also a good way to "fake" transparency in a composite image. For instance, say that you've composited a glass of iced tea from one photo onto a tabletop in another photo. You'll quickly notice a problem: if the tea had really been on the table, you'd see parts of the table through the glass and the tea. To fake this effect, you can create a new, transparent layer and use the History Brush (with greatly lowered opacity) to paint in the wannabe transparent areas of the glass. Since you're actually painting on a separate layer, you can further adjust the transparency effect by altering the layer opacity. Even better, you can use the Liquify filter if you need to distort the image as if you were seeing it through ice cubes or bent by the outer curve of the glass. This is one of the examples later in this book.

Tip 3: Take Advantage of Layer Masks

Let's assume that we've made a selection of the red flowers in Figure 5-32. If we move the underlying layer, the selection typically doesn't stay in place, and it can be frustrating trying to get the image and the marquee back into register. In addition, there are times when we want to create temporary selections atop a more permanent one.

Using layer masks easily remedies all that. Just look at what I did with Figure 5-33.

Here's the instant recipe:

1. Create a selection using any method that seems appropriate.

2. Create the layer you want to mask and select that layer in the Layers palette.

Figure 5-32. One interpretation of a layer-masked composite.

Figure 5-33. The layer mask allows us to easily change the composite and background independently of one another (in this case, the background was darkened and the image cropped and resized) without having to re-select or mask the image.

Making Selections from Layer Masks

To turn a layer mask into a selection, press Cmd/Ctrl and click on the Layer Mask icon. You can then use the selection to create an identical layer mask for any other layer.

Note that you can also use a layer mask to "paint in" a blend mode. Use the blend mode on the layer you want to blend a portion of, create a black layer mask, and then paint white over the area of the layer mask where you want the image on that layer to be revealed.

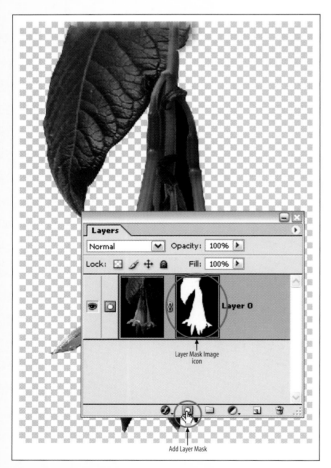

Figure 5-34. The Layers palette. The Add Layer Mask icon and the layer masks image icon are circled in red.

3. At the bottom of the Layers palette, click the "Add Layer Mask" icon (it looks like a gray box with a white circle in it). In the Layer Name bar of the target layer, a second image icon will appear as a grayscale image to show you the masked area for that layer (see Figure 5-34).

Most of the time, you don't have to mask a layer in order to get a selection to do what you want. Still, it's a good idea to get in the habit, so that any time you want to change the contents of a selection in any way, you can just do it—even if you've moved those contents in the meantime. Even if you haven't moved the contents, however, the big advantage of masking layers is that you don't have to stop to load a selection from an alpha channel. If you do want to save the selection as an independent alpha channel, select the Layer Masks icon in the Layers palette, and press Cmd/Ctrl-A and then Cmd/Ctrl-C. In the Channels palette, click the New Channel icon and press Cmd/Ctrl-V to paste the mask into an independent alpha channel.

Tip 4: Select Highly Complex Edges

One of the most common reasons for making selections is to create knockouts, a fancy name that means that the selection is removed from the background. This is a fairly straightforward process if the edges are smooth and geometric. But what if your job calls for knocking out a lady with a Rasta hairdo who's wearing a fur coat and standing in a jungle? For example, you're probably wondering how I knocked out the image in Figure 5-35 and placed it in Figure 5-36.

When edges are as complex as hair, fur, smoke, glass, or vegetation, the only time-efficient way to select them is via a more-or-less automated procedure. Two such procedures are built into Photoshop:

- The Color Range command
- The Extract filter

Figure 5-35. The original image of cellist Elaine Kreston after knocking it out of a blue studio background using Ultimatte AdvantEdge.

Figure 5-36. This image of the cellist against a new background.

Alternately, when you need extremely accurate knockouts that automatically eliminate stray color reflections from the background, you'll want to consider the two programs KnockOut and AdvantEdge, both invented by Ultimatte Corporation.[1] KnockOut is currently marketed by Corel Corporation; AdvantEdge is a brand-new program from Ultimatte that is intended for working with any solid-color background. Several other programs or plug-ins also make knockouts, but those were on the verge of being updated too late to evaluate for inclusion here. The following sections explore these Photoshop features and third-party programs.

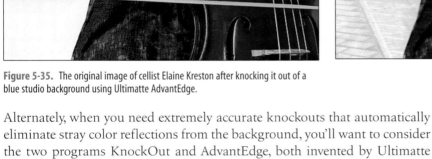

1. The founders of the Ultimatte Corporation won an Academy Award of Merit from the Academy of Motion Pictures Arts and Sciences in 1994 for their work on blue-screen compositing.

The Color Range command

The purpose of the Photoshop Color Range command is to make a selection based on an entire range of colors. It is the best "boring sky" knockout tool I've found (compare Figures 5-37 and 5-38), although you can use it for various purposes. Best of all, it's quick, easy, and cheap. Choose Select → Color Range to bring up the dialog in Figure 5-39.

Most of the time, all you need to do is put the eyedropper over the pixel that is the best average of the color range you want to knock out. As soon as you click, you'll see a preview of the mask. (If you choose Quick Mask in the Selection Preview drop-down menu at the bottom, you'll instantly see the masked portion over the active image window in transparent orange. This way, you'll get a good idea of how smooth the mask is going to be and how well it blends.) You can easily adjust the fit of the mask visually by dragging the Fuzziness slider to include a wider or narrower range of colors. You can also fine-tune your selection by adding or subtracting colors (for example, perhaps you have a vanilla sky that's part pink and part blue). To add colors, choose the + dropper; to subtract them, choose the − dropper. When you're happy with what you've got, click the OK button.

Figure 5-37. The image with a blank sky.

Figure 5-38. The same image with a sky from the Mojave Desert in early spring.

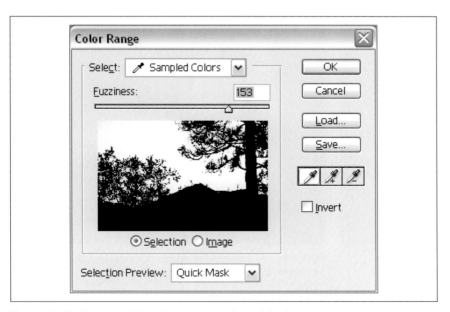

Figure 5-39. The Color Range dialog with the settings used to mask the sky.

Chapter 5, Photoshop Selections, Masks, and Paths

I finished the image in Figure 5-38 by copying the sky from another photograph, which also created a new layer. I then renamed the background layer to unlock it and dragged the sky layer below the original layer. Finally, I made image adjustments to each layer to make them match up better.

The Extract filter

The Extract filter (Filter → Extract) is a wonderful and amazing piece of gear that's built right into Photoshop. (See Figures 5-40 and 5-41 for an example of what it can do.) All you have to do to make it work as well as Corel Knockout is practice—and maybe learn to make good use of the Background Eraser once the filter has done its job. Even if it's not perfect, it is ideally suited for knocking out shapes that are natural, but not too complex. One of its best

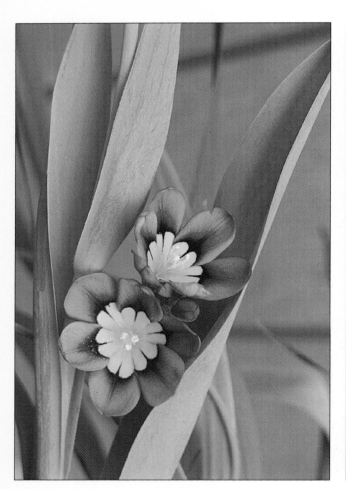

Figure 5-40. The flowers as shot outside my studio.

Figure 5-41. The same image after extraction and the addition of a graduated dark gray background layer.

features is that it works reasonably well against backgrounds that are busy and multicolored. You get to the Extract filter by choosing its menu item from the Filter menu, or by using the command Opt/Alt-Cmd/Ctrl-x, which brings up the dialog shown in Figure 5-42.

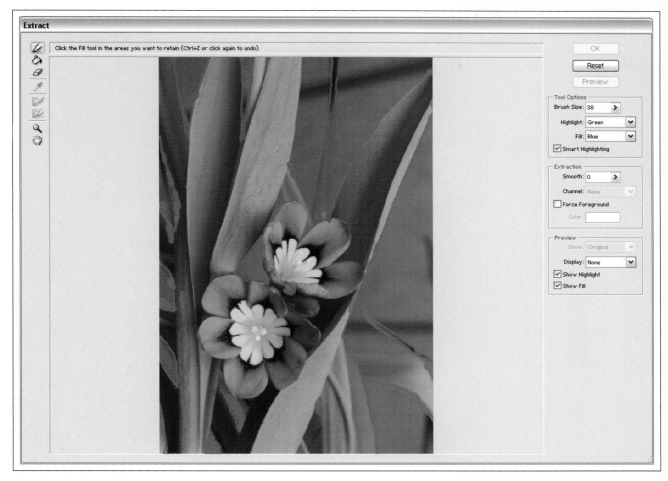

Figure 5-42. The Extract dialog, showing the marker path used to extract the image in Figure 5-40.

Here is how you use the Extract filter:

1. Highlight the edges of an object using the Edge Highlighter tool at the upper-left corner of the dialog. These highlighted areas should cover all the edges between the object you wish to retain and the background you wish to eliminate. Note that the Edge Highlighter tool is a marker that is similar to the brush tool in that it can have various brush sizes. The default highlight color is green, but that color can also be configured using the tool options on the right side of the dialog.

2. Fill in the areas that you want to retain using the Fill tool. The default fill color is blue, but that can also be configured using the options on the right side if the dialog. Using the Eraser tool to erase edge highlight areas may make filling easier.

3. Preview the extraction using the Preview button. You can use the Zoom tool to zoom into areas that need readjusting, and you can switch from the Preview back to the Original Image (and back again) by choosing from the Show menu on the right side of the dialog. When all the adjustments have been made, press the OK button.

This filter is easy to use as long as you keep the following principles in mind. First, I recommend that you check the Smart Highlighting box; this forces the marker width to be as small as necessary to cover the parts of the edge that will fade (or transition) from opaque to transparent in order to blend naturally with whatever new background you might want to use. If you have really wild and mixed edges, such as flying hair, you want the marker color to be as wide as the area that contains the transition, and to overlap as little as possible into the interior area that you want to keep. I start with Smart Highlighting turned on; then I turn it off, increase the brush size, and go over any areas that are broadly transitional.

Second, use the Eraser tool to refine the thickness of your marker outline wherever necessary. When the marker line appears to cover the entire area,

Figure 5-43. The digital shooter in the original photo. The chain-link black fence was a bit boring.

zoom in and inspect it to make sure there are no gaps. Then zoom all the way out, choose the Fill Bucket icon, and click inside the marker outline to fill with a contrasting color.

If the contrasting color spills over the outline, just choose the marker again, look for the gap, and fill it in. As soon as you do this, the fill color will disappear, so just continue the cycle until you've closed all the gaps in the outline. Click the Preview button in the upper right side of the dialog (note that transparent areas are indicated by a checkerboard pattern). You can use the Cleanup tool (paintbrush and mask icon) to erase edges that didn't transition, or—by pressing Opt/Alt—to replace areas that got wiped out of the foreground. The Edge Touchup tool works much like the Background Eraser, which can also be used to clean up the knockout within Photoshop after it's been extracted.

Corel KnockOut

Corel KnockOut is a third-party utility made expressly for knocking out images that have both complex edges and complex backgrounds (see Figures 5-43 and 5-44). You can generally do a more refined job using KnockOut than you can using the Photoshop Extract command (unless you're patient and extremely well trained in using Extract). Of course, if you're also well trained and patient in your use of KnockOut, you can get even better and more efficient results.

The principle is pretty much the same for both programs: you simply show the program what you want to

Figure 5-44. After using Procreate KnockOut to remove the chain-link fence, leave the wisps of hair, and substitute this sidewalk scene of a nighttime store window.

keep in and what you want to drop out. Whatever doesn't fit into either area becomes a transition, and then it's up to some very fancy mathematics to figure out what you're likely to want to keep. KnockOut just gives you more options and tools for refining the difference, so the results are more predictable.

In keeping with KnockOut's more powerful capabilities, the dialog's interface is a bit more complicated, as shown in Figure 5-45. However, once you catch on, the procedure is straightforward.

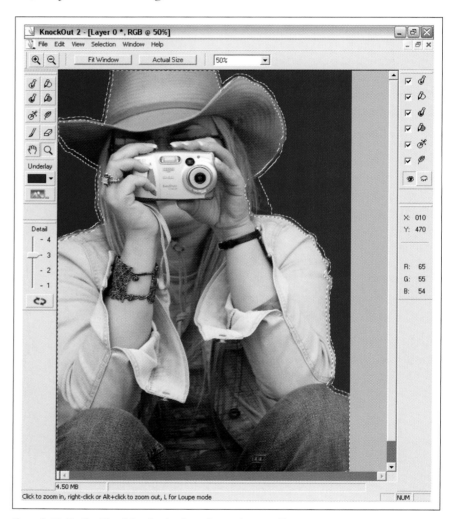

Figure 5-45. The KnockOut dialog, showing the settings used to create Figure 5-44.

1. Open the image or select the layer that you want to knock out. If the image is on the background layer, double-click the Layer Name bar and then rename the layer in the Layer Options dialog that appears (or just click OK to accept the default 0 as the layer name). This will unlock the layer so that it can be processed. See Figure 5-46.

Digital Photography: Expert Techniques

2. Choose the Draw Inside tool and draw a marquee that is just inside the object you want to separate from the background, making sure that you don't include *anything* that should belong to the background. You can use the + and – options in the toolbar to get the shape as accurate as possible without getting into transitional edges (such as wisps of hair or out-of-focus or motion-blurred shirtsleeves). See Figure 5-47.

3. Click the Auto Outside Object button. A marquee enclosing everything that should be knocked out will appear, as shown in Figure 5-48. If it includes any transitional areas that shouldn't be knocked out (yes, it's that danged hair again), click the Draw Outside icon and use its + and – options to modify the shape of the outside area selection as needed.

And that's all I needed to do to get this particular image right—even with its extremely complex background! I probably could have more precisely selected the flying hair by using some of the program's other tools; for example, I could have set the Detail setting even higher. However, the purpose of this example was simply to give you a good idea of how to get the job done, and to offer up a simple solution that might not be obvious to everyone.

Figure 5-46. The New Layer dialog showing the field for renaming the background layer.

Figure 5-47. The figure as it appears in the Knockout dialog after the Draw Inside selection has been made.

Figure 5-48. The same figure as it appears after the Auto Outside command has been issued.

Figure 5-49. The image showing the stroke that knocks out the background. No Magic Wand selection could ever do this.

Figure 5-50. It's easy to get amazingly perfect result from Ultimatte Advantage if you use solid blue or green as your original background.

Ultimatte AdvantEdge

The latest whiz-bang tool from Ultimatte, AdvantEdge works best when you've done your shooting against a solid color background, such as a studio seamless. In this case, you can usually create your knockout perfectly in well under a minute by dragging a stroke across the background color and clicking OK. If that doesn't do a perfect job, drag another stroke across your mask wherever it shows a texture until you get it right. See Figure 5-49.

AdvantEdge works best if the background is pure blue or green, as these colors are least likely to be found in the subject itself. Which color works best will depend on your subject: people usually knock out best from a green background (lots of people wear blue shirts and ties), while plants work best in front of blue backgrounds. The image in Figure 5-50 was knocked out from a blue background.

Knockouts are useful even when you don't want to create a new composite image or replace a background; they also provide you with a great way to instantly select the edges of an object so that you can adjust or edit that object separately from the background. To do this, simply use the Magic Wand: with the Contiguous box in the Options bar unchecked, just click in the transparent area (you may have to play with the Tolerance setting a bit, but it should usually be kept pretty low). That's all there is to it!

Tip 5: Blend Selections and Masks to Get Natural Edges

One of the telltale signs that portions of an image have been manipulated is an obvious dividing line between the base image and the area that's been "tweaked." Consider Figure 5-51.

Figure 5-51. A composite image in which the edge of the imported object, the tree, is unnaturally abrupt.

Various techniques can minimize these borders or even make them disappear altogether. Figure 5-52 shows the same composite, except the edges are gradiated. The following techniques are required skills for your digital darkroom master's degree.

Figure 5-52. The same composite, with the edges carefully gradiated to blend smoothly with the underlying image.

Blur the mask. This is generally the best technique to use if you have a composite image on its own layer. Select the image, save the selection as a channel, then go to the Layers palette while the selection is active and click the Add Layer Mask icon at the bottom of the palette. The selection will mask the layer, and the layer mask will be framed to indicate that it is selected (see Figure 5-53). Next, choose Filter → Blur → Gaussian Blur and blur the mask as much as you like. You will be able to see the result in the preview.

Figure 5-53. The Layers palette showing a layer that is masked with a layer mask. Note that the layer mask is highlighted, indicating that Photoshop's editing tools will process the mask rather than the image.

Feather the mask. To do this, you first feather the mask, then feather the selection tool to a different degree and add or subtract from the existing mask. You can make this as complex as you like by continuing to feather the selection tool(s). Figure 5-54 shows an example of a mask made in this way.

The Halo Effect

If you blur a layer mask that is exactly the same size as the object it's masking, you may get a halo effect. If this occurs, you can either blur it so much that you get no halo, or you can drag the layer mask to the Delete Layer (trash) icon in the Layers palette, re-create the selection from the saved selection (alpha channel), and then choose Select → Modify → Contract to shrink the selection. Blur the mask again, and keep experimenting until you get exactly the result you want.

Figure 5-54. A mask that has been feathered.

Edit the mask with a feathered paintbrush. If you use a pressure-sensitive pen pad, you can set pen pressure to change the size of the brush, which will vary the amount of apparent feathering. The mask shown in Figure 5-55 started as totally hard-edged; the edge was then painted with brushes of several different sizes, shapes, and degrees of edge hardness.

The Eraser Brush

Remember that the Eraser is a brush, too, and can use any of the brush styles and settings, so long as you choose Brush from the Mode pull-down menu in the Options bar.

Figure 5-55. A mask that has been feathered by painting its edges with a variety of brushes.

Edit the mask in Quick Mask mode. The easiest way to see how the techniques described above will affect the characteristics of the mask in relationship to the image is to convert the mask to a selection and then edit it in Quick Mask mode. See the section on Quick Masks earlier in the chapter for more information.

I've found that one of the easiest ways to make a mask with variously feathered edges is to make a hard-edged mask and then enter Quick Mask mode. Next, I use the Gaussian Blur filter to feather the mask to just the extent needed for *most* of the mask's perimeter. Once that's been done, a little work with variously feathered brushes will generally take care of the fine-tuning.

Basic Digital Photo Corrections

<div style="text-align: right;">6</div>

Now that you know how to work effectively with Photoshop selections, paths, and masks, it's time to put that knowledge to use and make some basic corrections to your images inside of Photoshop.

Getting Started

There are two items that we should discuss first: extending tonal range and color correction.

Extending tonal range

The eye can see more tonal range than a computer monitor or digital print can display, and the standard Levels and Curves exposure corrections described earlier don't always solve problems to our satisfaction. Figure 6-1 shows the best we could do with an image given what we've learned so far.

Digital cameras have an extraordinary ability to capture shadow detail, and there are several ways to bring that detail (such as that in Figure 6-2) out of hiding.

- Use multiple exposures in the same image file
- Extend tonal range with blend modes
- Burn and dodge small areas in softlight mode
- Use screen and multiply modes on adjustment layers

Use multiple exposures in the same image file

If your subject isn't moving, you can use the age-old technique of bracketing multiple exposures. Usually, you'll want to do this a little differently than you would if you were shooting slides. Instead of bracketing at 1/3- or 1/2-stop increments, you might want to set the bracketed shots a full stop apart. You should always use your camera's automatic bracket mode for this, if you have

Figure 6-1. The best we could do for this image using the image corrections discussed so far.

Figure 6-2. The same image after extending the tonal range of the photograph.

it, as it makes the bracketing operation much faster. It also makes it less likely that moving objects in the scene will move too far (unless the movement is at high speed). Be sure to keep the camera motionless—preferably by mounting it on a tripod—so that the layers match up when you put two or more bracketed shots into the same image.

If you want to expand the image when the objects within it are moving, just create two or more interpretations of the image (if you're using RAW files, export two or more interpretations from the Photoshop Camera RAW plug-in). Then you can blend the layers automatically by using the Fred Miranda Action, as described in the next section, or combine layers manually when you need to exercise more control over specific areas.

One of the easiest and most effective ways to blend two layers together into an expanded range image is to use one of Fred Miranda's tools (demonstrated in Figures 6-3 and 6-4). You can download and purchase the Miranda DRI (Dynamic Range Increase) Pro Plug-in for around $16, and, as you'll see when we extend the range manually, it can save you quite a bit of time. Here's all you have to do to use the Miranda DRI Action.

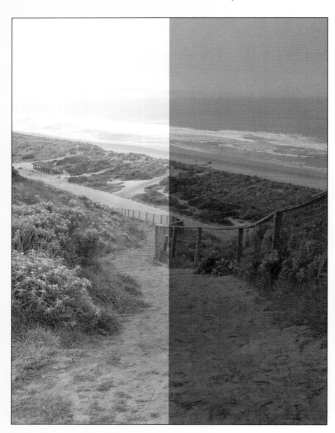

Figure 6-3. The light and dark versions of the same image.

Figure 6-4. The result of combining the two images using the Miranda DRI Pro filter. The resulting image is still a little flat, but that's easy to take care of.

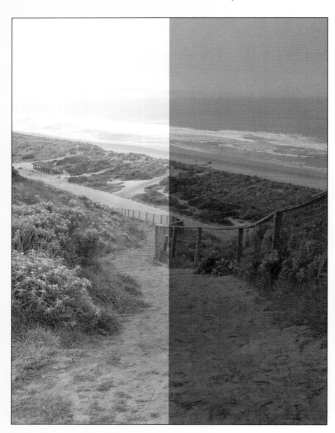

TIP

In Case You Missed It

Bracketing is the name given to the process of digitally combining two or more identical shots with different exposures. This allows you to get the best of each shot in your final work.

1. Download the DRI Pro plug-in from the Miranda site (*www.fredmiranda. com*). You'll find interesting reviews and updates on digital photography developments here as well.

2. Install the plug-in according to the instructions that come with the download.

3. Open both your images in Adobe Photoshop CS so that you can see their windows in the workspace (Figure 6-5).

4. Select the DRI Pro menu item under the File → Automate menu. At this point, enter the name of both the underexposed image as well as the overexposed image in the fields provided. Then click OK. Wait a second or two and you'll see an image with a vastly expanded dynamic range. It's as easy as that.

Figure 6-5. The under- and overexposed versions of the same image, as well as the DRI Pro dialog.

There will be times, however, when you need to combine very specific areas of the image manually. For example, look at the various interpretations in Figure 6-6. We need to combine them into a blended image, such as the one in Figure 6-7. This isn't hard. First, start with a series of images that have been

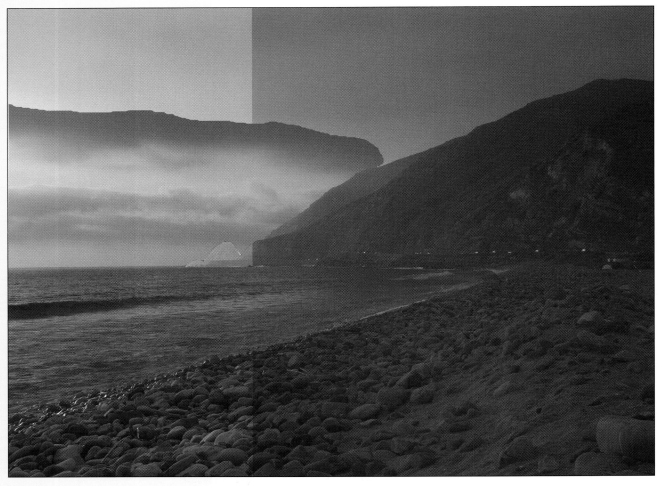

Figure 6-6. Several versions of the image that need blending together.

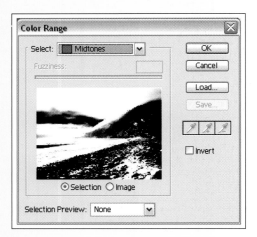

Figure 6-8. The Color Range dialog.

bracketed to cover an especially wide range, or create several versions of a single RAW file with different brightness ranges. Then take the following steps:

1. After making any basic corrections in Photoshop, move the darkest image to the left side of the workspace and set the image mode to 8-bit color.

2. Select the range of color in which you want to enhance the tonal range. You can use the Lasso tool if you're very careful, but it's often much faster (and more accurate) to use the Select Color Range tool (Select → Color Range). The Color Range dialog is shown in Figure 6-8. If you are going to improve only the highlights, shadows, or midtones, as I did in this example, choose one of them from the Select menu at the top. I chose to improve the midtones.

Digital Photography: Expert Techniques

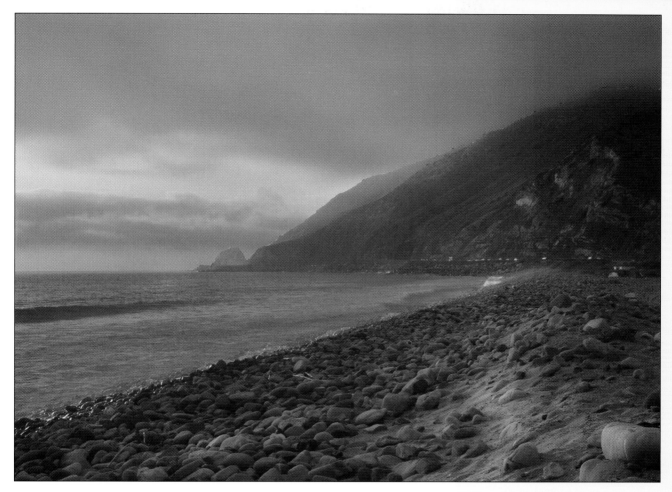

Figure 6-7. The finished blended image.

3. Save the midtone selection by choosing Selection → Save Selection (see Figure 6-9).

4. Open the other image file that contains the midtones that you want and copy and paste it atop the original (darker) image.

5. Load the selection you just saved (see Figure 6-10).

6. Open the Layers palette (see Figure 6-11) and click the Add Layer Mask icon at the bottom. At this point, the areas that were selected in the first image (in this case, the midtones you wished to correct) are the only areas of the top image (the correct midtones) that remain. Everything else is the layer below it, which was the darker image. An image of the layer mask appear

Figure 6-9. The Save Selection dialog. Be sure to enter a meaningful name for your selection so that you can find it easily.

Figure 6-10. The Load Selection dialog. Choose the selection you saved from the pull-down menu.

Figure 6-11. The Layers palette showing the layer mask with the tonal range extension.

beside the new image's thumbnail in the top layer. At this point your work may be done, but that's rarely the case. Often, you'll notice sharp lines between the two images, and the contrast in the two images won't blend very well. So now comes the fun part.

7. Make sure the layer mask is selected in the top layer. You are going to blur that mask so much that the images on the two layers will blend together seamlessly. Choose Filter → Blur → Gaussian Blur, making sure the Preview box is checked. Now, just start dragging the Blur slider to the right until you like what you see in the main image, and click OK. See Figure 6-12.

8. But wait—that's not all! It sometimes pays handsomely to experiment with the Blend modes and the Fill and Opacity sliders on the top layer.

9. If you have several exposures for this image, repeat the steps above for any areas that you want to emphasize or reinterpret. Be as elaborate as you want, but realize that you can make a real mess of things by overdoing it. On the other hand, you could end up with a few downright amazing images!

Figure 6-12. The Gaussian Blur dialog shown alongside the Layers palette.

Extend tonal range with blend modes

There may be times when it's easier and more effective to bring up shadow details by being very specific about which shadow areas need to come alive. Consider Figures 6-13 and 6-14. In Figure 6-13, the highlights are exposed properly, but the shadows are too dark. We want something more like Figure 6-14. The following technique uses blend modes to bring out more detail in our shadows—it works extremely well when you have a JPEG image that you can't pre-manipulate in the Camera RAW plug-in or that you just couldn't bracket.

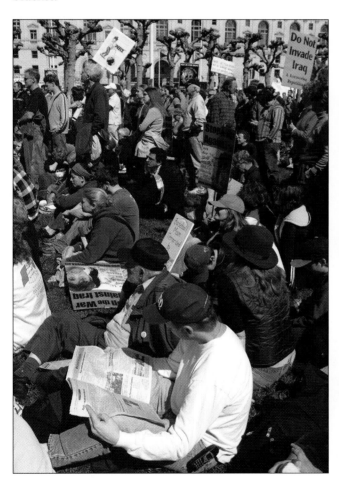

Figure 6-13. In this photo, the highlights are exposed properly, but the shadows are just too darn dark.

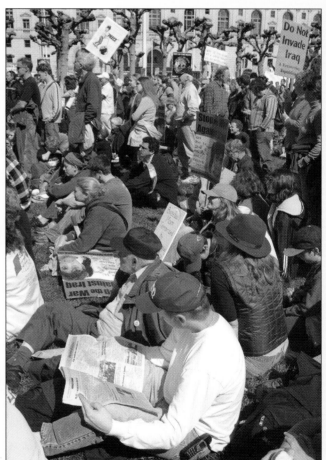

Figure 6-14. Here's the result of the digital fill-flash technique, along with a bit of paintbrush dodging on the white layer to darken the shadows along the edges and at the top.

1. Open the image you want to work on and choose Windows → Layers to open the Layers palette (unless it's already open). With the top layer selected, click the New Layer icon at the bottom of the Layers palette. The new layer, which is perfectly transparent, will appear as the top layer. See Figure 6-15.

Figure 6-15. The Layers palette after creating the new layer.

Figure 6-16. The new layer has been filled with white.

Blend Modes

If you use Adobe Photoshop Elements 2.0, you can get a very similar effect with the Fill Flash command (Enhance → Adjust Lighting → Fill Flash). Just drag the Fill Flash slider until the shadows open up just enough to please you. Adobe Photoshop Album also has a Fill Flash command that works in exactly the same way. The new Photoshop CS also has a very powerful Image → Highlights/Shadows command that gives you superb control over the detail range in various parts of the brightness spectrum. These features became available just as this book went to print.

Figure 6-17. The blend mode has been changed to Soft Light and the fill has been reduced to 50% opacity.

Figure 6-18. You can keep adding fill layers to make shadows even lighter.

2. With the new transparent top layer selected, choose Edit → Fill to bring up the Fill dialog. Choose white as the fill color, make sure Opacity is 100%, and click OK. Your image will now appear totally white. The layers palette is shown in Figure 6-16.

3. In the Layers palette, choose Soft Light from the Blend Modes menu at the upper left. The shadows will suddenly brighten and appear to be full of detail; in fact, they'll probably be too bright. To remedy this, just use the Opacity or the Fill slider (it makes no difference in the Soft Light blend mode) to adjust the brightness and contrast of the overall image to your liking (see Figure 6-17).

4. If Step 3 didn't brighten the shadows enough, just repeat the step to create another Soft Light layer (see Figure 6-18). This second layer will almost certainly brighten the shadows too much (unless what you're after is a very soft, high-key "dreamy" effect). Once again, simply adjust the intensity of the effect using the Opacity or Fill slider.

5. Some of the highlight areas may now be a bit washed out—that is, too bright and lacking in detail. You can either use the Eraser tool to erase the effect over specific areas, or choose a gray shade for the foreground color and use the Paintbrush on the overly bright

areas. The second method is a little less predictable, but with practice it will give you a greater degree of control. You'll learn more about this technique in the following section.

EXPERT TECHNIQUE

Blend Modes

If your highlights are still too washed out, you can also darken the highlights with blend modes. First select all of the highlight areas that appear to be washed out or blocked. With the selections active, press Cmd/Ctrl-J to lift the selections to a new layer. Make sure the new layer is highlighted and change the Blend mode to Multiply. If that overdoes it, drag the Opacity slider to the left; if it's not enough, duplicate the new highlight layer and then apply the Multiply mode to it, too. Much like our previous example, you can keep duplicating and multiplying as many times as necessary to get the tonality you want.

Burn and dodge small areas in Soft Light or Screen mode

The Photoshop Burn and Dodge tools are simply toolbox brushes that are meant to darken (burn) or lighten (dodge) whatever you brush over on a specific layer of the image. It's a digital imitation of the standard darkroom techniques, and the results are quite similar. Unfortunately, so are the problems: washed-out dodges and muddy burns that can't be fixed without starting all over—this can be frustrating and time-consuming. But take heart! There are better ways to control the lightness or darkness of specific areas of the image. For example, look at how we applied burning and dodging in Figure 6-19 to come up with the result in Figure 6-20.

Here is the method that was used:

1. Open the Layers palette and add a new layer immediately above the one you want to burn and dodge. Set the Layer mode to Soft Light (you might want to experiment with Screen mode as well). To lighten an area, choose white as your foreground color. Select the Brush tool and choose a brush that's about one-third the size of the area you want to dodge. Next, set the opacity of your brush to about 10%. Then just keep brushing over the areas you want to lighten until they look just as you want them to. See Figure 6-21 for a look at the layers palette.

2. You can use the Fill or Opacity slider to lower the intensity of the effect, as shown in Figure 6-22.

3. If you want to darken an area, choose black as your foreground color and repeat the steps above. If you want to further refine the tonality of this layer-based burning and dodging, you can use shades of gray, rather than pure black and white, to lighten and darken.

Too Much Noise

The one drawback to this method is that you are likely to create additional noise in the shadow area of the image. You can, however, select the shadow areas that you brightened, feather the selection, and use a noise reduction technique to smooth the noisy areas. A plug-in called Dfine, from nik Multimedia (which we'll talk about later) also does a phenomenal job of noise reduction.

Figure 6-19. The untouched original.

Figure 6-20. The people and the sidewalk were brightened by brushing white on a Soft Light layer; the trees and sky were darkened by brushing black on a Screen layer. Perspective was also corrected.

Figure 6-21. The Layers palette after burning and dodging.

Figure 6-22. The Fill or Opacity slider will lower the intensity of the effect.

4. Since you are working on a layer that is separate from your image, you can change Blend modes and layer opacity, or erase anything that looks overdone or out-of-bounds. That gives you a thousand times more flexibility than straight burning and dodging, and I think you'll agree that it looks a lot better, too! You can try the effect several times on different layers, then turn off each layer one at a time to see which effect you like best. Once again, there's no end to the flexibility in interpretation you can achieve when you're working with CS.

Register Your O'Reilly Book

Register your book with O'Reilly and receive a FREE copy of our latest catalog, email notification of new editions of this book, information about new titles, and special offers available only to registered O'Reilly customers.

Register online at register.oreilly.com or complete and return this postage paid card.

Which book(s) are you registering? Please include title and ISBN # (above bar code on back cover)

Title	ISBN #
Title	ISBN #
Title	ISBN #

Name	Job Title

Company/Organization

Address

City	State	Zip/Postal Code	Country

Telephone	Email address

register.oreilly.com

BUSINESS REPLY MAIL

FIRST CLASS MAIL PERMIT NO. 80 SEBASTOPOL, CA

Postage will be paid by addressee

O'Reilly & Associates, Inc.
Book Registration
1005 Gravenstein Highway North
Sebastopol, CA 95472-9910

Use Screen, Multiply, and other Blend modes on adjustment layers

Compare Figure 6-23 to Figure 6-24. I did this by layering several Photoshop adjustment layers on top of each other, each with its own Blend mode. This should inspire endless experimentation and some dramatically effective results. The method is easy:

1. Create any type of adjustment layer and perform any adjustments you intend to make for that type of layer.

2. Next, choose the Move tool and simply press Shift-+ repeatedly. This will cycle through each of the Blend modes so that you can see its effect.

3. If you see one that you like, stop cycling. Screen and Multiply tend to produce useful results most often, so you might just want to go directly to those two.

Figure 6-23. Sausalito Harbor as the camera saw it.

Figure 6-24. After layering several interpretations of the image and using Blend modes and masks to mix them. Notice the difference in the sky and the water. It's still a bit flat, but again, that's easy to take care of.

Of course, a little restraint goes a long way, unless your goal is to create an image that is an obvious fantasy. After all, there are people who make good money doing just that.

Also keep in mind that many of the techniques for altering the brightness of selected areas will also increase the noise level of that area. If that becomes a problem, place a selection around the area, feather the edges of the selection so that it blends with its surroundings, and apply a noise reduction filter. Grain Surgery and Dfine are excellent choices, but if you want to keep your budget to a minimum you can simply use the Gaussian blur filter. If you do use a noise reduction filter, be sure to use 100% magnification so that you can exactly match the existing grain structure that's outside the selection.

Figure 6-25. The water looks quite inviting.

Color correction

What if the overall image is perfect in every respect, except that it just doesn't create the mood you were after? For example, maybe the image in is just too cold to create that "look of love" that you had in mind. Maybe that warm and fuzzy picture is just too fuzzy to convey the texture of the surroundings. Or maybe you just want a certain starburst effect to transport the viewer into dreamland. Color can be your best friend—or your worst enemy.

There are various ways you can add color to your picture (compare Figure 6-25 with Figure 6-26 for a rather dramatic example), both inside Photoshop and by using third-party filters. And I can't even count the public domain plug-ins that will produce color effects!

Figure 6-26. The same scene after a mood swing.

Basic Photoshop color effects

Photoshop offers a number of ways to change the color balance and increase the intensity of color in your photo, many of which we have already covered. However, these are the basic tools you should always experiment with.

Levels. To open the Levels dialog (shown in Figure 6-27) press Cmd/Ctrl-L. The Levels dialog can change the color balance in midtones, highlights and shadows for each color channel. To control levels independently for each color channel, press Cmd/Ctrl-1 for Red, 2 for Green, and 3 for Blue, or choose it from the pull-down box at the top of the dialog.

Figure 6-27. The Levels dialog showing the Red color channel being adjusted.

Curves. Using Curves, you can change the brightness of any shade along the curve for each color channel (Figure 6-28).

Figure 6-28. The Curves dialog showing the Red color channel being adjusted.

Figure 6-29. This image was "reinterpreted" by making super-curvy variations in each curves channel.

You can also get some great-looking solarizations and other "psychedelic" effects by making really wild curves in various color channels. See Figure 6-29 for an example.

Channel Mixer. The Channel Mixer lets you mix the effects in any channel with the effects in any output channel interactively, simply by dragging the slider to control the intensity of each color channel. This is a great tool to fine-tune your effects after implementing one of the other techniques in this section. To get to the Channel Mixer, choose Image → Adjust → Channel Mixer to bring up the dialog shown in Figure 6-30.

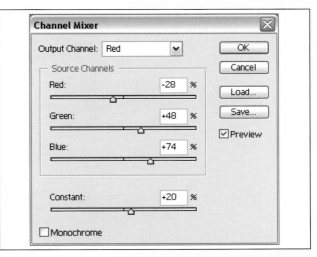

Figure 6-30. The Channel Mixer dialog also provides an easy way to create color filter effects when converting a color image to monochrome.

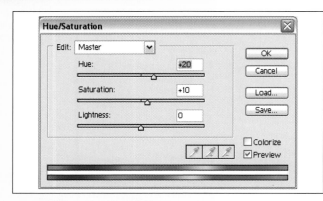

Figure 6-31. The Hue/Saturation dialog lets you change overall color tint or the intensity of colors by dragging the slider.

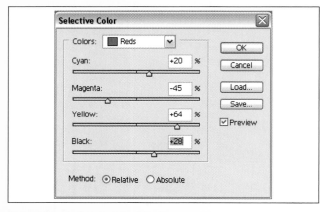

Figure 6-32. The Selective Color dialog. If you want to change the tint of a blue sky or the color of the water, try mixing other colors with the blues.

Figure 6-33. The Layers palette showing the settings used to create the effect in Figure 6-35.

Hue/Saturation. The Hue/Saturation menu item on the Image → Adjust menu lets you change the overall tint of the image to any median color in the spectrum. If you check Preview in the dialog (see Figure 6-31), you will see the effect of the sliders as you drag them. This is also the best place to intensify or play down the existing colors in your photo.

—— WARNING ——

If you drag the Saturation slider too far to the right, certain colors may not be printable. If you have set up color management in Photoshop to accurately reflect the device you'll be outputting to, Photoshop can automatically warn you when you've intensified colors to the point where they won't print ("out of gamut"). Just check Gamut Warning on the View menu; you can press Shift-Cmd/Ctrl-Y to turn the Gamut Warning on and off. When Gamut Warning is on, the out-of-gamut colors will flatten to a single uniform color. The default is 50% gray, but you can change that in the Preferences dialogs.

Selective Color. You hardly ever hear of Selective Color, but it's very useful when you want to alter the color contrast of a subject with its surroundings. This tool, shown in Figure 6-32, allows you to select a primary color—Reds, Yellows, Greens, Blues, Magentas, Cyan, White, Black, and Grays (Neutrals)—then alter all items that contain that color by mixing other colors into it. For example, if you had a green plant against a greenish-brown background of grass, you could make the plant stand out by changing the mixture of colors in the greens. Of course, this technique can produce unbelievably ugly results as well as attractive ones—it all depends on the individual image and the mix of colors you make.

Tinting the photo with a color layer in Photoshop

Another cool way to color or tint a photo is to add a new layer in the Layers palette, fill it with the color you want to tint with, and then use the Layer Blend Modes to mathematically influence the layers. The Layers palette in Figure 6-33 shows how I achieved this result (compare Figures 6-34 and 6-35). This is a variation of the approach used above to bring out more detail in an image's shadows.

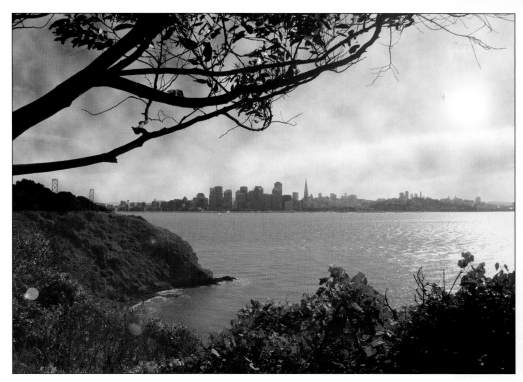

Figure 6-34. The original image, shot in late afternoon.

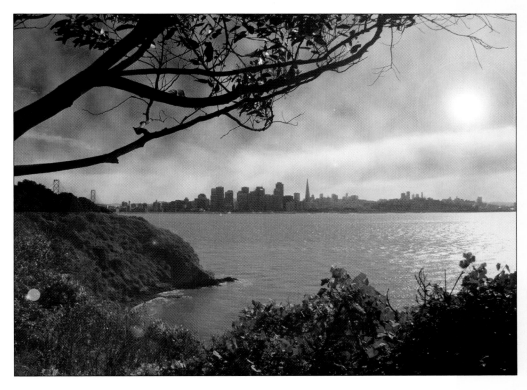

Figure 6-35. The same image, after my Photoshop-imposed sunset. (Granted, you don't see many purple-tinged sunsets over downtown San Francisco, but I'll claim artistic license on this one to emphasize the effect.)

EXPERT ADVICE

Real-Time Blends

You can instantly see the effect of the Blend modes on the underlying layer by dragging the Layers palette out of the Palette Well, choosing the Move tool, and repeatedly pressing Shift-+ to cycle through the Blend modes. Stop when you like what you see.

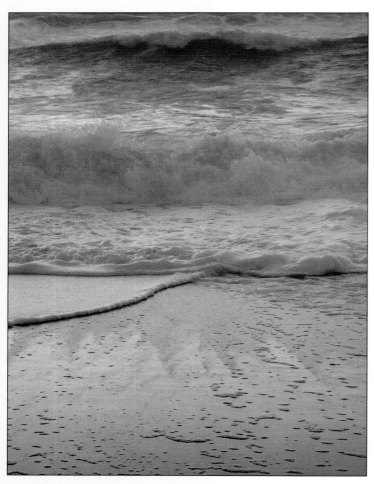

You can also use the airbrush to "spray paint" different colors on different areas of a layer and then use the same approach. In addition, you can make selections around portions of the image where you want to isolate the color effect, and then choose the color layer and click the Mask icon at the bottom of the Layers palette to create a Layer mask. Also, try filling the layer with a gradient instead of a solid color. You can choose any of the gradients in the presets or use the Gradient Editor to create your own.

nik Color Efex

If you don't want to spend the rest of your life experimenting with Photoshop's native color effects, there are a number of third-party plug-ins that can do the job quicker and in a more intuitive way. Both The Imaging Factory and Power Retouche offer filters that perform color corrections quite nicely. However, the power-tool award in this category goes to nik Color Efex. Compare Figures 6-36 and 6-37 to see how powerful this tool can be.

Color Efex filters come in several versions, ranging in price from $70 to $300. The top-of-the-line Color Efex Pro includes 45 filters. They include not only many variations of gradiated, mixed-

Figure 6-36. One of my famous wavescapes, in the original version.

color effects that can be "focused" on particular parts of the picture (as in Figure 6-37), but other effects that imitate (or improve upon) the following traditional photographic filters: Sunshine (warming filter), Polarization, Skylight, Graduated Sky Blue, and Solarization. The dialogs for each filter differ in the number and types of controls, but all of them have an interactive preview window that lets you instantly see an effect before you apply it. Figure 6-38, for example, shows the dialog for the filter that was used to produce the effect in Figure 6-37.

The techniques discussed here can produce an infinite variety of color effects, and the results need not be as extreme as those shown in the examples. In fact, it's generally much more effective when you can't tell that the photograph was altered at all.

The cold, hard fact is that the only way to get a desired result is to start with an idea and then tweak, tweak, tweak. Each picture is different and could be digitally interpreted in dozens or hundreds of different ways. I once asked a traditional

Figure 6-37. The same wavescape, after a bit of fooling around in nik Color Efex. Not exactly realistic, but it does demonstrate the power of the filter.

Figure 6-38. The nik Color Efex "Monday Morning" dialog.

artist friend if she'd ever considered computer graphics. Her answer: "Hell no! You could spend forever deciding what to do and never finish anything." It was one of the truest comments I've ever heard about digital media.

Tip 1: Increase the Picture Resolution

Enlarging an image can result in soft and jagged edges and excess noise, as shown in Figure 6-39. This is true even though Photoshop CS adds options to bicubic interpolation that lets you smooth or sharpen edges. So what do you do if you want to make a two-page editorial spread of an image you shot at low resolution?

Well, you can't actually add detail that isn't there in the original image. However, you can make an enlargement that is acceptably free of grain and noise, where all of the edges are sharp and smooth enough to create the illusion of very high resolution (see Figure 6-40).

Most digital photographers are religious about calculating how large a "quality image" can be produced given the number of megapixels captured by the camera's image sensor. However, if you are careful, use the right software, and have "forgiving" subject matter, there's no practical limit to how large a print you can make without incurring objectionable noise or soft, blurry edges.

Figure 6-39. A straight enlargement to 800% of the image at hand: thanks to bicubic interpolation, it's not terrible.

The first technique we'll discuss can sometimes surpass even the results of some fairly pricey third-party utilities. It is called the 110% method, and is very easily executed within Adobe Photoshop CS, Adobe Photoshop Elements 2.0, or just about any other image-editing software available. (You can do it faster in Adobe Photoshop 6.0 or later because all the 110% multiplications can be created with an action.) Just be warned that getting it exactly right will depend on the characteristics of the specific image you are working on. So if this technique doesn't work for a given image, you may need one or more third-party software packages.

The 110% method

The Photoshop community has only recently discovered that a simple trick with Photoshop's bicubic interpolation method of enlarging an image can produce astoundingly accurate enlargements, up to several hundred percent of the original image. Of course, you cannot actually make a higher-definition image than the one you started with—it's just that 99% of the people who view the image will think you did, as each hair and blade of grass will have smooth, straight edges, and the shades of color within their interiors will blend smoothly instead of having a blotchy or grainy appearance.

Figure 6-40. An enlargement to 800% using the 110% method: close examination shows slightly sharper edges in the eyelashes and eyebrows.

If Things Are Noisy

If you are starting with a file that already contains an unacceptable amount of noise (a subjective factor that's up to you to decide), use Dfine or one of the other noise reduction methods mentioned in this chapter before you make the enlargement.

Figure 6-41. The New Set dialog.

Figure 6-42. The New Action dialog.

Figure 6-43. The Image Size dialog. (Don't worry if the height field is not exactly 110 percent.)

Here's how it works:

1. Open your image. If you're starting with a RAW file (which is best because there's less inherent noise), open it in 16-bit mode to get the least amount of noise and the smoothest color transitions. If you can't open the file in 16-bit mode, you can still gain some advantage by converting it to 16-bit mode before you do the interpolation.

> — WARNING —
>
> *Most of the other utilities listed in this section will not work in 16-bit mode.*

2. Choose Window → Actions. From the Actions palette menu, choose New Set so that you will be able to save and load this and other personal actions at will. When the New Set dialog appears, enter a name that will make the contents of this set easy to remember and find. See Figure 6-41.

3. Next, choose New Action from the palette pull-down menu. When the New Action dialog appears, name it "110% Enlargement" and click Record (see Figure 6-42). Also be sure to designate a Function keystroke combination that will make it easy to manually repeat this action as often as necessary.

4. Choose Image → Image Size. When the Image Size dialog appears, be sure that Constrain Proportions and Resample Image are checked and that Bicubic is chosen from the Resample Image menu. From the Width pull-down menu, choose Percent. Enter 110 in the Width field and click OK (see Figure 6-43).

5. In the Actions palette, click the Stop button at the bottom left of the palette. Now, to enlarge an image to an arbitrary size, all you have to do is highlight the 110% enlargement bar in the Actions palette and click the Play button (the right-facing triangle at the bottom of the palette) as many times as it takes to get the image up to the desired size. See Figure 6-44.

Figure 6-44. The Actions Palette with the 110% action highlighted. If the Photoshop status bar is turned on, you will see the document size change each time you execute the action.

If you want, you can create another action that plays the above action a specific number of times. You can even use that action in a Batch command to enlarge an entire folder a specific number of times. Table 6-1 shows the approximate percentages that can be reached by performing a 110% scaling repeatedly.

Table 6-1. 110% enlargement sizes

Iterations	Size percentage
1	110%
2	121%
3	133.1%
4	146.4%
5	161.1%
6	177.2%
7	194.9%
7 (plus an additional 102.631% resize)	200%
8	214.4%

EXPERT ADVICE

Use the Unsharp Mask Filter

It is usually a good idea to use the Unsharp Mask filter to restore the apparent sharpness that is lost when edge pixels have been enlarged. The settings you use depend on how much you've enlarged the image. A good starting point, however, is:

Amount: 80%
Radius: 1
Threshold: 4

See Tip 4: Know How to Sharpen an Image, for more information.

EXPERT ADVICE

Fred Miranda to the Rescue

Thanks to Fred Miranda, there is a much more efficient way to do this. The FM Stair Interpolation Action, downloadable from *www. fredmiranda.com*, will save you hundreds of dollars worth of your professional time. You get preset and preprogrammed actions that enlarge the image one step at a time. Alternately, you can simply choose the end level of magnification and click. You even choose sharpening or no sharpening; this is useful because many people prefer to do their sharpening in separate stages to avoid an oversharpened result.

Genuine Fractals 3.0

Genuine Fractals (LizardTech) is a plug-in for Photoshop or Photoshop Elements. It uses fractal algorithms to create a highly compressed, lossless image that can be enlarged to virtually any size—although it helps to start with an image that is at least 2 megapixels. Most camera manufacturers use Genuine Fractals to enlarge their consumer digital camera images for trade-show displays. If you want to give it a test drive, you can download the trial version from *www.lizardtech.com*. If you find that you don't need the full capabilities of the professional version, LizardTech also offers an LE version for $50.

Using Genuine Fractals is a two-step process. First, you save the target image (using Save As) to the lossless compressed format. Then you open the .STN file that you just created. In the Genuine Fractals Options dialog that appears, check the Constrain Proportions checkbox, enter the file size resolution you want, and then enter either the width or height that you want the final image to be (see Figure 6-45). Click OK and wait while the program does its calculations. How long you wait will depend on the scale of magnification and on how much processing power and memory your computer has.

Figure 6-45. The Genuine Fractals Options dialog.

S-Spline 2

S-Spline 2 (Shortcut Software) is a standalone application, not a plug-in, so it's a good alternative if your image editor isn't compatible with Photoshop plug-ins. There are some other reasons you might prefer it as well:

- Its interface is easy to use.

- There's no intermediate file format that you have to save to before you can make the enlargement.

- It's relatively inexpensive.

To use S-Spline, simply open the file you want to enlarge. The application dialog immediately shows you the current size of the file, its resolution, and a preview of the image. See Figure 6-46.

Figure 6-46. The S-Spline user interface.

On the left side of the dialog, you can enter the desired output resolution for the interpolated file by either a percentage of enlargement or the actual dimensions. The latter can be in any of the popular unit designations such as pixels, inches, or centimeters. Once you've entered those dimensions, you instantly see the result of the enlargement in the preview window. If you like

what you see, press the "Okay" button. Note that if the enlargement is really huge, processing may take some time depending on your processor speed and RAM. However, the results are quite nice.

> **NOTE**
>
> *There is also a professional version of S-Spline that deals with images up to 48-bit depth and can be used either as an independent application or as a Photoshop plug-in. At $129, it's still very reasonably priced. See www.s-spline.com.*

At this point, you may be wondering why I'm recommending three different solutions to the same problem. Well, it's a tough lesson to learn, but pictures are a *subjective* thing. Each of these solutions does a decent job of enlarging images, but if one doesn't produce the results you're hoping for in a particular image, try one of the others. To start with, though, I'd go with the 110% solution; a great many professionals swear by it, and it's free.

EXPERT ADVICE

Smoothing Graduated Tones

If you want to smooth the tones in delicately graduated areas of color such as skin and skies, you might try reducing the image and then making a big enlargement. When you reduce the image, you'll lose some of the tiniest details (such as freckles and pimples). When you enlarge the image, those tiny details will be gone but the edges will be smooth and clean—so you don't get that "diffused" look. Of course, images that depend on lots of tiny details for impact will suffer with this technique.

Tip 2: Reduce Noise

Image noise is the appearance of speckles that look like film grain or blotchy color. If you're not expecting noise and it suddenly appears, it can look very unprofessional (see Figure 6-47). And if you are expecting it and it isn't there, it can look just as unprofessional. Yes, you heard right, there may also be times when you actually want to *create* noise. For example:

- You want to match noise in a pasted-in image with the noise in the background image.

- You want to re-create the noise that existed in all or part of the original before you did some retouching or applied a special effect.

- You just like noise—at least as an effect for that nightclub or war photo that you're trying to win a Pulitzer with.

Noise can be the result of many things: over-enlargement of the image, cross-talk between photoreceptors in the camera, cranking up the "volume" in order to achieve higher sensor sensitivity (ISO ratings), or just too much reprocessing and resizing of the image.

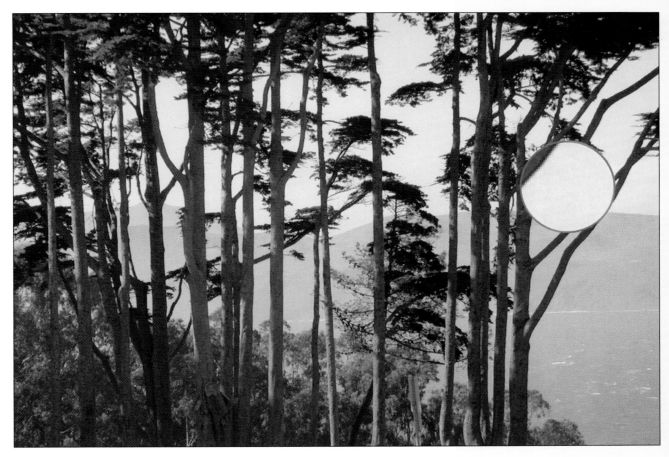

Figure 6-47. A noisy evening sky (though in an image this size, you may have to look very closely to see it).

One solution to reducing noise is to buy a higher-definition camera with a sensor that produces less than the average amount of noise. But that's currently a very expensive option. Many advanced digital cameras also have a noise reduction option. However, this feature by itself often isn't good enough—cameras typically don't offer a choice of how much noise reduction you want, and none will allow you to limit the effect to selected portions of the image.

The good news is that you *can* use Photoshop to more selectively reduce noise. The bad news is that the solution is not a filter, but instead consists of several steps that must be done by hand. A better option is to buy a third-party utility, several of which are discussed below. It's likely that an upcoming version of Adobe Photoshop and/or Adobe Photoshop Elements will come with a built-in noise reduction filter, but it remains to be seen whether such a feature will offer the versatility of the third-party applications I recommend below. Third-party tools are way ahead here. Figure 6-48 shows the earlier image, now totally noiseless after using a third-party tool called Dfine.

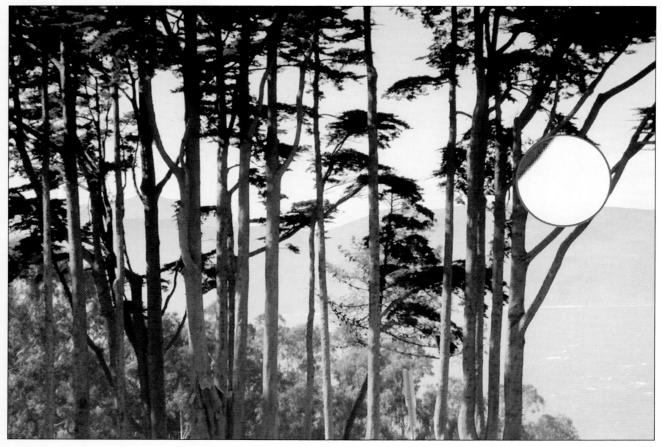

Figure 6-48. The same sky, totally noiseless, thanks to Dfine and fading the noise reduction using the Luminosity Blend mode.

Reducing noise in Photoshop

Let's start with the Photoshop. The following is the best way to use bare-bones Photoshop to eliminate JPEG noise:

1. Switch to LAB color mode (Image → Mode → Lab) and go to the Channels palette (Window → Channels). See Figure 6-49.

2. The Lightness channel is a monochrome image that defines all the edges in the image. If you choose one of the other channels (A in this case) and zoom to 100%, you can look to see if there are any areas of splotchiness. See Figure 6-50.

3. If there are, choose Filters → Blur → Gaussian Blur. Drag the slider to blur just enough to smooth the blotchiness in the image and click OK. If that doesn't do it, go back and choose the other A or B channel and repeat the blurring there as well. After you're finished, return to RGB mode before performing any other image corrections and effects. The result of blurring the A and B channel is shown in Figure 6-51.

Figure 6-49. You can see the color noise (and the Channels palette) in this enlargement of an evening sky.

Figure 6-50. The same sky with the A channel selected.

Figure 6-51. The same noisy sky in RGB mode after blurring both the A and B channels in Lab mode.

— WARNING —

Never work in CMYK mode until you're ready to make final prepress corrections. First, your images are RGB, and so is your monitor. Second, quite a few of Photoshop's commands and tools—as well as most filters and plug-ins—simply don't work in CMYK mode.

EXPERT ADVICE

Sharpening Images

If you're going to sharpen the image, the Lightness channel is a good place to do it. That's because you won't be adding new noise in the A or B channels—which have little or nothing to do with JPEG noise anyway.

If you still see any artifacts, you can also try using the Gaussian Blur technique on one of the color channels. You may see some strange color anomalies along edges, but I have made improvements by blurring the Blue channel in some images.

nik Dfine 1.0

Dfine from nik Multimedia (*www.nikmultimedia.com*) is a brand new utility. If you have legacy digital images that were shot on older, noisy, low-resolution digital cameras, this is the program to bring those images into the 21st century. If you're a professional photographer whose reputation rests on being a perfectionist, you'll also probably find this program irresistible. I find it especially useful for smoothing skin tones in portrait enlargements.

Dfine is an awesome piece of software. It can turn rugged-looking, low-resolution JPEGs into clean-looking photos whose edges look sharper and whose smooth areas (especially skies and skin) are so clean that you want to touch them. If you are willing to put some time into careful study and experimentation, you could gain a reputation for making perfect photographs out of sow's ears.

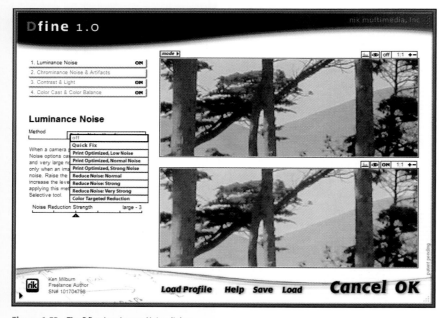

Of course, reaching that level of expertise is not going to happen by instinct. This program has a nearly infinite number of settings and does much more than just reduce noise. There are four aspects of images that the program works to improve:

Luminance noise. This is noise that looks similar to film grain because it imposes variations in brightness. It's often characterized by the presence of tiny white specks. The dialog for improving luminance noise is shown in Figure 6-52.

Figure 6-52. The Dfine Luminance Noise dialog.

Chrominance noise and artifacts. This is the plague that attacks most JPEG images—especially if the level of compression has been set to a lower-quality setting in order to cram more pictures onto a memory card. Dfine works well for cleaning up JPEG artifacts found in images sent through email or from older, lower-resolution cameras. It's also great for reducing noise that occurs when you over-crank your camera's ISO setting. See Figure 6-53 for the dialog used to improve chrominance noise.

Contrast and light. These adjustments increase the image contrast by adjusting the highlight and shadow areas of the picture. One of the adjustments is reminiscent of the Lighting adjustments in Photoshop Elements, creating fill flash or backlighting corrections. Dfine does an excellent job of this. Be sure to make these corrections after you've done the noise reduction; doing it beforehand could make it more difficult to reduce the noise. See Figure 6-54.

Color cast and color balance. While working with the Adobe Photoshop Camera RAW plug-in, I found myself wishing that I had the use of the color temperature and tint sliders after I'd exported the images into the image editor. Well, now you do... and it gets better. You can control the color temperature (warmth and coolness) of the highlights and shadows separately, but also interactively. You can also control an overall additive tint of any

Figure 6-53. The Dfine Chrominance Noise & Artifacts dialog.

Figure 6-54. The Dfine Contrast & Light dialog.

Figure 6-55. The Dfine Color Cast & Balance dialog.

color, remove any excess blue cast, and adjust overall saturation and warmth. See Figure 6-55.

There is a menu of four to eight methods for adjusting characteristics within each of the previous areas.

Not only is Dfine versatile and powerful, it's also easy to use. All you have to do is drag sliders and watch the result in a preview window. If you make a mistake, you can start each area over from scratch. Most important, there's a Quick Fix menu choice that automatically makes adjustments without your even asking.

You can buy pre-calibrated profiles for all of the popular professional and semi-professional digital cameras; nik has promised to keep adding profiles as quickly as possible. The cost of individual camera profiles seems to run between $35 and $50 each, so if you have several different camera models, this could get expensive.

On the other hand, you don't *need* to have any profiles. Without them, you can still use all the features of the program—you just can't automatically make all the improvements you may need. This brings up one more important point: Dfine is fully compatible with Photoshop Actions. Consequently, you can create an action that corrects for various shooting situations, then run a Batch command to perform that action on all the images within a given folder.

Dfine always remembers the last setting you used and automatically applies those settings to the next image you open. Since you can see the before and after images side-by-side, you can just make changes in the individual settings if you want to improve on the image. Using a profile to reduce noise is still much faster and more accurate than making manual choices, but manual choices are still the right option if you don't want to invest in the profile.

Grain Surgery 2.0

The purpose of Grain Surgery from Visual Infinity is to remove, add, or match image noise and film grain. It is especially helpful after you've used the 110% method described earlier and discovered that you've also perfectly enlarged noise and grain defects.

You can use Grain Surgery to either match the grain/noise in the original shot, remove the grain/noise, or—since removing the grain can also mean softening the image—remove the grain and then use an Unsharp Mask on the image inside the filter. So, while the purpose of Grain Surgery isn't necessarily enlargement, it can certainly be a worthwhile part of the process.

Using Grain Surgery is largely self-instructive; there's also adequate explanatory help available through the help menus. Mostly, it's a matter of choosing the end result you want, such as adding, matching, or eliminating grain, and moving a slider to indicate the degree. You can see a side-by-side before and after preview by clicking a button. This simple interface, shown in Figure 6-56, makes it easy to experiment until you get what you want.

Figure 6-56. The Grain Surgery 2.0 Remove Grain interface.

Other Uses for Grain Surgery

Grain Surgery is also extremely useful in compositing and retouching, and in working with low-light photography. In compositing, you can automatically match the grain of the image on one layer with the grain of the main image (which is usually on the background layer). In retouching, you can replace grain that you removed when you painted over or blurred certain areas of the image. In low-light photography, you can get rid of almost all of the noise that occurred when you cranked up the digital camera's ISO rating to shoot at a high enough shutter speed to allow you to hand-hold the shot.

I find it hard to take care of image noise satisfactorily using Photoshop alone, not to mention the annoyance of having to switch channel modes. Even though it's not really any more hassle than running a plug-in, it just *feels* that way. So which program does the better job? Well, Dfine gives you camera-specific profiles and is more comprehensive in its ability to reduce different types of noise. Grain Surgery is dead simple to use and does a fine job. I use both, mostly because Grain Surgery adds and matches grain, while Dfine lets me change color temperature and tint. In addition, Dfine does an amazing job of accurately manipulating brightness and contrast—much more easily than using the Photoshop commands alone.

Tip 3: Correct for Image Distortion

There are really two problems that fall under this heading: perspective distortion and lens distortion.

Perspective distortion, shown in Figure 6-57 and corrected in Figure 6-58, is most noticeable when you are photographing subjects that are outlined by fairly basic geometric shapes, such as buildings or landscapes with clean horizon lines. It occurs because you are not equidistant from all parts of the shape when you take the photograph. It's often easier to correct perspective distortion digitally than to do it in the camera.

As for lens distortion, the zoom lenses on many digital cameras tend to produce barrel or pincushion distortion—especially at extreme wide-angle and telephoto zoom levels. Barrel distortion is an optical phenomenon that makes the straight lines in the image bow outward; pincushion distortion makes the same lines bow inward. Unlike perspective distortion, lens distortion is difficult to repair using Adobe Photoshop or Adobe Photoshop Elements alone. There are simply no built-in commands that take care of the problem.

Figure 6-57. The image before distortion correction.

Figure 6-58. The image after distortion correction. Note that both perspective and barrel distortion have been corrected (compare the window panes).

This section will show you how to correct both types of distortion, making the image much more pleasing. Note that these must be done through separate processes.

Correcting perspective distortion in Photoshop

Let's correct perspective distortion in Adobe Photoshop without changing the size of the original image. You can see the problem and its correction in Figures 6-59 and 6-60.

1. Zoom out until the image is much smaller than the workspace. Then, choose Window → Layers and rename the background layer as "Layer 0" by double-clicking the Background Layer bar, entering a new name in the resulting New Layer dialog, and clicking OK. This is necessary because you cannot transform the Background Layer. See Figure 6-61.

2. Press Cmd/Ctrl-T to institute free transformation. Next, on the transformation box, Cmd/Ctrl-drag the corner handle closest to the edge that needs the most correction, dragging it outside the image. (Pressing Cmd/Ctrl lets you drag one corner of the image independent of the oth-

The Crop Tool's Perspective Option

You can also correct perspective distortion without changing the image size by using the Crop tool and checking Perspective in the Options bar. However, the method described here is much less error-prone. It also makes it possible to crop the image at the same time—still without changing the size of the original image.

Figure 6-59. A photo before correction of perspective distortion. (Look at the pole on the left side of the shot.)

Figure 6-60. The same photo after correction of perspective distortion.

Figure 6-61. A zoomed-out image, framed to leave room for making transformations such as correcting perspective distortion.

Figure 6-62. The same image as above, with one corner dragged to correct any perspective distortion on that side of the image. You can do the same to all four corners until all of the perspective distortion is corrected.

ers.) Whatever you do, make sure that none of the transformation marquee falls inside the original image's borders. See Figure 6-62.

3. Continue to Cmd/Ctrl-drag the handles until all the object's borders are parallel with the edges of the image. When you click OK, the transformation bounding box will disappear, and the image will seem to be corrected.

4. Note, however, that Photoshop is still storing the distorted part of the image that was dragged outside the original frame, giving you a chance to go back and make further corrections later. It also makes the file significantly larger than the original. If you don't want to keep all that information, press Cmd/Ctrl-A to Select All, then choose Image → Crop. Photoshop will throw away the data outside the image, and the file size will be reduced accordingly.

Correcting lens distortion

There are three third-party tools that I can recommend for correcting lens distortion. The easiest to use of these is the Andromeda LensDoc filter. Another is the set of very sophisticated freeware panorama-stitching tools from Helmut Dersch, which includes barrel distortion correction capability. Finally, there's a brand-new tool called Image Align that corrects both perspective and lens distortion automatically, regardless of which camera or lens took the original picture. You can even use Image Align to correct antique photos.

The Helmut Dersch solution

Helmut Dersch (*http://home.no.net/dmaurer/~dersch/barrel/barrel.html*) is a professor at Technical University Furtwangen. He has written a series of Photoshop plug-ins for Mac, Windows, and the GIMP that make corrections to images shot for panoramas. Because of their complexity, I didn't mention these as a simple solution for stitching panoramas in Chapter 4. However, if you are looking for panorama tools that can handle images of any size, make panoramas of any type (including multiple-row panoramas shot with a non-level camera or spherical panoramas), then this is the software to get. Aside from its sheer power, the best thing about this software is its price: $0. All you have to do is find a site that will let you download it from the Web. The site given above worked for me; many of the sites that appeared in my search engine had been closed.

The tool that corrects lens distortions requires you to enter calculations specific to the lens that you used to take the picture. Unfortunately, the program doesn't come with a list of popular lenses that you can cross-reference; you just have to experiment with all the variables until you get a result you like, and then save those settings yourself. The plug-in we'll use here is called Correct.

Here's the routine you would typically use:

1. Download and install Helmut Dersch's Panorama Tools in the version appropriate for your operating system (see the web site for more information). Next, from the Filters menu in Photoshop, choose Panorama Tools. From the flyout menu, choose Correct.

2. The Correct Options dialog will appear. Check Radial Shift, then click the Options button immediately to the right. The Set Polynomial Coefficients for Radial Correction dialog will appear; see Figure 6-63. (I used the numbers shown in Figure 6-64 to make the corrections for a 5MP image from a Nikon Coolpix.)

3. Click OK in both the open dialogs and take a look at the results. In the third column, use smaller numbers to create less compensation and larger numbers to create more compensation. In the fourth column, use larger numbers if you want to enlarge the

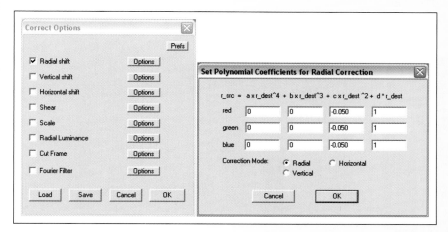

Figure 6-63. The Pan Tools Correct Options and Set Polynomial Coefficients for Radial Correction dialogs.

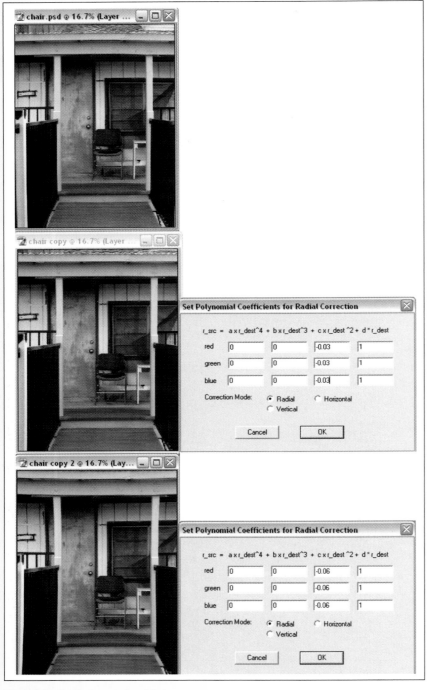

Figure 6-64. The top image is the original, showing slight barrel distortion. In the center image, the numbers in the third column provide the perfect amount of correction. In the bottom image, the numbers in the third column have over-corrected the image.

image and smaller numbers if you want to reduce it. The idea is to enlarge the image just enough to crop off the curved edges that result from making the correction. See Figure 6-64.

4. Repeat this routine until you get exactly the result you're looking for. At this point, you'll find that the program has not only corrected for the barrel distortion, but has also corrected for color shifts and lighting fall-off. Don't even try entering numbers in the first two columns until you've come very close to getting exactly what you want from the last two columns.

Unless you're an expert mathematician, it's going to take some fooling around to get this just right. When you do, click the Save button in the Correct Options dialog and enter a name that indicate the type of correction and the camera/lens combination. Once you've got it exactly right, you can apply the filter in a Batch command to a series of images taken with the same camera and lens combination.

You can correct many other types of distortion using the Panorama Tools/Correct plug-in if you want to keep experimenting, including color aberrations, pincushion distortion, and perspective distortion. For pincushion distortion, simply enter a positive set of numbers in the third column. However, pincushion distortion isn't a problem that comes up very often, and I find it easier and quicker to correct perspective distortion using the previous method.

The Olympus Wide Extension Lens

If you have just purchased a professional DSLR but can't afford the wider-angle zoom lenses that would give you the equivalent of, say, a 21mm lens on a 35mm camera, the Olympus Wide Extension Lens 0.8 model WCON-08B ($159) will give a 24mm zoom the equivalent of about a 28mm lens (instead of a 36mm equivalent) on a 35mm camera. Your lens needs to be able to accommodate a 62mm thread or be adaptable with a step-up ring. There is some barrel distortion, but it can be repaired fairly easily using any of the solutions described in this section. On the downside, it is big, awkward, and heavy.

Andromeda LensDoc

Andromeda LensDoc (Andromeda Software, $98) is a commercial Photoshop plug-in that can correct perspective, lens distortion, and rotation—all within a single transformation. You can download a demo version from *www.andromeda.com*. The results are impressive, and are shown in Figures 6-65 and 6-66. LensDoc is probably the easiest of the third-party tools mentioned here to

Figure 6-65. Before Andromeda LensDoc. (Again, note how the vertical columns and the pole seem to curve.)

Figure 6-66. After Andromeda LensDoc.

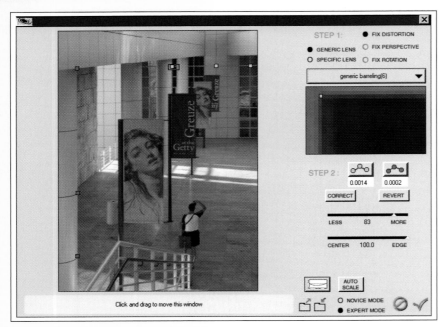

Figure 6-67. The Andromeda LensDoc dialog, shown with the settings that were used to correct the image.

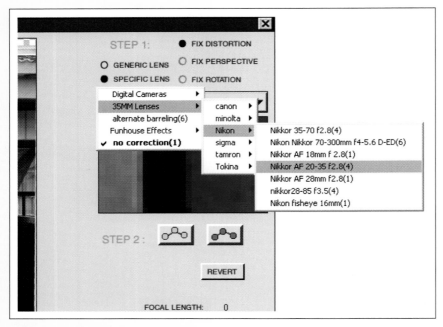

Figure 6-68. Selecting the specific lens.

learn and use, although I still find it faster to correct perspective and rotation using the standard Photoshop tools described earlier.

Here's how it works:

1. Rotate your image and correct perspective distortion. You can do this inside LensDoc, but again I find it easier and more accurate to do it using Free Transformations (Cmd/Ctrl-T), as described in the section above. Next, in Photoshop, choose Filter → Andromeda → LensDoc to bring up the LensDoc dialog, as shown in Figure 6-67.

2. If you own one of the cameras on Andromeda's list (the most popular Canon, Olympus, and Nikon lenses are listed), you can just choose the lens. If you own a pro DSLR or have scanned your image from film, many lenses from Nikon, Canon, Tamron, Sigma, and Tokina are also listed. If your lens and zoom settings are listed, all you have to do is choose the lens and click the checkmark. See Figure 6-68.

3. If you used a zoom setting or lens that isn't listed, you need to use the three yellow and three green squares in the image preview. Line one set up with the straight lines along one side of the image and the other with either a horizontal line or with straight lines along the other side of the image. You'll see a magnification of the location of the square in the smaller window at

right (Figure 6-69). Drag in the magnification window to align the square with the straight object as precisely as possible—otherwise you're bound to get unpredictable results.

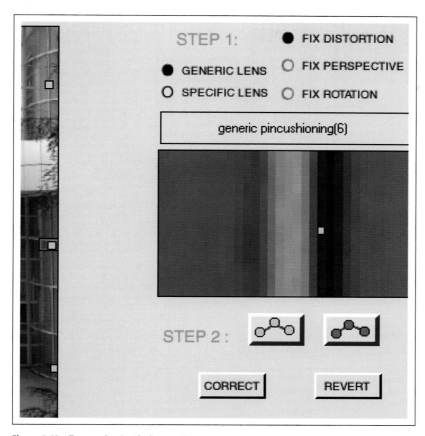

Figure 6-69. Close-up showing the lineup points.

4. Click the Correct button. If you like what you see in the preview, click the checkmark. After a short wait, you'll see the corrected image in the Photoshop workspace (Figure 6-70).

EXPERT ADVICE

Fish-Eye

LensDoc will also let you instantly create some highly distorted effects that resemble the results you might get from looking at a reflection of the image in a bubble or shooting with a fish-eye lens. They're neat effects, but not a substitute for a real fish-eye lens. The fish-eye lens effects can, however, be a good way to make a composited "reflection" on a curved surface (think hubcap or Christmas tree bulb) look authentic.

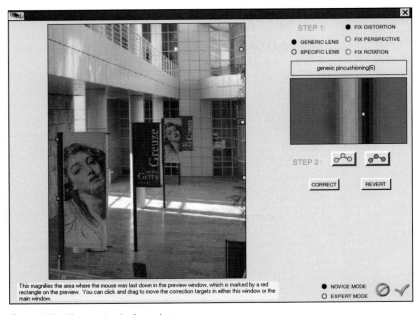

Figure 6-70. After pressing the Correct button.

5. Before clicking the checkmark, you may want to eliminate the black areas that show up on the edges of your corrected image. Click the Expert Mode radio button, then the Autoscale button. The image will be automatically scaled to eliminate the dark spaces, and you won't have to crop your image outside the program to make it smaller. In Expert Mode, you can also use sliders to fine-tune your adjustments if necessary (see Figure 6-71).

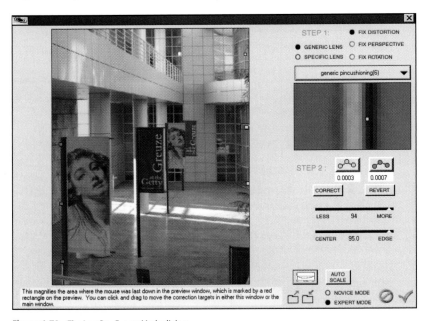

Figure 6-71. The LensDoc Expert Mode dialog.

The Imaging Factory Debarrelizer

For a really easy and inexpensive solution, go to *www.theimagingfactory.com* and purchase Debarrelizer—it's around $40. You can see an example of its effects in Figures 6-72 and 6-73.

Figure 6-72. Before barrel distortion correction with Debarrelizer. The white column on the right—which should be straight—gives away the distortion.

Figure 6-73. After barrel distortion correction with Debarrelizer.

Debarrelizer is a program that lets you correct barrel distortion simply by dragging the Correction Angle slider and watching the preview, as shown in Figure 6-74. When the lines are straight, choose Auto from the Scale to Fit menu, then click OK. The program will also let you scale the Red and Blue

channels in order to repair chromatic aberration that occurs with some digital cameras and wide-angle lenses.

Figure 6-74. The Debarrelizer dialog.

The Image Align program

ImageAlign (*www.imagealign.com*) is a brand-new program that can be purchased either standalone or as a Photoshop filter. The effects of this program are shown in Figures 6-75 and 6-76, using the settings shown in Figure 6-77.

There are three highly appealing aspects of ImageAlign: price, ease of use, and versatility. ImageAlign takes all the guesswork and tedious calculations out of correcting perspective and lens distortions. You can also rotate, skew, and adjust perspective interactively, simply by dragging sliders just as you do to correct barrel and pincushion distortion. ImageAlign isn't quite as accurate as LensDoc on the first try, but there's nothing to keep you from further adjusting the image if you don't like what you see the first time.

Figure 6-75. An architectural view that shows noticeable pincushion distortion, especially with the column on the right.

Digital Photography: Expert Techniques

Figure 6-76. The same image after correcting the pincushion distortion with ImageAlign.

Figure 6-77. The ImageAlign Control dialog, as it was set to make the corrections shown in Figure 6-38.

It seems like only yesterday when the only way to correct lens distortions was with Andromeda's LensDoc. Now you have choices ranging from tough but free to easy and relatively cheap to just unbelievably slick and easy. Helmut Dersch's Panorama Tools recipe is a bit painstaking to execute; however, it's a free download, and no other software makes corrections with such startlingly perfect results. The Imaging Factory's Debarrelizer is the easiest to use and comes at a very moderate price. Debarrelizer can be had as part of a package of a dozen filters for automating the correction of various photographic situations. The 8-bit RGB-only version of The Imaging Factory bundle is $85, and the pro version (both 8-bit and 16-bit in either RGB or CMYK) is $159. ImageAlign sells for $199, and you can download a working demo. It is compatible with both Mac (OS 9 and X) and Windows (98 through XP Pro).

Tip 4: Know How to Sharpen an Image

Often, the quality of a photograph is judged by its sharpness. This can be especially true of food, product, and landscape photos. Even in more romantic photos, where a diffused overall softness may be highly desirable, certain areas of the photo can be dramatized by making them razor-sharp. It's a technique often used in glamour portraiture to draw attention to the eyes and lips, as shown in Figures 6-78 and 6-79.

When to Sharpen

Of course, you can sharpen only those parts of the image that are not really fuzzy in the first place. If the picture is noticeably motion-blurred or just plain out of focus, these techniques won't help—period.

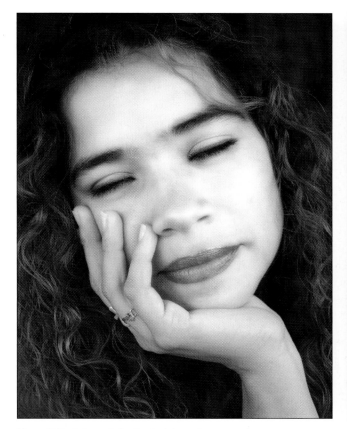

Figure 6-78. An image before localized sharpening.

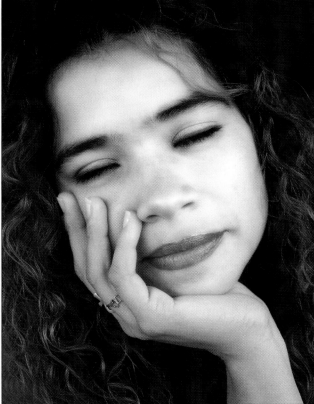

Figure 6-79. The same image after localized sharpening (look carefully at the eyes and lips).

Of course, if sharpness is *the* quality you want to create in a photo, you want the sharpest and highest-contrast lens you can get. Unfortunately, it's not always that simple. What if you just don't have that lens with you? Or you didn't think to mount it when the picture was taken? Or you just can't afford the sharpest available lens—especially if you just paid a bunch of bucks for your pro DSLR?

As usual, there are many techniques to sharpen images. It's easier to figure out which one is best if you remember that localized sharpening (which draws attention to a particular part of the subject) and overall sharpening (which sharpens everywhere) should occur at different stages of your workflow. Localized sharpening should be done at the end of the image adjustment stage. Overall sharpening should be the very last thing you do to the image before you publish it to the Web, make prints to distribute to your friends, or send the image to the printing press.

If you try to do intermediate overall sharpening, you'll end up with jagged edges, noisy skies, and skin tones that look like they belong on a 4-pack-a-day smoker. The reason is that sharpening works on whatever pixels most contrast in brightness or color with their neighboring pixels. If you sharpen at several different times, you're almost certain to oversharpen. Oversharpening

Chapter 6, Basic Digital Photo Corrections ————————————————————

is to be avoided at all costs—it makes your image look bad in such a subtle way that you may not know what it is that you don't like. You'll end up fooling with overall contrast, changing the color saturation, and altering the color balance—getting more frustrated and disappointed with each attempt at a cure.

Now that you understand *when* to sharpen, let's talk about *how* to sharpen. The four tools I find most useful are the Unsharp Mask filter built in to both Adobe Photoshop and Adobe Photoshop Elements (especially when used with the Find Edges filter); Power Retouche's Sharpness 6.0 Pro (part of their professional kit); The Imaging Factory's Unsharp Mask Pro; and nik's Sharpener Pro.

Photoshop Unsharp Mask and Find Edges filters

Photoshop has featured Unsharp Mask ever since plug-ins became available, and it is still one of the program's most powerful tools available. In fact, there isn't much that the other programs listed here can do that you can't do with this one plug-in. (Compare Figure 6-80 with Figure 6-81.) However, it

Figure 6-80. The Find Edges result after painting out areas not wanted in the mask.

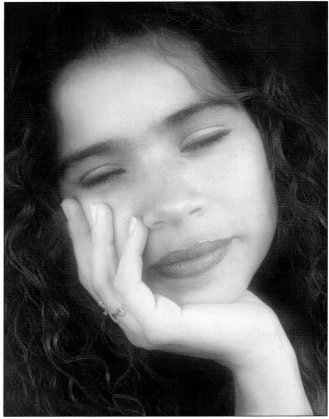

Figure 6-81. A portrait softened with the Andromeda Scatter Light filter and then edge-sharpened with the Unsharp Mask filter through a Find Edges–created mask.

Digital Photography: Expert Techniques

isn't always easy to grasp just how much sharpening you can get away with. There are no hard-and-fast rules; what works for one image may not work for another. As is the case with many digital darkroom operations, you just have to experiment until you're pleased with what you see. If you have (wisely) left in-camera sharpening at a neutral (off) setting, you may now want to do minimal overall sharpening on the computer, where you can control the result precisely. Again, just be careful not to oversharpen.

1. Start by choosing Filter → Sharpen → Unsharp Mask to bring up the Unsharp Mask dialog, as shown in Figure 6-82.

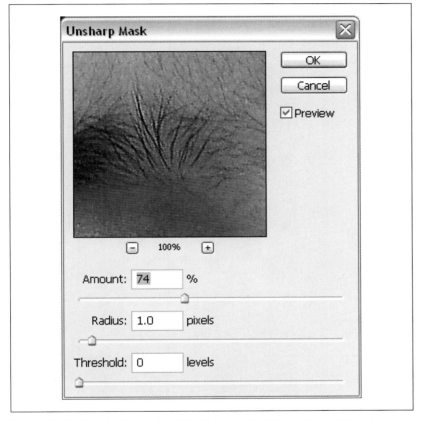

Figure 6-82. The Photoshop Unsharp Mask dialog. Notice the white halo around some of the center eyebrow hairs. This is a good indicator of oversharpening.

2. The Radius should be set at 1 pixel, and the Threshold at 0 levels. Make sure the preview window is set at 100% and drag inside the window until you find the highest contrasting edges in the picture. Now drag the Amount slider to the right until you start seeing a white halo appear along the contrasting edges; then drag to the left until that halo disappears. Back off just a wee bit more, and that should do it.

What Do the Amount, Radius, and Threshold Settings Do?

These three sliders determine the amount of sharpness to apply to the image. The Amount slider quantifies the amount of contrast. The Radius slider dictates the number of pixels out from an "edge" that will be sharpened. The Threshold slider determines how different one pixel must be from the next to be considered an edge (higher is more conservative). A Threshold value of 0 sharpens all the pixels in the image.

There will be times when you have some specific fuzzy edges that you'd like to sharpen. The safest way to do that is to mask the edges you want to sharpen so that they are the only things that will be affected. More commonly, you will want to sharpen all the edges of an image that you've diffused, as I did in Figure 6-81. Some of the programs discussed later in this recipe implement edge sharpening by creating the edge mask within the program. Doing this in Photoshop takes longer, but it's just as effective. Here's how it's done (note that in this example, I have already used Alien Skin's Scatter Light filter to diffuse the image):

1. Duplicate the layer the image is on. If the image is on several layers, duplicate the image and flatten it (Layer → Flatten Image), then drag the Background layer down to the New Layer icon at the bottom of the Layers palette to duplicate it. See Figure 6-83.

Figure 6-83. The Layers palette showing layers that have been duplicated by dragging them to the New Layer icon.

2. Name the new layer *Edges*, as shown in Figure 6-84.

Figure 6-84. The Layers palette showing a renamed layer that is the same as the layer below.

3. Choose Filter → Stylize → Find Edges. You will end up with a fine-line etching of your photo (see Figure 6-85).

Figure 6-85. The image layer after applying the Find Edges command.

4. Choose Image → Adjustments → Hue/Saturation and drag the Saturation slider to 0 (see Figure 6-86). This changes the image into monochrome, but technically it's still an RGB layer.

Figure 6-86. The Hue/Saturation slider.

5. There may be small edges that you do not want to sharpen, such as those around wrinkles and pores, the edges of teeth, etc. There may also be large areas of the image that you don't want to sharpen. In either case, choose white as your foreground color, choose the Brush tool, and simply paint out any edges that you do not want to sharpen. You can also eliminate many of the subtler edges by choosing Image → Adjust → Threshold and dragging the slider in the dialog until you see only what you want to keep. See Figure 6-87.

6. Now you want to invert this layer (Cmd/Ctrl-I) so that the edges are white and the rest of the image is black. You will use this to make a mask of the entire image. See Figure 6-88.

7. You may want to soften the edges of the lines so that when you apply sharpening, the sharpening will blend into the masked areas. Yes, this is unsharp masking, but you are controlling the size and shape of the mask. If you do want to soften the edges (and it's usually a good idea) choose Filter → Blur → Gaussian Blur and adjust the blur level to about 2 or 3 pixels, then click OK. See Figure 6-89.

Figure 6-87. The Find Edges image after using the Threshold slider (inset).

Figure 6-88. The inverted Find Edges image that will make the mask. Midtone "speckles" have been painted out by hand.

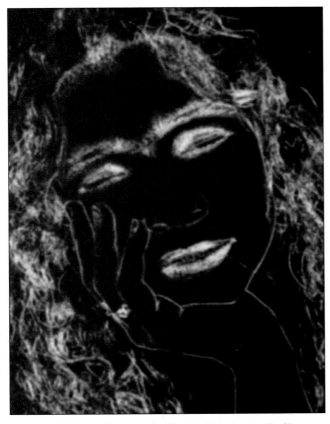

Figure 6-89. The Find Edges image after blurring with the Gaussian Blur filter.

8. Now you make the mask. While the black and white image is still visible and its layer is active, press Cmd/Ctrl-A to Select All. Now open the Channels palette (see Figure 6-90) and click the New Channel icon. A new alpha channel will appear at the bottom of the palette; click its name bar to make it the active channel and then press Cmd/Ctrl-V to paste. Your negative threshold image is now an alpha channel and can be used as a mask.

9. Open the Layers palette and either trash or turn off the layer you just used to make the mask. If you think you may want to keep and modify this mask later, simply move it below the image layer to keep it out of the way. If the image layer is the Background layer, you will need to rename the Background layer in order to move the mask below (behind) it.

Figure 6-90. The Channels palette. The channel at the bottom, below the primary color channels, is the alpha channel that will form the mask.

10. Choose Selection → Load Selection and choose the name of the alpha channel you just created (see Figure 6-91). A mask marquee will appear over the image. You will be able to better see the result of what you're about to do next if you press Cmd/Ctrl-H to hide the marquee.

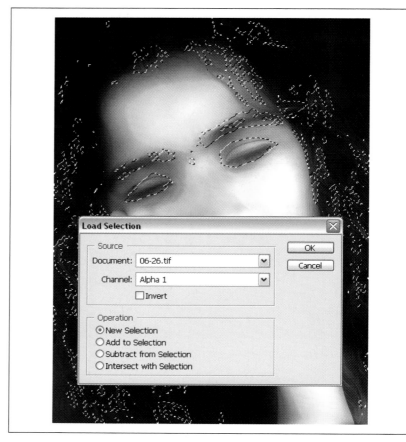

Figure 6-91. The Load Selection dialog showing the Channel menu. The radio buttons at the bottom let you add, subtract, or intersect the selection you are loading with any existing selection.

11. Choose Filter → Sharpen → Unsharp Mask, make your adjustments, and click OK. You have now localized sharpening to exactly the areas you wanted to emphasize—in this case, the model's hair, eyes, eyebrows, lips, and the outlines of her features and hand.

EXPERT ADVICE

Fade the Unsharp Mask

After you do any unsharp masking in Photoshop, choose Edit → Fade → Unsharp Mask. Leave the Opacity at 100% and choose Luminosity from the Mode pull-down menu. This forces the Unsharp Mask filter to pay attention only to the grayscale version of the image so that color anomalies don't occur.

Power Retouche Sharpness Editor

The Sharpness Editor 6.0 Pro (*www.powerretouche.com*) makes edge sharpening more specific and much faster. All you need to do is check the Edge Sharpening box, and then choose the contrasting colors that you want to sharpen by choosing their maximum and minimum range with a pair of color picker sliders (see Figure 6-92). You can continue to choose different color contrasts and repeat the sharpening, so it's easy to be very specific about which types of edges you sharpen and which you don't.

Combining Forces

If you want even more control, you could combine Power Retouche Sharpness with an edge mask in order to make edge sharpening even more specific.

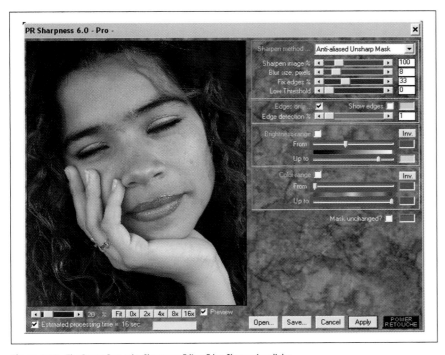

Figure 6-92. The Power Retouche Sharpness Editor Edge Sharpening dialog.

The really cool thing about the Sharpness Editor 6.0 Pro is that you can also eliminate edge halos simply by typing in an estimate of how wide the halos will be. You can either buy the Sharpness Editor by itself or purchase the entire suite of 12 photography plug-ins for $175—which may be the greatest bargain in digital photography computing.

Figure 6-93. The Imaging Factory Unsharp Mask Pro dialog.

Figure 6-94. The nik Sharpener Pro dialog.

The Imaging Factory Unsharp Mask Pro

Unsharp Mark Pro 2.0 (*www.theimagingfactory.com*) is a powerful tool for interactively creating sharpening effects. The dialog, shown in Figure 6-93, features a generously sized preview window that allows you to see the result of any changes you make in the option sliders. I find this tool especially exciting if I've used a masking technique, or if I've limited sharpening to a specific area and used a Lasso selection and feathering to blend it in.

nik Sharpener Pro

There are really two kinds of sharpening: detail-specific sharpening to call attention to specific areas or items in the photo, and pre-print sharpening to maximize the overall appearance of the image as it will be printed at a given resolution on a specific printer or printing plate.

For pre-print sharpening, the must-have tool is nik Sharpener Pro (*www.nikmultimedia.com*). All of the controls in this program are designed to maximize image sharpness and detail when printed at a given resolution. Operation is dead simple: you simply specify the desired print size and resolution using the interface shown in Figure 6-94.

If you only care about sharpening for printing on your desktop printer or for making inkjet prints through a service bureau, you can get all the benefits of nik Sharpener for much

less by not buying the $329.95 Pro version. The basic version sharpens for RGB desktop printers only and costs half as much. There's also a Home version, but you're restricted to inkjet printers.

Don't Oversharpen!

One of the ugliest things you can do to a digital image is oversharpen it. But when you print it out, it can get even worse: sharpening can cause a moiré pattern to appear in the finished print unless you're careful to sharpen specifically for your printer. When you do localized sharpening as a matter of retouching or for effect, it's not a bad idea to make a high-resolution test print of the portion of the image you've just sharpened. First, apply nik Sharpener or the Unsharp Mask settings that you're going to use on the overall print so that they'll be added to the effect. After you've looked at the test print, you can either go back and make adjustments to your original sharpening, or determine that final sharpening will be enough.

Tip 5: Know How to Soften an Image

As the designers at the Bauhaus school were so fond of saying, "Less is more." In other words, simplifying the amount of detail in a design often makes the design more appealing. There are many ways to simplify your photos, but one of the most effective is to throw the image (or its less-important parts) out of focus. Of course, you can do that in-camera (see Figure 6-95) by using a large f-stop and carefully focusing only an important detail, such as a model's eyes. But what if you want to precisely control the point at which depth of field falls off when you can't precisely control the level of light falling onto the subject (or just don't have time to think about it before you shoot)? What if you just want to fuzz out certain areas of the image, such as skin tones in a glamour portrait, while maintaining the appearance of infinite depth of field? Don't despair: as usual, the digital darkroom supplies us with many options.

Figure 6-96 shows an image that's been selectively softened. There are a variety of ways to do this; the trick is to choose the effect that works best for your intended purpose. In general, there are two ways to soften focus: blurring and diffusion.

- Blurring is the equivalent of simply taking the picture—or parts of it—out of focus. The tonality of the blurred area generally produces a result that looks a bit darker than the original because the grays are mixed with the whites—almost as though they'd been poured into a paint bucket together and stirred.

When to Use nik Sharpener

You should use nik Sharpener only as the very last modification you make to your image before you print; otherwise, other processes will destroy the overall printer-specific sharpening. If you sharpen it again before you print, you're likely to end up with an oversharpened print.

Figure 6-95. An image that's as sharp as the camera made it.

Figure 6-96. A more attractive image that's been noticeably softened.

- Diffusion, on the other hand, spreads the highlights out into the shadows. While focus seems softer as a result, most edges in the image are still clearly defined. Diffusion is produced in traditional photography (and can be produced in-camera in digital photography) by placing various types of special effects filters in front of the lens. Digital darkroom techniques can more or less re-create these same effects.

The following tools can help you create depth-of-field effects, as well as dreamy diffusion effects similar to those produced by the old trick of shooting through a nylon stocking or starburst filter.

Gaussian Blur

The Photoshop Gaussian Blur filter is the best tool around for controlling depth of field after the picture has been taken (see Figures 6-97 and 6-98). It is, in fact, the only blurring tool in Photoshop that really matters, as it is the only one that gives you absolute control over how much blurring occurs.

Figure 6-97. There is too much depth of field in this image to really separate the subject from the background.

Figure 6-98. This image shows the result of using the Gaussian Blur filter to different degrees in order to create realistically shallow depth of field.

The trick here lies in making knockouts and selections in order to isolate the foreground from the background. Generally, you follow this strategy:

1. Duplicate the background layer.

2. Knock out the foreground subject (a knockout is a subject that has no background) using the Extract filter (Chapter 7). See Figure 6-99.

Figure 6-99. The foreground after knocking it out with the Extract filter.

3. Soften the edges by making a lasso selection slightly inside the knockout. You can do this very quickly by clicking the Magic Wand tool in the transparent area of the knocked-out layer. Make sure the Contiguous box in the Magic Wand's Options bar is unchecked. Everything will be selected *except* the image itself. To bring the selection inside the image's edges, invert the selection (Cmd/Ctrl-Shift-I), choose Select → Modify →

Contract, and enter the number of pixels by which you want the image to shrink when the dialog appears (Figure 6-100).

Figure 6-100. The Contract Selection dialog.

4. Feather the edges of the selection (Select → Feather).

5. Press Cmd/Ctrl-Shift-I to invert that selection and use the Gaussian Blur filter to slightly soften the edges of the knockout (Figure 6-101).

Figure 6-101. The edges of the knockout after blurring only the edges with the Gaussian Blur filter. (The effect is exaggerated to make it easier to see.)

6. Use the Clone brush to paint the background over the edges of the original subject on the background layer. This keeps the background from making a halo around the subject when you blur it even more (again using the Gaussian Blur filter) to throw it even further out of focus. See Figure 6-102.

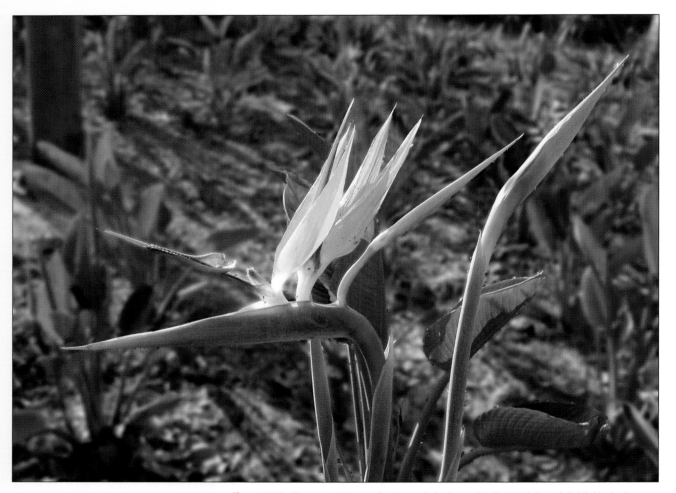

Figure 6-102. The composite image after cloning the background to eliminate halos and slightly blurring it.

7. Finally, lasso the objects that are extremely close or very far away from the lens, feather the selection even more, and blur the distant objects even more.

Digital Photography: Expert Techniques

Making accurate selections and masks is a key technique in the success of many other digital darkroom processes (see Chapter 5 for more information). For now, we'll just go over the technique for using the Gaussian Blur filter.

1. In order to activate Gaussian blur, choose Filter → Blur → Gaussian Blur. The Gaussian Blur dialog shown in Figure 6-103 appears.

2. Be sure you have checked the Preview box so that you get instant visual feedback of your manipulations. By default, the preview window shows a very tightly cropped portion of the image at 100% magnification. Since that's probably too small an area to give you a good idea of what the adjustments will do overall, you may want to click the minus button (–) under the preview window, which will cause the image to zoom out. (Click the + button to zoom in.) You will also instantly see the preview of the result any time you move the slider. When you like what you see in the overall image, click OK.

Figure 6-103. The Gaussian Blur dialog.

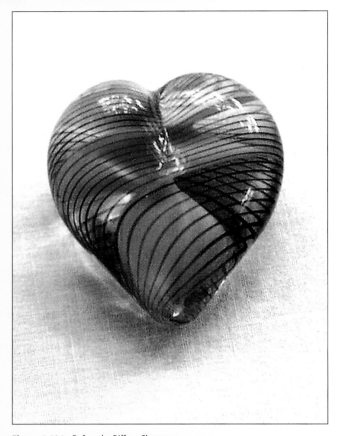

Figure 6-104. Before the Diffuse Glow was added.

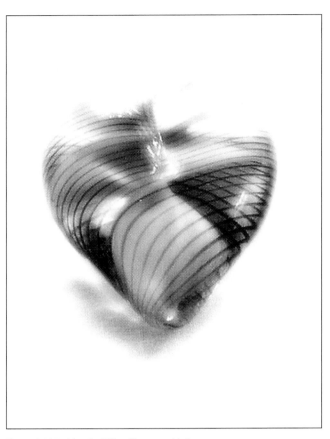

Figure 6-105. After the Diffuse Glow was added.

Diffuse Glow

The easiest way to spread the highlights is to use Photoshop's built-in Diffuse Glow filter (see Figures 6-104 and 6-105). Choose Filter → Distort → Diffuse Glow to access the Diffuse Glow filter dialog, shown in Figure 6-106. This filter is unique in that it also lets you add noise to the diffusion, as is sometimes necessary to match the grain in the rest of the picture. I also find this an excellent filter for softening skin tones in portraits. The results speak for themselves!

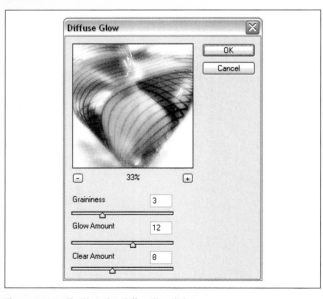

Figure 6-106. The Photoshop Diffuse Glow dialog.

Andromeda ScatterLight

If you're a control freak and you want to create a wide variety of diffuse glow effects, Andromeda ScatterLight is the plug-in for you. It's even easy to use: Andromeda has created a preset menu of effects (one of which is shown in Figure 6-107), and you simply choose an item from the menu. Be aware, however, that the extent (spread) of any effect will be different depending on the subject and the size of the photo, so you may have to make adjustments with the sliders after you've chosen an effect (see Figure 6-108).

Figure 6-107. This starburst effect is one of the special effects built into the Andromeda ScatterLight filter.

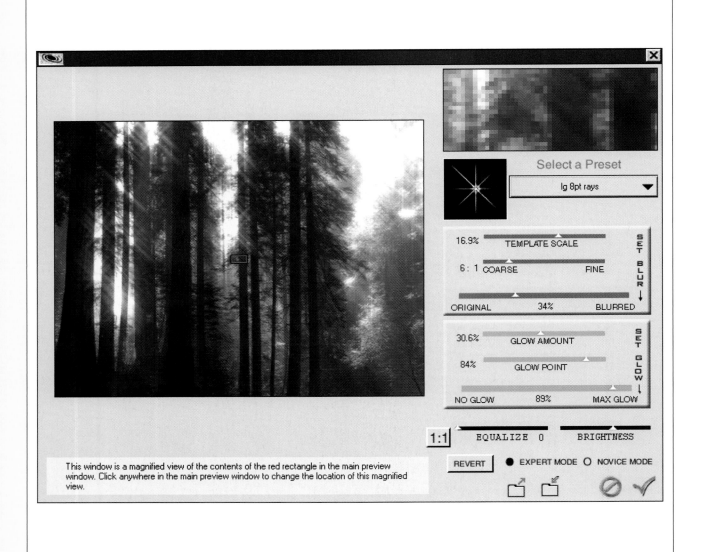

Figure 6-108. The Andromeda ScatterLight dialog.

Power Retouche Soft Filter

The visual effect of the Power Retouche Soft Filter is very similar to that of the Photoshop Diffuse Glow filter. The interface consists of a pair of sliders and a preview window that you can show at various magnifications. The sliders control the intensity of the effect and the area over which it spreads, as shown in Figure 6-109. The Soft Filter is a nice addition to your collection of filters, but no substitute for the Andromeda filter.

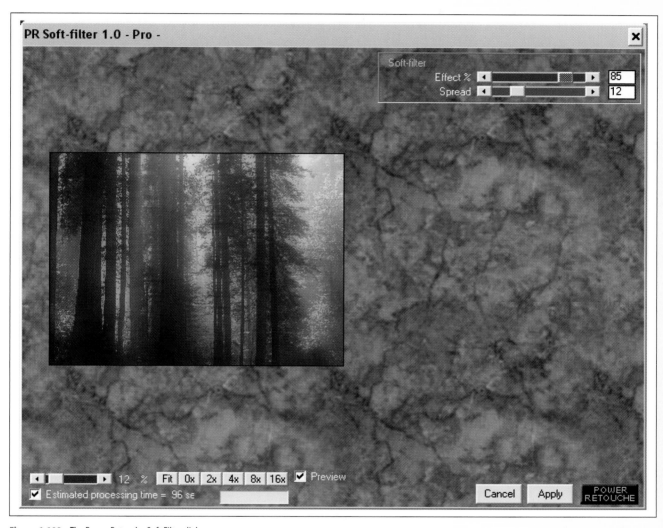

Figure 6-109. The Power Retouche Soft Filter dialog.

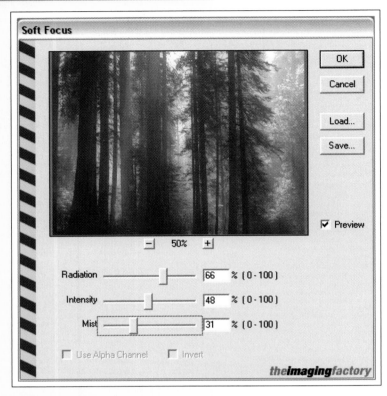

Figure 6-110. The Soft Focus dialog.

The Imaging Factory Soft Focus

This is a worthwhile compromise between the sophistication of the Andromeda ScatterLight filter and the simplicity of the Diffuse Glow filter or the Power Retouche Soft Filter. Soft Focus has three sliders and an instant preview window that shows the image at any magnification. The sliders, as shown in Figure 6-110, control the spread of the glow, the degree to which the darker tones are affected, and something called "mist" that appears to be nothing more than an adjustment in overall brightness and contrast. There doesn't seem to be any addition of noise, as there is in the Photoshop Diffuse Glow filter.

A few final notes:

- Don't forget to match the overall grain and texture of the image after you've softened portions of it. Otherwise, the result you produce is going to look phony.

- There are no hard and fast rules as to how you soften your image or where. Simply do what works for that image. If you don't like what you see the first time, then just try again. Practice is what gets you to Carnegie Hall.

- The Imaging Factory also makes a filter that it calls the Simulate DOF (Depth Of Field) filter. It lets you locate a horizontal area of sharpness and a degree to which (and how fast) the areas above and below the chosen area will go out of focus. This can provide a clever effect and it's very useful for treating those parts of the image that you might want to cover with type so that the sharp edges in the image don't compete for attention with the sharp edges in the type. It is *not* a very realistic approximation of the depth-of-field effect unless you are shooting across a flat plane (such as a desert, ocean, or the empty floor of a large hall).

You may be wondering why I haven't mentioned soft focus effects such as motion and radial blurs. We'll discuss that in Chapter 8, but let's first take a break and use some of the techniques in this chapter to create photo-paintings.

Converting Photos to Paintings

There are times when a photograph is just too literal or too cold to project the kind of visual appeal that you desire. There are also times when the photograph you have doesn't show all the elements you want shown or doesn't have the resolution you need. Of course, a traditional painting could be done, but that takes more time, sends the money elsewhere, and often destroys the impact of catching a precious moment in time. Luckily, you can learn to create a painting from a photograph without having to spend years in art school (though of course, any drawing or painting talent you do have will certainly help!). That's what this chapter is about.

Getting Started

Let's say that your art director wants an illustration that looks like a painting. Perhaps he or she doesn't like the detail or the mood that your "factual" photograph provides. What can you do? Well, you can try to create different moods using color and special photographic effects such as glows and star filters—we've already been there in Chapter 6. Sometimes, however, that's just not enough. Maybe it's time to do something drastic—like turning the photograph of the eucalyptus tree in Figure 7-1 into the "painting" in Figure 7-2.

This section will show you how to create "natural-media" brushes using the features in Photoshop CS and Photoshop Elements 2.0. The techniques in this chapter can be quickly mastered by a beginner, but it'll take practice to make your work truly look as though it were painted from scratch rather than "digitally manufactured."

Let's start by creating a painting from a digital photo using Adobe Photoshop CS or Adobe Photoshop Elements 2.0. The technique described here can be done quickly, is likely to look professional, and will whet your appetite for more experimentation.

1. Open the image that you want to reinterpret as a "painting" and duplicate it so that you don't destroy the original picture (Image → Duplicate).

Figure 7-1. A fairly boring photograph of a eucalyptus tree.

Figure 7-2. The same tree reinterpreted as a photo-painting, using the technique described in this section.

When the Duplicate Image dialog opens, add a "dwng" suffix to identify this as the drawing version of the original. Figure 7-3 shows the copy of our original photograph.

2. If necessary, flatten the image by selecting Layer → Flatten Image, and then duplicate the background layer by choosing Layer → NewLayer via Copy or by pressing Cmd/Ctrl-J. You've now preserved all the detail in the original image within this same picture, which may come in handy later in this process. Rename the layer "Background Copy" if necessary.

3. Create a "pencil sketch" of your subject by choosing Filter → Stylize → Find Edges. You will automatically see only the colored outlined edges of the image, as shown in Figure 7-4. You can keep this sketch as is, fill it in, or "paint" over it, but it will generally provide better guidelines than just brush-stroking over the original.

Figure 7-3. The photograph of the eucalyptus tree and staircase we started with.

Figure 7-4. A Find Edges "pencil sketch" of the tree.

4. This pencil image is usually too busy and is in color, so you'll probably want to use the Threshold command to convert it to black and white and to add or remove lines at a chosen point of brightness. Choose Image → Adjustments → Threshold to bring up the Threshold dialog (Figure 7-5). Choose the default level, 128, and press OK.

Figure 7-5. The Threshold dialog.

Figure 7-6. The tree photo outlined with the Find Edges layer in Darken Blend mode.

Figure 7-7. With the colors simplified to 6, we can see jagged edges along some of the colors.

Figure 7-8. Using the Diffuse Glow filter to get a "watercolor" effect in the colors.

5. Since the pencil sketched copy of the background is on its own layer, you can instantly make its white areas transparent by choosing the Darken blend mode for that layer in the Layers palette. The result is shown in Figure 7-6.

6. For now, simplify the colors in the original image by selecting the Background layer and using the Posterize command (Image → Adjustments → Posterize). I chose six colors in the Posterize dialog shown in Figure 7-7, but you should play with this until you get an effect you like.

Digital Photography: Expert Techniques

7. Oversimplifying the color range may make the edges a bit jagged. To get rid of those jaggies, you could simply blur the colors with the Gaussian Blur (Filter → Blur → Gaussian Blur) filter. I, however, used the Diffuse Glow filter (Filter → Distort → Diffuse Glow) here to get a more watercolor-type feeling (see Figure 7-8 for the settings). You could also just brush-stroke over the jagged edges using the Brush tool. If you do, remember that you should pick up colors from the image itself by pressing the Opt/Alt key to change the brush into an eyedropper to sample to foreground color.

8. Repeat this action as often as necessary to change colors to match existing colors. You could also use brush strokes to "sharpen" edges that are blurred too much when softening jaggies with the Gaussian Blur filter. The final result is shown in Figure 7-9.

As mentioned, there are many other ways you can interpret this sketch. For example, you could fill in the colors by hand or trace over the edges with colored brushes; you could even pick up the colors from the photo on the underlying layer. You could substitute various different effects in Step 7, such as texture filters, art brush filters, or any number of third-party filter effects. Finally, you could export this image from Photoshop to Painter and then use a watercolor wash on both layers.

Figure 7-9. The final result. This is just one style of photo-painting that any photographer could make.

EXPERT ADVICE

Corel Painter's Sketch Effect

This technique works even better if you use Corel Painter's Sketch Effect command. Sketch Effect lets you smooth jagged edges, choose highlight and shadow thresholds, introduce or remove a grain pattern, and indicate the amount of contrast (sensitivity) that will be considered an edge. You can then use one of the paintbrushes to emphasize the outlines of shapes that you want to stand out. The result looks much more like a real sketch, as shown in Figure 7-10. If you wanted a colored painting, you could then use the sketch as a digital coloring book.

Figure 7-10. The Corel Painter Sketch Effect interpretation of the same image, with hand-traced tree trunks and banisters.

Tip 1: Paint with Filters

Let's say you're crunched for time, and you don't really care if the result looks like a painting as long as it gets across the "feeling" you are looking for. You have no training as a painter, and you're one of those people who always say "I can't even draw a straight line." So how can you possibly make the lilies in Figure 7-11 look like a decent painting?

Luckily, there is an easy way out. If you pay attention to a few simple details and are willing to experiment, you'll find that you can quickly and easily create something that actually looks like art. For example, look at Figure 7-12.

Figure 7-11. Lilies photographed at a flower stand, as they appear to the camera.

Figure 7-12. The same lilies, painted as described below with the help of Photoshop's Rough Pastels filter.

Photoshop (and most other image editors) comes with a number of filters that can texturize your image to look as if it were painted with natural media. This effect will look much less mechanical if you use selections to isolate portions of the image and then use different settings options for the different areas. The technique in this section includes the rules for selecting each area to be individually filtered in an image. I'll also show you how to overlap and blend different filter effects applied to layers copied from the main image.

Photoshop comes with over 50 filters that simulate brushstrokes and other painterly effects. You'll also find endless numbers of these from Corel, Xaos Tools, Andromeda, Alien Skin, and others. There are even freeware artistic filters on the Internet. Check out *www.desktoppublishing.com/photoshopfilters.html*.

Get Creative

Altogether, thousands of filters produce painterly effects by texturing, abstracting, or mixing colors in the original. In the techniques that follow, which filters you use and which layers you put them on is entirely up to you.

Figure 7-13. The dialog used to create the painting of lilies in this section.

Xaos Tools Paint Alchemy

If you really want filters that look like brushstrokes, try the Xaos Tools Paint Alchemy filter set. The same company also has an awesome line-drawing and "watercolor" tool called Segmation. You can check out both products at *www.xaostools.com*.

Unfortunately, on the Adobe site, Photoshop CS no longer lists any of the Xaos Tools filters as compatible third-party filters. I have tested them and they still work in Photoshop Elements 2.0 and Photoshop 6.0, so you could create the effects in those versions and then import the results into Photoshop CS to take advantage of the newer features. If that's too much trouble, a good alternative would be to use Corel Painter's Effects → Esoterica → AutoClone or Auto VanGogh commands to automatically create a variety of natural brushstroke effects.

1. Start your project by opening the image you want to "paint" and moving the parts of the image into three or four layers that will represent the distance of the objects on those layers from the camera. First, select the area in which objects are closest, then press Cmd/Ctrl-J to lift the content to a new layer. Depending on the amount of depth in the photo, repeat this process for two or three more groups of objects. Each time, turn off the layers you've already done so that you can more easily trace the areas you want to lift from the background. The objects furthest from the camera can simply stay on the background.

2. When you've finished lifting objects to as many areas of depth as you want, turn off all the layers above the background. Choose a filter that will make a broad, blurry stroke. Some filters let you adjust the size and sharpness of the brush stroke by dragging sliders, as in Photoshop's Rough Pastels filter (Filter → Artistic). You can see a preview in the preview window of the filter's dialog, as shown in Figure 7-13.

3. When you like what you see in the preview window, click OK. Then go to the top layer and run the filter of choice again, this time choosing small brushes and high definition. You could also play around and choose different filters that give you different types of strokes, but be careful—the results of mixing filters can look pretty bizarre. Figure 7-14 shows you how the image looks after processing the main area of interest and the background.

4. Process each of the other layers with a filter, making the strokes show more or less definition depending on how close or far away the layer is meant to look.

5. Since each area was lifted to a different layer, you probably have hard edges between strokes. Finish the job by flattening the layers and using the Clone brush to blend the strokes at the edges of the layers.

The biggest objection people have to painting with filters is that the effects look "canned" or "phony." This problem usually results from using only one filter and one setting for the entire image, so the technique described above goes a long way toward disarming these objections. Don't tell them I told you, but I know quite a few highly regarded artists who do their "hand" painting (individual digital brushstrokes) only on the foreground objects, while the background is simply textured with an artistic filter to save time.

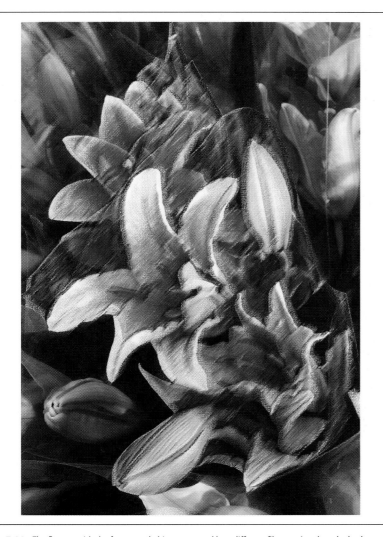

Figure 7-14. The flowers with the foreground object processed by a different filter setting than the background. (To get the end result shown in Figure 7-12, the middle layer was processed with yet another filter.)

Tip 2: Paint with the Art History and History Brushes, Filters, and Snapshots

So you like the speed that painting with filters affords, but want control over the degree and type of texture that's applied to specific areas of the "painting." Is there a way, for example, to just paint over certain areas of Figure 7-15?

Yes, there is. To paint only over certain areas of an image, first make several snapshots of the image, using a different filter on each, and then use Adobe Photoshop's History Brush to paint any area of the original image with the snapshots (see Figure 7-16). This isn't as speedy as filter painting, but it's quite a bit faster than doing all the stroking and texturing with a paintbrush.

—— **WARNING** ——

Each snapshot uses as much memory as the original image, and all of the snapshots will stay with the image when you save it. So if you need to conserve storage space, be sure to delete the snapshots by dragging them to the trash in the History palette once you're finished painting. You'll also want to delete the snapshots if you're making up a folder or CD of images to send to someone else.

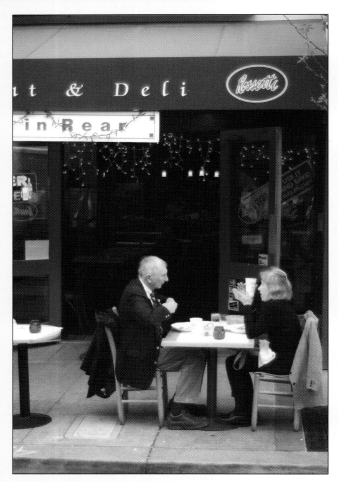

Figure 7-15. The original photograph of a couple taking a dinner break at a street festival.

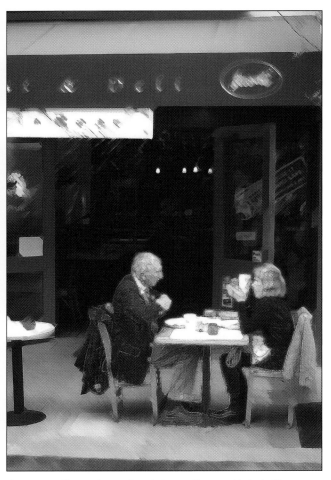

Figure 7-16. The same image after painting specific areas with the Art History brush.

When using this technique, the main thing to remember is *not* to use layers. If you need to create layers to make the base image look the way you want it to, do it before you start this process, make a duplicate of the image, and flatten it.

Here's how you would create a painting like the one shown in Figure 7-16:

1. Open the image, and make all the necessary adjustments to give it the mood and feeling you want from the resulting illustration.

2. Open the History palette and click the New Snapshot (camera) icon at the bottom of the palette. This creates a new snapshot that incorporates any of the changes you've made.

3. Choose a filter you think will be appropriate over parts of the image. Make the filter adjustments to your liking and apply it to the image.

4. Click the New Snapshot icon at the bottom of the History palette again. You will see a new Snapshot bar appear at the top of the palette (see Figure 7-17).

5. The instant the snapshot is recorded and before you do anything else, press Cmd/Ctrl-Z to undo the filter effect. The photo will regain its former appearance.

6. Double-click in the snapshot title (e.g., "Snapshot 2") and rename it to describe the filter effect you just applied.

7. Repeat these steps as many times as you like, using a different filter each time. You can't do any more filter effects once you start painting, so do as many as you think you might need.

8. Choose the History brush from the toolbox, and size and feather it to your satisfaction. You may also want to use other "natural media" brush characteristics (see Tip 3: Create and Use Natural-Media Brushes).

9. In the History palette, click in the History Brush Box of the filter effect you want to paint from. The History Brush Box is a small box just to the left of the icon and the name of the snapshot, as shown in Figure 7-18.

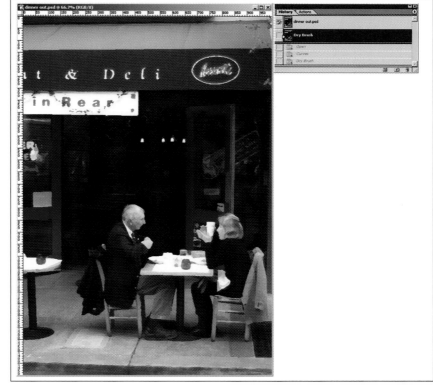

Figure 7-17. Our image with the Dry Brush filter applied (left) as well as the corresponding History palette (right).

Figure 7-18. A closeup of the History palette with the History Brush Box.

> — **WARNING** —
>
> *Be careful not to click in the name bar of one of the snapshots while you're painting with the History brush—if you do, the image in the workspace will change to the image of the snapshot. If you don't notice, you'll find yourself painting the other filters onto the snapshot rather than onto the current state of the image.*

10. Feather your brush so that it blends with the photograph rather than creating a sharp edge when you stroke. To do this, click the Brush Presets icon at the far right of the History brush's Options bar. The Brush Presets palette will appear in a pop-up below it, as shown in Figure 7-19. Choose Brush Tip Shape from the menu and drag the Hardness slider as far to the left as you want.

Figure 7-19. The Brushes palette as it should look when feathering.

11. Paint in the areas you want to paint with the currently chosen effect. Don't worry about going outside borders or changing your mind about which effect you want—you can repaint any area at any time with any filter by activating the History brush for the snapshot you want to paint from.

12. Continue to paint, switching from different snapshots and brush settings until you get the result you want.

These steps are just the basic principles—you're free to complicate and enrich this process in any way you choose. Note that this will be a much more enjoyable experience if you have at least 1 GB of RAM and plenty of free scratch disk space.

Tip 3: Create and Use Natural-Media Brushes

Most of the older Photoshop brushes simply "painted" a solid color. You could feather the edges, and if you had a pressure-sensitive pen pad, you could also vary the thickness and opacity while making the stroke. However, the only "natural media" that such strokes emulated was an airbrush: unlike charcoal, oil, acrylic, or watercolors, there was no variation in the density of the stroke, the thickness of the color at the edges or interior of the stroke, or "dabbing" of the brush (see Figure 7-20).

Figure 7-20. These brushstrokes were made with Photoshop's traditional brush shapes. As you can see, theres no variation in texture, depth, opacity, or stroke width.

However, that all changed with Photoshop 7. Starting with Version 7, Photoshop introduced a library of natural-media brushes as well as extensive capabilities for creating customized brushes that either imitate natural media or just create a unique brush style (see Figure 7-21).

The brush settings were so greatly expanded in Version 7 of Photoshop (and to a slightly lesser extent in Photoshop Elements 2.0) that you can now create just about any imaginable sort of brushstroke. In fact, the biggest drawback of all this versatility is that the possibilities can quickly overwhelm you!

For that reason, I'd recommend you start with the preset libraries of brushes. After that, move on to the Define Brush command, which paints using a pattern that looks like

Figure 7-21. These brushstrokes were made with Photoshops newer shape characteristics introduced in Version 7. Now there are almost limitless possibilities for variations in texture, depth, opacity, and stroke width.

the brush you want to create. Then, when you want ultimate control, you can use Photoshop's Brush Dynamics. I'll describe these approaches in the following sections.

Preset brush libraries

As you'll see in the later section on Brush Dynamics, Adobe Photoshop CS, Photoshop 7.0, and even Adobe Photoshop Elements 2.0 give you a mind-boggling number of settings that can control the characteristics of a brush. So if you can't find a brush that behaves exactly the way you want it to, you can make your own. However, it's much more efficient to start with a few of the several hundred that ship with the program and experiment with them enough to get a sense of what they can do. If you start by modifying brushes that approximate the look you're after, you'll have a much better sense of direction when you get around to building your own brushes from scratch. You'll also save endless wasted hours of confusion.

To get started, simply choose a brush tool, go to the Options bar, and click on the brush sample icon labeled "Brush" (or the down arrow to its right). The Brush palette will appear, as shown in Figure 7-22. Scroll down to see all the preset styles in the default brush library; there are about 70 of them, and because the more "painterly" brushes are so seldom used for normal photo editing, many photographers never scroll down the palette dialog far enough to find them.

Photoshop also ships with 11 additional sets of brushes: Assorted, Calligraphic, Drop Shadow, Dry Media, Faux Finish, Natural, Natural 2, Special Effect, Square, Thick Heavy, and Wet Media. These are shown in Figures 7-23 though 7-34.

Figure 7-22. The Brush pop-up palette. The column at left shows samples of the shape; the column at right shows what happens when you drag a brush with a pressure-sensitive pen.

Figure 7-23. The Default brushes palette.

Figure 7-24. The Assorted brushes palette.

Figure 7-25. The Calligraphic brushes palette.

Figure 7-26. The Drop Shadow brushes palette.

Figure 7-27. The Dry Media brushes palette.

Figure 7-28. The Faux Finish brushes palette.

Figure 7-29. The Natural brushes palette.

Figure 7-30. The Natural 2 brushes palette.

Figure 7-31. The Special Effect brushes palette.

Figure 7-32. The Square brushes palette.

Figure 7-33. The Thick Heavy brushes palette.

Figure 7-34. The Wet Media brushes palette.

When you're creating photo-paintings, you'll usually be cloning either from a photo or from another layer, so the original photo will be dictating the colors. When you want to simplify the original by having one color represent many colors, stop cloning and use the eyedropper to pick up colors from the original photo. You can do this interactively by pressing the Opt/Alt key to temporarily switch between the brush and the eyedropper.

You can also avoid having to go to the Color Picker when switching between often-used colors by simply choosing colors from the Swatches palette (Window → Swatches).

You can easily create your own Swatches palettes with colors that you typically use for specific purposes (for instance, skin tones or sky tones or portrait backgrounds). Simply use the color picker to select a color for each square in the palette, or by mixing colors and then choosing specific colors within the mix.

If you have some painting experience, you'll probably find it most natural to choose between colors you've mixed "by hand." The quickest way to do this is:

1. Make one color the foreground color and the other the background color.

2. Create a new, small image window to be left active in the Workspace. Choose File → New and enter a pixel size of about 40 × 60 pixels, keeping the background white and the resolution at 72 dpi, as shown in Figure 7-35.

Figure 7-35. The New File dialog.

Watch Those Plug-ins

If you have a pressure-sensitive pen, such as the Wacom tool suggested in Chapter 1, be sure you're using plug-ins that are strictly compatible with your current version of Photoshop; if you don't, the pressure-sensitivity may not work. Photoshop will tell you if this is the case by complaining about missing *.dll* files when you try to open the files. If you really need to use those old filters (and KPT 3.0 has some really cool ones), use them with Adobe Photoshop Elements 2.0.

3. Choose the gradient tool in the toolbox and drag it from the top to the bottom of the new image window. You can now use the eyedropper to choose any of the colors in the gradient that appears, as shown in Figure 7-36.

Figure 7-36. The gradient in the new window, made from the foreground and background colors.

Figure 7-37. The resulting image after adding the colors you want to mix.

You can also mix colors as if you were mixing them on a traditional artist's palette, and then use the eyedropper to pick from any of the colors in the mix. You can use this technique to mix as many colors together as you like.

1. Create a new file by following the instructions in Step 1 of the preceding exercise.

2. Use the eyedropper, the Swatches palette, or the color picker to select the colors you want to mix, and then use a fairly good-sized brush (about 20 pixels) to plop the color into the new window. Do this to as many colors as you want to mix, as shown in Figure 7-37.

3. Choose the Smudge tool and make the brush size about half the size of the color spots—though a bit of experimentation will soon tell you what size best works for your style. Now just mix the colors together as if you were finger-painting or using a painter's knife. You can re-smear colors together and add colors any time you want to change the mix. See Figure 7-38.

Figure 7-38. The above colors mixed with the Smudge tool.

4. Now use the eyedropper to pick a color. You can also set the eyedropper's options to pick up colors from only one pixel or to create a color that's an average of the nearest 3 or 5 pixels—just select from the Sample Size pull-down menu in the Eyedropper Options bar.

You can also mix colors by painting them so that their borders touch, and then using the Gaussian blur filter while experimenting with the number of pixels of blurring to get the degree of mixing that you want.

Using the Define Brush command

You can create a brush shape simply by painting one on a white background, selecting it within a marquee, and then choosing Edit → Define Brush. After the Brush Name dialog appears, enter a name for the brush that is descriptive and meaningful to you.

If you want to have the brush vary in size, mix colors, change opacity, and so forth, simply set the Brush Dynamics for your new brush (see the next section). Otherwise, you'll only be able to paint at the size the brush was when you created it.

EXPERT ADVICE

Multiple Sizes

If you want to make your brush range in size from very large to very small, it's a good idea to create it in several sizes—even if you have a pressure-sensitive pen. This is very easy to do: start with the largest size brush you're likely to need, select it with a marquee, and choose Define Brush. While the marquee is still active, press Cmd/Ctrl-J to lift it to a new layer, press Cmd/Ctrl-T to turn on Free Transform, and scale the brush to the next smallest size (pressing Shift while you drag a corner scales uniformly). Press Return to confirm the transformation, select the new size brush, and define it. Repeat this process as many times as you need to create different sizes of the brush.

Using Brush Dynamics

Brush Dynamics allows you to introduce a number of performance characteristics to any brush in the library—whether it was created by Adobe, a third party, or yourself. For simplicity, we'll just look at how these Brush Dynamics properties affect one round brush, but remember that you can combine any or all of the illustrated properties by checking its box in the left-hand column of the Brushes palette. You can also adjust the degree or intensity of these effects by clicking the name of the effect in that same column to reveal its controls in a larger window on the right side of the column. But we're getting ahead of ourselves. First, take a look at the types of effects you can achieve, as shown in Figures 7-39 through 7-50. I'll then show you how to use the controls to vary each effect.

Figure 7-39. Brush Tip Shape.

Figure 7-40. Shape Dynamics.

Figure 7-41. Scattering.

Figure 7-42. Texture.

Figure 7-43. Dual Brush (the effect is very dependent on the blending mode being chosen)

Figure 7-44. Color Dynamics.

Figure 7-45. Other Dynamics.

Figure 7-46. Noise.

Figure 7-47. Wet Edges.

Figure 7-48. Airbrush.

Figure 7-49. Smoothing.

Figure 7-50. Protect texture. This preserves the textured shape of the chosen brush, so texture doesnt smear when the brush is dragged.

The setting dialogs for these effects differ in the number and effect of the variations. Most of the settings are made with sliders, and you can immediately see the effect in the stroke preview at the bottom of the dialog. If you require consistent settings, you can enter an exact number in a field instead of dragging the slider. Be on the lookout for checkboxes: when they are checked, an effect is turned on. Finally, there are two kinds of pull-down menus: Blend Modes (the selection here is far more limited than for layers) and Control. Choices in the Control menu of the dialog allow you to choose between pen pressure or tilt (if you have a pressure-sensitive pen), or a mouse wheel to control the intensity or size of the effect.

WARNING

It's very easy to forget which controls you've used for a particular brush. If the brush is behaving in some unexpected way, check the various Brush Dynamics dialogs' Control menus to make sure that each is set properly.

To experiment with more brushes and settings, open the photo you want to turn into a painting, make a duplicate to protect the original, and flatten the layers. Make sure the Layers palette is open or handy so that you can switch layers quickly. Switch to the background layer when you want to choose a color from the original, switch back to the transparent layer, and then paint with that brush wherever you want that color to appear. Use different Brush Dynamics when you want to tighten the strokes on an area of interest, or loosen the strokes to create a more impressionistic effect.

Tip 4: Consider Hand-Painting in Photoshop or Photoshop Elements

There are several outstanding programs on the market that can create paintings that look very much like their traditional (non-digital) counterparts. The downside? These programs can be expensive, and if you're not an experienced painter or illustrator, you may not be able to fully utilize Corel Painter or Deep Paint. If you can spend some extra money, however, these programs are worth looking into. Table 7-1 shows some of the leading natural-media paint programs.

NOTE

Most image editing software, such as PaintShop Pro, features some natural-media brushes and artistic filters that will let you create photo-paintings. All of them have one or more unique features that may be worth experimenting with for certain effects.

Table 7-1. Leading natural-media paint programs

Software	Comments	Price
Corel Painter 9 *www.corel.com*	The most versatile and best-established natural-media paint program.	$299
Right Hemisphere Deep Paint *www.righthemisphere.com*	A very full-featured Windows-only paint program. Works as either a Photoshop plug-in or as a standalone application.	$249 (free demo available)
Synthetic Software's Studio Artist 2.0 *www.synthetic.com*	Mac only, unfortunately. Amazingly realistic, natural-media paint program. It is especially suited to modifying photos into paintings.	$379
Fo2PiX PhotoArtMaster *www.fo2pix.com*	Makes paintings automatically from digital photos. Unique interface requires some experimentation.	£85 (free demo available)

If you don't plan on purchasing any of the above software, then here's a technique to perform hand-painting. For our purposes here, it doesn't matter whether you work in Photoshop CS or Photoshop Elements 2.0. This exercise demonstrates that it is often easier to start a painting from a coloring-book type outline that has been automatically generated in Photoshop. In this case, the outline itself is an important part of the painting, but you can always just obliterate the outline—it's mostly there to guide you in your painting until you gain enough experience to do it on your own.

Having said that, here we go:

1. Open the image you are painting and choose Image → Duplicate. Keep one of these copies "as is" so that you can use it later to clone colors if you need them. As you will see shortly, the colors in the working image will be posterized, so without the copy we couldn't access the original, uncompromised colors.

2. Activate the duplicated copy and press Cmd/Ctrl-J to make a copy of the image on a new layer (if this started out as a multi-layer image, it should be flattened before copying the background layer). See Figure 7-53.

3. Activate the new top layer. You are now going to turn the image into coloring-book outlines. You can use any filter that makes outlines; Photoshop's built-in Find Edges (Filter → Stylize → Find Edges) is a readily accessible starting point. This is an automatic filter with no dialog boxes, so the result you see is the result you get. See Figure 7-54.

Figure 7-53. The Layers palette with a layer duplicated from the background layer.

Figure 7-54. The result after running the Find Edges filter.

4. The edges are in color, but I prefer a more stark black and white and having some control over how many edges I get. To make all the edges in the outline the same brightness, run the Equalize command (Image → Adjustments → Equalize). See Figure 7-55.

Figure 7-55. The result after running the Equalize filter.

Figure 7-56. The Threshold dialog box.

Figure 7-57. The result after running the Equalize and Threshold commands.

Figure 7-58. The Posterize dialog.

5. Next, run the Threshold command (Image → Adjustments → Threshold) and drag the dialog's slider left and right until you find the result pleasing. See Figure 7-56.

6. After closing the dialog by pressing OK, Photoshop will render the image. See Figure 7-57.

7. Depending on your image, adjusting the Threshold or executing the Equalize command may have left extraneous textures or outlines. Use the Brush tool at 100% opacity with white as the foreground color and the brush with full edge hardness to paint out any details you don't want to keep.

8. In the Layers palette, click the Layer Visibility icon in the Outline layer to temporarily hide the layer. You can now see the background layer.

9. The background layer still has the original, fully detailed photographic image in color. Most photographs have far too many colors for a painting. You could simply paint over them with fewer solid colors, but I find it quicker to posterize them first (Image → Adjustments → Posterize). When the Posterize dialog opens (Figure 7-58), enter the number of colors you want in the final image. If the preview box is checked, you will be able

to see the result of any number you enter. I used eight colors for this image; the exact number you need will depend on how much shading and detail you choose to keep in the image.

10. Go to back to the Layers palette and turn the top layer back on so that you now see only the outline. Choose Darken from the Layers palette's Blend mode pull-down menu. Everything on the top layer disappears except for the dark outlines, which now appear to be outlining the colors. See Figure 7-59.

11. If you find the dark outlines to be a bit jagged and unnatural-looking, you can smooth them by anti-aliasing them with the Gaussian Blur filter. Be sure not to blur by more than one or two pixels. You can often further dramatize the result by choosing the background layer and then adjusting it with the Brightness and Contrast, Levels, or Curves command; you might even want to change the color balance or tint of the colors. Another option would be to choose one of the natural-media brushes (charcoal is often very effective) and simply trace over the outline so that it looks hand-painted. You then get the extra advantage of being able to add edge outlines wherever you feel they're effective. See Figure 7-60 for the result before starting to paint.

Figure 7-59. The image after posterizing and outlining.

Figure 7-60. The result of all the Photoshop manipulations before starting to paint.

12. Chances are, you'll find your current result to look a little too mechanical. This is where the painting comes in. Flatten the image, choose the Brush tool, and use the Brush Dynamics and Brush Tip shapes (both found in the Brushes palette) to give the brush a form and texture. I find it helps to set the Brush Dynamics for pressure-sensitive pen control of size, opacity, wet edges, and color jitter. You may also want to add some colors of your own.

13. Before you start painting, zoom to 100% so that you can see the effects of each stroke you make. Start in one corner and pan across one full window at a time, then pan down one full window and work your way back in the opposite direction. You can pick your brush colors directly from the painting at any time by pressing Opt/Alt to turn the brush into an eyedropper.

Use Different Blend Modes

Experimenting with the different Blend modes in the Brush tool's Options bar will give some very interesting effects to the underlying colors.

14. Paint all the areas that can be painted with one color, then pick the next most prominent color and repeat the whole painting process. Repeat this routine until you get the look you want. When you finish, you may want to add some freehand strokes and additional colors, just to give your painting a little extra sass and dash.

This exercise only scratches the surface of the painterly effects you can achieve using Photoshop. Using this technique, almost anyone should be able to create a good-looking photo-painting. You'll be surprised at what you'll be turning out after a bit of practice and experimentation.

Tip 5: Consider Using Corel Painter 8 and Painter Classic

Photoshop's "natural-media" brushes can bring you closer to creating a more painterly look in your photos, and certainly give your art a more abstract and handmade feel. However, the hard truth is that effects using the Photoshop brushes rarely look and feel much like their analog counterparts. Furthermore, it just takes too long to do all that customization, and Photoshop isn't really set up to make cloning a painting from a photo as easy as it could be.

And Another Option...

You could also leave the layers intact, and then hand-paint both the outline and background layers. As always, experimentation is highly encouraged.

If you're already a painter, Corel Painter will feel more natural to you than other digital natural-media products. For example, if you're after a more emotional and impressionistic rendering of the subject, Painter can provide a perfect result; compare Figures 7-61 and 7-62.

There are many reasons why Corel Painter 8 is worth the investment—especially when it comes to features that are new to the latest version. The most important change is the new user interface, which is a great improvement over the notoriously overcrowded interface of Painter's precedents. Photoshop users will feel right at home with the new, vertical toolbox and a toolbar with the same location and function as the Photoshop options toolbar.

Figure 7-61. A photograph of a tree near Stafford Lake.

Figure 7-62. The photo-painting created with Corel Painter

The new features are intriguing as well. Digital Watercolor lets you create water washes and paint in transparent colors that run together. A new mixer lets you mix colors on a palette in exactly the same way that you'd mix oil colors—it's a feature that is more about letting artists do what comes naturally than about getting colors that you couldn't get before. There's a new Sketch effect that automatically converts a photo to a line drawing by tracing edges—the effect is similar to effects in Photoshop (such as Find Edges), but also gives you control over paper texture, line weight, and image detail. There's also a new and more versatile interface for creating your own brushes. And finally (in both senses of that word!), Painter has "real" (i.e., Photoshop-like and Photoshop-compatible) masks, layer masks, and channels.

There's another good reason why Painter might be the right solution for you: you may already own it. Wacom tablets come with a simplified version of Painter called Painter Classic, and unless I'm doing especially sophisticated work and need the horde of additional brushes and options, I actually prefer Painter Classic's directness and simplicity. In fact, everything covered in this section can be done in either program.

So how can you use Corel Painter and Painter Classic to create a photo-painting? Cloning is a good place to start, as it gives you a definite jumping-off point and keeps you focused on the form and function you want to follow. Let's start with a simple example:

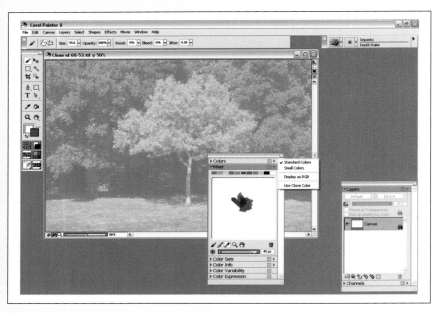

Figure 7-63. The Painter 8 workspace and interface. Very Photoshop-like, no?

1. Open the image you want to turn into a painting. Painter 8's redesigned interface is so Adobe Photoshop-like that it should feel very familiar! See Figure 7-63.

2. Choose Edit → Preferences → Brush Tracking. In the Brush Tracking dialog (Figure 7-64), simply draw in the preview window at the speed and pressure you want to indicate and click OK. Painter will "remember" your style until you reset it.

3. Choose File → Clone. Painter will automatically duplicate the original photo, flatten it, and add "Clone" to the name of the file.

4. Press Cmd/Ctrl-A to select everything in the cloned image, then press Delete/Backspace. You will be left with a blank white canvas.

Figure 7-64. The Brush Tracking dialog.

5. Click the Tracing Paper icon at the top of the workspace window's scrollbar to see a 50%-faded version of the original image (Figure 7-65). This gives it the appearance of having put a transparency on a light box and covering it with tracing paper, and in a digital sense, that's exactly what you've done—you can now paint anything atop the image without actually editing the original pixels. Later, when you want to clone a different type of stroke atop one that's already there, you can simply paint over or blend the two strokes together. Every cloned stroke will be able to draw from all the information in the original.

Figure 7-65. The cloned image in Tracing Paper view.

Painter Brush Characteristics

Brush characteristics in Painter are much more extensive than in Photoshop. Luckily, they're easier to keep straight because most of them apply media in much the same way that a traditional artist's tool of the same name would; for example, the Oil brushes apply the sheen and look of different types of oil color brushes (bristle, camel's hair, etc.). Other categories include acrylics, airbrushes, calligraphy, colored pencils, crayons, watercolor, felt pens, impasto, liquid ink, pencils, pens, and sponges; each of these choices provides numerous stylistic variations.

The Palette Knife Brush

Another very effective way to turn a photo into a believable painting is to use Painter's Palette Knife brush to put the colors in the photograph. This technique works best when you want the image to look modern or impressionistic.

6. Select the Brush tool and choose a brush that will give you a background "underpainting" in the style and texture you want. You can use the clone brushes or any of the other brushes. See Figure 7-66.

Figure 7-66. The basic library of brush tools. Click the icon to the right of the brush to get a menu of brush subtypes.

7. Set your brush preferences. When you choose the brush, an options bar (Painter calls it the "Preference Bar") appears, as shown in Figure 7-67. The preferences have different names than Photoshop's brush preferences: Size, Strength, Grain, and Jitter. Size refers to your brush's diameter, Strength is just another word for opacity, Grain has to do with how much the currently chosen paper grain will affect the appearance of the stroke, and Jitter is the amount of variance that will appear in a given brush setting.

Figure 7-67. The Painter 8 brush options bar.

8. Start painting in fairly bold strokes that are short enough to pull up the colors from the underlying cloned image, but that will also make a nice, flowing background for detailed strokes. See Figure 7-68 for an example.

9. Choose a smaller brush whose "bristles" are likely to show a bit more detail. Experiment with the brush's style settings, but stick with a brush in the same general category (such as Oils or Pastels).

10. I find it helpful to turn the Tracing Paper feature on and off from time to time, especially when working in this detail mode. You may also want to offset your clone source (original) image and your clone image so that you can more clearly see what you're cloning from (see Figure 7-69). All of this helps to bring in details and colors that help to define the shape you're depicting.

11. Finally, you may want to change to a non-clone brush or turn off the clone stamp if you're using a regular brush with the clone stamp turned on. Then you can use your detail brush to paint in outlines or any added detail you want to include. You can also use the same technique to paint over any details that you want to hide.

Painter is richly featured, and is as good at natural-media painting as Adobe Photoshop is at image editing. If you're new to natural-media paint programs, be aware that there

Figure 7-68. The underpainted image abstracts the original image and provides a quick background for more detailed strokes.

Figure 7-69. When cloning in detail, it sometimes helps to see the original and clone side-by-side.

are numerous big, fat books that are barely able to fully cover all aspects of Painter. The purpose here is simply to introduce you to what is arguably the most powerful and versatile tool for photo-painting and to give you a quick overview of just how powerful the possibilities are. In fact, Painter's even better for artists who want to paint from scratch.

Painter has some very worthy competition. The rest of this chapter is devoted to the best of these competitors and how you might want to use them.

Tip 6: Use buZZ Pro for Realistic Watercolors

The one painting style that most computer programs have trouble imitating realistically is watercolor (the Watercolor filter in Adobe Photoshop is a prime example). Consider the photograph in Figure 7-70. We want to achieve a realistic watercolor image from this photo as easily as possible.

Figure 7-70. The original photograph of a flower.

One solution that works better than any of the others I've seen of late is yet another Photoshop plug-in called buZZ Pro, which works both Macs and PCs. And you don't have to take my word for it: you can download a free 30-day trial version from *www.fo2pix.com*. buZZ comes in several iterations, each one more versatile than the last, ranging from £30 to £90. See Figure 7-71 for an example of what it can do.

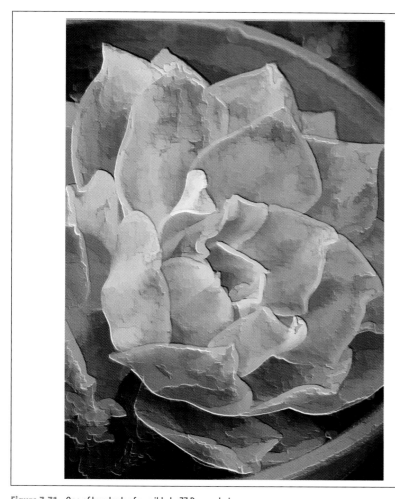

Figure 7-71. One of hundreds of possible buZZ Pro renderings.

buZZ actually comprises various sets or "stacks" of plug-ins with a common interface that allows them to interact with one another. Therefore, the "style" of what you end up with depends on the combination of filters you designate. (This is similar to the way the new Filter Gallery in Photoshop CS works.) Once you've picked out the filters, it's pretty much a "click and watch" routine. Here's how to create the image you see in Figure 7-71.

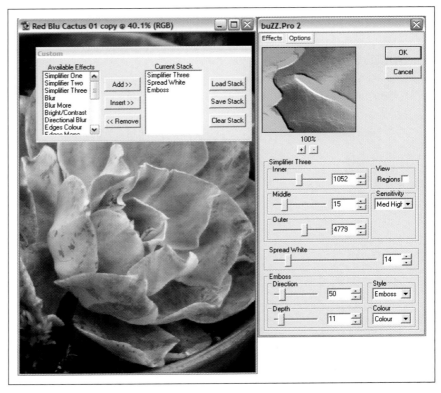

Figure 7-72. The buZZ dialogs.

Using buZZ Pro Inside of Painter

buZZ Pro (and all its junior brethren) is compatible with all Photoshop plug-in compatible graphics programs, including Painter, which is how I normally use it. Then, when the filters have rendered their interpretation, I can easily use Painter's watercolor brushes to give the painting a more individualized style, as well as to smooth any jaggies or edge halos that might result from some stack combinations. This is a powerful advantage.

1. Duplicate your original, flatten it, and choose Filters → buZZ.Pro → buZZ Stack. The two dialogs shown in Figure 7-72 will open side-by-side.

2. In the Custom dialog, choose any item from the Available Effects list and click the Add button. The name of that item will appear in the Current Stack list on the left side of the dialog. Repeat this step as many times as you like for different effects.

3. The order of the effects in the Current Stack list will greatly affect the end result. You can reorder the effects in the Current Stack by dragging them above and below other effects.

4. In the buZZ.Pro 2 dialog, you will see a preview of the various effects as they are dropped into the stack. On the left side, you'll also see interactive controls for each of the items in the stack (some items have more controls than others). Once again, the secret is to experiment until you like what you see...then do it over again until you like it even better. When you're absolutely thrilled with the preview, click OK.

Don't get discouraged if you don't like what you see once the entire image is rendered. buZZ is so easy to use that it's no big deal to just try another group of effects and settings.

Amazing as buZZ can be, it isn't entirely bug-free. Another problem is that it's not very good at managing memory, which can be an issue if you're working with the big files that professional cameras produce. The good news is that since watercolors tend to be soft and fairly flat, they can be more effectively enlarged than the typical photo. You can also smudge any resulting noise or brush in any details or edges after the enlargement, and the finished result will still look painterly and natural.

Another very interesting plug-in that I would recommend is Segmation, from Xaos Tools. Segmation's watercolors produce a somewhat different style from what you get in buZZ, and even though it doesn't have the range of settings that buZZ provides, it is still a very useful addition to your toolkit. Figure 7-73 shows an example of a Segmation rendering.

Tip 7: Deep Paint

Painting in Photoshop can be awkward, and it has a steep learning curve when creating brushes and strokes that imitate natural media. The process is much easier in Corel Painter, but its very richness of features can make getting started a bit intimidating, especially if you don't have painting experience.

There's yet another program that offers creative ways to photo-paint; compare Figure 7-74 to the finished image in Figure 7-75. Right Hemisphere's Deep Paint is a Windows paint program that can also be configured to run as a Photoshop plug-in. However, for the sake of speed and interactivity, I'd suggest running the standalone version (you get both when you buy the product). The program retails for $249. Mac users might want to look into Studio Artist from Synthetik Software ($350), a very interesting program that creates its magic through scalable vector graphics. You can download a free full-featured demo for either of these programs, so you can decide on the right solution without spending a penny in advance.

We'll concentrate here on Deep Paint because, besides being $100 cheaper, it's simply an easier and quicker solution for non-painters. Mac users who want to run Deep Paint will need a fast G4 (or, better, a G5) and Virtual PC software.

Like the other techniques in this chapter, the following steps will show you how to do an exciting interpretation of a photograph via a bit of experimentation with brushes and stroking. Just remember to always work on a duplicate image so you don't risk damaging the original.

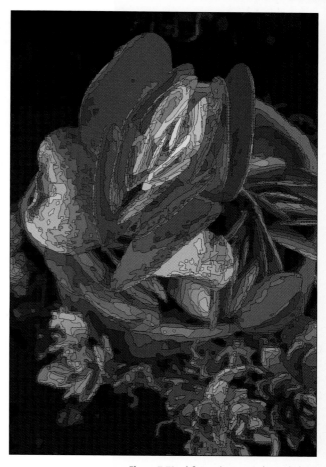

Figure 7-73. A Segmation watercolor made from a low-resolution photograph.

Figure 7-74. A snapshot taken at a street festival.

Figure 7-75. A photo-painting created in Deep Paint.

As mentioned, you can either open your image in Deep Paint as a stand-alone program, or open it in Adobe Photoshop and go to the Filter → Right Hemisphere → Deep Paint plug-in. If you work in the standalone program you don't have to wait around for the program to become functional; on the other hand, if you work with the plug-in you don't have to save the image you're working on, close Photoshop, and then open Deep Paint. I prefer the latter option, but it's entirely up to you, and the rest of the procedure is the same either way. You can see the Deep Paint interface in Figure 7-76.

1. Choose the Clone tab just above the toolbox.

2. Choose the Paintbrush tool. In clone mode, the paintbrush will pick up colors from the main image and "stylize" them into a new, textured mixture that will look like an impressionist painting. You can control the feel and detail by changing the settings in the Paint Settings area of the image.

3. Choose an Art Style from the menu in the lower right corner.

4. Choose a foreground color and background color that you want to have "jittered" into your painting as you stroke. If you don't want these color influences, just click the default color button to get black as the foreground color and white as the background color. These color-picking boxes work exactly as their Photoshop counterparts do.

5. Now just paint over your original photograph. Change the size of the brushes when you want to increase or decrease the fidelity of the details in the original photo and the size of the brushstrokes themselves. The

Strength setting will determine how much the original photo will show through the stroke.

Deep Paint is much more versatile than one brief example could possibly demonstrate. One of its most important capabilities is its natural-media brushes. For example, if you select wet oils or acrylics, you get an impasto brushstroke. Impasto is the look painters get when they are using heavy, undiluted oils straight out of the tube, so you can see the imprint made by the palette knife and the ruts made by a brush's bristles. It's not really much more difficult for a beginner to use the brushes than to work in clone mode, either. Just as with Corel Painter, you can pick up color directly from the underlying painting; you can also pick up color from the layer below (a great way to impose color atop color for some attractive tinting effects). Another very nice feature in Deep Paint is the ability to brush-trace vector lines using real natural-media brushes.

Zoom On In

It's a good idea to zoom in to 100% so that you can see the texture of the stroke. (You'll also see the texture of the canvas if you've checked the Canvas Texture box and chosen a canvas by clicking the canvas pattern in the toolbox.) Otherwise, you may end up leaving areas of the photo completely unpainted, which will look pretty bad when the image is printed at full size and resolution.

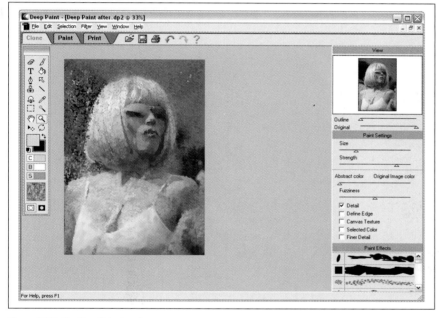

Figure 7-76. The Deep Paint interface.

Special Photographic Effects

8

This chapter contains invaluable ways to quickly add to the dynamism of certain photos without having to invest in special cameras or filters. Most of these effects are somewhat subtle rather than outlandish or bizarre—that is, they are practical solutions to often-encountered problems. However, there is no prerequisite to get started using them, so let's jump right in.

Tip 1: Create Realistic Motion Blurs

Motion blur almost always implies that the subject (or part of the subject) is moving rapidly. Unfortunately, setting the shutter speed low enough to show a motion-streaked subject is liable to blur the entire image to an unacceptable degree. As a result, we tend to err on the safe side by shooting at a high enough shutter speed to freeze everything into boring rigidity. See Figure 8-1.

A simple solution is to knock out the subject in the digital darkroom and use a motion blur filter on the background. See Figure 8-2. The following technique ensures that the result looks believable and professional by avoiding blurring the background when all you want to do is put the foreground subject into motion.

1. Knock out the object you want to blur from its background (see Figure 8-3). If you need to make complex knockouts, I suggest you use Corel Knockout 2 (most versatile and doesn't require a toggle) or Ultimatte AdvantEdge (quickest and easiest for plain backgrounds).

2. Duplicate the knockout layer (Layer → Duplicate Layer) in case you want to erase part of it after blurring. Blur the top layer (the duplicate) with the Motion Blur filter (Filters → Blur → Motion Blur). When the Motion Blur dialog appears, set the properties of the blur. I find it helpful to zoom the preview window out far enough to see the blurring as

Figure 8-1. A motionless shot.

Figure 8-2. After treatment with the Andromeda Velociraptor filter.

Figure 8-3. The knockout on a layer all its own.

Figure 8-4. The knockout blurred using the Motion Blur filter.

Figure 8-5. The cellist after erasing most of the blurred duplicate knockout layer, so that only her hand, her lower arm, and the bow are blurred.

it relates to the whole. You can also drag the preview around by selecting inside the window and moving it with the mouse. The exact settings will vary depending on the versatility of your particular filter; Figure 8-4 shows the settings I chose with the Photoshop Motion Blur filter.

3. If you're using the Photoshop Motion Blur filter (or the Andromeda Velociraptor filter) you'll want to erase any motion blur that doesn't belong. Since you've made a duplicate of the knocked-out object's base layer, whatever you erase on the motion-blurred layer will reveal the stationary object on the layer below. See Figure 8-5.

Alien Skin Eye Candy 4000 Motion Trail filter

Alien Skin's Eye Candy 4000 (*www.alienskin.com*) is a set of 23 filters that includes one called Motion Trail. When you compare Figure 8-6 with Figure 8-7, you'll see that the Motion Trail filter has several advantages over Photoshop's Motion Blur:

- There's no blur over the leading edge of the object you're blurring, so you don't have to go to the trouble of erasing the blur.

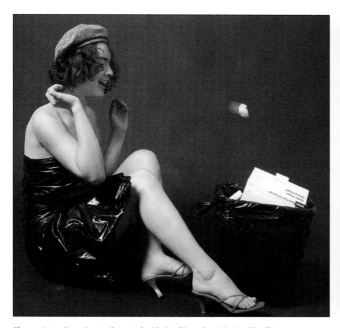

Figure 8-6. A motion trail created with the Photoshop Motion Blur filter.

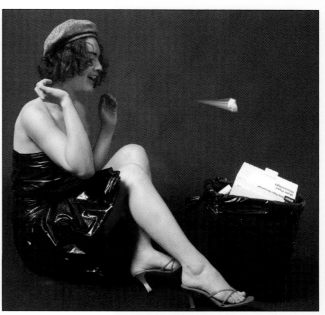

Figure 8-7. The same object trailed with the Alien Skin Eye Candy 4000 Motion Trail filter.

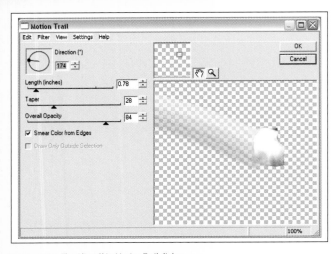

Figure 8-8. The Alien Skin Motion Trail dialog.

- You can control not only the direction and length, but also the taper of the blur. So the blur not only fades out, but tapers (diminishes) to a point as it moves away from the moving object.

- You can blur from the leading edge, the trailing edge, or in between.

The Motion Trail settings should feel quite familiar to Photoshop users, as you can see in Figure 8-8. It includes settings for the length, taper, and overall opacity of the blur for the selected portion of the image. It's use is relatively obvious.

Andromeda Velociraptor filter

You can get a much different kind of motion trail using Andromeda Software's Velociraptor (*www.andromeda.com*) filter. As you can see by comparing Figure 8-9 with Figure 8-10, Velociraptor can not only make traditional blurs and imitate Alien Skin's tapers, but can also create "comic book" style repetitions of the blurred object, creating the illusion that the object is moving so fast that it creates a stroboscopic effect.

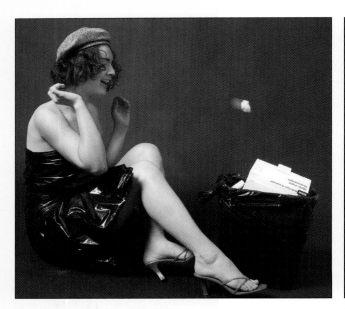

Figure 8-9. A motion trail created with the Photoshop Motion Blur filter.

Figure 8-10. The same object trailed with the Andromeda Velociraptor filter.

Velociraptor sells as an independent product and doesn't include any other types of filter effects. So if you're going to solve this problem with a third-party product, you'll have to decide between versatility (Eye Candy 4000) and absolute control (Velociraptor).

The Velociraptor interface (shown in Figure 8-11) is a bit more complex than the Motion Trail dialog, and includes options for controlling the size, direction, and length of the motion trail, as well as its trailing shape (straight, bounce, diagonal, wave, arc) and other options. It's a neat filter, but it takes some tweaking to use correctly.

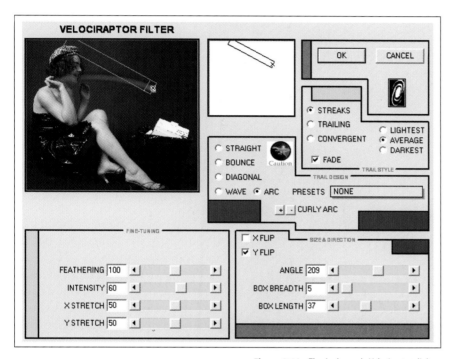

Figure 8-11. The Andromeda Velociraptor dialog.

Tip 2: Make the Picture Sparkle and Pop

Consider Figure 8-12. The composition is perfect, the brightness values and colors are right, but the picture somehow lacks energy and excitement. Now look at Figure 8-13. There are times when just a little change in brightness or a subtle filter effect in a small area of highlight or shadow will really capture the viewer's imagination. In Figure 8-13, several such lighting effects have been applied, as discussed below.

Burning and dodging are tools that darken or lighten the subject, respectively. They are generally perceived as exposure-correction tools. However, it's important to remember that even when the exposure of the overall image is perfect, you may want to make certain areas recede or bring other areas out of the background. For example, when you use the Photoshop Dodge tool to lighten the circles under a tired subject's eyes, you're making them less noticeable. When you do the same thing to whiten teeth or the whites of the eyes, you make them more noticeable.

Figure 8-12. A well-exposed image that just doesn't reach its attention-getting potential.

Figure 8-13. The same image after applying several of the techniques described in this section.

Photoshop's Lighting Effects filter

Lightening a small area with the Dodge tool is not unlike shining a spotlight on an actor to make him stand apart from the other people and things on the stage. There are lighting effects in Photoshop (and some third-party filters) that do just that and more. I find these effects quite useful in lending depth and atmosphere to a background. And as demonstrated at the beginning of this section, they can be equally useful in calling attention to a foreground subject.

Let's talk some more about the Lighting Effects filter. If you choose Filter → Render → Lighting Effects in Photoshop, you suddenly find yourself with a mobile studio filled with

lighting effects. Since you are working atop a flat image, you can only hope to simulate some of the effects of real lighting. Nonetheless, the Lighting Effects filter can perform some very effective tricks. In Figure 8-12, I wanted the lighting effects to affect only the subject. I used Corel Knockout 2 to remove the original background and created a new background with a combination of hand-painting, lighting effects, and filters. I then used the Lighting Effects filter to "light" the model.

You can place many different lighting effects into a single image. Each of these can be one of three types of light: spotlight, directional (which lights a wide area directionally—that is, it fades from one side to the other) and omni (which lights its entire area from the center). Figure 8-13 uses spotlight effects on the face and hair and an omni light on the model's torso. The Lighting Effects dialog showing the settings I used is displayed in Figure 8-14.

All you have to do to place a new light is drag the light-bulb icon from the bottom of the preview window and choose a style from the Light Type pull-down menu. Next, you can choose from a bevy of settings for each light. To aim the light, drag the handle attached to the diagonal between the light's center spot and the perimeter of the marquee. You make an individual light active by clicking its center spot in the preview window. When you activate the light, it is surrounded by an elliptical marquee with handles. The ellipse defines the area covered by the light. To change its roundness, just drag the three black handles.

In the Light Type area of the dialog, the Intensity and Focus sliders control the brightness of the currently active light. In the Properties area, the controls affect the appearance of the image outside the areas of light. There are sliders for Gloss, Material, Exposure, and Ambiance.

If you like, you can also texture the image as you light it. To do this, just place a black and white photo of a texture into one of the alpha channels and choose that channel from the Texture Channel menu. I find this command very useful for texturing backgrounds while I'm lighting them, though it doesn't have much utility when lighting the subject for dramatic effect.

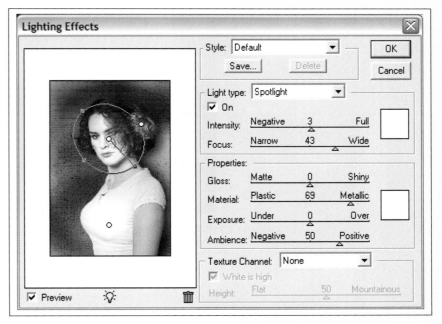

Figure 8-14. The Photoshop Lighting Effects dialog.

Photoshop's Lens Flare filter

Most of us think of lens flare as something to be avoided. But sometimes you may actually want to create it, molding its characteristics to your liking and placing it exactly where it's most likely to draw the viewer's eye into the picture, highlight the subject, or just add to the atmosphere. Look carefully at how lens flare was used to transform Figure 8-15 into Figure 8-16.

This procedure takes seconds. You certainly don't want to overdo it, but when it's used carefully and judiciously, there's no getting around the fact that it can make a picture more interesting.

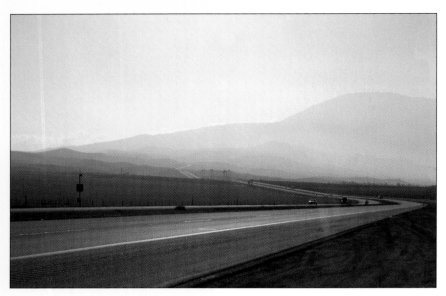

Figure 8-15. The road to Barstow, California, as you approach from the north on Highway 99. Shot with a wide-angle lens through my windshield.

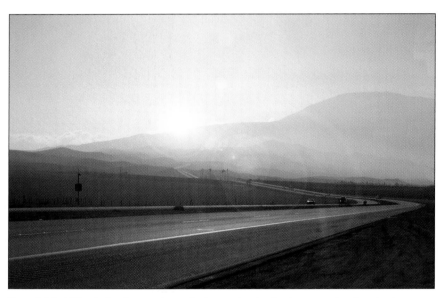

Figure 8-16. Adding the lens flare somehow makes it more okay that the picture was taken through a dusty windshield. It also increases the feeling of the deserts vastness.

Here's how to put a bit of flare into your pictures using Adobe Photoshop:

1. Choose Filter → Render → Lens Flare to bring up the Lens Flare dialog, as seen in Figure 8-17.

2. You'll now employ a trick that will let you scale the lens flare to any size you like, move it where you want, and adjust its color intensity and interpretation until you get exactly the result you're after. You're going to create a new, black layer immediately above the existing image. If the image already has several layers, you'd be wise to duplicate and flatten it before creating the new layer.

3. Unfortunately, the preview window is so small that it's very difficult to really see the lens flare's effect or to place it exactly where you want it. Fortunately, the black layer you just created eliminates that problem. All you see in the preview window now is a black rectangle against which you can easily see all the color variations in the lens flare, as shown in Figure 8-18. Choose the type of lens flare that you want by clicking the radio button at the bottom of the dialog next to the name of a lens focal length. Switch lens flare types until you like what you see, then adjust the brightness until the diameter of the main lens flare is as large as you want it. When you're happy with the results, click OK.

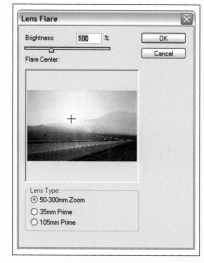

Figure 8-17. The Lens Flare dialog, showing our chosen settings.

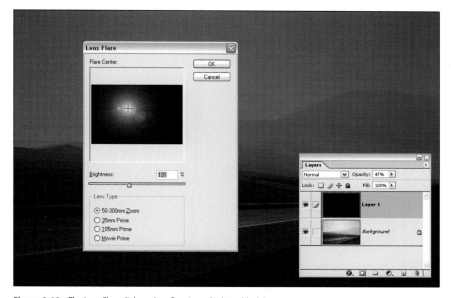

Figure 8-18. The Lens Flare dialog when flare is applied to a black layer.

4. The lens flare will appear on your black layer. If there are any rays or circles in the flare that you don't want to keep, simply paint over them with black.

5. Now here comes the fun part. Open the Layers palette from the Palette well; if it's not there, drag it over. If you don't see it in the workspace at all, open it from the Window menu. Choose the Move tool from the four icons near the top, then press Shift-+ to rotate through Blend modes until the black background disappears completely and you can see your lens flare over your image. Note that there are several Blend modes that make the black disappear (Soft Light, Screen, Lighten, and others), and each will have a different effect on the colors and brightness of the lens flare itself. With the Move tool still selected, drag in the image until the lens flare is centered exactly where you want it to be. In Figure 8-19, it's positioned just above the mountain horizon.

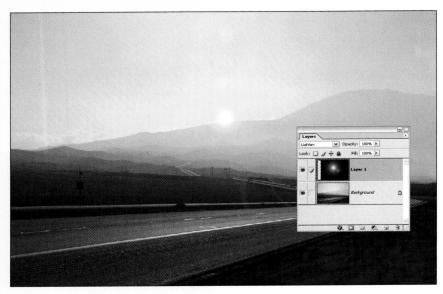

Figure 8-19. The lens flare on black, as rendered using Lighten Blend mode.

6. To ensure that the lens flare stays in this exact position while you do other things with other layers, you'll need to link the lens-flare layer to the image layer. To do that, go to the Layers palette and click the box in the second left-hand column next to the image layer while the lens flare layer is active. A chain-link icon will appear in the box, as shown in Figure 8-20.

Figure 8-20. The Layers dialog showing the linked lens flare layer.

KPT Lens Flare filter

If you really want to get expressive with lens flare effects and be able to exert extreme control, step up to Corel's KPT Collection (*www.corel.com*) and use KPT 6's Lens Flare filter. This is what the kids call a "cool tool." Figures 8-21 and 8-22 show a couple of the possible effects.

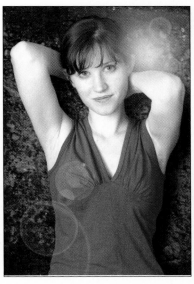

Figure 8-21. A KPT Lens Flare image on its own. (Just to give you an idea of how far you can take this, without even bothering to manipulate the effect with any other tools!)

Figure 8-22. A KPT Lens Flare effect.

The dialog for the KPT 6 Lens Flare interface is shown in Figure 8-23. You can create from 11 different styles and control both the intensity and scale of each. You can choose your own colors for most of the elements in the lens flare, so it's easy to make the colors work with those in the image. There are also three different styles of halos and different types of streaks. There are sliders for more aspects of the lens flares than most of us could contemplate. I can see making a whole collection of pure lens flare images with this tool.

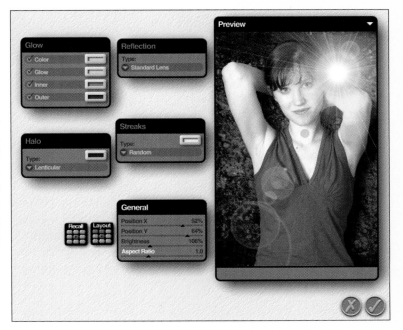

Figure 8-23. The KPT 6 Lens Flare interface.

Alien Skin Eye Candy 4000 Star filter

One of the coolest ways to call attention to a portion of the image is to add a bright starburst at the point of interest. Alien Skin's Eye Candy 4000 (*www. alienskin.com*) includes the Star filter, which will create all manner of geometric stars with any number of points or—more usefully—lighted starbursts with any number of rays. In this example, I used this filter on the image in Figure 8-24 to create a small glint in the model's eyes, as shown in Figure 8-25.

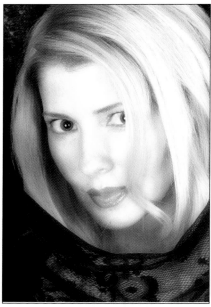

Figure 8-24. It's a nice picture...

Figure 8-25. ...but all the more intriguing with the glint in her eye.

Figure 8-26. The Eye Candy 4000 Star filter dialog. You can choose from many "styles" of stars by clicking the Color tab, then making adjustments to those styles in this tab.

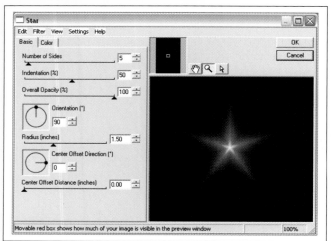

But there's a drawback: you can't position the starburst vertically, which means that you probably won't be able to put it exactly where you want it without using the following technique. First, put the starburst onto a black layer, as shown in Figure 8-26, and then use the Lighten, Screen, and other Layer modes to eliminate the black. You can then use the Move tool to precisely position the starburst exactly where you want it to appear. You can also control the opacity and fill of the starburst layer, and are able to choose a blend mode that will give you exactly the interaction of colors you are looking for.

Andromeda ScatterLight filter

The Andromeda ScatterLight filter (*www.andromeda.com*) is an extremely versatile glamour diffusion filter, and I discuss it at some length later in this chapter (see Tip 5: Create Glamour Glows for Portraits and Product Photos). However, it has one setting that is very useful for making small highlight stars.

Here, I used it to create a star flare to the glass in Figure 8-27, creating the image in Figure 8-28. The following technique is one that I've discovered on my own. It works beautifully when you want to place a star exactly where you want it and in a particular size, color, and number of points:

Figure 8-27. Nice photo...

Figure 8-28. ...just a bit nicer after adding the star flare to the left side of the glass.

1. First, make all the other adjustments and layer effects that that you plan to do to this image. Then, duplicate the image and flatten it to ensure that you have a layered version, just in case you later decide to make changes on those layers.

2. Add a new layer to the flattened duplicate and fill it with solid black. In the Layers palette, lower the opacity to around 50% so that you can see your main image. This will let you precisely place the stars you will create.

3. Choose the Brush tool, make the foreground color white, and place a white dot at each location where you want a star to appear. The size of the dot will determine the size and brightness of the center of the star.

4. Once you've placed all your stars-to-be, return the opacity of the layer to 100% and change the Blend mode to Screen.

5. Choose Filter → Andromeda → ScatterLight to bring up the dialog in Figure 8-29.

6. Previewing the star on black lets you see its exact size and colorations. Choose Stars from the Preset menu and then choose a star style from one of the submenus.

7. Changing the Template Scale or the Glow Amount will always re-render the preview window so that you can see the results of your settings. Experiment until you like what you see, then click the Checkmark button to render the stars.

Starbursts are a proven technique for drawing the viewer's eye to what you want them to focus on, but they're distinctive enough that overuse is likely to create a cliché. One of the cures is to own enough tools that you can create an endless variety of "looks" for your starbursts. You can also create your own library of starbursts by importing stars from shape libraries, scaling them with the pen tools, rendering those shapes to a transparent layer as bitmaps (they don't *have* to be stars, either), using filters to blur and texture them, and then using the Layer Blend modes to further interpret them. Try it, you'll like it!

Figure 8-29. The Andromeda ScatterLight dialog showing a star style and settings.

Tip 3: Reinterpret the Color

You may sometimes want to give your photos a certain stylistic look: punk, modern, romantic, old-fashioned, or whatever. Often, adding a tint or recoloring an image will do the trick. Compare Figure 8-30 to Figure 8-31.

One of the major advantages of digital photography is that there's no need to carry extra film and cameras to interpret color in different ways. You can make all your color changes in the digital darkroom, and the following are five of the most useful ways to do so in Photoshop.

Boost color saturation

One way to get more intense color into the images is to simply increase the color saturation, as shown in Figure 8-32. Do this from the RAW file by using the Adobe Photoshop Camera RAW plug-in (or Photoshop CS) and dragging the Saturation slider to the right. Be careful not to overdo it.

To increase saturation in a JPEG or other situation in which you can't do it from the RAW file, use the Image → Adjustments → Hue/Saturation command. Be sure to turn on View → Gamut Warning so that you'll immediately know when you've pushed saturation past the point where the printer can accurately reproduce the colors. If your only intended medium is video or computer screen, out-of-gamut colors are not a problem.

Figure 8-30. A wave at sunset as it was photographed.

Figure 8-31. Reinterpreting the wave's color with nik Color Efex Pro.

Figure 8-32. Colors can be made much more intense and interesting by simply boosting saturation.

Create black and white from color

If you want to convert a color image to monochrome (as with Figures 8-33 and 8-34), the simplest and most often used method is to simply choose Image → Mode → Grayscale. Bingo! You have monochrome. Unfortunately, it's probably not going to be an Ansel Adams-quality monochrome in which all the gray tonal values represent precisely what you would like to see. And actually, this approach is better suited to converting an image to grayscale mode *after* you've converted all the tonal values to what you want them to be in the end.

A better option is to choose Image → Adjust → Desaturate. All the color disappears, but you're still in color mode in case you want to add color back in or make just one channel of a color image monochrome. You can do the same thing by choosing Image → Adjust → Hue/Saturation and dragging the Saturation slider all the way to the left.

Figure 8-33. The colors in these flowers are lovely, but the client needs black and white.

Figure 8-34. Careful mixing of channels produces an attractive balance of brightness values and maintains detail in all parts of the image.

Trouble is, all of the above methods simply transfer the brightness of the existing colors to equivalent grayscale brightness. On the other hand, using the Channel Mixer (Image → Adjust → Channel Mixer) allows you to influence exactly how a particular range of colors translates to grayscale. For example, when I tried converting the color flowers in Figure 8-33 to grayscale, the pink flowers turned so white that there was hardly any shading detail. But by dragging the red slider to the left in the Channel Mixer, it became possible to darken the red petals while brightening the green leaves. Figure 8-35 shows the Channel Mixer dialog. Be sure to check the Monochrome box (in the lower-right corner) and the Preview box; then just move the sliders until what you see in the document window represents the tonal values you desire, and click OK.

Make sepias and duotones

Figure 8-36 shows our black and white flowers converted to a sepia duotone. To create a sepia image, do the following:

1. Convert the image to grayscale (Image → Mode → Grayscale) or create black and white from color per the instructions above.

2. Convert the black and white image to RGB color, make a new transparent layer, and fill it with the color desired for toning (it'll be brown for sepia, but this technique works equally well for other toning shades).

3. Change the layer Blend mode of the filled layer to Color.

4. Flatten the image.

To make a duotone, do the following:

1. Convert the image to grayscale per the instructions above.

2. Convert the image to duotone (or tritones, or quad-tones) using Image → Mode → Duotone.

Figure 8-35. The Channel Mixer dialog.

Figure 8-36. The black and white flowers converted to a "sepia" duotone.

Figure 8-37. The Duotone Options dialog.

In the dialog shown in Figure 8-37, select the colors you want to use. Lighter colors will give you lighter images because you are replacing the darker tones. It can be very interesting to work with tritones, using different variations of a color. Use warm colors (such as browns, yellows, and reds) when you want a soft, romantic, or old-fashioned look; use blues for night scenes, winters, and skies.

Hand-color images

It is very easy to hand-color images that have been toned. There are two basic effects that you can go after: partial coloring (usually in soft, "pastel-ish" colors) for a romantic, aged, or faded effect, or bright colors to give a more "collectible" look to the image. Figures 8-38 and 8-39 show the two techniques used on the same image.

Figure 8-38. Most of the image is a toned duotone, but certain areas have been emphasized by hand-coloring.

Figure 8-39. The entire image has been hand-colored.

Here are some helpful hand-coloring techniques:

- If you work in Color, Screen, Overlay, or Multiply modes, the brightness of the color will be determined by the brightness of the underlying image. This makes it much easier to choose colors. For instance, I only needed to pick three colors for both the fully colored and partially colored images in Figures 8-38 and 8-39.

- When you start applying a particular color, start with a small brush and outline all the edges first. You can then use a relatively large brush to fill in the interiors of the items you've outlined. This technique will save you lots of time.

- If you are working in Color Blend mode, don't worry about accidentally mixing colors. Painting over one color with another will simply replace the first color.

- Wherever there's a large area of color (such as the background in the flower picture above), select the area and use the Edit → Fill command. In the Fill dialog, select Color (or whatever Blend mode you've used on your brush when coloring) from the Blend menu. Then the only places you need to brush in by hand are the areas between the details in the subject and the colors filled in the selection.

The Replace Color command

There will be times when you just want to replace the color of an object in order to show all the available colors, to match the sponsor's logo color, or to just make the object stand out more. See Figures 8-40 and 8-41.

Making a Subtle Blend

If you want the hand-coloring to be a very subtle blend of the underlying image and the colors you've applied, try pasting a copy of the original monochrome image atop your hand-coloring and then lowering the opacity or changing the Blend mode of the monochrome upper layer.

Figure 8-40. The original image with yellow flowers.

Figure 8-41. After using the Replace Color command.

There are two ways you can do this: by hand, as just demonstrated, or by using the Replace Color command. Of course, you can also combine the two techniques.

The Replace Color command replaces all occurrences of any color within a user-specified range anywhere in the image; if you want to limit your replacement to one specific area of the image, simply select that area before implementing the command.

Use the following technique for the Replace Color command:

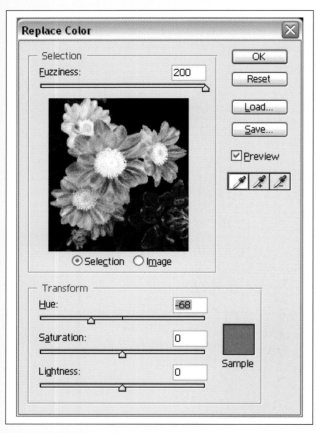

Figure 8-42. The Replace Color dialog.

1. Select all areas in which you don't want to mess with the color. Then, invert the selection (Cmd/Ctrl-Shift-I) so that the area you *do* want to change is selected.

2. Choose Image → Adjustments → Replace Color to bring up the dialog shown in Figure 8-42. To choose the color you want to change, select the Eyedropper, move the cursor into the image with the point directly over the color you want to change, and click. Drag the Fuzziness slider as far to the right as you can before other colors start to turn white in the preview window.

3. If there are similar colors that you want to choose that haven't been selected by the Fuzziness control, choose the Plus Eyedropper and click on those colors, then fiddle with the Fuzziness slider again. Remember, however, that any colors you choose will be replaced by one color (in the same shades of brightness as in the original).

4. At the bottom of the Replace Color dialog are the Transform controls, including a color swatch of your chosen color. To change the color(s) you've just selected, drag the Hue, Saturation, and Lightness sliders and watch the effects on the color swatch. When you get exactly the color you want, click OK.

WARNING

Earlier, I suggested this as a good way to match the color of something like a company logo. However, this sounds easier than it actually is. There's no way to specify a given swatch book color. You can only approximate the color by having a well-calibrated monitor and using the Replace Color command's sliders until the swatch color looks as much as possible like the swatch book color that you're holding next to the monitor. Luckily, that will be good enough most of the time.

Use your own judgment to decide whether toning and recoloring are appropriate to the image you're reinterpreting, as well as whether doing so would coincide with style guidelines for your client, publication, or gallery. For instance, it might be okay in a travel magazine to boost saturation or otherwise believably enhance colors that exist in reality, but strictly verboten to change reality by changing the color of the object or superimposing a nonexistent color tint.

Tip 4: Make Your Own Backgrounds

I know you've had it happen. You caught the subject at just the right moment, but the background stinks. Need to make a snapshot look like a studio portrait or still life? Need a background that matches the color of the company logo? Need a background that has just a little more class (or grit) than the drab office the subject works in? Want to know how the model in Figure 8-43 ended up with the background in Figure 8-44?

Figure 8-43. The original image, shot in the studio against a seamless blue background.

Figure 8-44. The same subject atop a client-requested background created with the Gradient tool, the Shape tool, and the Radial Blur filter.

Photoshop can replace virtually any background with any other background. However, there are three things you have to watch if you want to make the result believable:

1. Get the right amount of transition at the edges of your knockouts.

2. Match the direction of lighting of the foreground objects with the direction of lighting of the background objects.

3. Match the camera viewpoint and perspective of the foreground with that of the background.

You've already learned how to make knock-out knockouts. Here you'll find three different methods for creating and lighting new backgrounds for knocked-out subjects.

Use a texture-making program or plug-in

There are a number of plug-ins and filters whose specialty is creating textures, patterns, or both. So you can create a pattern, texturize it, and save it as a background image. When the time comes, you can adjust the Hue/Saturation/Brightness to change the colors (and their intensity) to match or complement those in the foreground object.

Photoshop provides several ways to texturize an image:

The Texture filters. There are five of these: Craquelure, Grain, Mosaic Tiles, Patchwork, and Stained Glass. Most of these filters provide you with numerous settings that let you specify the characteristics and lighting of the textures. Some of the textures that can be created with these filters are shown in Figure 8-45. Just remember that there's only room to show you one example of what might be done with each filter.

Grayscale Bump Maps

The only restriction on the type of black and white image you can use as a bump map is that it must be a Photoshop file in Grayscale mode.

Figure 8-45. The five texture filters, each applied to a different area of the same image.

The Texturizer. Found on the Filter → Texture menu, this program allows you to give a three-dimensional texture to any image using any of four standard textures (Brick, Burlap, Canvas, and Sandstone). You can also use any black and white image as a bump map for creating a texture. In fact, all of the textures are bump maps, which means that anything white will appear to be higher (closer), anything black will appear far away, and shades of gray will create the illusion of in-between heights or distances. This is the same technique used for creating three-dimensional topographical maps. The Texturizer dialog is shown in Figure 8-46, and a hand-made background with textures from this menu is shown in Figure 8-47.

Figure 8-46. The Texturizer dialog.

Figure 8-47. The four preset textures and a bump map each applied to a different area of the same image.

Lighting Effects filter. Choose Filter → Render → Lighting Effects to bring up the dialog shown in Figure 8-48. At the bottom of the Lighting Effects filter dialog is a menu that will let you choose any image channel as a texture channel. If you have a photograph that you want to use as a background, you can either designate one of its existing channels to use for the texture, or you can duplicate the image, change its mode to grayscale, press Cmd/Ctrl-A to select all, then Cmd/Ctrl-C to copy the entire image to the clipboard. Then open the Channels palette, create a new channel by clicking the New Channel icon at the bottom of the palette, and press Cmd/Ctrl-V to paste the grayscale image into the channel. Now run the Lighting Effects filter. Set your lights as you desire

Figure 8-48. The Lighting Effects dialog.

Figure 8-49. The image of the lighting effects on the user-created background, texturized with a black and white image.

(or use one of the preset lighting schemes), then choose the alpha channel into which you just pasted your image from the Texture Channel pull-down menu. When you click OK, you will see your photo as a relief texture in the areas you have lit. You can see an example of this technique in Figure 8-49.

Paint, texturize, and light a background

If you want a background that's interesting but not too distracting, one of the best techniques is to "paint" the background by making some large selections, feathering those selections to varying degrees, and then filling them with colors that are most likely to complement a foreground selection.

Always do as much of this process as possible on separate layers, and use Adjustment Layers whenever you can. And of course, be sure to save the backgrounds you make. This can save a lot of time when you want to make a similar background: just take the original background and just change one or two aspects of that design, such as the colors, the lighting, or the texture.

You can also make existing backgrounds look quite different from one another by relighting them, playing with the image Adjustments controls—especially Curves, Levels, Brightness/Contrast, and Hue/Saturation—or changing the layer Blend modes.

Photograph walls, entryways, and other likely background surroundings

Another good way to create backgrounds is to take pictures of natural textures that could make lovely backgrounds with bit of filter processing or photo-painting. When I find myself with a bit of time on my hands, I take a walk around the neighborhood and photograph textures and reflections. Some of my results are shown in Figure 8-50, and the final shots are shown in Figure 8-51. This should give you an idea of how a photo's mood and feeling can be influenced by its background, and how important the background is to the overall success of the image.

Keep in mind that replacing a background is not always a simple matter, nor is it appropriate for every situation. For one thing, you must be aware of when there are rules against "faking" the photo in any way, as I mentioned earlier. Second, you will want to ensure that the transition between the edges of the foreground object and the background is perfectly smooth and natural. Make sure that colors from the original background aren't reflected onto the foreground subject, or use a background in which those reflected colors are also prominent. You should also try to match the apparent direction of the main light source for both the foreground and background. Finally, be sure to shoot the foreground and background from the same position and with a lens of the same or similar focal length. There is more discussion of these techniques in Chapter 10.

Figure 8-50. A small sampling of photos I've taken for possible future use as backgrounds.

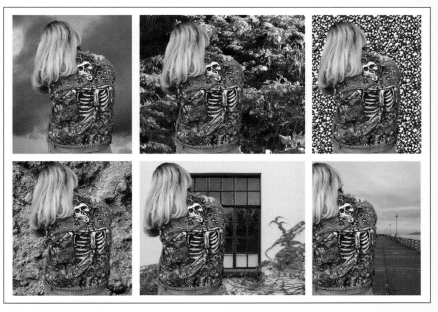

Figure 8-51. The photos in Figure 8-50 used as backgrounds for the same subject.

Tip 5: Create Glamour Glows for Portraits and Product Photos

Suppose you want to create this feeling in Figure 8-52: "The minute she walked into the room, a glowing aura surrounded her. I knew I was in love."

Here I'll present techniques to create radial glows, moonlight glows, glowing skin, and romantic moods. Compare Figures 8-52 and 8-53. Most of techniques were invented for glamour portraits, but as you'll see from the examples, they can also be used effectively for landscapes, still lifes, and interiors.

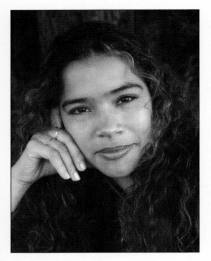

Figure 8-52. An un-retouched soft-light shot.

The principle behind all these effects is that the subject is blurred slightly, but the highlights spread out into the shadows, rather than having all tones mixed evenly. All the filters that allow you to do this give you some control over the degree to which the filter is applied, so you can come very close to getting a very high-key image (very light tones with few to no absolute blacks) without even making a brightness/contrast adjustment.

Glow filters not only add romance, they can be very effective retouching tools because the diffusion often automatically removes small skin blemishes in addition to giving the image a more romantic feel. On the other hand, they can sometimes remove more detail than you intended, especially in critical areas such as the eyes or other points of interest. The solution to this problem is to flatten the image and then duplicate the background layer before you apply the filter. Making sure that the duplicate layer is immediately above the original layer, you then apply your chosen diffuse glow filter. You can then do any or all of the following:

Figure 8-53. The same image with the Andromeda ScatterLight filter applied.

- Adjust the transparency of the diffuse glow layer so that a bit more definition comes through from the layer below.

- Delicately erase away portions of the diffuse glow layer that obscure the details that you'd like to have sharper. In order to get a smooth blend with the surrounding glowing areas, use a highly feathered brush for the eraser and lower its opacity to around 40% or less. In places where you want more detail from below, you can simply make more strokes until the blend is perfectly smooth.

- If you still want more sharpness as a contrast to the glow, you can make a feathered selection around those areas and apply an Unsharp Mask. Just be careful not to overdo it.

The most popular filters for creating diffuse glow effects are discussed below, including the particular characteristics that make them useful for certain subject matter categories.

Figure 8-54. The original photo has a nice, natural glow in the backlit weeds.

Figure 8-55. The Photoshop Diffuse Glow filter can also add color. Here the foreground color is midnight blue, and the background color a very light pink.

The Photoshop Diffuse Glow filter

The Photoshop Diffuse Glow filter was used on the weeds in Figure 8-54 to add the color in Figure 8-55. You won't find this filter under the Blur menu, where you might expect it. Instead, choose Filter → Distort → Diffuse Glow. This brings up the dialog in Figure 8-56. The settings you should use will depend on the size, brightness distribution, and contrast of the image, so just play with them until you like what you see in the preview.

The Diffuse Glow filter does a fine job of adding that romantic glow, but it also has a characteristic that none of the other filters listed in this section has. Rather than simply spreading the highlights into the shadows, it also spreads the currently chosen foreground color into the currently chosen background color in the highlights and shadows. You can also add noise to the diffusion effect, so it's the perfect tool for creating the illusion of fog.

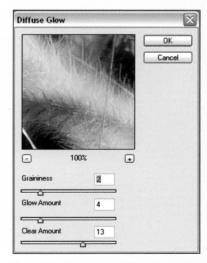

Figure 8-56. The Photoshop Diffuse Glow dialog.

Power Retouche Soft filter

Consider the two portraits in Figures 8-57 and 8-58. The first was shot in harsh sunlight with a fill flash, and could really use some help. Luckily, Power Retouche's Soft filter (*www.powerretouche.com*) is easy to use and does a fine job. As you can see in Figure 8-59, there are only two sliders, and you can instantly see their effects in a large preview window. It's simple, it's quick, and it does what it's supposed to do.

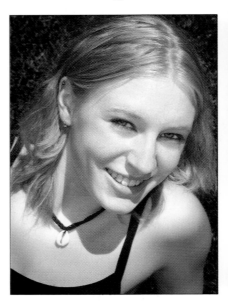

Figure 8-57. The original photo was photographed in harsh direct sunlight, though it got a lot of help from fill flash.

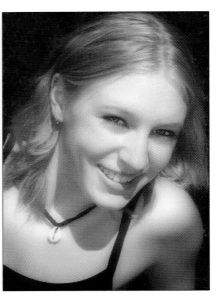

Figure 8-58. The Power Retouche Soft filter spreads the highlights.

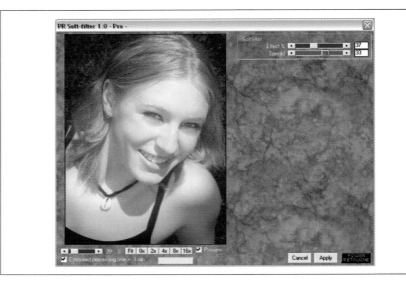

Figure 8-59. The PowerRetouche Soft filter dialog.

Alien Skin Eye Candy 400 Gradient Glow filter

The Alien Skin Gradient Glow filter (*www.alienskin.com*) doesn't fit neatly into this category; in some ways, it's really more of a color-effects filter, as you can see by comparing Figure 8-60 with Figure 8-61. The dialog permits you to choose either preset gradients or any colors you prefer. These colors are then made to glow on either side of the current selection, or, if you check the Draw Only Outside Selection checkbox, only from the outside of the selection. The effect usually feels a bit more natural (except with hard-edged type) if you feather the edges of the selection.

To use the Gradient Glow filter, first select the object around which you want to create a glowing halo. Next, choose Filter → Eye Candy 4000 → Gradient Glow to bring up the dialog in Figure 8-62.

Start by clicking the Color tab and choosing a scheme from the list. You can also use the color boxes and sliders to change the color and intensity of the effect. To change the color in a color box, just click it. The standard Color Picker dialog will appear, and you can choose colors just as you would a foreground or background color in Photoshop. When you click the Basic tab, you will see the effect in the preview window. You may want to zoom out to see the overall effect on the image, as this window is too small for the default 100% view to tell you much. Experiment with the settings until you like what you see, then click OK.

Figure 8-60. The original photo.

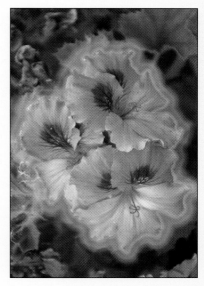

Figure 8-61. The Alien Skin Gradient Glow filter spreads a glow of the chosen gradient colors around the edges of a selection.

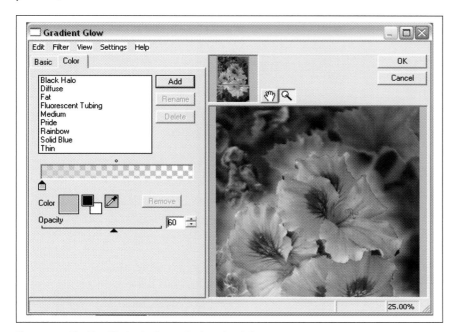

Figure 8-62. The Alien Skin Eye Candy 4000 Gradient Glow dialog.

Figure 8-63. The straight story.

Figure 8-64. The psychedelic version, thanks to the Bloat (eyes, nose) and Push (mouth) tools of the Liquify filter.

Tip 6: Bend It to Your Own Purposes

Suppose you want to make a caricature out of a photograph you've taken, create the illusion that the image has been bent by desert-mirage lightwaves or variations in the thickness of otherwise-transparent glass, or simply mush the image around to resemble a finger-painting or Polaroid transfer. Perhaps you simply want to whittle down your subject's waist-line without dietary supplements. Or maybe you just feel like having fun with the cat in Figure 8-63.

The Liquify filter

Once upon a time, the only good way to accomplish these tasks was to use a no-longer-in-circulation program called Live Picture. Today, you can do almost as well with a built-in Photoshop filter called Liquify. Figure 8-64 shows a touch of humor added to our feline.

If you just want to reshape an object separate from its background, select and lift it to its own layer (Cmd/Ctrl-J). Then choose Filter → Liquify to open the somewhat complex dialog shown in Figure 8-65.

Each tool in the Liquify toolbox is represented by an icon that lets you know whether the brush will push (displace) pixels ahead of it, swell or shrink the area under the brush, spin (rotate) pixels clockwise or counterclockwise, mirror pixels (skew) inside the brush, or restore what you've messed up. Let's take a closer look at each of the tools.

Digital Photography: Expert Techniques

Forward Warp tool →
Reconstruct tool →
Twirl tool →
Pucker tool →
Bloat tool →
Push tool →
Mirror tool →
Turbulence tool →
Freeze tool →
Thaw tool →
Hand tool →
Zoom tool →

Figure 8-65. The Liquify dialog.

Forward Warp tool. This tool will give the appearance of pushing, or displacing, pixels forward as you drag it across the image. You can hold down the shift button while clicking to push the pixels in a straight line from the last click point.

Reconstruct tool. This tool will allow you to gradually or completely undo the warping effects of the Liquify filter. You can reconstruct selectively with a brush using this tool, or you can apply the effect universally to the entire image using the Reconstruct Options at the right side of the dialog.

Twirl tool. This tool will give the appearance of twirling, or rotating pixels in either a clockwise or counterclockwise direction. The default direction is clockwise, but you can hold down the Alt/Option button to give the appearance of twirling pixels in the counterclockwise direction.

Pucker tool. If you click and hold down the mouse button, this tool will gradually displace pixels towards the middle of the brush.

Bloat tool. This tool is the opposite of the pucker tool. As you hold down the mouse button, this tool will gradually displace pixels away from the center of the brush.

Push tool. This tool will push the pixels inside the brush in a direction that is 90 degrees counterclockwise from the direction that you drag the mouse. For example, if you drag the mouse straight up, the pixels inside the brush area will be pushed to the left.

Mirror tool. This tool mirrors pixels that are 90-degrees counterclockwise from the stroke within the brush. You can hold down Alt/Option to mirror the area directly behind (180 degrees from) the stroke. This option is often used in conjunction with frozen areas to create reflections.

Turbulence tool. Creates a mathematical turbulence within the brush stroke, which is often useful for simulating natural elements such as fire and water. You can control the amount of jitter (or "shakiness") of the turbulence using the option on the right side of the dialog.

Freeze tool. You can click and drag using the freeze tool to create a reddish mask. This mask will protect the pixels below from any changes.

Thaw tool. The thaw tool simply undoes the effects of the freeze tool. Use this tool to unprotect various areas of the image so they can be warped again.

Hand tool. This tool allows you to pan throughout the image by holding the mouse button down and dragging. It is identical to the regular Photoshop Hand Tool.

Zoom tool. The zoom tool will zoom in or out of the image inside the dialog box. Click or drag to zoom in on the image, or hold down Alt/Option and click or drag to zoom out. You can also control the amount of zoom by modifying the numerical percentage at the bottom.

There are several other options on the right side of the dialog. You can control the standard brush options, as well as the amount of turbulence "jitter" (e.g., how much it has been shaken) with the Tool Options in the upper right of the dialog. There are also Mask Options on the right for creating masks, adding or subtracting from masks, taking the intersection, or inverting the mask. The mask options are similar to the selection options in Photoshop.

You can choose the view the image with our without a mesh (a fancy name for a warpable grid), using a preset size and color. Warped meshes can be saved and loaded using the buttons near the upper right of the dialog. You can also set the visibility and color (by default, the standard red) of the mask that prevents image changes. In addition, you can create a backdrop to be used in conjunction with the warped image, including where to place it and its opacity.

Finally, you can also configure how the Liquify filter performs reconstruction using the following options in the appropriate pull-down menus.

Revert. Completely undoes any warping effects within the radius of the brush. This option can be applied with a brush using the reconstruct tool, or uniformly to the entire image using the Reconstruct Options on the right side of the dialog.

Rigid. Uses the brush to reconstruct pixels near frozen areas to nearly their original appearance, even if that means creating a discontinuity between frozen and unfrozen areas. This option can be applied uniformly to the entire image as well.

Stiff. Similar to rigid, but allows slightly more warping of pixels, especially near borders between frozen pixels and unfrozen pixels. This option can be applied with the brush, or uniformly to the entire image using the Reconstruct Options on the right side of the dialog.

Smooth. Discourages a grid discontinuity (i.e., the mask can be warped but not broken) between frozen warped pixels and unfrozen pixels just outside the border by trying the match the "warpness" on both sides. This option can be applied with the brush, or uniformly to the entire image as well.

Loose. Prevents a grid discontinuity between frozen warped pixels and unfrozen pixels at all costs. This option can be applied with the brush, or uniformly to the entire image.

Displace. Uses the displacement of the pixels beneath the brush where the mouse button was first pressed as a reference for how much any pixels should be displaced back to their original location while dragging. This option is only available when reconstructing with a brush.

Amplitwist. Same as Displace, but also takes into consideration any pixel rotation and scale that may have been performed by the other tools. This option is available only when reconstructing with a brush.

Affine. Same as Displace, but also takes into consideration pixel rotation, scale, and skew. This option is available only when reconstructing with a brush.

KPT Fluid Effects

Corel's latest collection of KPT filters, called the KPT Collection, includes OS X/Photoshop 7-compatible filters from KPT 5, KPT 6, and KPT Effects in a single package at the bargain price of $99. A filter called KPT Fluid can create half-a-dozen or so effects over a large area in a matter of seconds. It's not as easy or intuitive to control specific areas of the image as it is in the Liquify filter, but it can be a very quick and efficient way to distort whole areas of

the image by twisting, spiraling, or pushing them in a specific way. You can animate these effects, and rewind them so that the effect is applied to any degree. The individual effects are shown in Figure 8-66.

Figure 8-66. The KPT Fluid Effects.

Here is how to use the KPT Fluid Effects:

1. Choose Filter → KPT Effects → KPT Fluid to bring up the dialog shown in Figure 8-67. From the pull-down menu at the top right corner of the preview window, choose Large Preview. I generally leave the rest of the menu choices at their defaults.

2. Click the Presets button at the bottom left of the screen to bring up the New Preset dialog (see Figure 8-68).

3. Select the effect for one of the thumbnails by clicking it. The image will almost instantly appear with the chosen distortion effect applied.

4. If you want to "fade" the effect so that it isn't so extreme, click and hold on the Rewind button just to the left of the Play button at the bottom of the preview window. The image will slowly start returning to normal. When you like the result, release the mouse button. At this point, you can rewind more by clicking the Play button. When you like what you see, click the Check button. If you just can't get what you want, click the Cancel (X) button.

Figure 8-67. The KPT Fluid dialog.

You can create your own effects simply by changing the brush parameters, stroking in the image, pressing pause, changing the brush parameters, making more brushstroke distortions, and continuing this routine until you get something you like (or are at least intrigued with). Then, open the New Presets panel by clicking the button at the lower-right side of the interface, and click the Add Preset button. Next time you want to use the effect you created, just choose its thumbnail button and click the Checkmark button. The effect will be applied to your image (or to any portions of the image you selected before starting the KPT Fluid filter).

Figure 8-68. The KPT New Preset dialog.

The process for making freehand distortions is the same as described above for creating an effect. The only difference is that instead of saving the effect in the Add Preset dialog, you simply click the Checkmark button to apply what you've done to your image.

> ── **GET THE GOO** ──────────
> *KPT 6 also comes with KPT GOO, a powerful tool that lets you create a variety of targeted and localized specific distortions. GOO is much like the Photoshop Liquify filter, which is why I haven't discussed it here, but you'll certainly want to experiment with this tool if you have the KPT Collection or KPT 6. Figure 8-69 gives you a look at the user interface.*

As you can see in the example featuring my cat, Tia, intentionally distorting a picture in any way has a strong potential to shock or embarrass the subject. When I showed the picture to Tia, she arched her back and hissed.

Figure 8-69. The KPT GOO filter interface.

The seamless liquid distortions demonstrated in this section have great potential for either good or bad. At the very least, make sure you have the client's permission and (if appropriate) an ironclad model release that states your intention to distort the image.

Tip 7: Simplify Shapes and Colors by Finding Edges and Limiting Color Range

Figure 8-70. The original photo of gourds (a type of vegetable).

Figure 8-71. The simplified and colorized version.

Figure 8-72. The Posterize dialog.

There are times when photographs are just too detailed for their own good, as demonstrated in Figure 8-70. You could make them less detailed by turning them into photo-paintings (as in Chapter 7), but we're after a more photographic effect.

Figure 8-71 shows a bolder, more poster-like version of the image created by limiting the range of color, delineating the edges, and then painting over rough areas that match the main color. If you want to take it even further, you could use different tools to continue the process.

The first thing you can do to simplify the photo is reduce the number of colors using Photoshop's Posterize command. This tends to blend together subtle details, since they are often represented as slight changes in color.

Choose Image → Adjustments → Posterize to bring up the dialog shown in Figure 8-72. Enter the number of colors you want in the final image; the lower the number, the fewer areas of color will result and the more poster-like your image will become. With the preview box checked, play with the number of colors until you like what you see, and then click OK.

The edges of the areas of color probably look jagged and unnatural. You can fix some of this by blurring and then reducing the number of colors again to gain sharper edges, but I find that I'm seldom pleased with the overall effect. Of course, it may work brilliantly for some images, so go ahead and try it.

However, I usually prefer the control of smoothing the colors together by hand. Choose the Smudge tool and select a brush size that is big enough to smush pixels together but not so large that it just muddies the picture. Try entering about 50% in the Options bar's Strength field. Now just start smearing similar colors together and smoothing the edges of the color bands so that they look more like brush strokes of color. If you want a more textured look, try some of the bristled brush styles.

The drawback to this solution is that edges aren't always as sharp as you'd like them to be. If you own an illustration program such as Adobe Illustrator or Corel Draw, consider using the bitmap tracing feature in those programs (in computerese, a photo is a bitmap). The program will place a vector outline

along all the edges and fill them with the closest available color, and you can then edit those edges as much as you like. I find that this is the best method for turning a photo into a flat-color and smooth-edged illustration.

Tip 8: Make a Polaroid Transfer Without a Polaroid Camera

Say that you want to make something you've already shot look like a Polaroid transfer, or you want to create a Polaroid transfer but don't have a Polaroid camera.

Polaroid transfers have become quite a popular item in the art world because they give a handmade feel to the artwork and because they abstract detail from the original image. Polaroid transfers are made by taking a picture on Polaroid film, then soaking the print in water until the emulsion containing the image begins to separate from the background. Next, the print is placed facedown on art paper and squeegeed to make the emulsion stick to the paper. When the original backing is peeled away, the image is now flipped from left to right, and the colors have faded and changed somewhat. After that, it is very common for the artist to pull and distort the gelatin that contains the image. These effects can all be imitated by Photoshop, with the added advantage that you can further enhance the result with any of Photoshop's tools and filters. Compare Figures 8-73 and 8-74. I'll also show you how to make a print on glossy paper that you can process in the same way as a Polaroid transfer.

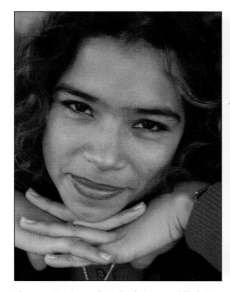

Figure 8-73. A more "artsy" technique would help to separate this picture from the crowd.

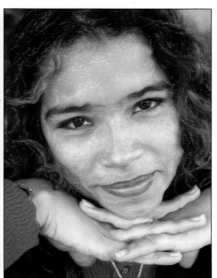

Figure 8-74. It now looks like a Polaroid photo, hand-transferred onto fabric. Furthermore, size isn't a problem at all.

Here's the method for creating a simulated Polaroid transfer in Photoshop. The result can vary quite a bit, depending on how you use the Plastic Wrap and Texturizer filters.

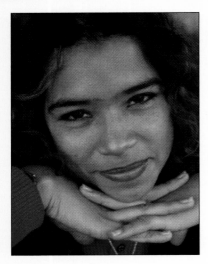

Figure 8-75. The flipped original.

1. A Polaroid transfer will always be flipped from left to right because you have to rub or squeegee the print's soaked emulsion onto the material you're transferring it to. This also tends to make the colors lighter because they're not being viewed through the gel (which increases contrast) and because the color and texture of the material is different. Of course, a darker material would make the color of the print darker. So first, choose Image → Rotate Canvas → Flip Horizontal. Then use the Levels command (or other exposure controls of your choice) to give the image a slightly washed-out look. You don't want any true blacks in the image. See Figure 8-75.

2. Polaroid transfers usually become distorted because the emulsion stretches when it is pressed into the target media. To imitate this effect, use the Liquify filter (Filter → Liquify...) to push and pull the pixels so they look as though the image were transferred with thumb pressure, rather than with a roller or squeegee. See Figure 8-76.

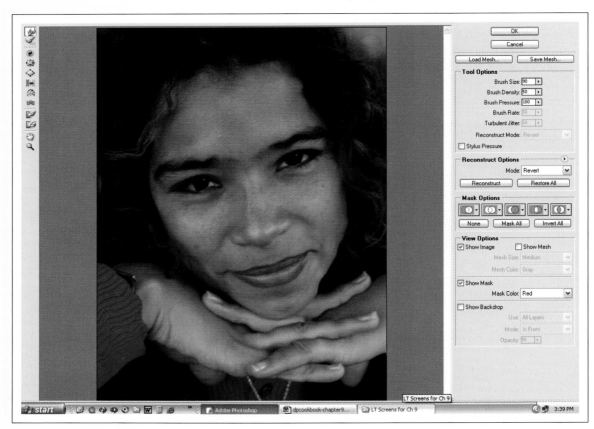

Figure 8-76. The Liquify filter can create the effect of "thumb" pressure transfer.

3. Now use the Plastic Wrap filter (Filter → Artistic → Plastic Wrap) to make the image look somewhat gelatinous, as shown in Figure 8-77. You will probably need to try several different combinations of slider settings before you get exactly the look you want. If the effect is too pronounced, choose Edit → Fade Plastic Wrap and use the Fade slider to lower the intensity of the effect.

Figure 8-77. Adding the Plastic Wrap effect.

4. The remaining steps are optional. Some simulated Polaroid transfers appear more interesting or appropriate if they're made to look as though they were transferred to a textured or "aged" piece of material, as shown in Figure 8-78. You can do this by using Photoshop's built-in Texturize filter. Open another window that contains a grayscale photo of the texture you want, making sure that the texture photo is the same size (or slightly larger) as the final image will be. Choose Cmd/Ctrl-C to copy the texture image to the clipboard; then open the Channels palette, click the New Channel icon to create a new alpha channel, and press Cmd/Ctrl-V to paste the texture image into the new alpha channel.

5. Choose Filter → Render → Texture → Texturizer. In the Texturizer dialog, you will see a menu for adding textures made from grayscale files. Canvas, Burlap, and Sandstone are already on this menu, but you can create your own textures using a grayscale photo of any texture. To load your own texture, click the menu arrow just to the right of the Texture menu and choose Load Texture. You can actually use any Photoshop

Figure 8-78. Adding a fabric texture in the Texturizer dialog.

.PSD file, but the texture is modeled strictly on the brightness values in the image, so you'll have a better idea of what the texture will look like if you use a grayscale image. Of course, the real list of possibilities is endless.

6. Use the controls in the Texturizer dialog to scale the texture in relation to the size of the photo. When you like the image in the preview window, click OK.

7. The final image is usually lighter and bluer in color than the original because you are seeing the reverse side of the emulsion. Simply make adjustments with the Levels command, including an increase in brightness in the Blue layer.

The method described here is intended merely as a starting point. It should work quite well for creating an image that resembles a Polaroid transfer, but as is the case with any art form, there is an infinite variety of possibilities. I've exaggerated the Liquify effects in this example to make it easy for you to see what I did to distort the image. Be sure to experiment with other distortion styles, color interpretations, and layer blend modes, and also try working with and without the Plastic Wrap filter.

Retouching and Rescuing Photos

9

The title of this chapter pretty much says it all. The tips contained herein are those you'll need to make your portraits more flattering and your landscapes more pristine. You'll also learn how to remove the damage, such as cracks, tears, and stains, from aged or otherwise mistreated photos.

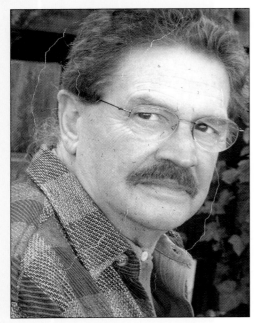

Figure 9-1. This photo of me isn't actually that old, but it was pinned to the wall near a sunlit window and was generally mistreated.

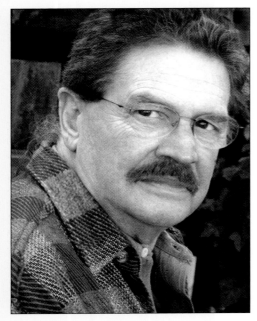

Figure 9-2. I employed all the techniques described here to restore the image to something very closely resembling the original.

Getting Started

Let's look at a common scenario: you have some precious old slides and negatives to which time has not been kind. Or perhaps you have a mistreated photo, such as the one in Figure 9-1. They deserve to be seen in all their original glory.

There are several tools built into Adobe Photoshop that will help you remove dust, cracks, and scratches from scanned film. The results can be quite impressive, as shown in Figure 9-2. The following routine allows you to automatically eliminate dust, restore the native noise texture, and restore sharpness to the image by using a combination of the Healing Brush, the History Brush, Snapshots, the Dust & Scratches filter, and the Noise filter.

1. Duplicate the original image and keep the two images side by side so that you can see the location of the dust, scratches, and other defects as you get rid of them. You may later need to compromise between restoring those blemishes in some areas or losing critical sharpness.

2. Duplicate the main layer of the duplicate image.

3. Choose Filter → Noise → Dust & Scratches, check the Preview box in the resulting dialog (see Figure 9-3), and then drag the Radius slider until all but the most prominent dust and scratches disappear. Note that the image will probably blur to an unacceptable degree, but don't worry about that yet. Next, drag the Threshold slider until you get most of the sharpness back, but stop before you start to restore dust and scratches. The settings that I chose are shown in Figure 9-4. Don't worry if you can't find the perfect compromise—we'll fix leftover defects further on. When you're satisfied, click OK.

4. The image will now be a bit softer than it was. If it's a portrait, that might be a good thing, but you'll probably at least want to restore the sharpness in the eyebrows, eyes, and other areas that will look more commanding or more natural if they are sharp. Here's where the original layer comes in. Click the Eraser tool and set its opacity to about 50% in the Options bar. Choose a brush that's roughly the size of the areas you want to erase, make sure its edges are feathered, and simply erase through to the original layer. Don't worry if this reveals a few of the original defects; Photoshop's Healing brush can take care of most of those.

5. At this point, you'll probably have a few scratches that remained after you compromised on the Dust & Scratches settings, and a few others that returned after you erased through to the original to restore sharpness. Use the Healing Brush tool or the Patch tool on those areas, as shown in Figure 9-5.

To use the Healing Brush, zoom in and examine the image closely. You'll find instances where the Dust & Scratches filter left small artifacts as well as features that may not have been retouched in the original. Unless you have a legal reason to maintain the historical integrity of the original, it's fine to do a little cosmetic retouching at this stage. The Healing Brush tool works by sampling an area (sometimes called an *anchor point*) a short distance away and using that as a basis for correcting the target pixels. Create a sample by selecting a brush size, moving the cursor over the desired area, holding down the Alt/Option key, and clicking the mouse. Next, move the cursor to the target pixels that you need to "heal," and paint over it using short strokes. The pixel blending that heals the area takes place after you let go of the mouse button, not before.

Figure 9-3. The Dust & Scratches dialog.

Figure 9-4. Drag the Radius slider until all but the biggest offenders disappear, then drag the Threshold slider until you get the best compromise between sharpness and auto-retouching.

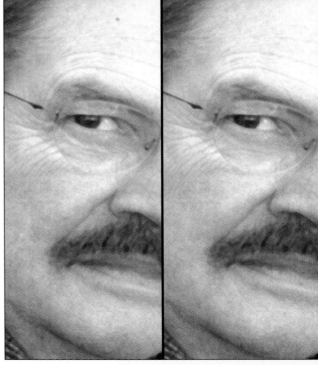

Figure 9-5. The Healing brush removed a few black spots that remained after the Dust & Scratches filter did its work, as well as a few of the most prominent wrinkles under the right eye.

The Healing Brush, Clone Stamp, and Patch tool

These three Photoshop tools are indispensable in repairing flaws in your photographs. Unfortunately, Photoshop Elements 2.0 has only the Clone Stamp tool, so it's a bit more work to perform blending with the source pixels. If you're doing a lot of photo restoration, you may want to upgrade to Photoshop CS.

The Patch tool works in a similar fashion. Once the Patch tool is selected (it's in the same menu as the Healing Brush tool in Photoshop CS), you first need to define a source. Choose the Source radio button in the tool options bar at the top, then drag the cursor around the area that you want to patch as if you were making a selection. You'll see the "marching ants" marquee. Next, place the cursor inside the selection and drag the selection shape. Note that the original selection remains, but its pixels shift as you drag the cursor around. Once you release the mouse button, the pixels in the original selection will blend with the pixels underneath the dragged selection.

6. By now, most of the dust, scratches, and tears should be invisible. If not, you'll have to resort to Photoshop's Clone Stamp tool. The Clone Stamp tool works also by sampling an area using the Alt/Option key and clicking the mouse button. In this case, however, the pixels are cloned over from the anchor point to the target area, and are not blended with the original pixels. My advice here is to keep the brush size just large enough to cover the defect, and don't rush the job. Keeping the anchor point as close to the brush as possible will increase your chances of picking up a texture and density that match the area you're repairing. Make sure the brush is feathered so that your strokes blend with their surroundings. Finally, be careful to set a new anchor point whenever you start to retouch an area with a different texture.

7. If the image is old enough to be age-damaged, it is probably faded as well. The first thing to do is restore the intensity of these faded colors with the Hue/Saturation command. Choose Image → Adjustments → Hue/Saturation to bring up the dialog shown in Figure 9-6, and drag the slider to the right until the colors approximate their original intensity.

Figure 9-6. The Hue/Saturation dialog.

8. You may not want to use the conventional Color Balance command (Image → Adjustments → Color Balance) to correct the overall color balance, because aging doesn't necessarily dim colors in the same ratio as the Hue/Saturation command would. So a subjective choice from some color-altered thumbnails may allow you to get closer to a color balance you like. Choose Image → Adjustments → Variations instead. Since the Variations command "remembers" the last settings that were used, you should start by pressing Opt/Alt and clicking the Reset button (in case you didn't already know, this is the way all Adobe Photoshop dialogs are restored to their default settings). Now simply look at the thumbnails (see Figure 9-7) and pick the one you like best.

9. There are often transparent stains on old prints. If that's your situation, you can try to remove the stain with the Brush tool in Color mode after making the foreground color the same color as the unstained area. To do this, click the Brush tool, choose Color from the Mode menu in the Options bar, press Opt/Alt to change the brush cursor to an eyedropper, and click with the eyedropper on a color in the image that is the same color you'd like to restore to the stained area. Now, simply paint over that area with the brush, and the stain will be gone. For more complicated stains, see Tip 2: Remove Stains.

10. The last thing you'll probably need to do is use the Levels command to restore the blacks that have faded from the image. Press Cmd/Ctrl-L to open the Levels dialog, and drag the leftmost slider to the right until the blacks are as dark as you want them. You should now be done.

11. If the photo has faded so much that the color has changed drastically, you might also want to try the Image → Adjustments → Auto Color command, or adjust the color channel-by-channel with the Levels command (see Chapter 5).

Figure 9-7. The Variations dialog makes it easy to see which color balance pleases you most.

Note that the routine described above requires no third-party Photoshop filters or software. This method also assumes that you have scanned the damaged image in order to turn it into a digital image. If the image is on film, an alternative is to scan it on a scanner equipped with a software product from Applied Science Fiction called Digital Ice. The latest film scanner models from Nikon, Minolta, Umax, BenQ, Durst, and several other manufacturers are equipped with this technology. Digital Ice is able to separate any detail found on the layer of protective gelatin that covers the image itself, so it can actually remove most scratches and dust spots automatically.

Tip 1: Restore Youth

Most people want to look as irresistible as possible in photographs, but we all have our flaws (consider Figure 9-8). Unfortunately, the high-resolution digital cameras and lenses that most pros are buying today will record these flaws with unforgiving accuracy.

Now look at Figure 9-9. What a change! The following tip makes use of the Healing and Clone brushes and the Patch tool that we described earlier, and also discusses some filters and settings that can soften the look of a portrait and diminish skin flaws more or less automatically. You'll also see how to use layers to lessen the effect of the retouching tools by changing the opacity of the retouched duplicate layer.

Figure 9-8. The strong side lighting really plays up minor skin irregularities.

Figure 9-9. The total glamour treatment, complete with glowing skin.

1. The first thing to do is to dodge unflattering shadows using Photoshop's Dodge tool. There may be small portions of the face that seem exaggerated because they are in shadow that contrasts with the surrounding area. You can make this look naturally smoother if you set the Dodge tool to a low exposure percentage (usually around 10%) and then delicately stroke those areas with a pressure-sensitive pen until the brightness blends with the surrounding tones. Also, in this example, the model's nose is a bit sunburned. That was corrected by dodging to make the overall shading of skin tones more even. See Figure 9-10.

2. Use the Healing Brush to remove small areas of freckles and blotchiness in the skin. This step is like applying face powder. You want to make most of the skin smooth enough so that when you clear up larger areas with the Patch tool, you won't be copying tiny defects back into the patched area. See Figure 9-11.

Figure 9-10. The portrait after dodging a few of the shadows and the whites of the eyes.

Figure 9-11. The portrait after using the Dodge and Healing Brush tools.

The Fade Command

Note that the Edit → Fade command changes based on the content. For example, if you last used the Patch tool to make an image correction, the menu changes to Edit → Fade Patch Selection.

3. Crop the photo to get rid of negative aspects of the image. For instance, in this example the model's hair was longer on one side; I was able to "even" the hair length by cropping the bottom of the photo.

4. Often, the Healing Brush and the Patch tool do such a good job that the subject ends up looking unrealistically young or overly airbrushed. And of course, a subject may have prominent scars or moles that you may not want to remove at all. In Photoshop 7 or CS, you can use the Edit → Fade command to diminish the intensity of the retouch, but it may be easier to do all your "fading" after you've finished all the retouching. To

do that, simply press Cmd/Ctrl-J to duplicate the base layer, and then do all your retouching on the duplicated layer. When you've finished, go to the Layers palette and reduce the opacity of the duplicated layer until the result looks natural.

5. If necessary (it wasn't in this case), use the Patch tool to remove any large blemishes that are still left over. You can also use the Clone brush to extend certain details into areas of the image where they don't presently exist. In this example, the Clone brush was used to replace the very small bumps along the lower edge of the model's chin with a smoother skin texture. (Both of these tools are described earlier in the Getting Started section.)

6. Often, you can flatter skin as well as the composition by carefully using the Curves command to change the contrast between highlight and shadow areas. Press Cmd/Ctrl-M to open the Curves command, and drag the dialog to one side so that you can see the relevant parts of the image. Press Cmd/Ctrl and click on the highlight tone you wish to brighten; you will notice that a new point appears on the Levels diagram. Tap the up arrow key until the highlight is as bright as you'd like. Then click on the shadow tone you want to darken, and tap the down arrow key until you get the tone you'd like. When you have the desired balance between highlights and shadows, click OK. (For a refresher on color-correcting images, see Chapter 3.)

Figure 9-12. The glamour portrait before the glamour glow. If you want a more realistic look, you may want to stop at Step 9 and skip the diffusion filter.

7. At this stage, if you want to bring back some of the detail that you've over-smoothed with the Healing brush and Patch tool, go to the Layers palette and lower the opacity of the top layer until you like the balance between the two layers. Now you can flatten the image.

8. Create a new Color Balance adjustment layer to give the overall image exactly the color balance you'd like. This image was a bit red, so I added bit of green and a bit of cyan. Figure 9-12 shows how the image looks at this point.

9. For some types of portraits and glamour shots, you may want to employ the Diffuse Glow filter to create a soft, high-key, and romantic look. If you decide to do this, save it until the very end. Before applying the filter, you first need to flatten the image. Also be sure to press D to set the foreground and background

colors to their default black and white, and, for reasons that will become clear in the next step, press Cmd/Ctrl-J to duplicate the background layer. (Chapter 8 contains some recommendations and procedures for employing diffuse glow effects.)

10. Often, the effects of a glamour filter such as Diffuse Glow will over-soften some details, usually in the eyes, eyelashes, eyebrows, lips, and portions of the hair. Since the layer you diffused is superimposed over the background layer, you can choose the Eraser tool, set it to a fairly low opacity, and erase through to the detail below.

When you're doing glamour retouching, be very careful not to overdo it. For instance, if you set the Healing brush at too large a size, you will end up with some very pasty-looking, almost posterized skin tones that can make your subject look more mannequin than human.

If you overuse glow filters, especially within a selected area, you run the same risk—colors can flatten out. Worse, you may lose the grain or texture of the photograph. If that happens, one possibility is to recall your selection, press Cmd/Ctrl-H to hide the selection, and choose Filter → Noise → Add Noise. When the dialog appears, click the Preview box, choose Gaussian if the grain is film grain or other irregularly spaced noise, and drag the slider until the grain in the area inside the selection matches the grain outside the selection as much as possible.

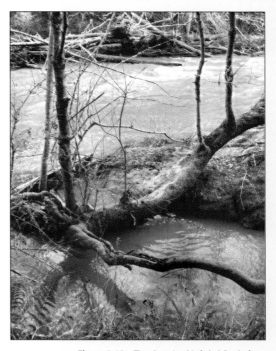

Figure 9-13. The photo is a bit faded. But before correcting the contrast and color, we should remove the coffee stain.

Tip 2: Remove Stains

There's always the chance that something will be spilled on your most prized photographs. For example, Figure 9-13 looks as if coffee or wine has been spilled near the bottom of it. Of course, if you have the digital original, you can reprint it. If not, things get more interesting.

There are really two kinds of stains: mottled and smooth. There's also the question of whether the image you're rescuing is monochrome or color. If you're dealing with a mottled stain, use the following method to produce great results like those in Figure 9-14.

1. To match small areas of color, use the Brush tool in Color mode. Press Opt/Alt to turn the paintbrush into an eyedropper and pick up a color from the surrounding area that you want the stain to match. In the Brush tool's Options bar, set the opacity to about 25%. Use a brush size that is large enough to cover most of the stain, but small enough so that a very light touch with a

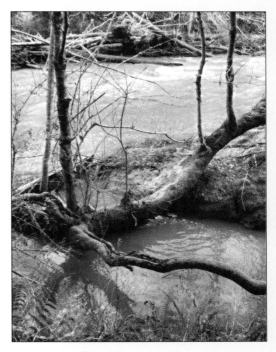

Figure 9-14. It's not quick or easy, but stain removal is possible.

EXPERT ADVICE

Work Your Way In

If you have several different areas of color within the main body of the stain, correct the colors that are nearest to the unstained portions first, then work your way inwards. Otherwise, it will be very hard for you to be sure that your colors match the main image. It will also be much easier to match the density of the various areas of color to the density of the image itself.

pressure-sensitive pen will allow you to carefully paint edges, bends, and turns. Now recolor the stain in stages, building up the color until the color of the stain matches the color of the original. Don't worry about brightness at this point; you will match the brightness in the same way for all stains after the color has been matched. Of course, if you have multiple colors within your stains, you will have to match each one separately.

2. To match large areas of color, select the area with the Lasso tool. Save the selection, as you will likely need to recall it (choose Select → Save Selection). Open the Layers palette and click the New Layer icon to create a new layer above the layer you are going to work on. Next, choose the Eyedropper tool, activate the background layer by clicking it in the Layers palette, and pick the color you want to match in the rest of the image. This color will become the foreground color. Now activate the new, transparent layer. Your selection should still be active; if it's not, recall it by choosing Select → Load Selection. Now fill the selection on the transparent layer with the color you want to match, and choose Color as the Blend mode for that layer (see Figure 9-15). Your color should match the color of the main image. If it doesn't, try adjusting the foreground color in the color picker, making the adjusted color your foreground color, and refilling the selection. You can also modify the saturation color by adjusting the opacity of the new color layer. Figure 9-16 shows how the stain was recolored with a sample from the water.

3. To match the brightness of the stain with the brightness of the rest of the image, select the stain (or recall the selection you used before). Choose Selection → Feather and enter a large enough number of pixels to cover the area around the edge of the stain that fades into the unstained area of the picture. Now, press Cmd/Ctrl-H to hide the selection so that you can tell when the brightness of the stained area and that of its surrounding match perfectly. Press Cmd/Ctrl-M to bring up the Levels dialog and drag the Midtones slider until the brightness of the stained area is a near-perfect match. Once you've come as close as you can, adjust the Highlight and Shadow sliders to fine-tune the brightness and contrast to match the surrounding area. If there's a slight mismatch in color, you can adjust each of the color channels

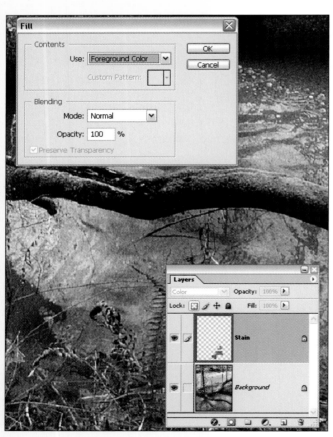

Figure 9-15. The stain has been removed from the branch by picking up the green from the unstained branch and then painting it in Color blend mode.

separately for a final, perfect balance. You can also do this while the Levels command is active by pressing Cmd/Ctrl-1 to adjust levels in the red channel, Cmd/Ctrl-2 for the green channel, and Cmd/Ctrl-3 for the blue channel. (See Chapter 3 for more information on the Levels command.)

Some stains are really tough, with so much variation in edge feathering and so many blotchy colors that they are near-impossible to fix. If you can't remove the stain any other way, here's another method to consider. Select the area of the stain, then eliminate all the color by choosing Image → Adjustments → Desaturate. Next, use the Dodge tool to lighten the areas that were darkened by the stains. Then, select the Brush tool, choose Color from the Mode menu in the Options bar, and use the Opt/Alt-click method to pick up color from the image and recolor the formerly stained area. I can't guarantee that this method will work on every image, but it will often produce an acceptable result when no other methods work.

When a stain obliterates the detail beneath it, you have no choice but to clone the detail back in from surrounding areas. If the missing detail doesn't exist elsewhere in the photo, you best hope is to find another photo that does have that detail and clone it in from there (see Tip 8: Clone Detail from Another Photo for more information).

EXPERT ADVICE

Painting Stains Away

If you have several small, "spotty" stains or a stain whose edges are feathered to different degrees, you may prefer to "paint" your selection with the Brush tool. Create your new layer, reduce the opacity to 50% so that you can see the stained area clearly, then paint over the stain with black, with the brush flow reduced to about 15%. Build up until the non-feathered parts of the stain are solid black. Now, return your layer to 100% opacity, turn off all the other layers, and press Cmd/Ctrl-C to copy the painted selection to the clipboard. Finally, open the Channels palette, click the New Channel icon to create a new alpha channel, and press Cmd/Ctrl-V to paste the painted selection into the alpha channel. You can now load this channel as a selection for any of the operations described above.

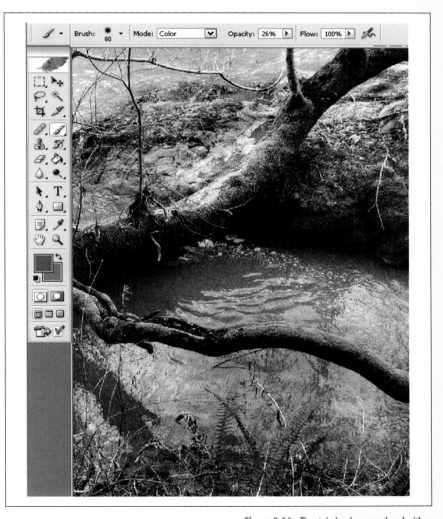

Figure 9-16. The stain has been recolored with a color sample from the surrounding water.

Tip 3: Eliminate Junk from the Landscape

It's unfortunate that as our planet gets more crowded, more people leave trash lying around. It's a fact of life, but nobody wants to see it in a photograph. Unsightly telephone lines, signs, or even unwanted people pose the same problem, as shown in Figure 9-17.

You can remove a great many varieties of distracting elements from a photo quickly by using the Clone Stamp, the Patch tool, and the Healing Brush (see Figure 9-18). It doesn't stop there, however. You can also copy and move large areas of the image so that they cover other portions of the image, or you can replace certain areas with a texture that already exists in the photo. For example, you could create a texture tile of a brick wall in order to "brick over" unwanted windows and doors (or to replace them with better-looking windows and doors), or create vegetation from the texture of bushes that already exist in the scene.

Can You Tell the Difference?

Two cropped bodies in the upper-left corner of Figure 9-17 were removed, as well as two smaller bodies (cropped by a black object) in the upper-right corner. The small pole near the center was excised as well. All of this was done using the Clone Stamp.

Figure 9-17. The subject and composition are promising, but there are some distracting elements in the scene.

Figure 9-18. The Clone Stamp was the only tool needed to eliminate several bodies that were cropped or overly bright, as well as a utility pole that sliced into the composition.

Since this tip reuses tools (e.g., the Clone Stamp) that we discussed in the Getting Started section as well as in Tips 1 and 2, and also moves into territory covered in the next chapter, I won't go through a step-by-step description here. However, unlike portraits, the secret here is this: *be sure to keep varying the anchor point* so that you blend the texture or detail that you're painting in. Otherwise, you'll start to see unnatural-looking repeating patterns and poor blending of edges.

Tip 4: Cosmetic Emphasis

Eyes, lips, and other facial details often benefit from some specific cleanup and sharpening techniques. These techniques are necessary for two reasons:

1. They make the subject look more appealing.

2. They focus the viewer's attention on these important details.

Compare Figures 9-19 and 9-20.

Figure 9-19. In this photo, we want to brighten the eyes, slim the cheekbones, and smooth the lips.

Figure 9-20. The differences are subtle but dramatic, and the brightness in the eyes establishes communication with the viewer.

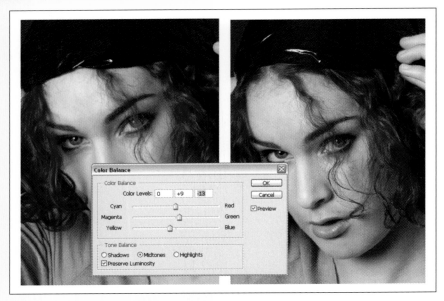

Figure 9-21. You can match the color balance of different images shot in the same circumstances by entering the same numbers in the R, G, and B fields after adjusting the first image to your liking.

Figure 9-22. The selection was feathered by 80 pixels and inverted. Then the Brightness/Contrast command was used to darken the edges of the image to focus interest on the face.

The following method really makes glamour portraits come to life.

1. Compare the skin tone in the image to that of similar photographs in your file browser or in Photoshop Album. If the photo you're working on needs to change, use the Image → Adjustments → Color Balance command, as in Figure 9-21.

2. Darken the areas outside the center of interest (i.e., create a vignette). To do this, just place a lasso selection around the areas you want to darken (or select the opposite area and use the Select → Inverse command), feather the selection over a large number of pixels, and then use the Image → Adjustments → Brightness/Contrast command or any other exposure-adjusting command to darken the area, as shown in Figure 9-22.

3. Look for areas that should be darker or lighter. In this instance, I used a large-diameter Burn brush to cast a shadow on the model's neck and left cheek to give more form to the image. Then, to smooth the lips, I first removed the cracks with the Healing Brush, and then used the Diffuse Glow filter to "light" the lower lip and make it look more moist. See Figure 9-23.

4. It's a good idea to whiten the eyeballs and lighten the iris in most portraits, especially glamour shots and portraits of executives who are supposed to have

Figure 9-23. The Diffuse
Glow dialog as it was
adjusted to produce the
result seen in the preview
window.

a commanding aura about them. Zoom in so that
the eyes are shown at 100%. Set the Dodge tool to a
relatively small radius and a low opacity, then stroke
over and over in the white area of the eye to lighten
it. (Be careful not to get it too white, or your model
will look like a vampire!) Do the same for the col-
ored part of the eye, but you'll want to be even more
subtle here. See Figure 9-24.

EXPERT ADVICE

Being Overly Dramatic

If you really want to dramatize the eyes and feel you
can get away with a touch of surrealism, use the
Sponge tool set on Saturate to intensify the color of
the eyes. Watch out, though—a little saturation goes a
long way!

5. While you still have the Dodge tool in your hand,
 drop the opacity even lower and carefully stroke
 over any lines in the lower eyelid. This will make
 any creases under the eyelid less obvious without

Figure 9-24. The right (camera left) eye has been
dodged to brighten it. The untouched opposite eye
is much less attention-getting.

Figure 9-25. Careful dodging has removed the creases and shadows under the eyes.

totally erasing them. Alternatively, you could use the Patch tool and choose Edit → Fade Patch Selection to achieve a similar result. See Figure 9-25.

6. Use the Burn tool, set to a very small diameter and about 25% opacity, to darken the outline around the colored part of the eye. You may want to darken the pupils a bit, too.

2. Finally, you may be able to add to the dimensionality of the image by creating some subtle highlights. You can do this with the Dodge tool if you have a steady hand, but it's more reliable to lasso the area you want to highlight and then feather the selection just enough to give you the modeling and shape that you want. If you want less blending on one side of the highlighted area, you can fix that with the Dodge tool.

The big gotcha in this technique is being careful not to overdo the effects—especially when sharpening and brightening the eyes and teeth.

Tip 5: Focus the Light on Points of Interest

As any good film director knows, the drama is often in the lighting. Sometimes what we want to show is hidden in the shadows, or what we want to hide is so brightly lit that it jumps out at us. Frequently, the existing lighting just may not place the viewer's focus just where we want it, as in Figure 9-26. Of course, you should pay attention to these factors when you're shooting the picture, but what if it's too late for that?

We need to add highlights and shadows to specific areas or objects in the photo, thus drawing the attention of the viewer toward or away from those objects. And this is familiar territory to us from our popping, sparkling model in Chapter 8.

Use any of the exposure controls in Photoshop (or any other image editor) to create the areas of lightness and darkness. The trick with scenic images is to make careful

selections to cover just the area you want to "light," feather the edges so that they blend on either side of the light, and then (if you want to make the lighting look directional) use the same technique in an adjacent area to create a highlight or shadow. Consider Figure 9-27.

Let's look at this in more detail.

1. Most of the time, I prefer to create lighted areas by using QuickMask mode (use the QuickMask icon just under the Color Swatches on the right of the Toolbox). With the Brushes palette open, keep the Brush Tip Shape selected so that you can easily change the feathering of the brush. This way, it's easy to make the light fall off to just the degree required by changes in the height and shape of the edges that you want to "paint with light."

2. If there are several of these areas, paint each one separately, switch back to Standard Mode (click the icon to the left of the QuickMask icon), and the QuickMask you just painted will become a selection. Save the selection and give it a name to tell you where it belongs and what it will do.

3. Once you've done all the selecting, simply recall each selection and use whatever lighting control you wish (Brightness/Contrast, Levels, Curves, Diffuse Glow, and so on).

Figure 9-26. This image could use some "fill flash" and darkening of overly bright areas.

Figure 9-27. The same image after applying the Shadow/Highlight command. Note the difference in the vegetation in the middle of the lake.

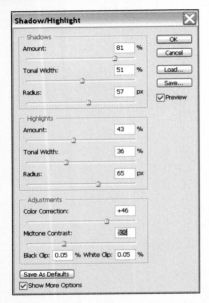

Figure 9-28. Amount controls overall brightness, Tonal Width is the width of the part of the Histogram to be adjusted, and Radius is the area within the selection that will be affected.

Secrets of Shadows and Highlights

The Shadow/Highlight command is Photoshop CS's answer to Photoshop Elements' very handy Fill Flash and Backlight commands, and is much more versatile. In addition to being useful for "lighting" specific areas of the image when you don't want to resort to the Lighting Effects filter, it is an excellent tool for influencing the overall shadow and highlight densities without changing the overall density or color balance of the image; compare Figures 9-26 and 9-27. (For this purpose, it is usually easier to uncheck the Show More Options box.)

The new Shadow/Highlight command (Image → Adjustments → Shadow/Highlight) in Photoshop CS is especially useful for lighting effects. I recommend checking the Show More Options box at the bottom of the dialog (see Figure 9-28). As you can see, all the adjustments can be made either with sliders or by entering a number in the adjoining field. If you check the Preview box and use the sliders, your adjustments become interactive. On the other hand, the numerical fields are useful when you want to exactly match the settings you've made for one selection with those in another.

I didn't cover the Lighting Effects filter here because it was discussed in Chapter 8. If you compare those effects with the results of the techniques described above you'll get an idea of the difference in look and feel. I'm not saying that either technique is more or less valid than the other. Both have their place.

Tip 6: Punch Out the Paunch

Your subjects will almost always want to see an image of perfection. For example, the subject in Figure 9-29 really wanted her picture to look more like Figure 9-30. If there's even a hint of a chubby thigh, oversized derriere, or saggy upper arm, you're likely to have an unhappy subject.

If you suspect that you'll be dealing with this problem, shoot your subject in the studio against a seamless backdrop using a knockout color. This way, you can easily knock out the subject's silhouette without having to worry about cloning in background. If your shooting situation forces you on location, you can still use one of the more sophisticated knockout tools, such as Extract or the more versatile Corel Knockout 2. It will just take a bit more time and effort to clone the background in the parts that were formerly hidden by the subject's shape.

Here's how to slim down your subject:

1. Decide how extensive the changes need to be. If just one small area needs work, you can just clone into a carefully made selection on the original layer. For a bigger job, you should start by duplicating the background layer and then using the Extract filter or one of the knockout plug-ins (Ultimatte AdvantEdge and Corel Knockout 2 are my favorites) to isolate the subject onto its own layer.

2. Use the Pen tool to carefully outline the area(s) you want to whittle away from the body. Be sure you have the Paths option chosen in the Options bar. You want to draw a path that's outside the main shape of the body (see Figure 9-31).

Figure 9-29. The subject wanted a slimmer-waisted look.

Figure 9-30. After subtle reshaping (and a new background for a bit of drama).

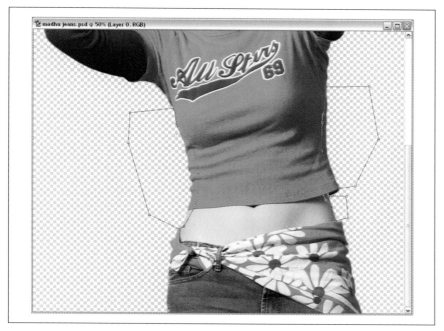

Figure 9-31. The paths drawn outside the main shape of the body.

Chapter 9, Retouching and Rescuing Photos

Figure 9-32. The Paths palette.

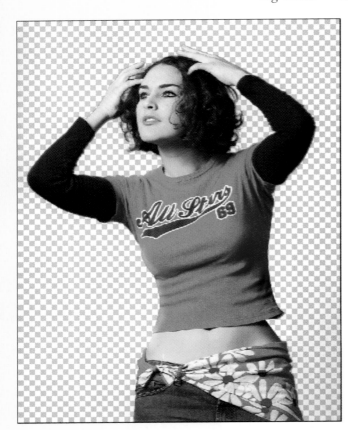

Figure 9-33. The left side of the body has been highlighted with the Dodge tool and the right side has been darkened with the Burn tool in order to give a more three dimensional look to the cutaway parts of the body.

3. Convert the paths to selections by clicking the Convert to Path icon at the bottom of the Paths palette (see Figure 9-32). Save this path (Select → Save Selection) just in case you need it again in the future.

4. If the subject's edges were a bit soft in the original, you will want to keep them that way. Feather your selections just enough to soften the edges very slightly. Often, feathering by one pixel is enough.

5. If your subject is on its own layer, just press Delete/Backspace. The contents of the selections will evaporate. If the subject was not knocked out of a plain background that you're going to substitute with another, keep the selection active in order to protect the subject and use the Clone Stamp tool to clone in the surrounding background details. Of course, the less detail-filled the background, the easier this will be.

6. You will probably need to "light" the edges you have trimmed so that they seem rounded rather than flat. First, recall your selections by choosing Select → Load Selection. If you're going to light with a highlight, brighten the selection on the shadow side. If you're going to light with a shadow, lighten the selections on the highlight side. Feather your selection enough to make the drop-off in lighting look natural, and use the Brightness/Contrast command to adjust the highlight or shadow edge's luminosity.

7. The edges of the lighting are likely to be a bit too regular. Fine-tune the edges of the lighting fall-off with the Dodge and Burn tool. See Figure 9-33.

You can't always plan ahead, but if you know you're going to have to do some trimming after shooting on a set or on location, try to remember to take a shot of the setting in the same light and at roughly the same time as you shot the model. Then, if you have a really tough time cloning in the background, you can just knock out the model and substitute the unpopulated background. If you are careful to adjust the brightness and color balance of both layers so that they look like they belong together, it should all look perfectly natural.

If it turns out you don't need the saved paths after you've finished your retouching, it's a good idea to delete the channels in order to save file space. Just open the Channels palette and drag the selection channels to the trash can at the bottom right.

Tip 7: Proboscis Pruning and Changing Expressions

Sometimes you want to create a straighter nose, or thinner or fuller lips. Or perhaps you want the corners of the mouth to turn up just enough to make the model look less bored. Compare Figure 9-34 to Figure 9-35.

You can make all these adjustments with the Liquify filter. There may also be times when cloning from another photo is a more appropriate technique; see the next section for details. Basically, if one technique doesn't work, try the other. The resculpturing of the cheeks and neck in Figure 9-34 could only be done with the Liquify filter in this instance. This is because the dark background was so monotone that it didn't look distorted when the cheeks were pulled in.

The secret to doing a believable and attractive job lies in being subtle. The following method shows you enough of the process to let you do any of the corrections described at the beginning of this section.

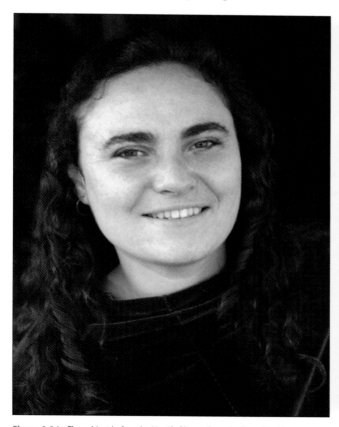

Figure 9-34. The subject before the Liquify filter reshaped a few of her features.

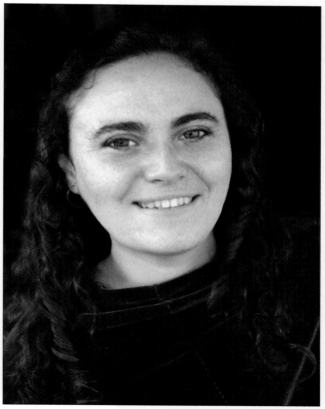

Figure 9-35. The subject's eyes were enlarged, her smile broadened, her nose straightened, her nostrils squeezed in a bit, and her neck and cheekbones slimmed to make her face a little less circular.

A Better Liquify

Though I didn't mention this in the previous chapter, the Liquify filter in Photoshop CS gives you much more control over subtle changes. You can now enter a specific brush size, density, and brush pressure. With some tools, you can also enter a brush rate (the speed with which the operation proceeds) and can even make the brush "vibrant" by entering a turbulent jitter rate. The new Liquify dialog is shown in Figure 9-36.

Forward Warp →

Reconstruct →

Twirl Clockwise →

Pucker →

Bloat →

Push →

Mirror →

Turbulence →

Freeze mask →

Thaw Mask →

Hand →

Zoom →

Figure 9-36. The new Photoshop CS Liquify dialog.

1. Duplicate the background layer (Cmd/Ctrl-J). Alternately, if the image consists of several layers that you don't want to flatten, duplicate the image (Image → Duplicate), flatten the duplicate (Layers → Flatten Image), then select all of the duplicate (Cmd/Ctrl-A) and copy it to the clipboard (Cmd/Ctrl-C). Activate the target image and press Cmd/Ctrl-V to paste it in register over the original.

2. Making sure the new layer is still active (highlighted in the Layers palette), choose Filter → Liquify.

3. The Warp, Pucker, and Bloat tools tend to be the most useful for reshaping and resizing details in the part of the image you want to resculpt. In Photoshop 7, these tools work very quickly, and it's easy to overdo it. You can use the Reconstruct tool (R) to reverse the direction of your warping or return it to the original state. (If you need a refresher on how to use the Liquify filter, see Tip 6: Bend It to Your Own Purposes in Chapter 8.)

To make sure that you don't stretch or reshape areas adjacent to the area you are reshaping, paint a mask over those areas.

There are several other applications and plug-ins that let you stretch, morph, and reshape all or part of your photo. You might want to experiment with some of the Kai's Power Tool filters or with Human Software's Squizz plug-in.

> **EXPERT ADVICE**
>
> ### Don't Do It All at Once
>
> It can be very difficult to resize or reshape to exactly what you intended. Try to reshape only one feature each time you use the Liquify filter. Then, when you click OK to return to the main Photoshop interface, you can use the Edit → Fade Liquify command to reduce the effect to exactly what you were looking for. Also, by Liquifying one feature at a time, you can control exactly how much you change each feature. In the example shown here, that approach was essential in making both eyes the same size.

Tip 8: Clone Detail from Another Photo

Maybe it would've been a great shot if only your model hadn't blinked, or had straight teeth or perfect forearms. Or maybe you just really want the hat in Figure 9-37 to appear with the costume in Figure 9-38.

If you can find the details you need in another photograph, you can just paint them in with a clone stamp brush on a superimposed and transparent layer. There are several advantages to using a layer to paint on. First, you can blend

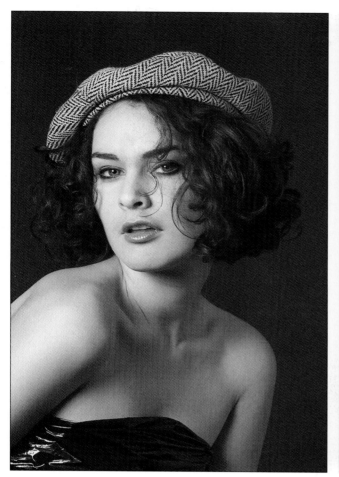

Figure 9-37. The client wanted the hat in this picture...

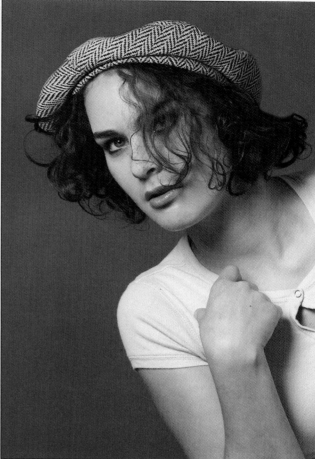

Figure 9-38. ...to appear with the costume in this picture.

that layer with the underlying layers by changing the opacity or blend mode. Second, you can alter the exposure and color balance of the layer so that the painted-in detail matches the original's (or, if you have Adobe Photoshop CS, you can even replace the color by using the Replace Color brush). You can also use the Free Transform command (Cmd/Ctrl-T) to reshape or rotate the item so that it appears at the natural-looking angle, size, and perspective.

1. This method is most likely to work if the object or characteristics that you'll be transferring from another photo are inside the silhouette of the same part of the subject. That is, it's much easier to add or subtract muscle tone from *inside* the silhouette of an arm, chest, or stomach. If you actually have to reshape the subject, see Tip 6: Punch Out the Paunch. Of course, you can combine both of these methods.

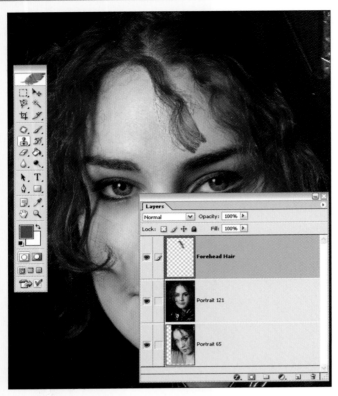

Figure 9-39. The bottom layer has been moved and transformed so that the swatch of hair on the forehead is positioned where we want to clone it over the layer above.

Here's the typical workflow:

1. Scale or transform the area inside both images that you are going to clone to and from to exactly the same size and orientation. As mentioned previously, it's best to cut and paste the information you're incorporating onto a new layer in the target image, and then use the Free Transform command to scale it properly. See Figure 9-39.

Decide which parts of your image could be improved. Do you need a better-arching eyebrow, a more elaborate piece of jewelry? Make a list so that you can deliberately find or make the images to clone from. You'll need photos with the required detail photographed at the same camera angle and perspective, and with the same lighting and resolution. If you have none, you'll have to shoot new photos. For example, if it's jewelry you want, put the piece on a mannequin and set up or find lighting that's the same as the original.

2. Back at your computer, open both photos side-by-side. Copy the photo you're going to clone from (the source) to a new layer in the photo you're going to clone to (the destination). To do this, press Cmd/Ctrl-A to select all, then Cmd/Ctrl-C to copy to the clipboard. Activate the target image's window and press Cmd/Ctrl-V to paste the photo to a new layer. In the Layers palette, place the new layer (from the source image) above the target image layer.

3. Use the Layer palette's Opacity slider to make the new layer blend with the target image, and use the Eraser tool to brush away any unneeded portions of the imported layer.

The biggest problem with this method is matching the texture of the original with the texture of the image you borrow from. This is typically not an issue with eyes or clothing accessories, but skin is another matter altogether. If you have to transfer a tattoo, or some muscle tone, or a different nose, use transparency in the new layer. If you're using Photoshop CS, it's also a good idea to use the Healing Brush and anchor it on the original layer, and then stroke *around* the parts of the transfer that show bare skin. The Healing Brush will transfer the texture from the anchor point without transferring the original details. Don't try this on the focal area you've transferred because the Healing Brush will blur it; instead, do it only on the surrounding skin.

If that approach doesn't work for your particular image, try using the Eraser tool on the new layer to reveal the skin in the original layer. Be sure to feather your Eraser brush and set its opacity low enough that your strokes will blend the new layer with the target image.

Creating Fictitious Photos

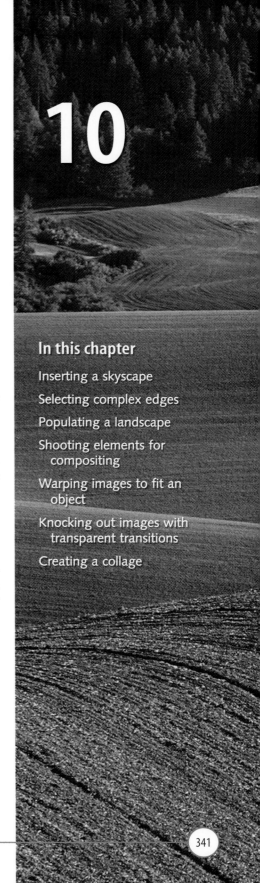

10

In the context of this chapter, a fictitious photo depicts a scene that is different from what the camera originally saw. For the most part, we'll be talking here about the fine art of making photos from multiple original photos, also referred to as photomontage or compositing.

Now before I go any further, I think a little philosophical note is called for here. Some people insist that photomontage in an insult to the photographic art—the essence of which is the camera's inherent ability to capture the moment. However, I would argue that the essence of art is self-expression, and that any means of conveying a message more powerfully is a legitimate one. Am I saying that reporters have a right to alter news photos or that lawyers have a right to alter documentary legal photos or that you have a right to claim that a composite is a statement of literal fact? Of course not. You need to use a little common sense when determining when fictitious photos are appropriate and when they're not.

Getting Started

It's easy enough to cut out images and paste them into another document. Unfortunately, the result will usually be laughable unless you follow a logical workflow to make your images look at home in a different environment. For example, it takes a bit of work to turn Figure 10-1 into Figure 10-2.

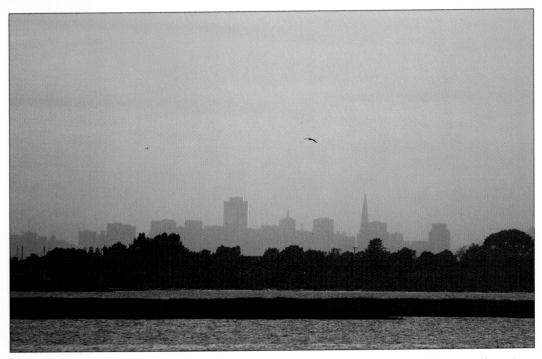

Figure 10-1. A nice photo of the San Francisco skyline from a park in East Oakland. A bird or two could warm it up and add interest.

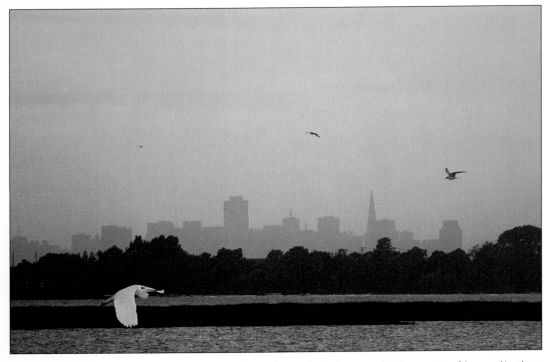

Figure 10-2. Fortunately, the birds were photographed in the same park at the same time of day, so making them look natural in these surroundings was comparatively easy. Knockouts courtesy of Corel KnockOut 2.

The following steps allow you to make the perfect match between images. If you do it right, only a practiced expert would guess that your photograph is actually a composite.

1. *Match the color mode and bit depth.* Make sure that both images are in the same color mode and bit depth. To do this, first choose Image → Mode → 16 (or 8) bits per channel to set the images to the same number of bits. Next, choose Image → Mode → Color Mode (RGB, Grayscale, Lab, etc.) to make sure the color mode in both pictures is the same.

2. *Match the size.* If both images were shot with the same camera settings and are the same size, you will have an easier time matching grain, sharpness, and noise. If this is impossible, scale the image you're bringing in to the approximate size it will be when it is inserted into the target image.

3. *Match the grain structure.* Zoom both images to 100% and carefully examine the noise and grain structure. If one image is noisier than the other, you'll find it much easier to match the smoother image to the noisier one by adding noise (Filter → Noise → Add Noise). There are also numerous third-party filters that will let you add noise: try Alien Skin Eye Candy 4000's HSB Noise, Grain Surgery Match Grain (when you need a technically perfect match), or KPT 5 Noize. You can also remove grain and noise, if it's not too prominent, with such third-party tools as Grain Surgery, Power Retouche, and nik Dfine.

4. *Match the exposure.* The easiest way to do this is to apply the exposure controls to an *individual layer* after it has been imported into the image as part of a composite. This is because you have more control when you're trying to match only one image at a time. And if you perform the exposure matching right after you've imported the image, you won't have to keep readjusting the images to match one another.

5. *Match the color balance.* The Color Balance dialog (Image → Adjust → Color Balance) and the Hue/Saturation dialog (Image → Adjust → Hue/Saturation) are the most likely to help you here. Again, adjust the color balance of each composite layer as it is imported, rather than trying to use Adjustment Layers.

6. *Match the lighting direction.* This is something you'll have to "fake" by hand, using the techniques demonstrated earlier in Chapters 8 and 9. The idea is to produce highlights on one side and shadows on the other.

7. *Match the perspective and point of view.* Try to shoot images containing foreground objects from the same angle and distance as you shot the background scene. If the object is grounded, height is especially important in making a believable match.

8. *Create transitional edges.* If you've had to cut out your selection, rather than knocking it out with a program or filter that creates transitional (i.e., graduated transparency) edges, it will be useful to "round" those edges with highlights and shadows (see Figures 10-3 and 10-4). It's also a good idea to lightly brush cutouts with the edge of a fully feathered and low-opacity eraser so that the imported object's edges merge with the background.

9. *Create shadows.* Create a new, empty layer and drag it below the imported object's layer. Use the Lasso to draw a shape representing the shadow, feather it, and then fill it with black. Press Cmd/Ctrl-T to bring up the Free Transform marquee, then drag the center of the selection to the spot where the object is grounded. Now press Cmd/Ctrl and drag the corners of the marquee so that the shadow grows and bends in the opposite direction of the main light source. Once you've finished shaping your shadow, you'll realize the benefit of keeping it on its own layer: you can adjust the opacity of the layer to make the shadow just as transparent as you like, which will make it look much more natural. Finally, use the techniques described in Tip 5: Bend and Warp Images to Fit Another Object.

Of course, you'll invent your own rules as you go along, and you'll also find reasons to argue with the ones described here. The point here is to get you started along a workflow path that's most likely to be successful. If your personal style causes you to discard or bend some of these "rules," then you know you're moving up!

Tip 1: Insert a More Interesting Skyscape

Any time the weather is really pleasant, the sky is likely to be a flat, washed-out blue. This makes for uninteresting photographs. Compare Figures 10-5 and 10-6.

Substituting a new sky can make a landscape come to life. The following technique also shows you how to match the color and brightness of the sky to the landscape and how to blend the horizon line so that there's no obvious dark line separating earth and sky. You can also liven up the sky by painting in a few clouds from another photo or by simply making adjustments to the existing sky. You can even create your own Action for adding in the sky from another image.

1. Duplicate the background layer so that you can go back easily or in case you want to combine the two skies. Place the duplicate layer at the bottom of the layer stack so that the other layers hide it unless it is needed. See Figure 10-7.

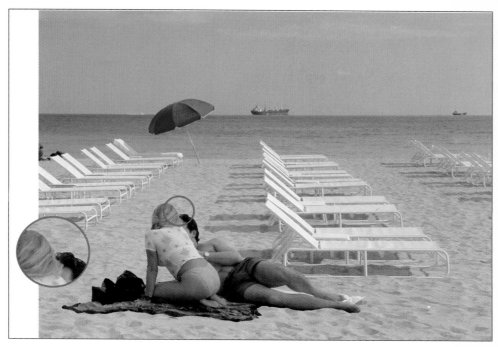

Figure 10-3. This couple was imported from another photograph after being selected with Photoshop's Magic Wand tool. The edges are just a little too clean, which gives away that this is a paste-up.

Figure 10-4. Same composite, but this time the couple was knocked out of the original image with the Extract command, which creates transitional edges. The difference here is so subtle that it's almost hard to tell why this composite looks so much more natural.

Figure 10-5. The lighting is lovely, but the blank sky makes for a boring picture.

Figure 10-6. Now the sky is a darker blue, and clouds add detail to the sky.

Figure 10-7. The original and duplicate layers as they should be labeled and ordered for clarity. Once you've renamed a background layer, you can duplicate it by dragging it to the New Layer icon.

2. Find another photo that has the sky you want. Try to make sure that it has the same sort of lighting as the foreground photo so that the composite will look believable (especially if the new sky is of a brightly lit day). It's also a good idea to find a photo in which the sky area is approximately the same size as the image you're placing it into.

3. Choose the Move tool and drag the new sky into the target image. In the target image's Layers palette, put the new sky's layer between the duplicate of the original layer and the original layer. See Figure 10-8.

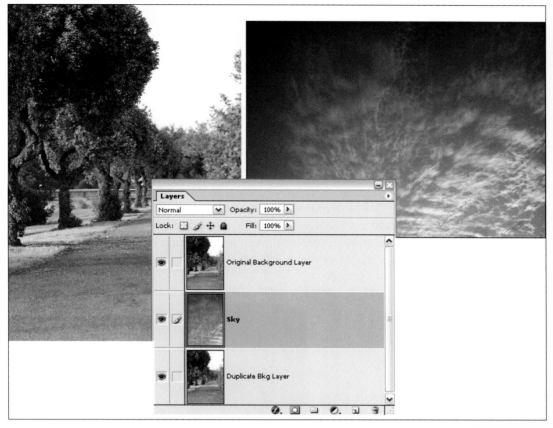

Figure 10-8. The target image, the new sky image, and the Layers palette after the new sky has been dragged into the target image.

4. Transform the sky to the desired size and proportion. Making sure its layer is active, zoom out so that you have a fairly small window, then stretch the borders of the window so that you have a large gray margin all around. When you press Cmd/Ctrl-T you will see the Free Transform marquee; if it is larger than the target photo, you will see it in the gray area surrounding the photo (see Figure 10-9). Transform the sky image to the size, proportion, and rotation you want it to have in relation to the target image.

5. Remove the sky from the second layer of the old photo, which is now the top layer in the Layers palette. (Be sure to select the top layer first!) Sky removal is usually best done with the Magic Wand; if there are gaps in the foreground image that reveal the sky, be sure to uncheck Contiguous in the Options bar. Also, adjust the Tolerance so that the Magic Wand selects all of the sky but none of the foreground.

In Search of New Clouds

What if the sky isn't blank, but you're just not crazy about the cloud configuration? Use the method described in Tip 2: Select Ultra-Complex Discontinuous Edges.

6. Select those colors in the original image's sky that are contiguous with (touching) the foreground. If there are clouds that are contiguous with the foreground as well as blue sky, you may need to press Shift to add another color range to the selection. It doesn't matter if there are colors in the sky that don't get selected, as long as those colors don't touch the horizon line. Just choose the Lasso tool (L), press Shift, and add the unselected colors in the sky to those that have been selected near the horizon. Also, if there are colors below the horizon line that are the same brightness as the sky, keep the Lasso tool selected, press Opt/Alt to sub-tract the selection, and lasso all those extraneous marquees. You should now have all of the sky, and only the sky, selected; see Figure 10-10.

7. Save the selection (name it Sky Selection) in case you need to change its size or feathering. Start first with no feathering, but if the transition is too abrupt, start experimenting. Choose Select → Feather and then enter the number of pixels you want to feather on either side of the marquee. How much feathering you need will depend on the specific foreground and sky images.

Figure 10-9. Window borders enlarged to make it easier to see and adjust the Transform marquee's handles. Note that we've completed Step 5 here as well to give you a sense of how the photos relate to each other.

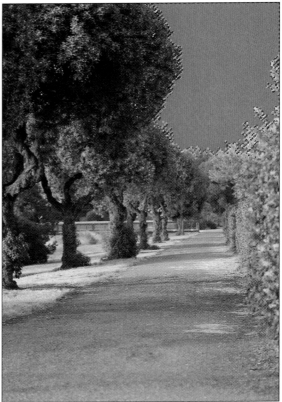

Figure 10-10. The image with the entire sky selected. (I have filled the selection with red so that you can see it more easily.)

8. Press Cmd/Ctrl-H to hide the selection so that you can see the result exactly. Then press Delete/Backspace, and the sky on the layer below will be instantly revealed (see Figure 10-11). If there is a white halo around the horizon line, use the History palette to go back to reveal the original selection. Choose Select → Modify → Expand and enter the number of pixels you think the selection needs to expand. It is often a good idea to expand it one or two pixels past the horizon, then feather it by the same

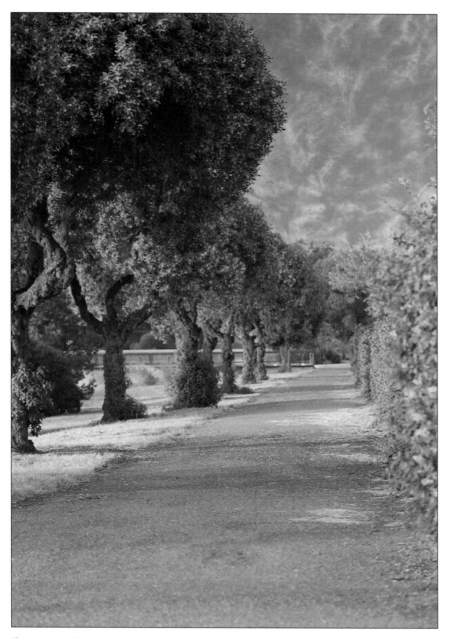

Figure 10-11. The new sky after deleting the contents of the selection of the old sky.

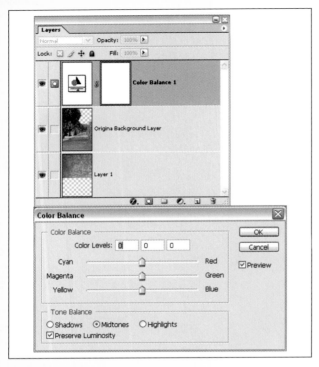

Figure 10-12. A Color Balance adjustment layer atop the stack in the Layers palette. In this position, it will affect the color balance of all layers equally.

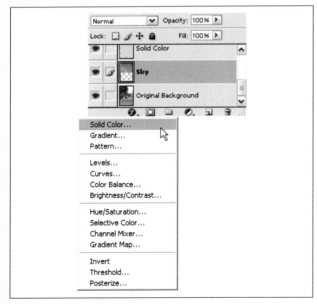

Figure 10-13. The Layers palette Adjustment Layer menu allows you to choose from many different types of adjustment layers.

amount to create a transitional blend between the sky and the foreground. Experiment until you get this just right—each individual image will be different due to variations in size, focus, color balance, and so forth.

9. Now all you have to do is match the exposure and color balance of the sky and the foreground. First, get the exposure of both the sky and foreground as close to perfection as you can. It's best to use the Color Balance command to match the color balance of the sky with that of the main image.

10. Once you've matched the color balance of the foreground and sky, you may want to change the overall color balance of all the layers in the image. If so, select the top layer and then create a Color Balance adjustment layer (go to the Layers palette and choose Color Balance from the Adjustment Layer icon at the bottom; see Figures 10-12 and 10-13). Using an adjustment layer makes it possible to adjust both layers equally, so that when you adjust the color balance of the foreground, the color balance of the sky will change to match. As long as you haven't flattened the layers, you can always readjust the color balance at a later time.

It's never a bad idea to keep a collection of sky shots so that you can match the right lighting, cloud formation, and sky color to any landscape. The exposure controls and the Hue/Saturation command (Image → Adjust → Hue/Saturation) are the best tools to help match the color balance and brightness of the landscape to that of the sky.

Tip 2: Select Ultra-Complex Discontinuous Edges

Sometimes if you try to composite an object with highly irregular edges and countless gaps, you'll find that the knockout plug-ins we discussed in Chapter 5 have trouble finding all the edges. Another problem which arises with ultra-complex edges is edge halos (also known as spill areas), where there is a slight glow that appears around the knocked-out object. You can manually retouch those spill areas, but I doubt that you'll want to make a career out of a single job.

In this example, we'll cut out the tree in Figure 10-14 and place it in front of the building in Figure 10-15 to create the composite image shown in Figure 10-16. Instead of using your knockout plug-in, you can specify your selection with Photoshop's Color Range or Threshold command, both of which are described below. You may want to try both to see which gives you the best selection for the image you want to knock out.

Figure 10-14. We want to put the tree in this photograph...

Figure 10-15. ...in front of the blue building in this one.

Figure 10-16. There's not a bit of spill in this perfectly matched composite, despite the difficulty of selecting all the complex edges in the tree and its foliage.

The Color Range command

1. If you've just opened the image with the object you would like to knock-out, make it into its own layer (i.e., not the background) by opening the Layers palette and double-clicking the background layer. The New Layer dialog will appear. Name this new layer "Knockout", or, if you're going to have several knockouts, name it by its contents. See Figure 10-17.

2. Choose Select → Color Range (see Figure 10-18). Just as we did in Chapter 5, use the eyedropper to click in the color that most borders the item you want to knock out. The colors you've knocked out will turn white. If there are still colors left, choose the + eyedropper and click the next lightest color outside the item. Continue until virtually everything in the image is white except the image you want to keep. You probably won't be able to get it perfect with the eyedroppers alone, so once you've done the best you can, drag the Fuzziness slider to get as much of the item as you can without reintroducing any background colors. When you're satisfied, click OK.

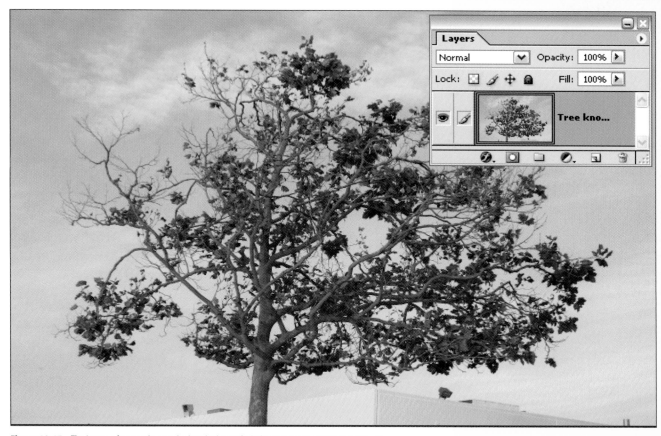

Figure 10-17. The image of a tree about to be knocked out of a lighter background with the Color Range command.

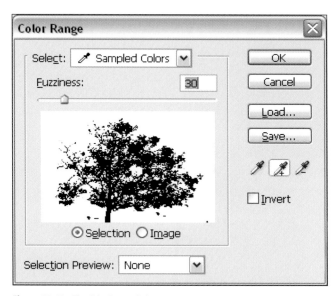

Figure 10-18. The Color Range dialog.

Chapter 10, Creating Fictitious Photos ⎯⎯⎯⎯⎯⎯⎯⎯⎯⎯⎯⎯⎯⎯⎯⎯⎯⎯⎯⎯⎯ 353

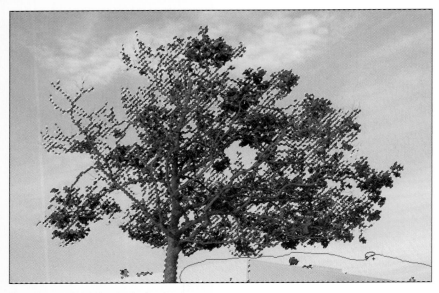

Figure 10-19. Add to the selection by using the Lasso tool to select colors that are outside the color range specified in the dialog.

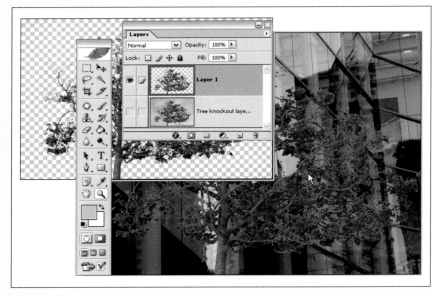

Figure 10-20. The tree with a new background.

3. Use the Lasso tool to select any bordering colors that are left, as shown in Figure 10-19.

4. Invert the selection so that the item you want to keep is selected (press Cmd/Ctrl-I), then save the selection (Select → Save Selection) and name it "Knockout".

5. Open the item you want to use as a background. Choose the Move tool and drag the layer you knocked out into the new background's document window, then copy and paste it into the same file as the item you knocked out. You may need to scale one of the layers to make the two images seem like a natural fit (see Figure 10-20).

6. In the Layers palette, drag the background image layer (not the background layer) to the position immediately below the knockout layer. Then select the knockout layer, choose the Move tool, and drag the knockout into the desired position in the composition.

7. Unless you're lucky, you'll probably encounter some spill along most all of the smallest edges (see Figure 10-21). To see how to fix it, see the upcoming section Getting rid of knockout spill.

Figure 10-21. The gray halo around the tiny branches is left over from the original background. This is called "spill."

The Threshold command

1. Duplicate the layer of the image you're going to knock out.

2. Choose Image → Adjust → Threshold to bring up the Threshold dialog (see Figure 10-22). Your image will change to very high-contrast black and white. Drag the slider until you see as much of the fine detail in the image you want to keep as possible, but make sure that most of the background (especially if it touches the object you want to knock out) is solid white. When that's the case, click OK.

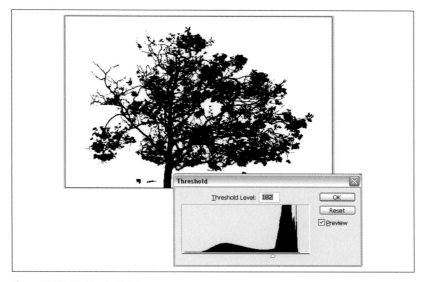

Figure 10-22. The Threshold dialog.

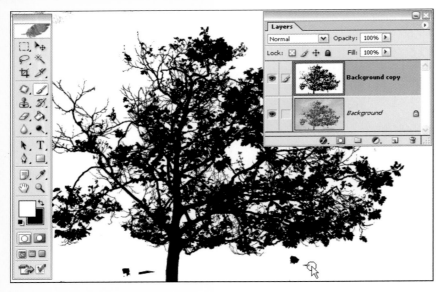

Figure 10-23. Use the Brush tool to paint out unwanted areas of the Threshold selection (layer).

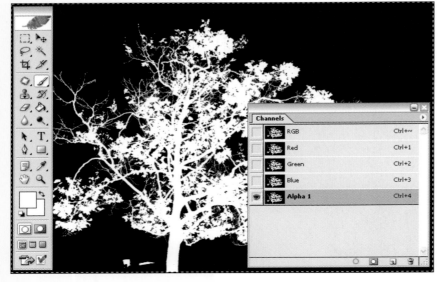

Figure 10-24. Turn the Threshold layer into a selection by copying it into the Channels palette.

3. If there's any black left in the area you wanted to be white, paint it out with a white Brush tool (see Figure 10-23).

4. Invert the image to a negative (press Cmd/Ctrl-I). If there are any white areas that should be black, paint them black. Select the result and copy it to the clipboard by pressing Cmd/Ctrl-A, then Cmd/Ctrl-C.

5. Open the Channels palette and click the New Channel icon at the bottom. When the new channel's name bar appears, press Cmd/Ctrl-V to paste the Threshold negative image into it. You've just saved a selection (see Figure 10-24).

6. In the Layers palette, drag the black and white image to the trash. You will now see your RGB original. Press Cmd/Ctrl-J to duplicate it again. See Figure 10-25.

7. In the Channels palette, make sure the new alpha channel is selected, then click the Make Selection icon at the bottom of the Channels palette. Your knock-out image will be selected. Press Cmd/Ctrl-Shift-I to invert the selection, and then press Delete/Backspace to delete everything but what you wanted to save. In the Layers palette, turn off the background image. See Figure 10-26.

8. Open the image you want to use as a background, then copy and paste the item you knocked out into the background image.

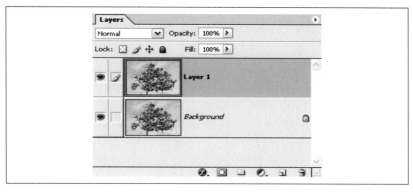

Figure 10-25. Copy the background layer to a new layer by dragging it to the New Layers icon in the Layers palette.

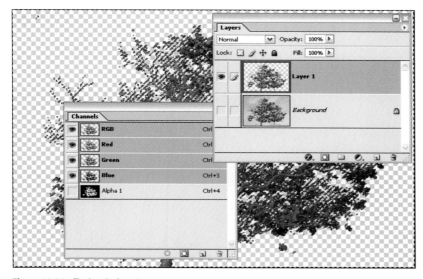

Figure 10-26. The knocked-out image.

9. In the Layers palette, drag the background image layer (again, not the background layer) to the position immediately below the knockout layer. Then select the knockout layer, choose the Move tool, and drag the knockout into the desired position in the composite. Resize and crop layers as needed to make the foreground and background objects relate in the desired positions and sizes.

Getting rid of knockout spill

1. You did remember to save those selection channels, right? Good. Go to the background layer with the knockout, choose Select → Load Selection, and choose the selection that made the knockout.

2. Now you'll turn the selection into a border, which looks like a pair of parallel selection marquees; the selection lies in between them. Choose Select → Modify → Border, enter a pixel width that is twice as wide as

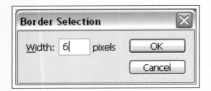

Figure 10-27. The Border Selection dialog.

the spill (try 4–7 pixels as a starting point), and click OK (see Figure 10-27).

3. Feather the selection by one or two pixels (Select → Feather); see Figure 10-28. Now activate the layer that contains the background image; the feathered border selection will still be active. Press Cmd/Ctrl-J to lift the contents of the feathered border to a new layer. Drag the new layer to above the layer that contains the knockout, and in the Layers palette, change the Blend mode of the border layer to Overlay. Miraculously, the spill will disappear, but the fine lines in the original will still remain intact.

Sadly, there will still be times when your only choice is manual retouching. There are two things you should try in this case: Photoshop's History Brush tool and the Eraser tool. The History Brush will paint what was in the original back onto the composited layer, so you can overpaint the spill. You'll usually include some of the old background, too—just gently erase it away with a small-tipped and half-feathered brush set at 25% opacity so you can make multiple strokes to blend the edges.

Figure 10-28. An extreme close-up of a selection bordered at 2 pixels and feathered by 1 pixel.

Tip 3: Populate a Landscape

Most of the time, you want to shoot landscapes with the camera on a tripod, so that you can slow down the shutter and use a minimum aperture for virtually infinite depth of field. Unfortunately, if you're shooting at sunrise or sunset, any people or animals in that landscape are likely to be blurred. And anyway, it's highly unlikely that the perfect pair of lovers will be sitting on that park bench, or that lovely retriever will be catching a Frisbee, or the egret will just be taking off from the marsh at the moment you shoot the picture. See Figure 10-29 for an example.

Figure 10-29. This familiar-looking landscape would benefit greatly from a little human interest.

Figure 10-30. These cyclists were photographed just moments after the first picture was taken. The composition wasn't as nice, so I just extracted them from their own photograph and put them in here.

The addition of a group of cyclists to the original image was a vast improvement (Figure 10-30). Here's an easy technique for adding lifeforms that will really make the scene for you.

1. Clean up the landscape, removing objects that you don't really want in the scene if needed.

2. Correct the exposure, color balance, and lighting for the background, as we discussed in Chapters 3 and 6.

3. Open the image you want to place into the landscape and scale it (Image → Image Size) to the approximate final size. To determine the current size of an image, press Cmd/Ctrl-A to select the entire image and open the Info palette (Window → Info or F8)to see the height and width of the image in pixels (see Figure 10-31). You could also look at the Image Size command's dialog (Image → Image Size). Do this for both images to figure out their relative sizes. If you have to scale down the object, be sure to scale its original image to be just a little larger than it's likely to be in the target scene.

Figure 10-31. The Info palette showing the pixel dimensions of the currently open image.

4. Knock out the image to be composited. You can use the Knockout filter or any of the third-party filters covered in Chapter 5. The knockout in Figure 10-32 was created with the Extract filter.

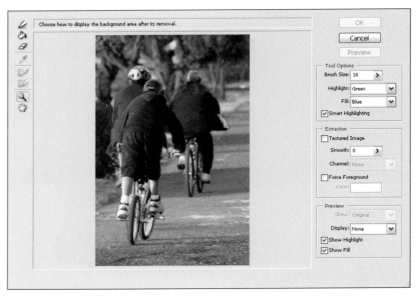

Figure 10-32. The Extract filter is usually the most convenient way to make a knockout if the subject was shot against a complex background.

5. Choose the Move tool and drag the image into the target image's window, then press Cmd/Ctrl-T to place a Free Transform marquee around the imported image (see Figure 10-33). You'll probably want to resize the object proportionately to its original dimensions, so press Shift while dragging the transformation handles. If you then want to rotate the object to give it the proper orientation for its new location, place the cursor just outside one of the corner handles and drag to the right or left.

6. The next step is crucial. You'll want to "light" the image you've just introduced. Ideally, you've chosen an image that was lighted in the same manner and direction as the background; if that was impossible, at least choose an object that has been photographed in diffuse lighting conditions. You can then simulate directional light to some extent by dodging the highlights and burning the shadows to match those in the target (background) scene.

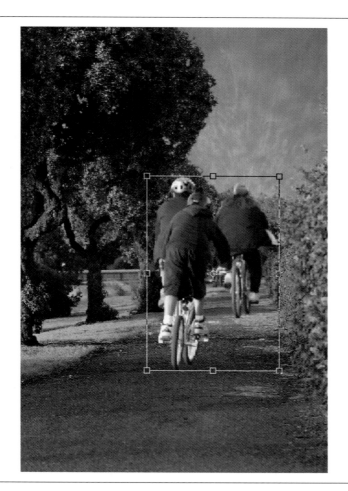

Figure 10-33. The Free Transform marquee lets you scale, stretch, or rotate the image to make it fit its new surroundings.

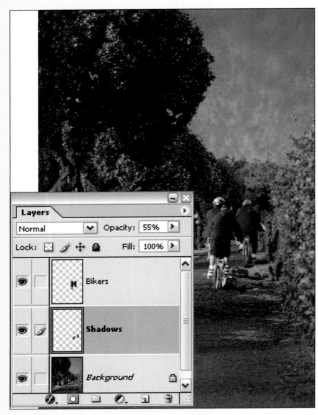

Figure 10-34. The object copied, flipped, and stretched for reflection.

The 100% View

Always view any composite image at 100% before you flatten layers. You may often find the need to do some erasing or cloning along the edges in order to make them transition smoothly into the background.

7. If the object should be backlit or will cast a reflection, choose Edit → Transform → Flip Vertical. Select the Move tool and drag the flipped image so that it projects from the base of the imported object, then press Cmd/Ctrl-T to get back to the Free Transform marquee (see Figure 10-33). Press Cmd/Ctrl and drag the bottom center handle to stretch the reflection away from the object. The result is shown in Figure 10-34.

8. If this is a reflection rather than a shadow, use the Liquify filter (Filter → Liquify) to simulate the distortions that would occur if the object were reflected on the background's surface (e.g., water, pavement, a store window). Finally, blur the reflection if appropriate to the reflective surface and adjust the transparency of the image to reveal the texture of the surface below. You may also want to experiment with blend modes (Multiply is often the most appropriate).

9. If the object is casting a shadow rather than a reflection, click the Lock Layer icon in the Layers palette and choose Edit → Fill. Choose Black in the resulting Fill dialog; you will now have a black silhouette of the original imported image (see Figure 10-35). Go back to the Layers palette and click the Lock Layer icon again to toggle off layer locking; otherwise, you won't be

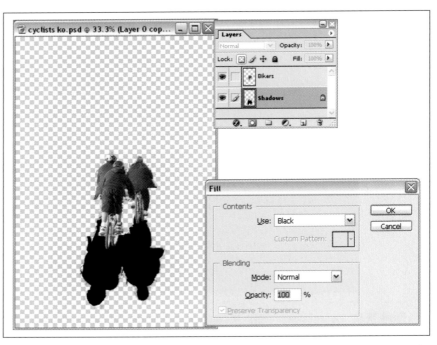

Figure 10-35. The Fill dialog

able to blur outside the original image's boundaries. To give fall-off feathering to the shadow, choose Filter → Blur → Gaussian Blur, check the Preview box, and drag the slider to the right until you see the amount of feathering you want. Now lower the opacity of the layer so that the shadow becomes transparent and has the right amount of darkness considering the hardness or softness of the surrounding light. The result is shown in Figure 10-36.

10. Put the finishing touches on the image by making whatever exposure and color balance adjustments seem appropriate. You may also choose to do some final retouching to tweak the appearance of the lighting and the smoothness of edge blending.

The EXIF data that gets recorded when you shoot a digital image can be a great help when you are looking for individual pictures to composite into a whole. Look at the image size, date shot, and time shot. Also, the combination of f-stop and exposure length will help you determine the color temperature of the light, since longer exposures and wider apertures are usually needed when the subject was in the shade or photographed on a cloudy day. If the direction of light and the point of view are the same, and if the EXIF data matches, it should be fairly easy to make the images look like they truly existed in the same time and space.

Tip 4: Shoot Elements Specifically for Compositing

The previous tip brings us to another element of digital photography: shooting elements specifically for compositing. Let's say you want to illustrate a given situation, but don't have time to wait for all the elements to come together at exactly the right time and place. For example, in the case of Figure 10-37, we wanted to populate the scene with more people.

Figure 10-38 shows the final result. The following technique shows you how to plan ahead so that all the elements in the final picture look as if they were actually there when the photo was taken.

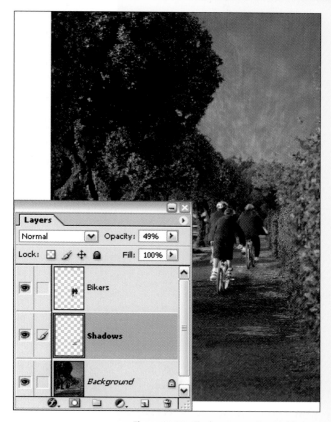

Figure 10-36. Shadows were painted in black on a transparent layer underlying the imported cyclists. The layer was then blurred and the transparency lowered to give the shadows a more natural look .

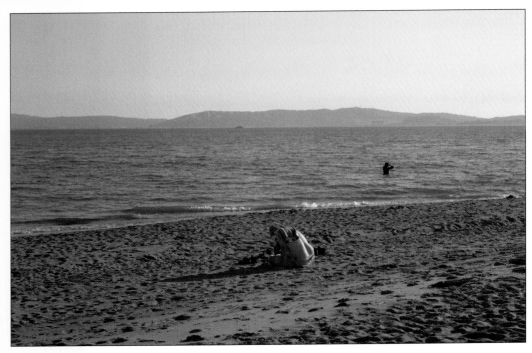

Figure 10-37. The client wanted to populate this beach with particular people and activities.

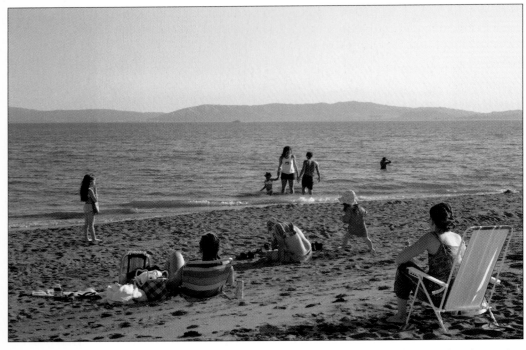

Figure 10-38. All of these people were photographed on the same beach, from the same angle, at the same time of day. They were then carefully arranged with just the right composition and showing just the activities we wanted to show.

1. Collect images or draw a sketch of what you want the final product to look like. Some of the images used in this example are shown in Figure 10-39.

2. If you haven't already, shoot the background image you need, making sure that lighting and angle convey the mood you want. (You can see the background image in Figure 10-37.)

Figure 10-39. A few snapshots were taken of various people and activities at the same time of day and at nearly the same location and angle.

3. If possible, print the background image so that you can look at it while shooting other images. This way, you can ensure that the other images are shot at the right distance and focal length to match the background.

4. Optionally, make a print of the background image that is exactly the same size and proportion as your camera's preview LCD. Place a piece of clear plastic over the print and trace the rough outline of the main elements in the image using an indelible fine-point marker. This way, you can more easily see whether you shot each composite element at the right height, distance, and focal length.

5. Be sure to shoot each composite element with the main light (sun, moon, or artificial lighting) at the same height and pointed in the same direction.

6. Once you have shot the photographs for your composite, use the techniques in the previous sections to bring the various elements together.

We have all seen those laughable photos on the covers of tabloids that try to convince us that an alien was dating Madonna during her pregnancy. They're obviously manufactured, but they make us laugh and they catch our attention. What we may not realize, however, are that many of the photos in modern advertising are also manufactured from photographs taken at different times and different places.

Adjusting Reality

A famous tabloid fake in the dawning age of digital photography occurred in the early 1990s. It showed figure skaters Nancy Kerrigan and Tonya Harding skating side by side on the Olympic practice rink. Of course, this never happened—they were each shot at different times and locations, and digitally mixed. But many gullible readers believed it!

Figure 10-40. Elke Savala's modern painting, composited onto the model's body.

Figure 10-41. The same composite after using the Liquify filter to bend it to flow with the contours of the model's body. Now it really looks like a tattoo.

Tip 5: Bend and Warp Images to Fit Another Object

It is entirely possible that you may want to drape a nude model in a flag, create a tattoo where none exists, or give a new surface design to a vase. However, it's very unlikely that those designs were photographed on an object with the same contours as the object you wish to place them on. In fact, in the case of decorative details and tattoos, you may have just scanned the original on a flat-bed scanner. Consider Figure 10-40.

You need to find a way to bend and warp the image so that it appears to follow the shape of another object, as in Figure 10-41. There are several ways you might go about doing this. I'll start with the simplest and most accessible, and move on to a solution that requires money and time, but that is guaranteed to produce a totally believable result.

Warp with the Liquify filter

1. Place the image that you want to map onto a shape on its own layer.

2. Use a grease pencil to mark the computer monitor with the boundaries of the shape you are mapping to. If you don't want to mark your monitor, cover it with plastic wrap and mark that.

3. Open the Liquify filter and use Bloat, Pinch, and other warping tools to expand that part of the image that is closest and shrink the parts that fall away, and the Push tools to stretch the image around a particular shape. Render the result back to Photoshop (see Figure 10-42).

Figure 10-42. Warping the painting with the Liquify filter.

3. Use the Multiply blend mode and adjust the opacity and fill until you get the image to either shade or replace the surface of the object you're fitting it to. For instance, you'd want the image of a tattoo to be faded and transparent; ditto if you're projecting a slide or light show. If it's fabric, you will probably want it to be totally opaque. Compare Figures 10-40 and 10-41.

EXPERT ADVICE

Small Steps...

If the item you are warping is on its own layer, you can warp, swell, or push one area of the image, then click OK in the Liquify filter. Next, make a careful study of what you'd like to do next, return to the Liquify filter, and do a bit more warping. Keep repeating this process until you get it just right. This may sound tedious, but trying to do the whole job "by guess and by golly" can cause innumerable restarts.

Last-Minute Update

The Photoshop CS Liquify filter has been updated to make it much easier to warp the object on one layer to fit the shape of an object on another. That's because you can now see the underlying layer within the Liquify workspace. At the bottom right of the new Liquify dialog is a checkbox entitled Show Backdrop. As soon as you check the box, you will see all of the underlying layers. The Use menu lets you choose between displaying all layers and any individual layers, and the Mode menu lets you choose how the background displays. An Opacity menu lets you adjust the intensity of the image on the underlying layers. So now it's really easy to see how what you adjust in the Liquify dialog will align with the underlying image.

Use the Displace filter

The Displace filter warps objects by making the dark parts of the image seem to recede and the light parts seem to project from the two-dimensional surface. Compare Figure 10-43 with Figure 10-44.

Figure 10-43. Zucchini in a farmers market bin.

Figure 10-44. Grasses and leaves have been "wrapped" around the zucchini using the Displace filter and the Multiply blend mode.

Digital Photography: Expert Techniques

The following technique describes how to do this.

1. Open two images: the one containing the object that you want to wrap something around, and the one containing the picture, pattern, or whatever that you want to project onto the surface of the first object (see Figure 10-45).

Figure 10-45. The target image (left) and the image that will be used as a surface texture (right).

2. Activate the image you want to wrap around the target object, choose the Move tool, and drag the wrapping image into the target image. Press Cmd/Ctrl-T to transform the wrapping image to the appropriate size and orientation (see Figure 10-46). Once you've rendered the transformation, close the wrapping image to save working RAM. Your target image now has two layers; before we're finished, there will be more.

Figure 10-46. Use Free Transform to scale and place the texture image over the target image.

3. Next, make your displacement map. You should be able to make a passably good one by creating a transparent layer above the main image and then tracing the outlines of the main shapes in the image. To do this, knock out the target object from its background, save the selection, and press Cmd/Ctrl-J to lift the object to its own layer (see Figure 10-47). (I used the Magnetic Lasso for this shape. If you used a knockout filter that placed it on its own layer automatically, use the Magic Wand to create and save the selection.)

Figure 10-47. The Layers palette after selecting the target zucchini and lifting it to its own layer.

Figure 10-48. A gray-shaded topographical map of the zucchini.

Figure 10-49. The Gaussian Blurred displacement map with a white background.

4. Turn off all the other layers except the one that contains the knockout of the target image. Duplicate the layer by dragging it to the New Layer icon in the Layers palette, and click the Lock Layer icon. Now you can make freehand brushstrokes that define the depth of individual areas. Use a brush that's about 15% as wide as your object and feather it 100%. Place a black stroke around the farthest parts of the object, and white on the highest plane. Place 50% gray along areas that are just about in the middle. Now open the Swatches palette and choose in-between shades of gray to stroke the other depth levels. Figure 10-48 should give you an idea of how this is done. Notice how the edges blend together due to the feathering of the brush, and that the edge of the selection is still sharp because the layer was locked.

5. Now, you want to blur all your strokes together so that they blend seamlessly. Use the Gaussian Blur filter, dragging the blur slider just far enough to the right so that all the strokes blend.

6. Unlock the layer, set your foreground color to white, and use the Paint Bucket tool to fill the transparent areas of the layer with white. See Figure 10-49.

7. Duplicate the image and name the duplicate "*subject displacement map.*" Then flatten the image and save as a .PSD (Photoshop) file in a directory where you can easily find it. You might find it convenient to keep all of your displacement maps in the same folder.

8. Go back to your original image and trash the layer you made the displacement map from. Knock out the object that you want to texture map (e.g., wrap) and raise it to its own layer. Duplicate the image and convert it to Grayscale (Image → Mode → Grayscale). Paint over the closest areas with white, the furthest areas with black, and leave gaps in the in-between areas. Select the silhouette of the object that your texture will be wrapped around, and use the Gaussian Blur filter to blur the back and white just enough that the in-between areas become blurring shades of gray.

9. Go back to your original image. Lift the pattern that you want to use to its own layer or import that pattern from another file. Making sure the pattern layer is active, then choose Filters → Distort → Displace to bring up the dialog shown in Figure 10-50. Make the adjustments needed to indicate the extent of the displacement effect and then click OK. A file browser dialog will appear; navigate to your displacement map, select it from the directory, and click OK. The image will be distorted to reflect the displacement.

10. The distortion won't be obvious. With the wrapping image still the active layer, retrieve your selection (Select → Load Selection), invert it (Cmd/Ctrl-Shift-I), and press Delete/Backspace. Now the wrapping will be much more obvious, as you can see the original background.

11. Now for the refinements that really make this work. Use the Eraser and History Brush to blend the edges of the wrap, and then use the Opacity, Fill, and Layer blend modes to marry the displaced image to the image you want it to cover. You see the end result back in Figure 10-44.

Figure 10-50. The Displace dialog.

Use a 3D program

Your third option is to use a 3D program that can do texture mapping. If you're not already well versed in a professional 3D program, you may want to hire this out to a graphics studio that specializes in these types of effects.

If the image you want to shape is terribly complex, you will need to use a professional 3D modeling program. The best ones, such as Discreet 3D Studio Max, NewTek Lightwave 3D, and Maya's Alias Wavefront, are those made for creating special-effects animations for film and video productions, and are available for many of the high-horsepower Mac and Windows computers. All of these applications are so versatile that learning to use them can involve considerable time and expense, so you may want to hire the work out to an expert. There are also several affordable programs that can do a better job than most Photoshop plug-ins and can be learned with reasonable facility within a week or so. My favorite is Calligari TrueSpace, but StrataStudio Pro is also quite well regarded.

Tip 6: Knock Out Images with Transparent Transitions

You have a portrait of a person wearing glasses, an automobile with windows, or a glass of iced tea that you want to place into a scene (as in Figure 10-51). You already know how easy it is to knock out the object's main silhouette, but how do you get the the new background to show through the transparent parts of the image?

If you want a result like the one shown in Figure 10-52, the best solution is to use Corel Knockout 2 or Ultimatte AdvantEdge on a photograph shot against a solid-color background—preferably knockout green or blue. You can then "peg" the transparent parts of the image (note that the tea in Figure 10-53 is not transparent) so that the program makes the background color inside the image transparent. I won't walk you through this process, as it's different for each product, and you should be able to do it easily enough just by reading the online help.

What if you're in a hurry and don't have time to learn a new program, or you can't afford to buy one of the two programs mentioned above? The following technique shows how to do a passably believable job in Photoshop.

1. Create a duplicate layer, make it transparent, move it under the original, and then erase away the original wherever partial transparency is desired. If you need to change the depth of the transparency, feather the eraser and vary its opacity. See Figure 10-54.

Figure 10-51. The client wanted a glass of tea served with the meal, as well as the latte.

Figure 10-52. Partially erasing the contents of the tea glass allows us to see through the tea.

Figure 10-53. The tea after knocking it out with the Photoshop Extract command.

Figure 10-54. Use the Eraser, set at low opacity, to erase portions of the inserted items layer just enough to make it semitransparent.

2. Alternatively, for larger or more complex transparent areas, click the Photoshop Quick Mask icon and paint any translucent areas with a shade of gray. This will show the background details according to the percent of gray (see Figure 10-55).

3. If you are looking through a transparent object that distorts the background, use the Liquify filter on the background image (see Figure 10-56). You may need to do this even if you've used Knockout or AdvantEdge to get the transparency.

4. If the effect you need is translucency rather than transparency, follow the same procedures, and then go to the background image and select the area that is seen through the transparent knockout. Feather the selection so that it blends with its surroundings and then use the Gaussian Blur filter to blur the image to be completely out of focus.

Knockout and AdvantEdge are the perfect tools for the job only about 90 percent of the time. Either way, chances are you can do the job quite well in Photoshop—it just takes significantly longer and requires more patience.

Figure 10-55. You can click the Layer Mask icon in the Layers palette to add a layer mask to the image you want to see through, click that layer mask to make it active, and then paint inside it with the Brush Options set to a low level of opacity.

Figure 10-56. The Liquify filter can be used to introduce distortion in the area of the background layer that is seen through the glass.

Chapter 10, Creating Fictitious Photos —————————————————————————

Figure 10-57. This background shot gives an overview of the event, but isn't very interesting on its own.

Figure 10-58. This "scrapbook" montage give us a much more comprehensive idea of the farmers market experience.

Tip 7: Use the Art of Collage

Take a good look at Figure 10-57. Perhaps you want to show several more things in the same frame, but the things you want to show wouldn't make sense or be believable as part of the same photo.

The solution here may be to make a collage, as in Figure 10-58. Collage involves putting separate images—even scanned items—together so that the composition is unified, even though the subjects are disparate. Most of the time, the photos in a collage retain their backgrounds—or it is plainly evident that a large part of the background has been removed. Collage can be a great way to tell a story.

The methods presented in this section will be familiar to the experienced digital darkroom technician. The following is a suggested workflow for making a digital collage, and uses several methods of creating borders for the different images. (If you don't want borders, simply skip those steps.)

1. Collect the images that tell the story you want to tell. Some artists start with a sketch and then go out and create all the art; others pull the art mostly from their existing collections or even from prepublished content such as newspaper headlines and brochure photos (see Figure 10-59).

(If you do the latter, make sure you aren't violating copyright laws. Check the catalog for Nolo Press in Berkeley, CA to find several guides to copyright rules.) Digitize the images and move them into a single folder so that they'll be easy to find and track.

2. Create a new document in Photoshop, making it whatever size you'd like your collage to be. You may want to use the Pencil tool to sketch a layout for where you want to put the various images. The layout will need to be exact if you're following a client's specs—otherwise, it will just help you visualize where you will place the various elements.

3. Open each of the image files that will become part of the collage and drag it onto the new document. Each will appear on its own layer; you can use the Layers palette to arrange the stacking order (see Figure 10-60).

4. You should drag images into place in the order that they will appear to be "stacked," so that a given image will be revealed or hidden in the areas that you intend. However, if you want to change the stacking order, simply drag the target layer's name bar up or down in the Layers palette.

Figure 10-59. Save all the images you want to use in the same folder, or flag them in Album or iPhoto so that you can find them quickly.

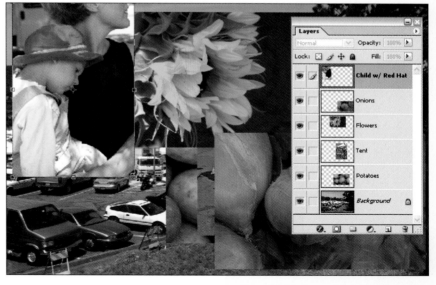

Figure 10-60. Open each individual file and use the Move tool to drag them into the background image's document window.

5. If you want some of the images to have special-effect edges that require processing by a plug-in, run that process before you drag the image into the main target image (see Figure 10-61). You can create your own edge effects using inverted selections and Layer Styles, or by using third-party filters such as Extensis PhotoFrame, Auto FX Software's Photo/Graphic Edges filters, and Dream Suite's frames and depth effects. There are also quite a few public domain Actions that will produce various types of frames, borders, and edge effects. Photoshop framing is covered in some depth in Chapter 12.

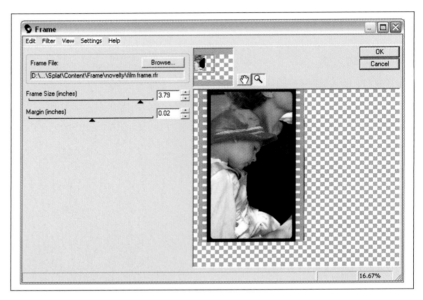

Figure 10-61. Creating an "edge" with the Splat! frame filter.

6. If you need to change the size or orientation of an image, select its layer in the Layers palette and press Cmd/Ctrl-T to surround the layer with a Free Transform marquee. Occasionally, the Free Transform marquee will extend outside the visible dimensions of the image; if you can't see all the handles, choose the Zoom tool, press Opt/Alt, and click until the image is smaller than the document window. If you have Photoshop set up to shrink the image with the window when you zoom out, just drag the corner of the window outward to make it larger than the image. Drag the center handles to stretch or shrink the image in one dimension. Drag a corner handle to stretch or shrink the entire image; Shift-drag a corner handle to resize the image proportionately; Cmd/Ctrl-drag a corner handle to create a perspective distortion. Drag outside the corner to rotate the image. When you finish making your transformation adjustments, click the checkmark in the Options bar to render it.

7. Once you have all the layers sized and arranged, use any of the image editing commands to change such things as the appearance, exposure, color balance, and texture of any individual image. You can also use layer opacity and the layer blend modes.

You may also want to make the layers transition (fade or dissolve) among themselves (see Figure 10-62). You can either brush in those transitions with the Eraser brush (set the opacity and feathering you desire in the Options bar) or you can create a layer mask that is partially filled with a gradient or texture. To do that, refer to the Use Layer Masks sidebar to get the basic shape for the layer mask. Then go to the Channels palette and find the channel that contains the layer mask. Select its name bar, and you will see its grayscale image in your document window. You can then fill part of it by making a selection and filling it with a gradient, or by painting in shades of gray to change the apparent opacity of the layer in specific areas.

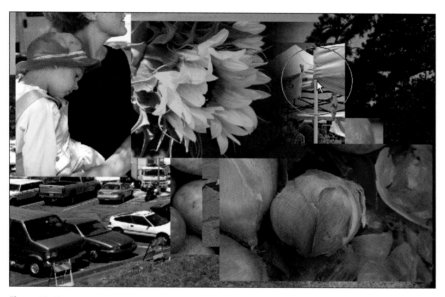

Figure 10-62. The sunflower image is made to "transition" (fade) into the images beneath it by using a low-opacity Eraser tool.

EXPERT ADVICE

Use Layer Masks

You can use layer masks even in Photoshop Elements. There may be times when you want to have the option of keeping the original background for something you are compositing or montage-ing into another picture. In this case, the solution is to do the knockout with a layer mask. To create a layer mask, use whatever selection process you deem appropriate to your subject. While the selection is still active, choose Layer → Add Layer Mask → Reveal/Hide Selection. Now the mask will always stay with the layer, even if you move or transform it, and you can turn it off whenever you want to see the unmasked part of the image.

Color Printing

11

Digital photo printing has become very popular in the past year. This chapter discusses how to get state-of-the-art prints from your in-house printer, or, at the very least, a very close approximation of what you see on your monitor. We'll also discuss workflow planning and how to select papers and inks.

Getting Started

There are four topics that we need to discuss to get you started: resolution, color management systems, and monitor and printer calibration.

How much resolution do you need?

To get the right resolution for the size of the print you plan to produce, you must first understand several realities:

Printer resolution and image resolution do not have a direct correlation. The printer resolution describes the number of dots that the printer will apply *regardless* of the resolution of the original image. You can force a correlation between image resolution and print resolution in Photoshop's Image Size (Image → Image Size) dialog, but doing so will not actually improve the amount of detail shown in the image. An inkjet printer does not match every pixel in your image to an individual ink droplet on the paper.

Digital images don't have grain. Digital images may have imaging artifacts (noise), and very high resolution scans of film will show the grain of the film, but enlarging pixels will only make their square edges more visible, and even then only if you don't use bi-linear or bi-polar sampling. This is why the sharpness of the lens that takes the picture is so important, and why image enlargement, noise reduction, and edge sharpening techniques and software can be crucial.

How much definition you need also depends on how far the viewer will be from the print. The larger the print (or other output such as digital projectors and HDTV plasma screens), the more likely we are to move farther away from them. The standard equation for the ideal viewing distance for a print is 1.5 times its diagonal dimension. According to that formula, the typical viewing distance for an 8 × 10 inch print would be about 20 inches, and about 9 feet for a 40 × 60 inch print.

So, using the Pythagorean Theorem:

$$8^2 + 10^2 = (\text{diagonal})^2$$
diagonal = 13.42 inches
ideal viewing distance = 13.42 × 1.5 = 20.12 inches

$$40^2 + 60^2 = (\text{diagonal})^2$$
diagonal = 72.11 inches
ideal viewing distance = 72.11 × 1.5 = 108.12 inches = 9.01 feet

Recall from Chapter 1 that you need *at least* three megapixels of camera resolution for professional-looking 8 × 10 prints. If you have more than six megapixels, you have plenty of resolution for a print of any size, provided that the success of your concept isn't dependent on extremely accurate detail (such assignments typically include landscapes, architecture, food, and some scientific photography). As a rule of thumb, if 35mm film is acceptable for the assignment, six megapixels should work just fine—unless you were doing your 35mm work using lenses that cost over $1,000 and super-high-resolution professional film rated at ISO 100 or less. You will need between 10 and 14 megapixels of resolution if detail is so important that you feel compelled to shoot with a medium-to-large format camera. A few professional 35mm-type digital SLR cameras currently fall into that category: the Canon 1Ds, the Kodak 14n, and the Fuji S2 Pro. It's a good bet that there will be more of these cameras, and at affordable prices, before this book hits the stands.

Believe it or not, your printer will print a perfectly acceptable looking print from an image of much lower resolution than the printer would normally specify. At the very least, I can say that you're likely to be surprised at the quality of print you will get from an image sized to 8 × 10 inches that has only 72 dpi of image resolution—nominally 1/10th of the 720 dpi that most of today's inkjet printers print at.

So, how much resolution you need for a given size print? I prefer to use one of the more sophisticated resampling methods to make the image equivalent to about one-third of the printer's base resolution. Why? The 3:1 ratio is used because the printer's resolution is based on the total number of dots printed, but it's easy to forget that it takes *at least* three of those dots, printed more-or-less atop one another, to produce one area of color. The fact that some printers use as many as seven or eight different colors to produce a single area

makes for more accurate color and more continuous transitions in shaded colors, but it has no relationship to the resolution required of the original.

Printing at higher dots-per-inch resolutions puts more ink on the paper, which accomplishes two things: first, it becomes harder to see the individual color dots, and second, color depth feels richer and deeper because more ink is sitting atop the paper and it becomes less transparent. Ideal image resolution for fine-art printing is around 300 dpi. However, popular inkjet photo-printers won't show significant improvement at image resolutions over 240 dpi, regardless of how high the stated resolution of the printer is.

So, let's assume that we have a standard inkjet photoprinter printing at 240 dpi with each of those dots composed of three primary-color dots from the printer. Table 11-1 shows some common resolutions that we would need.

Table 11-1. Required image resolution with a 240 dpi photoprinter

Image size	Resolution pixels needed to print
4 × 6	960 × 1440
5 × 7	1200 × 1680
8 × 10	1920 × 2400
11 × 14	2640 × 3360
16 × 20	3840 × 4800

There are techniques you can employ prior to using Photoshop's Image Size dialog that can have a very beneficial effect on the *illusion* of higher resolution. For example, you can try resizing, dFine, Extensis pxl Smart Scale, the 110% enlargement method, the Fred Miranda DRI Actions, PrintShop Pro, nik Sharpener Pro, Power Sharpen, High Pass, and Unsharp Mask Pro.

Some photographers may question the concept of the "illusion of high resolution," arguing that the job of the photographer is to record reality. However, it is my belief that the job of the photographer is to show others what you perceived as or wished to be reality when you recorded the scene. Of course, some types of photography, such as legal work and reportage, should restrict the degree to which you should bend reality, but even then, the medium we are working in is an interpretative one.

Always use the best quality lens you can afford, as it will make a bigger difference in the perceived resolution of your image than will the actual resolution of that image (at least until the resolution is significantly higher than six megapixels). If your camera has options for sharpening the image, turn them off unless you have to immediately send the image elsewhere (in that case, go by the client's rules). The reason you want to turn camera sharpening off is that Photoshop and other software gives you much more flexible and powerful sharpening tools, as well as control over what gets sharpened and what doesn't.

Understand the nature and importance of color management systems

Your eyes and mind can see or "add up" an almost unlimited range of color and brightness. A good digital or film camera can record an impressive amount of that range; your monitor can display somewhat less; and your printer, no matter how good it is, can see only a fraction of the colors that your monitor displays. So, in order to get an image on paper that resembles what you saw when you took the photograph, you're using a series of devices that each displays fewer colors than the previous one. At each step, you need to translate those limited colors into an image that, in the mind's eye of the viewer, resembles the full range of color in the original.

In order to get each downward translation right, you need to use a color management system (CMS). For example, Figure 11-1 shows the Adobe Gamma color management system and Figure 11-2 shows the ColorVision Spyder hardware and software kit, both useful tools for calibrating your monitor.

There are basically two kinds of color management systems: pure software, or—if you expect more accurate results—a combination of digital color measurement hardware and software. Both create something called a profile. All profiles have to meet the standards set for a color management system. Today, there are essentially two color management systems: ICC for Windows and ColorSync for the Macintosh For the end user, it doesn't matter much whether you are using one or the other—the steps you take will be essentially the same. Besides, ICC (International Color Consortium) also defines the standards for Apple's ColorSync.

The difference in the way a monitor, camera, or scanner image looks and the way that printed output looks isn't entirely due to the difference in color range, either. Another problem is that cameras, monitors, and scanners use a transmissive color scheme in which the primary colors are Red, Green, and Blue (RGB). Printers, printing presses, and other devices that provide portable hard copy use a reflective color scheme in which the four primary colors are Cyan, Magenta, Yellow, and blacK (CMYK). If you look at the primary colors for RGB next to the prima-

Figure 11-1. Adobe gamma, the starting point for a manual color management system.

Figure 11-2. ColorVision Spyder kit and OptiCal manual.

Not Just Apples Anymore

By the way, the advent of an industry-standard color management system was fully realized only recently with Windows XP (and to a lesser extent with Windows ME and 98), so don't be surprised if some Mac users tell you that only Macs are capable of full-system color management.

ry colors for CMY (the black is used only to create a credibly neutral shadow density), you'll find it even more amazing that today's CMSes can reconcile those different colors to produce an image on paper that so closely matches what your camera recorded.

Before standardized color management came along, imaging professionals simply had to keep experimenting with the settings for different combinations of camera, scanner, monitor, printer, and printing press. There were measuring instruments, but they were so expensive that only enterprises doing enough volume to justify the cost (or amateurs who had just won the lottery) could afford them. Today, you can buy a full-system (camera, scanner, monitor, printer) CMS, complete with instruments for making the measurements to compare color interpretation between one device and another, for less than $600. And the prices continue to fall as the accuracy and ease-of-use keep getting better!

WARNING ————————————————

Up until very recently, the weakest link of color management systems has been the increasingly popular LCD flat-panel displays. Now, however, most LCDs made for desktop use and all of those made for Mac laptops can now be calibrated—provided you have a monitor calibration system that uses a colorimeter that can be placed over an LCD monitor without resorting to suction cups (which can severely damage an LCD screen) and that the screen can "filter" the LCD display so that it looks to the colorimeter like a CRT display. Today, the most recent models from ColorVision, Monaco Systems, and ITEK all meet this requirement. If you do use an LCD screen, choose one with a brightness range of 500:1 or better and do not attempt to use a colorimeter that was made strictly for calibrating CRTs—it won't work and could damage your LCD screen. Also, all of the companies just mentioned offer older colorimeters that do not work on LCDs, so make sure you buy the most up-to-date model. The other problem with LCD screens is that most have a very narrow angle of view in which color relationships appear as they are intended to appear. That is to say, the brightness of different colors changes as you view the screen from different angles.

Calibrate the monitor

Instituting a color management system always starts with calibrating your monitor. This is the only way to find out whether the images produced by incoming devices such as cameras and scanners will need further adjustment in order to look as you want them to. It also allows you to confirm that the image on your monitor will look very much like what comes out of the printer or printing press or what comes up on the web site or in the PowerPoint presentation. The following sections show you how to accomplish each stage of color management.

If your monitor isn't properly adjusted to show a standardized color balance and brightness range (gamma), it will be impossible to judge whether what

Figure 11-3. The contrast adjustment screen in the Adobe Gamma Wizard.

Figure 11-4. The Monaco Optix colorimeter and software.

you see on your monitor will bear any predictable relationship to what others see on their monitors or to what comes out of your printer. You can calibrate your cameras and scanners, but no matter how well you do that, you'll still want to make adjustments to the resulting images. Only by getting consistent output from your monitor can you hope to see the results you want from your editing adjustments when you send the image elsewhere or print it out. Monitor phosphors and settings vary so widely that it is highly unlikely that what you see on your monitor will even vaguely resemble what you get from your printer or printing house. Properly calibrating your monitor will ensure that what you see is what you get.

Figure 11-3 again shows the Adobe Gamma Wizard. Figure 11-4 shows another hardware/software combination, the Monaco Optix colorimeter and software. Both are excellent tools for calibrating your monitor.

I'll provide you with techniques for calibrating your monitor for both Mac and PC, and for doing so both manually and with the use of a spectrometer and software as an example of a more accurate instrument-based method of establishing monitor calibration. Either way, the process takes only a few minutes and will save you a lot of grief.

Calibrate manually using Adobe Gamma or Monaco EZcolor

> **WARNING**
>
> *Manual monitor calibration will not work optimally on most LCD monitors, as they don't have manual brightness and contrast controls. Still, some adjustments (especially color and profile adjustments) may be better than none.*

If you haven't done anything to calibrate your monitor, you should at least do it manually before the next time you do image editing. If you're using an Adobe graphics product, you probably already own Adobe Gamma. Furthermore, if you're running Windows 2000, 98, Me, or XP or working from a Mac, the software calibration will apply *systemwide*. That is, you'll be calibrating your monitor for all applications running on that system.

To use Adobe Gamma, go to the Windows Control Panel or the Mac Desktop and click the Adobe Gamma icon. The Adobe Gamma dialog will ask if you want to use the

Setting Up Your Workspace

Your work area for editing and printing photos needs to be large enough to hold the following: two monitors, a pressure-sensitive digitizing pad, and a printer that can make 16 × 20 or larger prints. Of course, you may not have all this stuff right now, but planning ahead will pay off when the time comes.

Pick a space with windows that you can darken. It may be lovely to sit and look at the lake or the skyscrapers while you're working, but too much light ensures difficulty in seeing an accurate picture on your monitor. When you're adjusting the image on your monitor to match the image that should come from your printer, the room light should be just bright enough to read by. Make sure that the lightbulbs are daylight-balanced, too.

Of course, nobody wants to work in the dark all the time, and you will need lights bright enough to judge the quality of the prints after they come out of the printer. You might try those Quartz-Halogen daylight-balanced lamps that have a dimmer; this way, you can brighten the lighting when you're reading, doing paperwork, or organizing your workspace. Or, you could simply raise the window shades when you don't want to be working in a darkened room.

It's also important to keep your walls in neutral colors. White is OK, but can cause reflections on the surface of your monitor. A neutral gray is peaceful, not too dingy, and doesn't reflect colors onto your monitor that can ruin your judgment.

By the same token, you should also keep a gray artist's smock handy; you can get one at any large art supply store. Your body is likely to reflect color into the monitor, neither bright white shirts nor loud colors are a good idea. If you don't have a smock, a gray shirt or sweater can work just as well.

Speaking of being on a budget, if you can't afford to entirely rearrange and ideally equip your digital photo lab, just go to a fabric store and buy enough black felt to cover the windows. Then simply hang the felt over the windows when you're doing critical image adjustments and monitor calibration.

Wizard or the Control Panel. If you've never done this before (or just like to keep it simple), choose the Step by Step Wizard. Next, perform the first step in almost any monitor calibration routine: turn your monitor's contrast control to its highest setting, and then adjust the center box to be just barely bright enough to be visible. I won't take you through each step in the routine—the program coaches you through each step and makes it totally painless. However, I will point out a few things you need to know in advance.

- When you are asked to choose your monitor phosphors, just look on the list for your make and model.

- When you are asked to adjust the color, do it in the dark if possible. If you can't get the room dark, just drape a dark, heavy blanket over the monitor and stick your head under it. The idea is to make sure that ambient light and reflections don't influence your color judgment.

Adobe Gamma

Several calibration software programs depend on the profile used by Adobe Gamma, so it's a good idea to at least do the Adobe Gamma calibration to set your monitor to a wide-gamut profile, such as Adobe RGB. The much narrower sRGB standard is often used as a default because it is a better "lowest common denominator" for web images.

If you don't have Adobe Gamma, your image editing software probably comes with a similar utility. If you don't want to invest $200 to $600 in a colorimeter for instrumental calibration, one sure bet is to use Monaco's EZcolor software (*www.monacosys.com*). This gives you the added bonus of being able to move up to using a colorimeter when you can afford one, and you will already have a good understanding of how to use the software.

Manually calibrating your monitor using Monaco EZcolor is nearly identical to using Adobe Gamma. The design of the wizard is a bit more dynamic and colorful, and it is easier to set the brightness control properly. As with Adobe Gamma, the big advantage is that you can use this software to profile your entire color management system, and to "grow into" instrumental monitor calibration. The EZcolor software lists for just under $300, and its companion Monaco Optix colorimeter sells for the same price. You can also get the two bundled for a $100 savings.

> **WARNING**
>
> *Be careful not to have manual calibration software running at the same time as a profile made with a colorimeter. You should be able to find complete instructions for uninstalling or turning off manual calibration on the manufacturer's web site. For information on disabling Adobe Gamma, go to www.adobe.com/support/ techdocs/13252.htm.*

Calibrate with a colorimeter

Instrumental monitor calibration is even easier than manual calibration. The three big advantages are:

- It's faster.
- It's less subjective and doesn't depend on the lack of ambient light for consistency.
- It's much more accurate because the interaction between the instrument and the software actually controls the color output to the monitor from the color card.

Instrumental monitor calibration has only recently become affordable outside of prepress print shops. Both the highly regarded Pantone/ColorVision Spyder with OptiCal software and Monaco Optix can currently calibrate either LCD or CRT displays. The operating procedure for both devices is similar.

1. Start the software and set the brightness and contrast levels for the monitor just as you would in Adobe Gamma or Monaco EZcolor.

2. Attach the colorimeter to the monitor according to some very simple instructions, and click a button to tell the software to start reading and adjusting the monitor.

3. Go have a cup of coffee. By the time you take the last sip, the software will have finished the job and asked you whether you want to give a name to the profile or accept the default.

Make a strict habit of calibrating your monitor at the beginning of your work week. In the meantime, turn on your computer and monitor, answer your emails and check your appointment calendar and to-do list. If it's still not done yet, have another cup of coffee. You want to give your monitor phosphors time to reach their normal brightness and saturation. Then stick your colorimeter onto your monitor and run the software. It's the best assurance you can give yourself that what you see on your monitor is what you can expect when you publish your pictures.

Calibrate the printer

Every printer model and ink set interprets color in a different way. The only way you can be reasonably sure that the print you get will look like the image you prepared in Photoshop is to calibrate the printer for the particular set of inks and paper that you will use to make that particular print. (By the way, it's often a good idea to use a test image, such as the ones in Figure 11-5.) Then the monitor calibration profile and the printer calibration profile can be matched so that what you see on the monitor is what you get on paper. Figure 11-6 shows the Monaco EZcolor printer calibration dialog.

In this section you'll learn the significance of accurate printer profiles, where to find prepublished profiles if they exist for your printer (highly likely if you've bought a name brand), and how to install them for your OS and image editing software (with Photoshop 7 used as the benchmark). You'll also learn how to make your own printer profiles by using either trial-and-error or profiling kits.

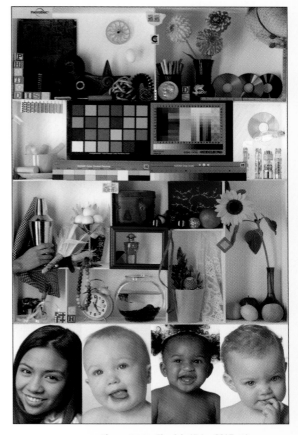

Figure 11-5. The ColorVision PDI Test Image, available from PhotoDisc, is an excellent example of the kind of test image you should use to calibrate manually.

Figure 11-6. The Monaco EZcolor printer calibration dialog.

EXPERT ADVICE

Profiles, Profiles, Profiles

I mentioned this earlier, but it bears repeating: you need a different profile for each combination of printer, ink, and paper. Of course, this is a good reason to limit paper/ink options to a few combinations that cover a wide range of your needs. The problem comes if you're working for a client that prefers an ink-and-paper combination that is different from the one you're used to. In that case, either buy the right profile or learn to make profiles yourself.

Purchase or download a profile

If you don't want to make your own profiles and need to get acceptable prints with a minimum of fuss, check around for a supplier who will sell you a profile for an ink-and-paper combination that you find acceptable for your subject matter. Then buy both the ink-and-paper combination and the profile from the same source, as one vendor's supplies may differ slightly from another's if they were purchased at different times or came from different batches.

The drawback to purchasing profiles is that the cost can add up quickly, as you need a different profile for each ink-and-paper combo. Worse, profiles are often available only in sets, so you may have to pay for profiles that you don't really need. For instance, the profile libraries at *www.inkjetmall.com* sell for $175 each, and each library consists of a set of profiles for a specific ink and printer that covers several choices of papers. The library that supports the Epson 1270 printer and Epson inks includes 42 different papers from a variety of manufacturers. As you can see, if you had several printers and used several different ink sets, purchasing profile libraries could run you thousands of dollars. To be fair, there are individual profile downloads for about $25 each, but the choices are limited to only a few of the most popular combinations.

Some notes:

- Some paper-and-ink companies will give you free profiles, or you may be able to find some on user group sites. Just be sure that free profiles aren't the only reason for choosing a particular paper/ink combination.

- If you buy your favorite combination from two different manufacturers, you aren't likely to find a free profile unless that combination is so popular that someone has posted it on a user group.

- The biggest problem with other people's profiles, however, is that they're (obviously) created by other people. Since each of us has subjective ideas about color, contrast, and lighting, what works for someone else (no matter how expert) will seldom work as well for you as something you've created yourself.

Make your own profile

Once you've calibrated your monitor, find a test chart that shows a typical image and a set of standard colors. You can make up your own test chart by creating a screen-size file that includes most of the basic colors in the Swatches palette for your OS, a grayscale chart that progresses in 10% gray level increments, and a photograph of something colorful.

Then do the following:

1. Open the calibration image on your calibrated monitor, choose the printer you want to print on, load a sample of the paper you want to print on, and print it.

2. Install a light source next to your monitor that is the same color temperature as your monitor. (You should be able to get monitor color temperature from your monitor's manual or from the manufacturer's web site, and the bulbs from a large photographer's supply house such as B&H Photo or Samy's Camera). Place the print next to the chart displayed on the monitor.

3. The rest of this process is intended to make the printer's output match what you see on-screen in the color chart. Start by using the printer adjustments in Photoshop. Choose File → Page Setup to bring up the dialog shown in Figure 11-7. Choose the name of the printer you want to profile from the Name pull-down menu, then click the Properties button. The printer's setup dialog will appear (see Figure 11-8).

4. From the Media pull-down menu, choose the paper with the surface that's closest to what you'll be printing on. If you're printing photographs using an Epson 1270 printer, use Premium Glossy Photo paper or Matte Paper – Heavyweight. If you're using another printer make or model, the choices will be different. The paper you're actually using may not be listed if it's from a third-party vendor or is of a later generation than the papers supported by your printer. In Quality Setting, choose Best. In the Color section, choose Color only if you are not printing a black and white image. Duotone images and toned images count as Color images.

Figure 11-7. The Page Setup dialog.

Figure 11-8. The printer's setup dialog.

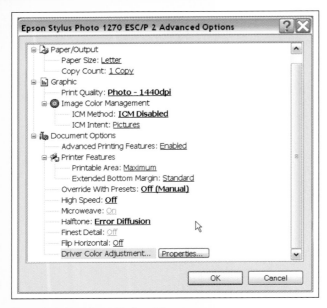

Figure 11-9. The Advanced Options dialog.

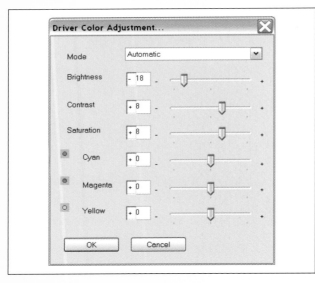

Figure 11-10. The Driver Color Adjustment dialog.

5. Now we come to the most important part. Click the Advanced button to bring up the Advanced Options dialog (see Figure 11-9). Each underlined item in this dialog opens a pull-down menu. First, choose your paper size; half-letter is usually big enough for a test like this. Choose 1 for the Copy Count. Select the highest available resolution for print quality (it usually results in richer colors), unless you have printed on a paper that is uncoated—uncoated papers tend to cause dots to spread, and too much ink can exacerbate the problem. From the ICM Method menu, choose ICM Disabled. For ICM Intent, choose Pictures. Advanced Printing Features should be Enabled. Since you probably want your picture exactly centered on the page, choose Maximum for Printable Area and Extended for Extended Bottom Margin. Override with Presets should be off, High Speed should be off, Halftone should be Error Diffusion, and Flip Horizontal should be off. Finally, click Driver Color Adjustment to bring up the dialog shown in Figure 11-10.

6. From the Mode pull-down menu, choose Photorealistic. You don't want to make any other driver color adjustments until you see how the default settings compare to the soft proof of the test chart on your monitor, so just click OK for this dialog and for all the other open dialogs.

8. Now you're ready to make your first test print. It will be most informative if you use the Print with Preview command. You can either choose File → Print with Preview or Cmd/Ctrl + P. The Print with Preview dialog is shown in Figure 11-11.

9. In the Print with Preview dialog, you will see a bounding box for your image. If the image isn't precisely centered on the page, check to make sure the Center Image box is checked. The Scaled Print Size should be 100% because it might make it easier to judge the intensity of inks, especially in the midtones. From the Print Space menu, choose the profile for your printer (if one is installed). Click the Print button.

Figure 11-11. The Print with Preview dialog.

10. When your print is done, hold it next to the monitor under that light you just installed. Don't aim the light at the monitor, and don't make it so bright that the white of the paper is whiter than the brightest white on the monitor. Now you should be able to accurately judge how close your print is to the soft proof on the color chart.

11. Now let's make the proof print match the soft proof on your monitor. Do this by repeating steps 1 through 4. However, when you reach step 5, this time move the sliders to adjust for the differences between the last printed proof and the soft proof on the monitor. Then print the result and make another comparison to the soft proof. I typically start by leaving the individual color sliders alone and guessing at the compensation needed for Brightness, Contrast, and Saturation. I then print, compare that print, and repeat the process until I'm as close as possible to what I want using just those three adjustments. I then start fine-tuning for color balance, changing only one color slider per print.

12. When you like what you see, save the profile so that you can easily repeat it for other images. Choose Image → Mode → Convert to Profile to bring up the dialog shown in Figure 11-12. From the Profile menu, choose Custom RGB and enter a name that describes your printer/paper/ink combination in the resulting dialog (see Figure 11-13). The other settings should already be the same as your original profile and whatever adjustments you've made, so just click OK.

Figure 11-12. The Convert to Profile dialog.

Figure 11-13. The Custom RGB dialog.

Use a traditional profile maker such as Monaco EZcolor

The two profiling kits I'm specifically recommending here, Monaco EZcolor (*www.monacosys.com*) and ColorVision PrintFIX (*www.colorvision.com*) are both accessibly priced (under $500) and have a reputation for producing decent results.

Monaco EZcolor is the best route to take if you need one piece of software that can be adapted to a variety of situations and devices. It can profile cameras, scanners, monitors, and printers. It's been around for a while (the current version is 2.5), and you can upgrade from any older version, such as the one that comes bundled with many Epson printers.

The method described here shows you how to use EZcolor to create a printer profile. However, it also has the capability of calibrating monitors in a manner similar to ColorVision's Spyder and OptiCAL.

To create the printer profile, you first have to create a scanner profile for your flatbed scanner. EZcolor can also profile film scanners, but that requires you to purchase a separate target, and you'll still need to profile a flatbed scanner in order to create a printer profile. Profiling a film scanner is similar to profiling a flatbed, and the program comes with documentation, so we'll only cover profiling a flatbed in this section.

Digital Photography: Expert Techniques

Here's how you'd typically go about creating a printer profile using Monaco EZcolor 2.5:

1. Power on your printer and load the paper you intend to use. Remember, you have to make a different profile for each printer/paper/ink combination. Be sure to make note of the combination.

2. Open Monaco EZcolor, select Create Printer Profile, and click the Next button. Choose RGB as the printer type you plan to output to and click Next. Now, click Print. The Print dialog will appear, as shown in Figure 11-14.

3. From the pull-down menus, choose the following: the paper you will be printing on; the resolution you will be printing at; Auto Color Correction options off (see your printer manual if necessary); and 100% as the size to print the target. Be sure to write down all these settings so you can refer to them later. In the "Print a Target" dialog, click the Next button. Now save the printer target file as a TIFF file.

Write Things Down

I typically use the base word processor on my operating system to create a file called "profile notes" that contains all the settings for all my profiles.

Figure 11-14. The EZcolor Print dialog.

Figure 11-15. The MonacoEZcolor "Prepare to Scan" dialog.

Figure 11-16. The Select Reference File dialog.

4. Attach the IT8 target that was supplied with EZcolor to the target you just printed. If you have other targets, don't use them—they won't work. Let the printed target dry in the dark for an hour or so, then place the attached targets on your scanner and click the Next button. The Monaco EZcolor dialog for preparing to scan will appear (see Figure 11-15)

5. Choose the TWAIN or Mac driver for your scanner. (Note that a few scanners are incompatible with EZcolor, but the program gives you a workaround if that is the case.)

6. Set the scanner resolution at 200 dpi. Turn off all color correction and management options in the scanner driver's dialog. Take note off all the scanner settings that stay in effect so that you can make sure they are consistent from one profile to the next.

7. Prescan (preview) the targets and then crop them to exclude all whitespace.

8. Click the Scan button and scan the targets. EZcolor will display a thumbnail of the scanned targets. Make sure the scan is straight and properly cropped. If it's not, reposition, recrop and rescan. When you've got it right, click Next. The Select Reference File dialog will appear (see Figure 11-16).

9. Locate the proper reference settings in the Select Reference File dialog; you'll have to refer to the EZcolor manual for directions for locating these files on your particular OS version. EZcolor then asks you to confirm a variety of settings for cropping, straightening, scan resolution, etc. Once you've done that, you can name and save the profile that EZcolor will automatically generate during the printer profiling process. You can name the profile whatever you want, but you'll probably want to use something that describes the printer, model, paper type, printing resolution, and date in some kind of understandable shorthand. EZcolor also gives you the option to save the scanner profile that was automatically created by this process.

Use ColorVision PrintFIX

The problem with most printer calibrators is that you also need to have a calibrated scanner. If the scanner is reset, you risk getting unreliable results. What sets PrintFIX apart is that it comes with its own scanner that is dedicated to doing nothing but reading a test chart printed on a given printer with a given ink and paper set, and automatically creating a printer profile that will honor the soft proof on your calibrated monitor. Since that's the scanner's only job, it becomes an easy, quick process. Another thing that differentiates PrintFIX is that it runs right inside Photoshop as an Import plug-in.

Here's how it works:

1. Open Photoshop and choose File → Import → PrintFIX. From the PrintFIX dialog, choose the ColorVision color chart for your specific printer (see Figure 11-17). This is a very specific color chart that is sized and resolved for the small scanner that comes with PrintFIX (see Figure 11-18).

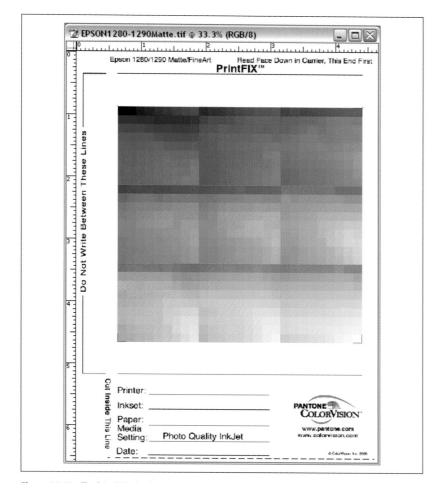

Figure 11-17. The PrintFIX color chart.

Figure 11-18. The PrintFIX Patch Reader scanner.

Figure 11-19. The PrintFIX dialog.

2. Choose File → Print with Preview and go through the routine you normally use to choose your printer, print size, paper type, and other settings (some printer- and model-specific settings are recommended in the PrintFIX documentation).

3. When the chart is printed, remove it from the printer and trim it precisely to the dotted lines indicated in the print.

4. Follow the short routine recommended for cleaning and calibrating the Patch Reader scanner.

5. Insert the print in the holder made for the Patch Reader and place it in the scanner slot.

6. Choose File → Automate → PrintFIX to bring up the dialog shown in Figure 11-19. Don't change any of the default settings in the dialog.

7. Click the Read Patch Reader button. The scanner will read the calibration chart and display the result in Photoshop. Crop the result so that only a narrow white margin is visible around the color chart.

8. Choose File → Automate → PrintFIX. This time, when the PrintFIX dialog appears, choose Build Profile from the pull-down menu. Leave all the sliders at their defaults and click OK. When the Save As dialog appears, name your profile with a name specifying the printer, paper, and ink combo, and perhaps a six-digit date or a version number to distinguish it from profiles made at other times.

9. Close Photoshop and reload it so that the profile you just saved will appear when you need it in the next step.

10. You'll now make a test print. Load the PDI Test Image, which is an excellent image to use for making your first print because if you can match all of its content, then virtually any image should match.

11. Choose File → Print with Preview, and be sure that Show More Options is checked in the resulting dialog. From the Show More Options pull-down menu, choose Color Management. Choose the Document radio button and then select the profile you just created from the Profile menu. From the Intent menu, choose Saturation.

12. Click the Page Preview button. When the first Page Setup dialog appears, click the Printer button. When the second Page Setup dialog appears, click the Properties button. In the printer's setup dialog (see Figure 11-20), choose any matte paper available on the Media menu, and choose the Best and Color radio buttons. (You may also want to adjust some of the Advanced settings.)

13. Click as many OK buttons as it takes to get you back to the main Print with Preview dialog. Click the Print button; the second Print dialog will appear. Click the Print button.

14. When the chart is printed, let it dry for at least five minutes. Then take it over to the monitor and compare it to the original.

15. Fine-tune your adjustments if necessary.

Use a software profile maker such as ColorVision's DoctorPRO

Trying to match color charts by entering numbers in a traditional profile making application can seem pretty counterintuitive, especially to those of us used to making all of our adjustments on the fly using traditional darkroom techniques or the Photoshop commands that emulate them. Happily, there is a brand-new tool from ColorVision that records your adjustments and then has Photoshop apply them to a profile so that any image you print subsequently can use the same adjustments. It's not the most precise method for creating a profile that works well on every image, but it sure is a godsend when you want to cut the number of needed test prints for those images that just seem to work better when you tweak them manually. It's also a lifesaver if you just don't have the discipline required for using a traditional printer profiler. You can use DoctorPRO to tweak a profile you've already created (for instance, with ColorVision's PrintFIX) or any of the existing profiles in your system.

Here how to use DoctorPRO:

1. Install the software and restart Photoshop.

2. DoctorPRO requires lots of RAM, so you should be using a system with at least 512 MB. In Photoshop, choose Edit → Preferences → Memory & Image

Figure 11-20. The setup dialog for the Epson 1270.

> **EXPERT ADVICE**
>
> ## Always Use Matte
>
> When using PrintFIX, always choose a matte paper in the printer's setup dialog, regardless of the paper you are actually going to print on. The surface differences of other papers are automatically taken into account as a result of the scan.

Figure 11-21. The Photoshop Memory & Image Cache dialog.

Figure 11-22. The DoctorPRO dialog.

You Must Restart…

As you've probably figured out by now, you have to quit Photoshop and restart it whenever you create a new profile. Otherwise, it won't show up in the Profiles menu when you try to apply it.

Cache and enter at least 75% as the maximum amount of RAM used by Photoshop (see Figure 11-21). You should also make sure that all applications other than Photoshop are closed.

3. Open the image that you want to create a new profile for, open the Actions palette, and create a new action. Name it something like "DoctorPRO *Profile Tweak*" where *Profile* is the name of the monitor calibrator or printer profile that created the image you are going to alter and *Tweak* is an abbreviated description of how you made the adjustments. You can use any Photoshop image-adjustment command in this action. When you've finished making the adjustments, stop recording the action.

4. Making sure that the name of the action is selected in the Actions palette, choose File → Automate → DoctorPRO to bring up the dialog in Figure 11-22.

5. Select the DoctorPRO radio button and choose the name of the profile you want to modify (this could be your printer's native profile or one you created). Choose the printer's color printing mode (RGB for most inkjets) and click OK. A DoctorPRO image of a horse will appear (don't ask why it's a horse—I have no idea) as well as a Save As dialog that opens the folder where your OS keeps its color management profiles. Create a new profile name that incorporates the name of the profile you are modifying and its intent. Finally, click the Save button.

6. Close Photoshop, reopen it, and open the image you want to print with the new profile. Choose File → Page Setup. When the Page Setup dialog appears, choose the printer and the advanced printer settings that you normally use for this paper and ink combination.

7. Choose File → Print with Preview. Make sure the Show More Options box is checked, set your Source Space as Document, and choose the profile you saved from DoctorPRO from the Print Space Profile menu.

8. Verify that your other printer settings are set for the correct paper size, media, number of copies, and so forth. To print the now correctly profiled image, click OK.

Be sure to recalibrate each particular ink-and-paper combination whenever you get an unexpected result. Large manufacturers sometimes buy their supplies from more than one source or "improve" the formulation as they gain experience with it. Also, the materials themselves may interact in different ways because of the influence of atmospheric chemicals, storage temperature, and the plain fact that nothing really stays static over time.

Tip 1: Take Good Care of Your Printer

Modern printers are usually so rugged and trouble-free that it's easy to forget that it only takes a little bit of dirt in the wrong place to streak your prints beyond viability. Figure 11-23 shows what you don't want your printer to look like. Why? One little clog in a print head can cause results that are equally unacceptable, and sometimes maddeningly mysterious.

A few precautions and routines can save you hours of grief and embarrassment. (For example, Figure 11-24 shows what a simple cover can do.) Here are some simple things you should get into the habit of doing:

- Make sure the paper is loaded properly.

- Make sure the cartridges are installed properly.

- Don't use printer cartridges made by companies you never heard of. The colors aren't likely to match the OEM colors, and print heads may clog.

Figure 11-23. A cluttered and uncovered printer.

Figure 11-24. This cover, a large kitchen wastebasket bag, costs only pennies, fits all desktop printers, and is easily replaced if soiled or torn.

- Do your research. Make sure that plenty of other people have good things to say about the printer cartridges or buy them from a company with a very good reputation.

- Keep your printer covered. Most printer manufacturers will sell you a dust cover; in a pinch, just throw a towel over the machine. Otherwise, you may see prints with stripes running down them, or streaks from print heads that have been blocked by dirt. It's harder to clean inside printers than it is to vacuum keyboards or wipe monitor screens.

- Keep the nozzles clean and run a nozzle check. All printer manufacturers include a software utility that you can use to check whether the nozzles are clogged (see Figure 11-25), and a routine that will clean any clogged nozzles. If the printer has been unused for more than a couple of days or if you're using third-party or pigmented inks, it's a good idea to run these checks using plain paper before you start any serious print job.

- Don't use paper that is too thick or rough. Some art papers and canvases, especially if they are quite thick, can scrape against the printer heads and cause severe damage. Permanent print heads, such as those used in Epson printers, can be costly to repair.

Figure 11-25. The Epson Utilities dialog lets you do a nozzle check.

When Things Get Inky

Occasionally you may forget to set the proper print size in your printer software and end up making a print that is larger than the paper. This can leave considerable ink residue inside the printer's paper slot and on the rollers. If this happens, create a blank image the size of your paper. Place a tiny image in the center (some printers won't print if there's nothing but white in the image) and then print a dozen or more copies on plain paper to absorb the excess ink.

— WARNING —

Don't use paper sizes that your printer won't let you specify as your print size; doing so makes it difficult to place the image on the page at the location you want. There's also the chance that the printer will spray ink on the paper transport; this ink will then smudge or streak from the leading edge of subsequent prints. There is really no good reason why you shouldn't be able to specify a custom paper size, but some printer manufacturers don't give you that option.

Every printer has its foibles and weak points, so it's a good idea to go online and read the printer manufacturer's FAQs (Frequently Asked Questions) and troubleshooting tips. Just glancing to see which topics arise most frequently will give you a good idea of the preventative maintenance most appropriate to your make and model.

Tip 2: Know When to Calibrate the Camera

When you're shooting on the run, you generally don't want to calibrate the camera because varying lighting circumstances can make the end result difficult to predict whether the camera is calibrated or not. But what if you are shooting a number of photographs with consistent lighting (same brightness, color and angle)—especially if the resulting photographs need to reproduce exact color interpretations? For example, scientific and catalog photography are two fields in which accurate camera calibration could save you significant postproduction time and potential embarrassment. Figure 11-26 shows a calibrated camera on location.

The secret to successful camera calibration depends primarily on having a proper industry-standard target to shoot and measure, along with profiling software that can read the target and create a profile. Here are some simple steps to follow:

1. Obtain a calibration test chart from your local photography store. Begin by making sure that the target is placed in the same position and lit with the same lighting as the subject. Then position the camera so that the target fills the entire frame (or as close to it as the proportions of your image sensor will allow), and photograph it using the same exposure settings you will be using to photograph the assignment. See Figure 11-27.

2. If this is a location job that you're not likely to repeat, you can use the camera profile later for the entire assignment. If this is a job that will take place in your own studio in lighting conditions that you can easily repeat, you may want to change the lighting for all of the most common situations and shoot a separate target to profile each situation. In that case, make notes as to which frame is the basis for profiling which specific situation so that you can later name the profile after the situation.

3. In either case, once the targets have been recorded, load them to your computer and run them through camera profiling software such as Monaco's MonacoDCcolor or EZcolor (*www.monacosys.com*). To do this, simply open each image in the profiling software and then

Figure 11-26. A photographer shooting on location.

Figure 11-27. A studio still-life setup with a calibration test chart.

have the software create the profile. When you save the profile, name it for the shooting situation.

4. Go to your word processor and create a settings sheet for each situation so that you know exactly how to set the camera so that you can use the same profile. Or reshoot the calibration target in each situation before actual shooting starts, then create a profile for each individual shoot.

As I've mentioned throughout the book, the best way to ensure that you'll get the colors and exposure you really want is to shoot RAW files rather than JPEGs. Since RAW files retain all the information that the sensor captured in any given situation, any alteration you made with a calibration setting would simply be a subset of that data anyway. In fact, if you're shooting with a professional camera, the only reason to profile the camera would be to give each frame similar color and tonal balance.

Tip 3: Pick the Right Ink-and-Paper Combination

Figure 11-28. Epson inks and matte paper for the Epson 3000.

As I mentioned earlier, every ink-and-paper combination requires a different profile for your printer. If you don't have the combination profiled properly, you're likely to get an unpleasant surprise when you make a print.

There are hundreds of different ink-and-paper combinations. The trick is to settle on a few "sets" of ink and paper that meet the requirements for specific types of print jobs that you do. (For the Epson 3000, for example, a good choice is the inks and matte paper shown in Figure 11-28.) For instance, prints that are being submitted for proofing purposes will generally be cut up and marked up by an editor. They need to be of high enough quality to represent your work well, but their longevity is of little consequence. The same is true of prints that will be photographed for reproduction and then immediately discarded. On the other hand, prints that are made for your work portfolio, to hang in your studio as permanent examples of your work, or to be offered for sale as fine art should be printed to last as long as possible after all of the other qualities have been taken into consideration. The type of subject matter will also influence your choice.

There are so many choices, so many materials, and so many presentation methods. All of these considerations influence the final effect, and you have to be careful not to get so scattered that you produce an unrecognizable mishmash of presentation styles. It's a good idea to pick an ink, paper, portfolio system, and framing technique that best represents your work, at least in specific categories. Don't be afraid to experiment, though. Nothing's worse than making lots of prints in the wrong style.

First, you will want to show your prints in the form and format expected by your client or representative. Most editors want to see prints made on glossy paper, often simply because tradition dies hard. Many ad agency art directors, on the other hand, don't like the reflections in glossy papers and prefer a semi-glossy or smooth matte surface. If you are selling your work as fine art, you will usually want prints to last at least 20 *tested* years, equivalent to the life of a high-quality Type C color print. If your work is more "painterly" or impressionistic, you may want to print on art or watercolor surfaces and use pigmented inks with a tested life of up to 100 years.

Order test packets of paper; *www.inkjetmall.com*, Royce Bair's *www.inkjetart. com*, and *www.inkjetgoodies.com* all offer excellent assortments of papers, and they also test and recommend different papers. In addition, I often read reviews of papers and talk to my photographer colleagues and my associates at art galleries and ad agencies to see what their experience has been. Once I've decided on a paper, I'll generally check around to see if any professional photo dealers in my area carry it; it's good to support local vendors so that they'll be around to support you.

Bull Dog Products, Canon, Crane, Epson, Hannemuhle, Hawk Mountain, HP, Ilford, International Paper, Kodak, Legion, Luminos, Lyson, M&M Studios, Media Street, MIS Associates, Pictorico, and Schoellershammer are a few of the most popular manufacturers of inks, papers, or both. These names may look very familiar if you're a painter or if you buy papers for photographic printing. The various manufacturers' paper lines are constantly evolving and expanding, and you will continually discover new sources.

Don't be afraid to make up or obtain a color chart that also has some "typical" sample photos on it. The PDI Test Image that comes with ColorVision PrintFIX (see Figure 11-17) is a good example of the kind of chart that is excellent for this purpose; you could also create your own by making a collage of several of your images and scans of some of the Kodak test charts available from your local pro camera store. Each test packet should have at least four sheets of each type of paper. Make a test print from the chart using the profile you created for the kind of paper that mostly closely resembles the paper you want to judge. In other words, use a profile for glossy papers on glossy papers, a profile for art papers on watercolor papers, and so on. These "rough tests" should give you an idea of how various tonalities and subjects will work on that particular paper.

Once you've narrowed down your choices to two or three papers per category, I suggest actually creating a profile specific to that paper (this is where the time saved by PrintFIX really pays for itself). Once you've done that, make test prints of several subjects that you feel will work for that category of paper. Do the same for other samples of paper. You should now be able to choose the one paper that works best for you with a variety of subjects within the same category.

In addition to the print quality you get from a given paper, you need to research the archival quality of that paper in combination with the inks that you're using to print. You can run elaborate tests to prove archival qualities, but it's quicker and easier to simply rely on information from other sources. You can start by listening to manufacturer's claims; this is becoming a safer and safer route because customers tend to protest vehemently when those claims are false. You can also research the subject at *www.wilhelm-research. com*. Henry Wilhelm, the founder of this institute, is regarded by the entire industry as the guru of archivability.

Because digital imaging and digital photography are a new art form/media, there are numerous and vehement arguments over what is considered archival in a digital print. There are many aspects to these arguments, but the most important one for our purposes is that those of us involved in this new media want it to be the best it can be. When you sell a print, include a documented statement of what you expect the archival qualities of the image to be and on what basis and authority you came to that conclusion.

Finally, I want to discuss continuous inking systems (CIS); these are bulk ink systems that attach to printers that normally use small cartridges as an ink supply. The initial cost is high, but in the long run you can save hundreds over the cost of individual ink cartridges. However, there are several potential drawbacks that you should keep in mind:

- Inks that sit for too long can settle, so the ink that gets fed to the printer may be lighter than your profile expects it to be. The cure is to create new profiles from time to time, but if you don't print in volume you could get to the point where the profiling just doesn't work.

- Continuous inking systems aren't available for all printers. You don't want to use one with a printer that's not widely supported.

- Buy from a reputable and well-tested source with a good reputation to protect. There have been a lot of complaints about irreparably clogged printer heads, though that hasn't been my experience so far.

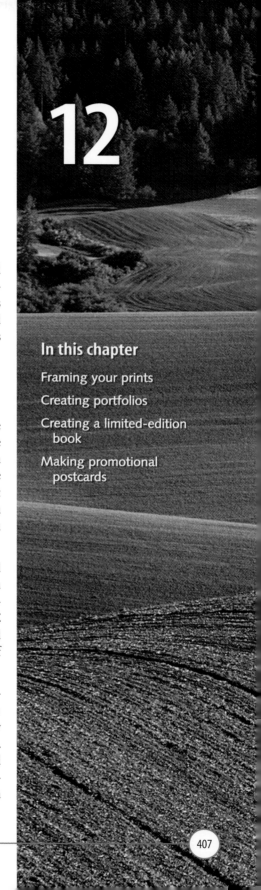

Use Pictures to Sell Yourself

12

If you hope to get filthy rich and world-famous in the world of digital photography, the first thing you need to learn after people praise your photographs is how to use those photographs to get jobs. The first rule: get as much prominent exposure for your work as possible. The second rule: find the most likely audience for the sort of work you do. This chapter discusses how to use pictures to sell yourself in the context of these two rules.

Getting Started

Look carefully at the difference between Figures 12-1 and 12-2. It might take a bit of looking to see the difference, but when you do, you'll notice that the image in Figure 12-1 has faded slightly (look at the model's pants, which are a lighter shade of green). That's not good. You want your display prints to have the truest color possible—for the longest time possible. This is called print permanence. Everything about print permanence is dependent on how you take care of the print. If you don't know how to care for your prints and you don't inform your clients, then you will ultimately have unhappy clients.

What you want instead is to create an archival print. As applied to digital prints, the word "archival" is a relative term. The generally accepted definition of an archival-quality print is one that, under reasonable display and storage conditions, will last longer than such traditional media as Kodak Type C color prints or fine-art watercolors. The lifespan of typical Type C prints and watercolors is between 12 and 20 years under display for 12 hours a day of indirect sunlight, mounted behind glass.

Many of the recommendations in this section are based on information provided by Wilhelm Research and their publications. Wilhelm Research (*www. wilhelm-research.com*) is almost universally considered to be the primary authority on the permanence of all sorts of photographic and digital images. If you take a look at the Wilhelm site, you'll discover a wide range of tested lifespans for archival prints. Some pigmented or combination dye and pigment inks test to over a hundred years. Note that the time stated for Wilhelm

In this chapter

Framing your prints

Creating portfolios

Creating a limited-edition book

Making promotional postcards

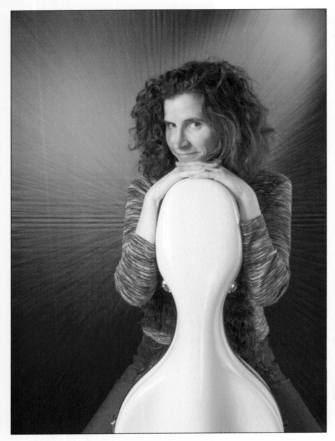

Figure 12-1. The result of using non-archival papers and storing prints where there are chemical contaminants such as excess ozone. This picture has faded.

Figure 12-2. The same print after printing and mounting for archival shows no perceptible deterioration.

test results is the time before noticeable fading occurs—*not* the time before the print is so faded that it looked unsightly.

<div style="border">

EXPERT ADVICE

Pigment-Based Inks

Here's the rub: the longest-lasting inkjet prints tend to be those made with pigment-based inks. But pigment-based inks often do not produce the gamut of colors or the pure blacks that photographers are used to. Therefore, you may have to compromise between the longest longevity and enough longevity to give you the image quality that you consider acceptable.

</div>

So, what does this mean for you? Well, if you frame your prints, follow the instructions in this section to frame them in the safest way. If you don't frame your prints, storing them in the dark in acid-free plastic or Lucite sleeves will

greatly extend the rated life of the print. Lucite sleeves are available from several sources, including RediMat (*www.redimat.com*), inkjetmall (*www.inkjetmall.com*), and Digital Art Supplies (*www.digitalartsupplies.com*). Finally, if you're selling or delivering prints meant for exhibition or collections, be sure to attach proper care instructions.

A pound of cure

Here is a list of components and techniques you should use to ensure that your images last as long as their inks and papers will permit:

Make your prints with wide borders. There are a couple of reasons for this. Wider borders will keep the image flatter under a mat board, so you won't have to use rubber cement or other mounting methods that could shorten print life. Also, since most staining "creeps" in from the fibers along the border, there's less chance that the main part of the print will be stained.

Frames, mats, and mounting boards should always be 100% cotton rag and 100% acid-free. This is usually called *museum board*, and can be easily spotted at art-supply stores because, among other things, it is two or three times the price of ordinary mat boards. If the board is white, its core is just as white as its exterior, which makes the beveled mat opening that much more attractive and professional-looking.

Use corner mounting. Archival mounting corners make it east to exchange prints in the same frame and mat, and also help to eliminate the risk of using mounting chemicals. These are basically the same corner mounts as those used in scrapbooks for 1-hour photo lab prints, but you should be sure to choose only archival quality.

Use graphite pencils for signing photos. For glossy prints, use waterproof India ink. Never use ordinary inks. At best, very few of these have been tested for archival qualities. Be sure to use archival India inks that are acid free. If the bottle isn't plainly marked as such, chances are there's a reason why, so avoid it. You should also sign prints on a very hard surface so that the point pressure of the stylus won't dent the print. Prints should always be signed on the print, not on the mat.

An ounce of prevention

"Acid free, ozone free, dirt free, moderate temperatures."

This is a great phrase that you should take as your mantra. Acid, ozone, dirt, and excessive temperatures are a print's worst enemy. Anything even slightly acidic can damage a print. Ozone has been proven to destroy most cyan dyes which, in turn, causes the color of the image to shift to orange. (This is especially true in areas with unusually high levels, such as that produced by an

oxygen tank or an electrostatic air filter. Extreme temperature and humidity changes can cause prints to wrinkle or wave. Also, sudden changes in atmospheric conditions have also been known to cause mounted prints to crack due to expansion and contraction.

Here are some other things to avoid:

Rubber cement. This can shorten the life of an archival print to just a few years. Most other common types of mounting, such as household glues, paper paste, self-stick album pages, and double-sided tapes, are also no-no's. Hinge tapes aren't a very good idea either, as exchanging a print can damage both the print and the mat.

Contact cement. This can cause serious discoloration and fading in less than a week.

Rubber-stamping. Stamping the back of a print can shorten its life to a few weeks. If there's an absolute requirement that a print be rubber-stamped, the only material that Wilhelm has tested with reasonably positive results is Jackson Marking Products Company's Mark II Photomark pre-inked stamp pads. Be sure to apply the stamp gently so as not to bend or dent the print, and don't apply any more ink to the stamp than is absolutely necessary.

Dry mounting presses. These can get excessively hot, causing possible chemical changes in the inks or blistering of the polyethylene layer in resin-coated (RC) papers.

Cleaning solutions. The only cleaning solution Wilhelm recommends is Kodak Film Cleaner. Many cleaning solutions contain chlorine and other powerful chemicals that can quickly alter the appearance of dyes and pigments.

Obtaining archival supplies

It helps to have good and reliable resources for archival supplies. The following suggestions should get you started, but over time you'll undoubtedly expand this list greatly.

Clean plastic bags. These should be used for storing and protecting prints as soon as they are printed. Pricing varies according to the current price of oil. Bags are generally sold in lots of 1000, but you can get assorted sizes to suit your needs. At press time, a 20 × 30 inch bag was around 25 cents. For volume purchases, try the Ultrasonic Cleaning/Film Division (*www. cleanbags.com*).

Archivally Safe

There will be times when you need to use one of the "forbidden" items listed above. In this case, try to find a version that is marked as archivally safe—at least it will be likely to behave better than other products it its category.

Photo mounting corners. These are special mounting corners for attaching a photo to a mat, and typically look like plastic triangular pockets. Photo mounting corners make it easy to exchange same-size prints on the mat board, and to replace backing materials should they become stained or wet. Make sure they're acid free. Lineco Archival Photo Mounting Corners come in several sizes with prices from $6 to $10 per bag of 100, and are sold through many art supply stores. Utrecht Art Supplies (*www.utrechtart.com*) has very reasonable prices and quick delivery; also try University Products (*www.universityproducts.com*).

Archival mat board. You want a 100% cotton rag, acid- and lignin-free mat board. This is generally called a museum board and comes in both 4-ounce and 8-ounce thicknesses. The cores of these boards are either white or off-white, and the mat should be cut at a 45-degree angle. Museum boards will look solid along the cutout edge, rather than showing a different color or texture of core, as is usually the case with less expensive (and less archival-quality) mat boards. Most connoisseurs and collectors prefer that single mats be 8-ply and that most double or triple mats be 4-ply. Archival mat boards can be purchased from most professional art supply stores. For more information about mat boards, check out *www.artboxvirginia.com/mats.html*. If you are interested in purchasing mats in volume for fine art shows and installations, one of the best online wholesale sources I've found is RediMat at *www.redimat.com*.

Backing board. If your frame comes with a corrugated cardboard or chipboard backing, it is probably going to reduce the longevity of your image. Play it safe and discard it—instead, get an acid- and lignin-free backing board. Two popular types are acid-free white and acid-free foam core, both of which are available in a couple of weights. For prints larger than 11 × 14 inches, I suggest the heavier-weight board; the larger the print, the greater the chance that a lighter-weight backing board will buckle or bend. If your photos are being used in traveling exhibits, I personally prefer foam core boards because they keep the weight down.

Glass or plexiglass. Be sure to get UV-coated materials that don't discolor the image in the frame. Use glare-free glass or plexiglass over matte or other rough surfaces; it will cost significantly more, but you'll be assured that viewers can see the images without objectionable reflections. (However, be careful that the glare-free glass isn't so roughly etched that it diffuses the artwork; if you are showing very high-detail glossy prints, glare-free glass may soften the image to an unacceptable degree.) Take along a print when you shop so that you can try before you buy. It's a good idea to get your glass and plexiglass from a local supplier to avoid the risk of breakage or scratching during shipping. If you'll be shipping your framed prints to clients, galleries, or festivals, then be sure to use plexiglass.

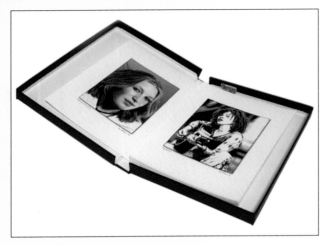

Figure 12-3. A portfolio in a Century Box.

Digital photography portfolios. University Products (*www.universityproducts.com*) has a whole line of portfolio boxes especially meant to preserve digital images. Each box will hold up to 60 "double-weight" (heavyweight) unmounted prints or 10 4-ply matted prints. You can have the boxes debossed with your name or with the name of the collection being shown in that portfolio.

The company also makes shipping boxes that maintain a professional look while protecting your portfolio boxes during transport. Probably the most popular product for this purpose is Pohlig Brothers' Incorporated (*www.pohlig.com*) line of acid-free portfolio boxes called The Century Box. These boxes are more affordable than most and come in a wide variety of sizes and thicknesses (see Figure 12-3). You can also find a huge variety of high-end and very professional portfolio books and cases at The House of Portfolios Co. Inc. (*www.houseofportfolios.com*).

Frame-sealing tape. Frame-sealing tape is generally used with frame-sealing paper that covers the back of the frame. The tape is placed around the outer edge of the back of the frame; the paper is then stretched across the tape, which adheres to the frame because the tape is double-sided. This forms a complete seal so that atmospheric contaminants, moisture, and dust can't enter from behind the frame. Again, be sure to get archival quality tape. It generally comes in 1–1/2-inch rolls.

Frames. As you know, frames come in innumerable styles and finishes. If you have to do considerable research to find just the right frame for a client's specifications, you should start with a large company that makes custom frames to see what the most popular options are. I recommend *www.pictureframes.com*.

If you need to frame collections of prints for gallery showings or for business installations, I recommend that you stick with gallery frames or metal frames (see Figure 12-4 for examples of both). Both styles are sturdy and professional without being so fancy that you risk calling more attention to the frame than the art. IKEA makes a large selection of gallery frames (called

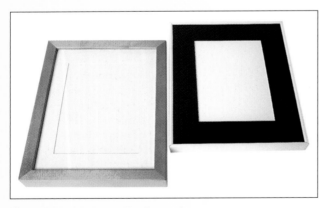

Figure 12-4. A "regulation" gallery frame and aluminum frame.

RIBBA) that come in birch, cherry, or black, complete with glass and a non-archival mat and corrugated backing. I then cut museum-quality double-mats and acid-free foam core backing to fit the frames. I also buy custom-cut UV-coated glass or (more often) plexiglass, as the IKEA glass appears to be ordinary window glass. I especially like these frames because they are well finished and are the right proportion (approximately 2:3) for uncropped 35mm frames or for most professional 35mm SLR-type digital cameras.

IKEA's frames are not fully listed on their web site (*www.ikea.com*); however, the site can direct you to the store nearest you, or you can call 1-800-434-4532 to have frames shipped to you. RIBBA frames ordered in quantities of 10 will come in a box that is ideal for shipping frames from show to show or gallery to gallery. Other gallery frames and metal frames are available from most frame and art supply outlets. If I'm framing panoramas or artwork that must be cropped to an odd size, I have the frames custom-made.

Framing gun. The best way to fasten the glass, mats, backing boards, and image into the frame is with a flex-point framing gun, as shown in Figure 12-5. These operate much like a staple gun, but instead of a staple, the gun fires a flat, black piece of metal into the side of a wood frame. You can then bend it back and forth when you want to remove the image from its mount to clean it or exchange it for another image. Even if you do only occasional framing, this is an excellent $50 investment. The manufacturer is Maestri Fastener Systems Company (*www.maestriusa.net*). They will be happy to give you a list of retail outlets for this product.

Tip 1: Frame Your Prints for Exhibition

Framing prints is a problem only if you try to do it with the wrong materials, or you just don't know how (compare Figure 12-6 with Figure 12-7 for an example). Remember, the marketplace tends to be very picky about sticking to known standards to enhance the value and life of the artwork.

This section will teach you the standard procedure for professionally framing a print in a metal or wooden frame. It does not, however, teach you how to make the frame or the mat. There's a reason for this: unless you're intent on creating something totally unique, you'll save both time and money by buying your frames, mats, and other supplies wholesale. If you are ordering multiple units—even if they are different styles and sizes—most custom houses will give you significant professional discounts. So if you're willing to stick to standard photo sizes, you can simply order frames and mats in quantity.

Figure 12-5. The manual Maestri flex-point framing gun.

Figure 12-6. A frame that uses a thin mat and covers too much of the edges, detracting from the image.

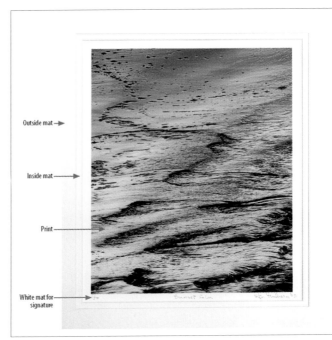

Outside mat →

Inside mat →

Print

White mat for signature →

Figure 12-7. A framed print with two mats that uses the techniques described below.

Where to Get Frames

You probably don't want frames with ill-fit corners, cracks, discoloration, or knots, but if you order blind from a mass merchandiser, you're likely to get a few. (If this does occur, you can always paint the frames black, or buff and stain them.) So, if possible, buy your frames from a supplier who will guarantee your approval of the product, or from a place where you can see before you buy.

Here's a quick rundown of the frame game:

1. Create your prints so that they have at least a 2-inch border (some photographers even recommend a minimum 4 inches). Wide borders look much more professional when you are selling or presenting un-mounted prints, and will ensure that the print stays flatter under the mat.

2. Create your prints so that there will be about 1/4 το 1/2 αν inch of space between the start of the image and the edge of the inside (or only) mat. If you are printing limited editions, there must be a signature and edition number on the print itself. The best way to do this is to sign your print in the border between the image itself and the mat. See Figure 12-7 for an example.

3. Place your print face-up on a flat, smooth, clean surface. Dust it with a soft, antistatic brush and place mounting corners on the top two corners.

4. Hold your precut over-mat just slightly above the print so that you can position it precisely before making the mounting corners stick. When it is in the right spot, gently lower the mat into position and attach the top two corners to it.

5. Turn the print and mat over and attach the two bottom corners after making sure that the top of the print is nestled snugly into the top two corners.

6. Set the print to one side and take the frame out of its protective packaging. As we mentioned above, if the glass that came with the frame is ordinary window glass, you may want to replace it with glare-free glass or plexiglass. Vacuum the inside and outside of the frame to get rid of any dust particles or paper fibers that might creep in front of your image.

7. Place the matted print face-forward inside the frame. The mat should fit neatly within the frame, but shouldn't press against the sides. Pressure on the sides will cause buckling.

8. Place the backing mat behind the matted print. Acid-free foam core is best because it is light and stays flat.

9. Use a framing gun to secure the image, mat, print, and backing inside the frame. A framing gun tab is shown in Figure 12-8.

Figure 12-8. The tab placed by a framing gun.

10. Vacuum the back of the frame again. Place the backing paper behind the backing board and press so that it lies flat. Use acid-free tape to seal around the backing paper so that no dust (or atmospheric chemicals) can get inside the frame.

Choices, Choices

Many photographers prefer not to use white mats or white borders—they feel that the white color will detract from the highlights in the image. You'll just have to weigh the advantages of using the more "museum standard" system described here versus another popular approach: using a somewhat less-archival black mat board, dyeing the bevel black, and potentially covering the print border (which hides the signature and edition number).

Frame Pairs

If you don't want to make completely custom frames but need specially proportioned frames for panoramas or the occasional oddly cropped image, consider using frame pairs. Many suppliers will sell either metal or wood pairs of precut frame moldings in a variety of sizes with all the hardware needed to join the corners professionally. You will probably need to have custom mats cut to fit the frames, but this is much cheaper than contracting for completely custom-made frames, and much less time-consuming than making your own frames unless you have the proper power tools and the space to use them.

11. If you're using eye hooks, screw them inside the frame, about half an inch from the back edge of the frame. String the hanging wire tightly between the eye hooks. Alternatively, you can use a notched hanging bar, as shown in Figure 12-9. You can now hang the frame flat against a wall.

Figure 12-9. A notched hanging bar lets you keep the frame close to the wall.

This procedure is certainly not the only legitimate framing style. However, it utilizes the most pertinent techniques and is the basic style approved by the largest number of prestige galleries and museums.

Now having said that, I've noticed that many prestige galleries in major art centers are wide open to more elaborate and original framing methods. With framing, there's certainly no law against breaking the rules. For example, Ansel Adams, the father of American nature photography, dry-mounted his prints to a black backing board trimmed to match the edges of the image. His prints never appeared under glass and were hung so that they floated away from the wall. However, his prints have been known to crack when the backing was bent or when temperature changes caused the backing and the print to shrink to different degrees. In addition, his "bleed" mounting technique also produced prints that were easily damaged on the corners and that tended to curl away slightly along the edges.

EXPERT ADVICE

Creating Custom Frames and Mats

If your style and preferences dictate frequent cropping of your images to random sizes after they are shot, you may want to create your own custom frames and mats. Try taking a class or buying a book on the subject. I recommend the following:

Home Book of Picture Framing by Kenn Oberrecht (Stackpole Books)

Frame It Yourself by the editors of Creative Publishing (Creative Publishing International)

Matting and Framing Made Easy by Janean Thompson (Watson-Guptil)

Tip 2: Create a Portfolio

When it comes to making yourself and your images look good, let's face it: presentation is everything. The problem arises from the fact that no single presentation method, size, style, or form factor is right for all situations. For example, a web-based portfolio is shown in Figure 12-10. A binder portfolio is another possibility, and is shown in Figure 12-11. No matter what route you go, you need to know what sizes, styles, and form factors are accepted in specific industries and specific places; and of course, you also want to *adopt a style that promotes your own unique perspective*.

Figure 12-10. A web portfolio.

Figure 12-11. A typical presentation binder portfolio book.

There isn't room here to tell you everything there is to know about portfolio presentation, but you'll find concise, rule-based techniques for creating binder, boxed, and electronic portfolios.

Binder Portfolios

Loose-leaf binder portfolios are a great way to make a quick presentation with a few prints. Prints are generally placed inside an acid-free glassine sleeve, which helps to protect them as clients flip through the portfolio. Prints are most often shown borderless and hinge-mounted on black matte paper. The loose-leaf rings allow you to remove any blank pages. Loose-leaf portfolios come in a variety of sizes, but the ones that hold 11 × 14 and 16 × 20 prints seem to be the most popular. Be sure that any loose-leaf portfolio you buy is clearly labeled as archival.

With binder portfolios, photos are held in place with acid-free tape hinges (see Figure 12-12) so that they can be easily removed and replaced without damage to the book, print, or page. This allows you to easily vary the size of prints and pages.

Figure 12-12. Taped hinge for temporary mounting of prints in a portfolio.

Itoya (*www.itoya.com*) makes a large series of black polypropylene ("poly") binders in sizes ranging from 4 × 6 to 18 × 24 inches. The pages are acid- and lignin-free black pages with polypropylene sleeves. The poly sleeves keep the prints safe and unscathed, and even better, you can easily slide prints in and out of the sleeves so you can quickly target a book towards a specific client. Since the average cost of these books is well under $20, it's not a bad idea to just keep a couple around.

Most art supply and photographer's supply stores also provide leather zippered binders with handles or black hardcover binders that will hold the same archival sleeves with black pages. Of course, these portfolios tend to be a bit pricier than the Itoya binders. If you need to protect those less expensive Itoya binders while you are pounding the pavement in search of clients, there are portfolio-sized briefcases that will both do the job and add a look of class and prestige to your presentation.

In My Humble Opinion

I don't love the look of plastic sleeves, but so many pros use this type of presentation that it's not likely to prejudice your audience against your portfolio.

Most professionals make borderless prints for loose-leaf portfolios. The black backgrounds make it possible to include prints in a variety of sizes and shapes by providing an element of uniformity.

Boxed portfolios

Despite the convenience of loose-leaf portfolios, I generally prefer boxed portfolios of loose prints, such as the one shown in Figure 12-13. I leave the prints unmounted so that the viewer can easily flip through and rearrange them to put their favorites at the top of the stack. This has its drawbacks, most notably that you'll have to warn the viewers to keep their fingers off the surface of the prints, but I still like knowing that the audience gets to see and appreciate the quality of the printing, printing paper, and image in a more honest, up-close, and personal way.

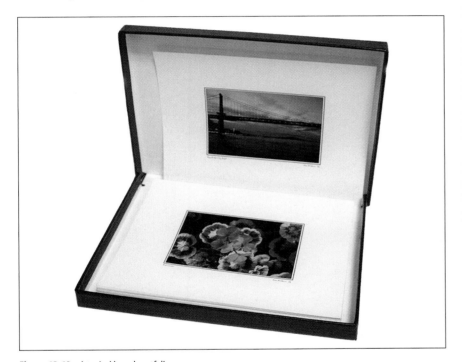

Figure 12-13. A typical boxed portfolio.

I always make prints for a boxed portfolio in a uniform paper size and use the most heavyweight paper that is consistent with the image type I'm presenting—for instance, sports and food seem to look snappier on glossy papers, romantic portraits and nature scenes seem to be more compatible with the softer look of matte papers, and painterly interpretations of digital photos work best on watercolor or other types of artist's papers. I also leave a generous amount of border space around each image.

Digital and web portfolios

One of the easiest ways to quickly pull together a portfolio is to create one that can be viewed on the computer, either via the Web or CD-ROM. Several products help you do this in a variety of ways, and are shown in Table 12-1.

Table 12-1. Digital and web portfolio products

Product	Platform	On-screen slide show (email or burn to CD)	Create web galleries
Roxio PhotoSUITE	Windows	Yes	No
Ulead PhotoImpact	Windows	Yes	Yes
Microsoft PictureIt!	Windows	Yes	Yes
Paintshop Pro	Windows	Yes	Yes
ArcSoft PhotoStudio	Mac, Windows	Limited	Limited
Corel Photopaint	Mac, Windows	Limited	Limited

On the Macintosh, you can use iPhoto. There are also programs such as E-Book Systems' FlipAlbum Pro that let you create a classy-looking digital portfolio book, complete with flipping pages, as shown in Figure 12-14.

Figure 12-14. An on-screen book created in FlipAlbum Pro.

The range of possibilities for portfolio presentation goes far beyond what is covered here. Still, you now have a start on some functional and commercially respectable means of presenting portfolios to different audiences and for different purposes.

Tip 3: Create a Limited-Edition Book

If you specialize in fine-art photography or want to move some of your commercial work into that arena, you might find that the high cost of large prints and the lack of consumer wall space given today's high cost of real estate are limiting the market for fine-art prints. If so, you might consider a fairly new idea that is catching on quickly in the fine-art world: the limited-edition book, sometimes referred to as a monograph. Monographs are bound volumes of limited-edition fine-art prints. At press time, a typical price for a book of 8 × 10 prints on 11 × 14 paper from a credentialed but not internationally known artist is between $400 and $1200.

Monographs should have all the same parts as other books: a title page, table of contents, and text introduction. The most important function of the introduction is to present the techniques and the materials that were used to make the monograph. There should also be a statement regarding the edition number, the archival qualities of the prints, and the value of the monograph versus the value of framing individual prints. Finally, you should also include an artist's biography, credit and credentials, and a statement of purpose and artistic philosophy.

Here's a useful list of "do's" for creating monographs:

- Follow the recommendations earlier in this chapter for archival printing. For example, use archival inks and papers. The paper should also be heavyweight enough to have a substantial feel.

- Choose a paper surface that suits your style and, more importantly, the subject matter being portrayed.

- Decide whether you want to print on both sides of the paper. Even if you don't, it's a good idea to print on double-sided paper because the backs of the pages won't be discolored or have watermarks showing. Also, papers coated on both sides will lie flatter.

- Consider using binders that are premade for monographs; this will allow you to make smaller editions at more affordable prices. These monograph-friendly binders come in several styles and sizes and usually have space for a title and/or cover art.

- Test the layout and content of your book by first making an electronic version. I love what FlipAlbum Pro can do in this area.

Event Monographs

A monograph is also an impressive way to present a book or brochure idea to a publisher or client. For example, there is currently a huge market for monograph books in wedding and event photography.

- One of the simplest and easiest ways to create a book is through an online service. This option is offered by Adobe Photoshop Album and Apple iPhoto, among other products.

- You can also send your printed pages to a custom book bindery, which will stitch the pages together and bind the book in leather, canvas, linen, or some other traditional and professional-looking material. Prices for this service range all over the map.

For an excellent example of a monograph, check out *www.luminous-landscape.com/about/monograph.shtml*. It will give you many good ideas about how you might want to produce your own monograph. photo-eye Books & Prints at *www.photoeye.com*, an expansive source for books on photography, also sells limited-edition monographs of many of their authors' works. Their prices generally range from $400 to $1200, depending on the number of prints, the size of the book, and the number of books in the edition.

Many artists, and especially fine-art photographers, have small digital offset-press books made of their work. They generally print around 500 to 1,000 copies, and the cost of printing averages around $15 per book. These artists then sell these books at the art fairs, festivals, and galleries where they exhibit their work, and often also make them available online. At an average retail price of $25 to $35, these books are an affordable way for people to start collecting an artist's work and showing it to friends. Over time, making these books available also builds mailing lists and repeat orders for both larger art prints and monographs. Most of the books I've seen in this category are either 8 1/2 × 11 or half that size, contain 25 to 50 images, and are printed on good varnished stock.

If you want to experiment with the idea of a monograph or would like to create a less expensive version to use as a "leave-by" (a give-away promotional item left with a potential client), consider submitting your photos as pre-edited digital images to an online photo-processing service such as PhotoWorks (*www.photoworks.com*). PhotoWorks will make you a book of photos and captions printed directly on 4 × 6 pages with a spiral-bound hard cover for a mere $6.95. You can add up to 50 more pages for $.25 each.

Tip 4: Make Self-Promoting Postcards

Nobody will hire or buy from a photographer they don't know about, so it is essential that you have something impressive that you can leave behind. If you have an event coming up, it is also a good idea to let everyone who has shown an interest in your work and career know about it. Furthermore, you'll be giving them something that they can hang on the wall, on the refrigerator, or on the company soft drink machine to remember you by.

There are two ways you can make promotional cards: you can print them yourself, as shown in Figure 12-15, or have them commercially printed, as shown in Figure 12-16. Either way, you'll be designing and picking the subject matter yourself.

Figure 12-15. A self-printed promotional card.

Figure 12-16. An offset-printed card done by a commercial print shop.

Printing the card yourself

When printing your promotional cards, you'll want to use an inexpensive paper, but one that shows off the photograph well. Personally, I'm more concerned about cost than archival properties—obviously, you don't want to give away the same quality of photograph you'd be printing as a limited-edition print. Of course, you could also argue that the more you are collected, the more you will be remembered.

EXPERT ADVICE

A Six-Color Printer

Consider buying an inexpensive six-color printer that prints a very good photo-quality image and equipping it with a CIS (Continuous Inking System) just for printing promotional work. Printing from 4oz bottles of ink, I can print hundreds of pages of glossy photos before I have to replace the ink.

Of course, if the time you spend printing your own cards keeps you from a more profitable endeavor, it's not a smart idea. However, by and large, the real advantage of printing my own cards lies in the fact that I can print an unlimited number of different subjects for the same amount of time and money.

Having the card offset-printed

Offset-printed cards tend to look a bit more professional just by the fact that, well, they are offset printed. If you go this route, remember that offset printers work from CMYK images. The easiest way to see what will happen when the image is converted to CMYK is simply to duplicate the image in Photoshop, convert the duplicate to CMYK, and compare it side-by-side with the original.

A quick look through Sunshine Artist Magazine or Photo District News (PDN) Magazine will supply you with several sources for printing promotional cards and postcards. To give you a quick reference and an idea of what's available and what pricing is like, here's a short list of card printing services:

Postcard Press (www.postcardpress.com). At press time, 1000 4 × 6 cards were priced at $145; 1000 5 × 7 cards were $219. Both prices are for full color front, black printing on reverse.

PSPrint (www.psprint.com). This company prints all sorts of promotional materials including calendars, stickers, and postcards. Several of the galleries in my area employ PSPrint's services steadily. Postcards can be ordered in gloss or matte surfaces, and are available in 4 × 6, 5 × 8, and 6 × 9. Again, at press time, 1000 full-color front 5 × 8 cards were $191.25 with a 10-day turnaround.

The Great American Printing Company (www.gapco.com). At press time, this company printed 4 × 6 cards only, at a cost of $99.50 for 500 cards. For an additional price, you can add addition items such as extra text to the back, new type to the front, etc. You can download an order form from the web site.

Sell It on the Web

13

If you read through Chapter 12 already, you probably noticed that there wasn't much information on using the Web to sell your pictures. Well, that was intentional. There are so many ways to use the Web to sell your pictures and so many aspects of preparing pictures specifically for web publication that I decided that these issues merited their own chapter. However, much of what was discussed in Chapter 12 is also relevant here, so if you haven't already, be sure to read that chapter first.

Getting Started

Creating a web gallery is by far the most immediate and efficient way to show your portfolio—you can then post it on your own web site or on other sites that cater to photographers. There are also numerous sites that will allow you to display your web portfolio for the purpose of selling your prints.

If you own your own web site domain, you can create different pages for different categories of photos. For example, you might want to have a link called "portfolios" or "photographs" on your main menu and have that link direct the viewer to another page listing different styles, types of subject matter, specific events, or what-have-you. Each of these topics could then link to an individual page.

There are a number of additional considerations that you'll want to keep in mind if you're publishing your images on the web. For example, your images may be perfectly exposed, color-balanced, and adjusted for viewing individually as prints. However, when you put them on a web site they're going to be viewed as part of a group, so it's ideal to have more uniform brightness, contrast, and color values between them. (For example, compare the three side-by-side photographs in both Figures 13-1 and 13-2). You'll also want to crop and transform these images in such a way as to make them complement one another as much as possible. The difficult part is doing this efficiently to lots of images at once so that you don't run into any holdups getting your site up and running.

In this chapter

Creating digital slide shows

Selling through other people's web sites

Optimizing images

Protecting your copyright

Making photos for web animations

Figure 13-1. The original images as the camera saw them.

Figure 13-2. After matching the exposure and contrast so that all three images have a uniform appearance.

Preparing the images

The solution to these issues lies in setting up a routine that is likely to produce the most pleasing and uniform results. Don't have one yet? No problem. Just use mine.

1. First, gather all the files together and place them in individual folders that will hold the contents for each portfolio category.

2. Create an Action in Photoshop that will save the files in each folder to JPEG format at the highest quality setting mode (12). This keeps the originals in excellent shape but also compresses them so that they will be easy to store on a CD. (It also makes them quick to render if the portfolio-making software has to resize and optimize them.) Feel free to add whatever other changes you need (e.g., color correction) to the images before you save them. For example, Figure 13-3 shows an Action that will apply a levels adjustment in the same way to each image before saving. If you click in the small window to the right of the checkmark, the Action will stop to allow you to adjust the command settings for each individual image.

3. Use the Photoshop File Browser to quickly compare images. Here, you can eliminate any duplicates, check to make sure all files are large enough for your purposes, and easily see which images require adjustments in color saturation, contrast, or brightness when seen in the context of the rest of the collection. See Figure 13-4.

4. If the files have coded names (such as those in Figure 13-4), go through all the images and give them names that will serve as titles. This will make it much easier to retitle images when you do the final editing on your gallery in your HTML editor (e.g., Macromedia Dreamweaver or Adobe GoLive).

Once you've done all this, use the Photoshop Browser to pick the images that are most in need of editing. Then use the following routine for each of those images.

1. Crop and transform the image to improve composition and straighten perspective.

2. Use the Levels command to get the range and brightness of that image into the ballpark.

3. Use the Curves command to tweak the brightness and contrast of the image, if needed.

4. Use the Soft Light layer technique (and/or Photoshop CS's Shadows/Highlights command) to extend the range of shadows where needed.

5. Use a Brightness/Contrast Adjustment Layer for vignetting, burning, or dodging large areas. To do this, use the Lasso to select the general area and then feather the selection so that the Brightness/Contrast command will blend smoothly with the rest of the image.

6. Use the Hue/Saturation command to bring the images colors to life, if necessary.

Figure 13-3. This Action will apply the image adjustment (in this case, Levels) in the same way to each of the images you apply it to.

Figure 13-4. Viewing the adjusted images in the Photoshop Browser after matching their exposure and contrast.

7. If you work in layers, remember that the layers will flatten when you save to JPEG. Therefore, you may want to save a copy of your adjustments as a PSD so that later on you can retrieve it later on.

8. Consider preframing your images. The quickest way to do fancy framing is to pick a plug-in that automatically frames images, create an Action that preframes one image, and then use the Photoshop File Browser's Automate → Batch command to frame all the images in the gallery.

EXPERT ADVICE

A Solid-Color Frame

If you just want a quick, solid-color frame, record the following Action. First, choose Select All; choose Image → Canvas Size and increase the canvas size by half the number of pixels you want in the frame; choose Edit → Stroke and enter a pixel width for the frame that's twice the desired width (the other half will be outside the current canvas); choose the color you want for the frame and click OK. Stop recording the Action. You can now play it for all the images you want to frame.

9. Finally, you may want to watermark the images that will appear in your web galleries. Refer to Tip 4: Watermark to Protect Your Copyright for how to do this.

You may have noticed that we haven't said anything about *optimization*, which is the buzzword for making GIF and JPEG images look as good as possible while making the file size as small as possible. If you've followed the recommendations above, you'll find that most of the automated web gallery routines do a decent job of optimization on their own. (If they don't, see Tip 3: Optimize Images for Web Viewing for information on how to do it yourself.) Note, however, that what you'll actually be doing is optimizing the images individually and substituting them for the images automatically optimized by the web gallery application.

Put together the web gallery

Great web designers are expensive to hire and hard to find. Even if you do end up having someone else do most of your web design, it's a good idea to learn enough about it to speak knowledgeably to your designer and to have reasonable expectations.

You'll probably end up to creating web portfolios in Photoshop and E-mail/CD portfolios in Photoshop Album because these are the applications you're most likely to have at your disposal. However, it would be worth your while to examine all the products mentioned in this section because each one creates galleries (portfolios) in different styles and some of them have bigger "style collections." For example, Figure 13-5 shows a web gallery created by an inexpensive program called ArcSoft PhotoBase. Figure 13-6, on the other hand, shows a gallery created by Photoshop CS.

Figure 13-5. A web gallery automatically created by an inexpensive program called ArcSoft PhotoBase. PhotoBase offers only one gallery style, but you can change the caption information and the background color.

Figure 13-6. A web gallery automatically created by Adobe Photoshop CS, which offers a collection of 11 different professional-looking styles and half-a-dozen sub-options (such as banners and custom colors).

Creating the pages is the easy part; you can do it in either Photoshop CS (actually, Version 6 and above) or in Photoshop Elements 2, each of which offer different sets of gallery styles. The styles in Photoshop CS are much more professional and flexible than those in earlier versions. With a basic understanding of HTML, it is quite easy to customize any gallery you automatically create. Photoshop writes the end result in legal HTML code, which you can easily edit using the search and replace command in your HTML editor if you want to change the positioning, size, text style, or any other characteristic of an element.

The following method will give you a good idea of how to create an automatic portfolio in Photoshop Album. By studying the screen shots, you'll see that you have quite a few style and format options that you can modify.

1. I prefer to use Photoshop Album, rather than an image editing program or a more complex image management program, to locate and organize the photos that I will place into any of the individual galleries. In the Workspace window, click the Select Command button and choose Export from the pull-down menu. The Export Workspace Items dialog appears (see Figure 13-7). Choose JPEG as the file type because doing so will speed up the rest of the process. Photoshop will automatically convert images from any file format recognized by Photoshop to JPEG format when it makes the gallery, but if it starts with smaller files, it will save you time. You should also select a photo size. For photographers, I find 800 × 600 to be best, but you can choose your own preference. As far as Location, I generally use the Browse button to create a new directory and folder to make it easier to re-locate this specific folder if I want to do some editing later. The rest of the options are up to you. Click Export.

Figure 13-7. The Export Workspace Items dialog.

If you're using Photoshop or Photoshop Elements, open the Photoshop File Browser, locate the directories that contain the images you want to use in your gallery, and then drag them into the Photoshop workspace and save all of them to a specific folder.

2. You should now have all your images placed in a single folder. Open Photoshop CS and choose File → Automate → Web Photo Gallery, or create a web photo gallery in Photoshop Album. The Web Photo Gallery dialog appears. See Figure 13-8 for an example of this dialog in Photoshop Album and Figure 13-9 for an example in Photoshop CS.

Figure 13-8. The Web Photo Gallery dialog for Photoshop Album.

3. First, choose the Gallery Style you want to use (it's called Styles in Photoshop CS). You'll get a preview of these styles each time you choose one, so you can go through the list until what you see is as close as possible to what you want.

4. Enter your email address in the E-mail field—unless you don't want any feedback from the people who view your gallery, or want to make it really difficult for them to contact you.

5. Under Source Images, choose Folder as the source and click the Browse button to locate the folder into which you placed the images for the gallery. Be sure to uncheck the Include all Subfolders box unless you had a very odd way of storing your images. Next, click the Destination button, browse to the location where you want to place the finished web gallery and HTML code, and create a folder.

Getting Feedback on Styles

There are many noteworthy new features in Photoshop CS's Web Gallery command, such as gallery styles with the word "feedback" in their name. Choosing one of these styles creates a gallery with a feedback banner that appears beneath the large image. If the viewer clicks the feedback banner, a two-tab dialog appears. One tab says "Image Info" and the other says "Image Feedback."

If the Image Info tab is clicked, all of the EXIF data for that image appears—provided you have told the program to preserve EXIF data. If the Image Feedback tab is clicked, an email form appears. The viewer can click the E-mail tab, type a name into the Explorer User Prompt dialog, and click OK. This opens the viewer's OS-assigned email editor. The viewer can then type an email message of any length and automatically mail it to the address assigned to that web gallery.

Figure 13-9. The Web Photo Gallery dialog for Photoshop CS.

6. Now comes the fun part: choosing the Options settings that will allow you to customize your gallery. The options in Photoshop Album consist of four tabs near the bottom of the dialog (see Figure 13-10). In Photoshop CS, they appear as a set of configurable items inside the Options box that switch depending on which pull-down menu is selected (see Figure 13-11).

Figure 13-10. The options in Photoshop Album's Web Photo Gallery dialog.

Figure 13-11. The General Options in Photoshop CS's Web Photo Gallery

7. Choose Banner from the Options tab or pull-down menu. In the Site Name field, enter a name as you want it to appear on your site. In the Photographer field, enter the name of the person or organization you would like to designate as the owner of the photo (e.g., yourself). You can actually enter any information you wish in any of the Banner Options fields. For instance, I put all my contact information in the Contact Info field, but if I want to include ordering instructions or comments about the photos, I write that information in the Date field. (I don't like to "date" my galleries, unless it's a private gallery for use by a specific client, where the creation date might be important. Note that the date is automatically entered in the date field by default, so be sure to delete it if you don't want that information there.) Finally, you can change the font style and size of the banner text—just be sure to choose a small enough font size that all your information will fit within the banner when the gallery is displayed on the Web.

8. Choose Large Images from the Options pull-down menu in Photoshop CS (see Figure 13-12), or the Large Photos tab in Photoshop Album (Figure 13-10). The options presented here tell Photoshop how to resample and resave your existing images for the Web. Happily, Photoshop does all the work for you, saving you much time and pain. These settings also allow you to customize the look of the currently chosen style. For example, you can automatically place borders around the images. Note that you can't choose the border color, but you can change the width of the border by entering a specific number of pixels in the Border Size field. You will also notice a Titles Use section with several checkboxes. This will extract the appropriate EXIF information about the photo and insert it into the title. Some sample settings are shown in Figure 13-13, but be sure to experiment to find the settings you like best.

9. The Custom Colors tab or pull-down menu options will let you choose any color for the following items: Background, Text, Link, Banner, Active Link, and Visited Link. To change a color, simply click the color swatch for that item to bring up the standard Color Picker for your OS, and then follow the standard procedure for picking that color.

Figure 13-12. The Options pull-down menu in Photoshop CS.

Figure 13-13. The Large Images options in the Web Photo Gallery dialog for Photoshop CS.

10. The remaining options are self-explanatory and a matter of personal preference. You'll often find that the defaults are the best choices for a given style. Finally, you should preview your gallery in a web browser. When you click the OK button at the top right of the Web Photo Gallery dialog (regardless of which Options screen is showing), the program will do everything it needs to do to optimize and size both the thumbnail and large images, implement all the options for styling the gallery, store the images in the appropriate folder, and write all the HTML code needed to run the gallery on your web site. When it finishes doing all that, your default file browser will automatically open and your web gallery will appear. It will behave exactly as it does on the Web.

I believe it's important to use several different programs for creating automatic web galleries so that you can choose from a wider variety of prefab styles. That way, you can get some quick previews of a variety of visual alternatives. Most of these programs are quite inexpensive. Here's a list of a few that I like.

iPhoto (www.apple.com/software/). Mac only. Free download.

ImageRodeo (www.imagerodeo.com). This Mac-only program is by far the best and most versatile of all the products that automatically create web galleries. There are 15 templates that you can edit. You can also drag and drop to rearrange images in the gallery, delete the ones you don't want, and add your own HTML text and titles. Now, if somebody would just make a program just like this for Windows, we'd all be happy.

iView Media (www.iview-multimedia.com) is a cross-platform, $29 program that does slideshows and web galleries. It has a Mac-only big brother.

ACDsee 5.0 (www.acdsystems.com). This excellent image management software for Windows lets you create web galleries for both your own and for their own online image sharing service.

Thumbs Plus 6.0 (www.cerious.com) offers easy choices for background colors, generates easily editable HTML, and can be made to publish directly to your web site. Windows only.

Express Thumbnail Creator (www.express-soft.com) creates thumbnail galleries and editable HTML.

Ulead PhotoImpact 8 (www.ulead.com). Windows only; not only does web galleries, but publishes web pages with interactive slide shows.

Ulead Photo Explorer (www.ulead.com) creates web slide shows. There's a lot of versatility here. You can change the background color of all the elements, choose font styles (but not, oddly, text color), and choose from a number of template layouts. There's only one style, but it is very clean and professional looking.

Make Sure You Have the EXIF Data

In order for the Titles Use settings to have any effect at all, you must have entered additional EXIF data in the File Browser for the images in your gallery before you start creating the gallery according to these instructions. To do this, open the source image folder in the Photoshop CS File Browser. Click the Metadata tab in the bottom left of the File Browser dialog and scroll down until you start to see pencil icons in the left columns, which indicate editable fields into which you can enter data. (Note that this does not work in Photoshop Elements 2.0.)

Corel PhotoPaint 10 (www.corel.com) will publish a single image to an HTML page, but doesn't create web galleries as a whole.

Jasc PhotoAlbum (www.jasc.com). This program used to be called After Shot. It's one of my favorites for automatic web gallery creation because it's intelligent enough to use the filenames as image titles without adding the file extension (which is usually one of the main reasons for having to edit the results of most other editors in a WYSIWYG HTML editor). You can also instantly add your own photos as backgrounds—just make them up in your image editing program and just pop them in. The one issue I have is that there's no way to scale the thumbnails and gallery shots; hopefully this will change with the next upgrade. The last upgrade added a couple of new features, not least of which is very nice automatic web gallery creator with a set of 40 templates that result in easily edited HTML pages. Windows only.

Roxio PhotoSuite (www.roxio.com). This program does a very complete job of letting you create and edit sites. The templates are oriented toward holidays and family photos and therefore do not look very commercial or business-like, but it is much easier to redesign various aspects of these templates than in most of the other programs. PhotoSuite also lets you send a web site as email, so you can make interactive attachments.

Extensis PortWeb (www.extensis.com) is a free download plug-in that works with Extensis Portfolio 6 to automatically generate web portfolios from the Extensis Portfolio catalogs. Available for both Mac and PC. According to Extensis, some knowledge of HTML is required.

Canto Cumulus 5.5 (www.canto.com) can export thumbnails to HTML, which is not the same as creating a web gallery. It creates a web page with thumbnails, but there's no obvious way to edit the page in Dreamweaver. A web publishing option for Cumulus, Web Publisher Pro, is available for $1,495. This add-on will publish in a Dreamweaver-compatible format and offers so many options that there's no room to cover them here. If you're interested in an industrial-strength solution, check out Canto's web site.

For instructions and resources on automatically creating web photo galleries, check out this excellent site:

www.graphicssoft.about.com/cs/webgallery/ht/

A Good Way to Start

Even if you want a very sophisticated design for your Web gallery, it's a good idea to start with a program like Photoshop or Photoshop Album that automatically creates it. This way, all the basic HTML is written and all the images are collected into the appropriate folders. You can then use a WYSIWYG HTML editor (such as Macromedia Dreamweaver, Adobe GoLive, or Microsoft FrontPage) to open your site and tweak it from there. If you're used to Photoshop, a little practice makes it easy to change titles and captions, background colors and patterns, and text styles.

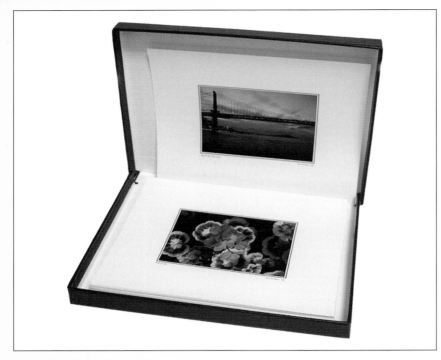

Figure 13-14. A conventional portfolio.

Figure 13-15. A digital slide show. You can view it as either pages in a PDF document or (the default) full-screen on the monitor.

Tip 1: Create a Digital Slide Show

Creating a physical portfolio like the one in Figure 13-14 (which we did in the previous chapter) can take both time and money. Fortunately, the solution is easy: digital slide shows, such as the one shown in Figure 13-15, that will run on virtually anyone's computer. If there are only a few images in the slide show (or if you don't mind keeping them small), you can simply email them to anyone you like. If you want to show more or larger photos in the collection, you can record them to CD and drop them in the mail. At 30 to 50 cents per CD, you won't even mind too much if it doesn't get sent back—in fact, if the CD is kept and passed around the office, it may have a greater potential for bringing you new business.

EXPERT ADVICE

Before You Start Handing Out CDs

Be sure that the images on the CD are copyrighted and that they are not print-quality size and resolution.

It is every bit as easy to create slide shows automatically as it is to create web galleries. In fact, it's even easier because optimization is less critical (unless you're sending it via email) and because there's no need to do any HTML editing afterwards. Using the method described below, you can create a slide show using Photoshop

Album, Photoshop Elements 2.0, or any post-6.0 version of Photoshop. All of these programs create an Acrobat PDF (Portable Document Format) slide show that can be played on any computer as long as a recent version of the Adobe PDF reader is installed. PDF readers can be downloaded and distributed for use on most computer operating systems and Internet browsers.

1. Before you get started, you might want to collect all the images for your slide show into their own folder. There is no need to resize images, as they will all be scaled automatically by the PDF routine. On the other hand, if you have only a dozen or so images, you can just drag them out of the Browser into the Photoshop CS or Elements 2 workspace.

2. In Photoshop, choose File → Automate → PDF Presentation; in Photoshop Elements 2, choose File → Automation Tools → PDF Slideshow. In either program, you will get the dialog shown in Figure 13-16.

3. In the PDF Presentation dialog, check the Add Open Files box if you have opened the files you want to include in Photoshop or Photoshop Elements 2. The names and paths of all these files will immediately appear in the dialog. If you want to add more files or if you want to start from scratch, click the Browse button to navigate to and open any additional files.

4. The PDF presentation slide show doesn't offer any "VCR" controls; instead, it either runs automatically at timed intervals or changes slides when the viewer clicks the mouse button or Return/Enter. You can move back and forth in the sequence by clicking the Up/Down or Right/Left arrow keys as well. It is up to you how you want your slide show to run. Under Slide Show Options, check the Advance Every (integer) Seconds box and enter a specified number of seconds if you want your slide show run automatically. If the box is unchecked, the slides will advance only when the mouse is clicked.

5. Check the "Loop after last page" box to make the slide show play continuously until the Escape button is pressed.

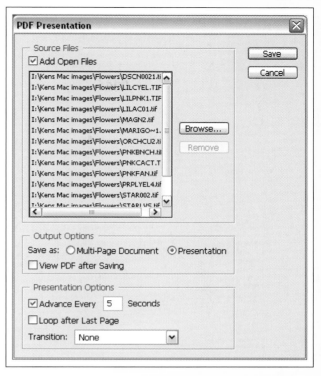

Figure 13-16. The PDF Presentation dialog.

Create a Text Slide

It is a good idea to create a text slide for the first image in the show so that your viewer can read instructions telling them to click when they are ready to move ahead and to press Esc to show the images as pages in a PDF document so that they can move to specific images at will.

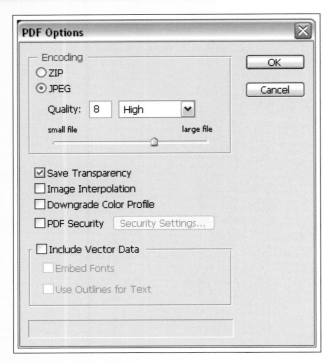

Figure 13-17. The PDF Options dialog.

Signature Frames and Edges

One way to give a unique look to slide shows is to create frames or edges for the images. Each slide show will then have a unique "look and feel" that is appropriate to the subject matter or that helps to "brand" your photographs as unique.

6. You can use the Transition menu to choose between any of the specific transition types, or, if you choose Random Transition, the program will automatically change the transition type each time the slide changes. If you are making this show for a professional audience, I suggest you simply choose Dissolve or None (Cut) as the transition type.

7. In order to control image compression and scaling, click the Advanced button to bring up the PDF Options dialog. Set the options to the defaults shown in Figure 13-17 unless you have specific reason to change them, and click OK.

8. Click OK in the PDF Slideshow dialog. A file-saving dialog will let you specify where you want to save the file. I usually save slide shows to the desktop—that way, I can easily find them when I want someone to view the show or when I want to quickly review certain slides.

> **EXPERT ADVICE**
>
> ### A Slide Show on the Side
>
> If you host open houses or do photo exhibits, you might consider running a slide show on a computer alongside the exhibit. That way, you can show many more images than you're likely to have room for on the walls.

You can create a slide show even more quickly and efficiently in Adobe Photoshop Album than in Elements or Photoshop. One of the advantages of using Photoshop Album is that you can assign category "tags" to images. At the click of a button, you can see thumbnails of all the images in that particular category, and you can then collect the images for a particular slide show by dragging the thumbnails into the Workspace window.

Here's how to use Photoshop Album to create a slide show:

1. You may want to go through all the possible files on your system and drop a tag on any images that might fall within the category of your slide show. To do this, you'll need to create a tag for the slide show and then drag-and-drop it on any image you like. Choose View → Tags to make the Tags window appear; you can

then click the Tag box next to the tag for the category that you've assigned so that all the images you see in Album are those in that category.

2. Click the Create button; a Workspace dialog window will appear. Leave this window open, and as you peruse the thumbnails, drag the chosen images into the Workspace window. This will not erase them from any current directories or affect the tags that have been assigned to them.

3. Once all the files you want in your slide show are in the Workspace window, their thumbnails will appear in the left-to-right, top-to-bottom order in which they will appear in the slide show. You can rearrange the order by dragging the images, which is an especially important capability if you want your portfolio to tell a story.

4. To preview your slide show, click the Select Command button and choose Play Slideshow from the pull-down menu. The slide show will begin to play with only one image per slide and a very smooth and professional dissolve between one slide and the next. You may want to view the slide show several times to get a sense of how much time you want between slides, the order of the slides, and so on.

5. Edit the slide show as necessary.

6. Click the Start Creations Wizard button, and the Creations Wizard dialog will appear (see Figure 13-18). Choose Slideshow from the template type list and click Next. You can now choose from a number of different style templates for your slide show. Click Next again.

Figure 13-18. The Creations Wizard in the Workspace window.

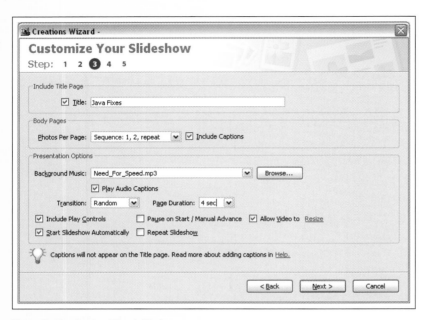

Figure 13-19. Creations Wizard slide show options are extremely versatile.

Figure 13-20. The Creations Wizard Preview Your Slideshow page.

7. On the next page of the Creations Wizard, you can customize the slide show to be silent or to play music (any MP3 file), designate the number of photos per page, choose random or specific transitions from the Transition menu, show play controls on screen, start the slide show automatically (when you double-click its icon or insert the CD), set the individual slide duration, pause and start on manual advance, and specify whether you want the video to automatically resize to fit the resolution of the display. See Figure 13-19.

8. The next page of the Wizard is the Preview Your Slideshow dialog, and is shown in Figure 13-20. If you want a last minute check, click either the Play button or the Full Screen Preview icon. In the latter case, the slide show will take over the entire screen and the background will switch to black.

9. When the preview is finished, you can either click the Rearrange Photos button to go back to the Workspace, or click the Next button to render the slideshow and save it.

10. The last page of the Creations Wizard is the Publish Your Slideshow dialog (see Figure 13-21). You can immediately click the Done button to simply save the slide show into the Album's Photo Well, or you can do any of the following: save the slide show as a PDF (which you can later exchange any way you like);

Figure 13-21. The Creations Wizard Publish Your Slideshow page.

print the slide show; email the slide show to anyone you like; burn the slide show to a CD; or (at some future date) send all the slides in the show to an online print service.

Of course, Adobe products are by no means the only ones that create slide shows automatically; in fact, almost all image-editing or image-managing programs have this capability. There are at least two advantages to using an alternative program:

- You won't need to worry about whether your target audience has a PDF reader installed.

- Other programs give your slide shows different design styles. Many of these may be "too cute" for a pro, but could be just the thing for a family or wedding client.

And just as with web galleries, you can create a unique look for your slide shows by preframing the images before you create the slide show.

Tip 2: Sell Through Other People's Web Sites

The more places your photographs appear, the sooner you will become a household name. However, you'll want to keep it looking professional at all times (for example, not what you see in Figure 13-22). The Web is no exception. There are any number of family photo processing services that allow

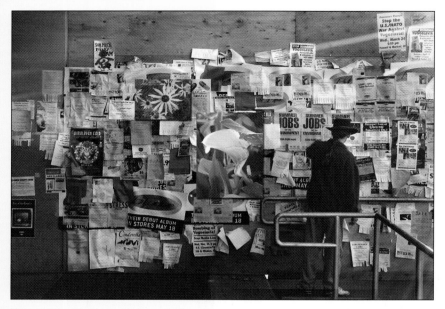

Figure 13-22. Would you order from a site that looks like this bulletin board?

Figure 13-23. A professional photo ordering site on Printroom.com.

you to post your digital images to the Web. These programs work in various ways, but for the most part, you have very little control over the appearance and layout of the pages. Visitors to the site can look up your name, browse your photos, and order any photos they'd like to add to their collections. A few of these sites allow you to require a password from anyone who orders the pictures, but you still have no control over the price or quality of the photos. As a professional or serious photographer, you are going to want to be in complete control over the pricing and distribution of your art. Figure 13-23 shows a photo ordering site on Printroom.com.

Fortunately, there are many sites that cater to professionals and fine artists. Most of these sites will want a commission on your sales, which can be up to 50%. They may also *jury* your submissions (there is often a jurying fee), accepting only those artists who live up to their quality or artistic standards; they may also impose a waiting period. Many of these sites will help you set up pricing structures, payment options, shipping services, and promotional services. Different web sites offer different methods of selling your photography, such as the use of online galleries. You can use the site as a place for visitors to your shows to place orders for your work. You may also be able to work on cross-promotional deals with the site.

Each site listed below gets thousands of visitors per month, so they are a potentially great way to call attention to your work. Most of these sites cater

to collectors, gallery owners, and art directors who are looking for artists with fresh approaches.

- The gallery at photo-eye (*www.photoeye.com/Gallery*) sells collector's prints from famous photographers and art prints from anyone who can get in. There is also a huge online collection of photography books.

- Mark Zane's International Photo Galleries (*www.markzane.com*) provides links to photographic gallery sites. You can submit your site for consideration, and any sales are made directly from your site.

- FolioFinder (*www.foliofinder.com*) lists bios and provides links to all sorts of artists, including photographers. FolioFinder does not enter into deals or act as an agent. This is a good place to go if you just want to see other photographers' portfolios.

- ArtistBiography (*www.artistbiography.com*) publishes bios and small folios (five images, maximum) of all artists who submit. There's no charge, but you must submit diplomas, prizes, exhibition announcements, and newspaper cuttings (as applicable) to establish the validity of your bio. This is a division of ArtPrice.com, which maintains a huge amount of information on the pricing of art.

- ArtCrawl (*www.artcrawl.com*) currently has about 50 members, two of whom are photographers. You can have your own web address on the site and can change the content of what is shown at any time. There is an annual fee of $250 for up to 20 pieces, plus $5 for each additional piece.

- ElectronicCottage (*www.electroniccottage.com*) features all sorts of artists, including photographers. The site claims to host links to over 1,000 online galleries of photos. Listings must have their own domain names, so subsites are not accepted. Since this site simply guides others to your site, you can do all sales and other contacts directly. ElectronicCottage will view your site and decide whether it meets their standards; there's an extensive (but easily met) list of qualifications meant to ensure that the sites are tasteful.

- Afterzed (*www.afterzed.com*) is sort of an all-purpose site—it's hosted by a web design firm that specializes in creating web sites for artists of all stripes. These designs are reasonably priced and look quite professional. You can also design your own site and use their web-hosting services, or simply link to their site. If you take the last option, there is no charge.

This list is in no way exhaustive—it's only a beginning.

I haven't really discussed any of the plethora of online consumer photo-processing sites, most of which will let you post galleries of your own images. Even though they're more consumer-oriented, pros may find some uses for these galleries; for instance, they're a great way to have promotional items printed with your photos so that you can give them away at trade shows or sell them at outdoor exhibits. They also offer a quick way to get prints made

on actual photographic paper. Below is a list of some of the best-known sites.

- Club Photo (*www.clubphoto.com*)
- DotPhoto (*www.dotphoto.com*)
- ez prints (*www.ezprints.com*)
- fujifilm.net (*www.fujifilm.net*). *fujifilm.com* will take you to Fuji's general-purpose site for all the company's photo and digital photo products.
- Ofoto (*www.ofoto.com*). Ofoto is a division of Eastman Kodak.
- PhotoAccess (*www.photoaccess.com*)
- Printroom.com (*www.printroom.com*)
- Shutterfly (*www.shutterfly.com*)
- Snapfish (*www.snapfish.com*)
- Walmart.com Photo Center (*www.walmart.com*). Click the Photo Center tab at the top of the page.

Getting Above Wholesale

The problem with almost all of these sites is that anyone can order and download prints or projects made with your photos at the site's wholesale prices. One exception is Printroom.com, shown in Figure 13-23, which has a division especially for professionals that will not allow downloads by anyone who is not paying the price you set for your prints. This can be an especially good scheme for event photographers who want to allow others to purchase pictures taken at the event, and may also have applications for fine-art photographers. Prints are made on photographic paper and prices are quite reasonable, so it's easy to make a profit. It's surprising that the other sites listed below don't offer similar services for professionals (yet).

Tip 3: Optimize Images for Web Viewing

If you've gone to the trouble and expense of putting up a web portfolio, you're going to want as many people to view it as possible. You'll also want plenty of space for all of your best images. If your thumbnails don't appear instantly—or if people have to wait more than three or four seconds for the larger image to appear—it is quite likely that your audience will quickly surf to someone else's web site.

By the same token, if your pictures don't impress the viewer with their quality, it is unlikely that you'll get swamped with requests for assignments or orders for exhibition prints. You must learn to make the right compromises so that your portfolio will perform efficiently and still look stunning. Compare Figures 13-24 and 13-25 to see both extremes.

If you have followed the instructions above for creating a web gallery, you will probably find that most of your pictures have been acceptably optimized. Still, there will always be exceptions—and some of them may be truly glaring. Every picture is different, and the same compression rules won't work for all of them. The automation programs just have to choose a compression formula that works more often than not.

Here's the most efficient workflow I've found for optimizing web photos.

1. Using the Photoshop Browser (or an image management program that produces large thumbnails and lets you drag and drop), go to the folder where the auto-generated web portfolio has been stored. Open each image in Photoshop and examine it carefully.

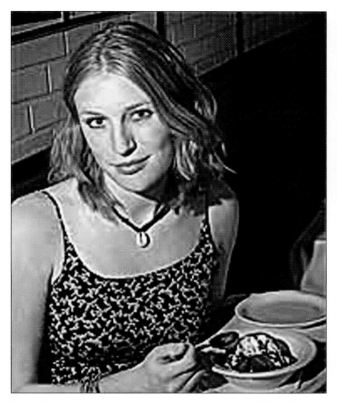

Figure 13-24. This image was oversharpened and saved at low JPEG quality and resolution. It loads fast, but would you want to show it to an art director?

Figure 13-25. The same image when optimization is not an issue.

2. Make sure that each image is set at 100% magnification. If you can't see compression problems at normal magnification, neither can your audience. If an individual image seems just fine, simply close it without saving it. If it doesn't, minimize the window or drag it out of the way so that you can use it in the next step.

3. When you have a set of images that you'd like to see improved, make a list of all the images and their dimensions and then close them. You are going to have to resize the originals and then do your own manual optimizations on each image.

4. Minimize Photoshop and use your operating system's file browser in thumbnail mode to open the folder that contains the original JPEGs. Press Cmd/Ctrl and click on each image you want to reoptimize. Now create a new subfolder in a new browser window (Finder on the Mac) that uses the name of the original folder with "man-opt" appended to the end of the filename (this will tell you that the folder contains manually optimized files). Now drag the files that you wish to optimize into the new folder.

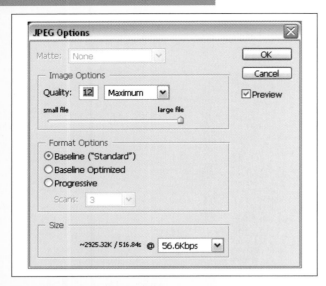

Figure 13-26. The JPEG Options dialog.

5. Create an Action that will automatically resize the files in the new "man-opt" subfolder to the same size as was created automatically by the web gallery program you used. Be sure to save them with the same filenames and that the JPEG quality is set to the maximum of 12 (see Figure 13-26). Now run the Action and resize all the files in the subfolder.

6. Use the Browser to navigate to the "man-opt" folder. Select all the images in that folder and drag them into the workspace.

7. Click the Edit in ImageReady button at the bottom of the Tools palette. The on-screen interface will change to the ImageReady interface, and you will see a series of tabs at the top of each image window.

8. Start with the image on the top of the stack and click the 2-Up tab. You will see the original image on the left and the version that has been optimized according to the present Optimize palette settings on the right (see Figure 13-27). On the right side of the screen are

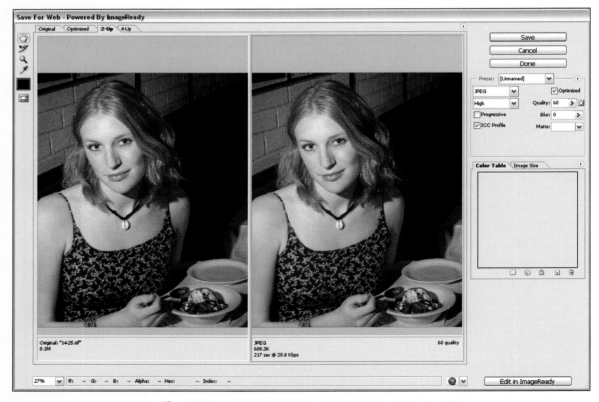

Figure 13-27. The Save for Web dialog with the Optimize palette on the right.

several palettes; one of them should be the Optimize palette (if it's not there, choose Window → Optimize).

9. Make adjustments in the Optimize palette and watch the results in the righthand image of the 2-Up window. Because you can immediately see the effects of your optimizations, you'll know when the result is of acceptable quality. When you reach that point, the next question will be whether the image will display quickly enough for your purposes.

10. If you edit the image in ImageReady in Photoshop CS, you will see the Information menu in the status line at the bottom of the document window (see Figure 13-28). Since most people viewing my site will be professional buyers and gallery owners, and since high-speed Internet connections are now the rule rather than the exception, I generally go by how the image looks and how fast it loads at 512Mb, an average speed for DSL and cable high-speed Internet connections. I also look at its performance at 56Kb, the typical speed for dial-up modem connections. If that speed is slower than 15 seconds, I will consider lowering the quality of the image. However, my rationale is that dial-up viewers are used to relatively poor performance and are willing to put up with it to some extent.

Additional Tabs

There are also tabs for showing only the optimized version of the file and for showing a 4-Up view that displays the original and three optimized views. You can then apply three different optimizations to the same original and choose the one you like best.

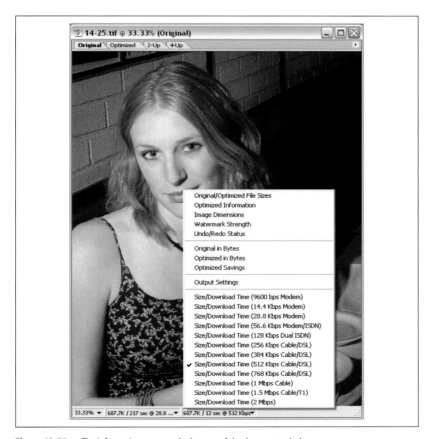

Figure 13-28. The Information menu at the bottom of the document window.

11. Once an image is optimized, save it to the same directory from which it was opened. When all the files have been optimized and saved, copy and paste them into the Image directory in the HTML folder that was created by the web gallery program. When the program asks if you want the new file to overwrite the original, click Yes.

Tip 4: Watermark to Protect Your Copyright

Many expert photographers are afraid to put their photos on the Web for fear they'll be stolen and then used without pay or be claimed as the work of someone else. But giving up web exposure for your photography means giving up one of best ways of becoming known (especially if your career is just starting) and of communicating with clients. Also, web graphics are highly compressed and merely 72 dpi in resolution which is so low that, even if an image is easily stolen, its use is pretty much limited to the Web anyway. You certainly couldn't make prints of high enough definition to have any commercial value, nor could you use the images in print publications (unless they were just used as small "icons"). Of course, it's still not a very pleasant idea that someone could use your image for their own web site or put it into their web portfolio and claim it as their own. And while there's no surefire way to prevent that, there *is* a way to prove the image is yours if it's stolen. At least, that could be grounds for a profitable lawsuit.

The way to do this is to watermark your images. Watermarking places identification text over the surface of the image in such a way that it is not visible to the naked eye, but can be easily read by the appropriate software—even if the image has been cropped or otherwise modified.

The most widely used—and therefore easiest to verify—watermaking system at the time of this writing is Digimarc (*www.digimarc.com*). Digimarc ships with Photoshop 5.5 and later, as well as with some other image editing programs such as PaintShop Pro.

> **NOTE**
>
> *You can watermark only RGB images. If you want to watermark GIFs, you have to "cheat" by first converting the GIF to JPEG, embedding the watermark, and converting it back to GIF.*

Before you can actually watermark your images, you need to create and register your watermark with the company whose watermarking software you are using. Instructions for doing this will be included with the program. The following method shows you how to watermark your files using Digimarc from within either Photoshop or ImageReady. (Note that you must be online for this procedure to work.)

1. Choose Other → Digimarc to bring up the Embed Watermark dialog (see Figure 13-29). Click the Personalize button.

2. The Personalize Digimarc ID dialog will appear (see Figure 13-30). You will first need to register with Digimarc, so click the Info button.

3. The Digimarc registration site will appear. You will see a chart of rates for different numbers of images. (These rates may inspire you to watermark only your most important images, but that's up to you.) Also note that for an additional charge, Digimarc can automatically search the Web for your watermarked images, which can be a very valuable service. Follow the instructions to register with Digimarc for the number of images you want to watermark.

4. When you have finished registering, enter your Digimarc ID and PIN number in the appropriate fields in the Personalize Digimarc ID dialog and click OK.

5. A new dialog will appear; fill in the required fields and click OK when complete.

Watermarking is an annual and not inconsequential expense. You can do it a little at a time, however, by adding new registrations whenever you have new images to watermark.

There is another "free" way to protect your images: use Photoshop (or any other layer-supporting image editor) to superimpose your copyright information over the image. To do this, simply create a new transparent layer at the top of the Layers palette and then use the Text tool to type in any size and style that will fit inside the image frame. You can make the watermark semi-transparent by adjusting the layer's Transparency or Fill sliders. If you have lots of contrast in the print, use a light-colored type and a Layer Style that creates a dark edge (choose Window → Layer Styles to get a thumbnail dialog that will automatically apply the style shown). This way, your watermark will be readable in both light and dark areas of the photo.

There are two major drawbacks to such "free watermarks":

- They can't be automatically traced.

- If you place them so they can't be easily cropped out, you'll probably end up hiding the most important part of your picture.

Still, it's good to have options, and you will probably discover situations in which these watermarks will work just fine.

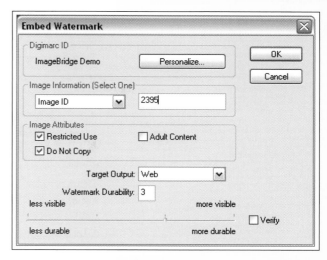

Figure 13-29. The Digimarc Embed Watermark dialog.

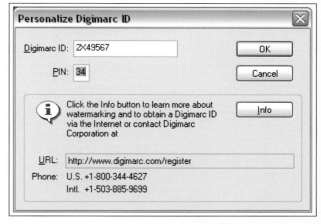

Figure 13-30. The Personalize Digimarc ID dialog (the information shown in the fields is entirely fictitious).

Tip 5: Make Photos for Web Animations

Making animations is easy—simply use an image management program that specializes in editing photos for the Web that automates turning a series of photos into an animated GIF. I'll show you how to do that below. The bigger problem lies in creating a series of photos that will make an animation that gets your message across and that looks professional.

To create photos to use in an animation, you'll need to open a photograph of a single object, knock it out of its background, and then duplicate the background layer as many times as you want to have frames in the animation. Then just transform (e.g., shrink, rotate, enlarge, etc.) each foreground layer in sequence. While the layered image is open, open the Animation palette; each layer will appear as an individual frame. You can then drag frames to rearrange their order, set the amount of time each image will be on-screen, and even "tween" between frames to create dissolve effects.

You can also use the same process to create more complex animations from rapid-fire sequences shot with your digital camera or from digital camera movies. You can easily turn any sequence you shoot with a digital camera into an animation using the following procedure.

Figure 13-31. All the individual frames have been opened in Photoshop.

1. Open all the frames in the sequence in the Photoshop workspace. The easiest way to do this is to simply highlight them and then drag them into place in the Photoshop browser. See Figure 13-31.

2. Make the first frame in the sequence the target file for the other frames in the sequence. In first-to-last order, cut and paste each of the frames into the first frame's window; each frame will automatically become a new layer in that window (see Figure 13-32). It is most efficient if you paste in each frame in the order in which it was shot. However, if you get a frame out of sequence, you can easily rearrange frames later when you are working in ImageReady.

Figure 13-32. All the frames are now layers.

3. Close all but the target (first) image's window. You should now crop and resize the image in Photoshop before you move the image into ImageReady, especially if you are using full-resolution digital camera image files. This is much easier, faster, and more accurate if you do it after you've placed all the images into the same file. First, use the Crop tool (not the Image → Crop command) to crop out any superfluous background. If the space used by the subject expands over the course of the animation (as in this example), be sure you crop the pose that takes up the most space in the frame; otherwise, you may end up losing part of the poses in other frames. See Figure 13-33.

4. Choose Image → Image Size, uncheck the Resample box and set the resolution to 72 dpi (typical web screen resolution). Then, recheck the Resample box, choose pixels as the unit in the Pixel Dimensions menus, and enter the pixel dimensions you want to use for your web animation. The smaller your image, the faster your animation will be able to play. See Figure 13-34.

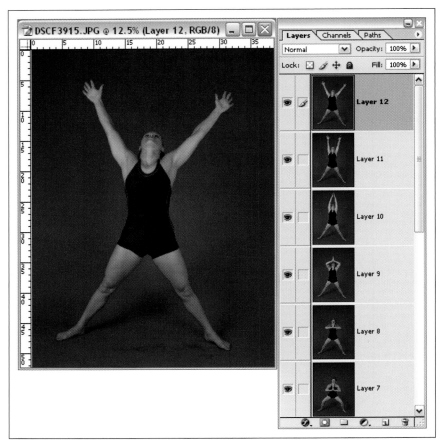

Figure 13-33. The layers after cropping.

Figure 13-34. The Image Size dialog.

5. If you want to substitute the background, now is the time to do it. Doing so is often a good idea because you will have an easier time ensuring that the animated objects are positioned correctly within each frame. In this instance, I used the Photoshop Extract filter to remove the blue background. You should use the knockout technique that is most appropriate to your subject. See Figure 13-35.

Figure 13-35. The animation after knocking out each of the frames. You may find it helpful to toggle the Layer Visibility (eye) icon as you make the knockouts and register the frames.

6. Once you've finished the knockouts, click the Edit in ImageReady button (the very bottom button in the Toolbox) to jump to ImageReady. In ImageReady, choose Window → Animation to open the Animation palette (if it's not already open) and choose Make Frames from Layers from the menu. All the frames will be in place, and you can preview your animation simply by clicking the Play button at the bottom of the Animation palette. See Figure 13-36.

Figure 13-36. The animation as seen in the ImageReady editor after opening the Animation palette. The settings shown in the Optimize and Optimize Animation palette (opened from the Animation palette menu) are those most frequently used.

7. Choose the settings in the Animation palette that will time the animation as you'd like it to play. You can choose the timing for each frame from the timing menu at the bottom of the palette. See Figure 13-37.

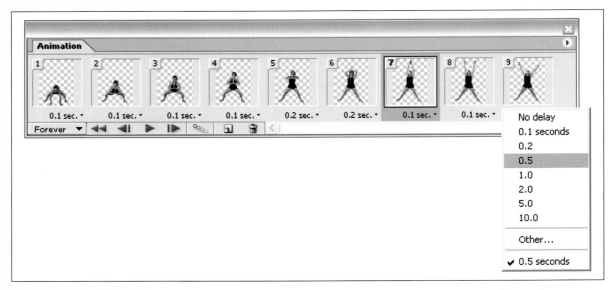

Figure 13-37. The timing for each frame can be seen immediately below each frame number.

Digital Photography: Expert Techniques

8. In ImageReady 8.0, you can save an animation as an animated GIF, a QuickTime movie, or a Flash Animation. If you're using another program or an older version of Photoshop, you may be limited to an animated GIF. Animated GIFs can be read by any reasonably recent browser, so it's always the safest way to go; however, you can use only 128 colors. That may not be as awful as it sounds—Photoshop will let you intermingle (dither) those 128 colors so that it looks more like a full range. This is especially if an individual image is only on-screen for a quarter of a second—your mind won't have time to analyze the construction of the image. At any rate, to save to an animated GIF, go to the Optimize palette and choose GIF 128 Dithered from the Preset menu.

9. Save the file as a GIF.

If you want to create a Flash animation, follow the procedures above except for the final two steps. You needn't use the Optimize palette to convert the file to GIF format; Flash animations can play full-color JPEGs. Once you've made the animation, choose File → Export → Macromedia Flash SWF to bring up the Macromedia Flash (SWF) Export dialog (see Figure 13-38). You may want to change the JPEG quality for speedier performance. You can also choose to have ImageReady generate the HTML page for your Flash file, but you'll probably want to let your WYSIWYG HTML editor do that job when you place the animation on a web page.

If you want to create a QuickTime movie, first make sure that QuickTime is installed on your computer (a given if you're on a Mac). Then choose File → Export Original to bring up the Export Original dialog. Choose QuickTime Movie from the Save as Type menu. The rest of the procedure is the same as for saving any file in any format.

Figure 13-38. The Macromedia Flash Export dialog.

Index

Ken Milburn started his career as a professional photographer when he was still in high school by specializing in weddings and portraits of his classmates. Since then, his photographic career has included publicity photos for Universal Pictures, album covers for several labels (including Capitol Records), editorial work for a number of publications (including *The Los Angeles Times Sunday Magazine* and *TV Guide*), and a long list of advertising clients (including Southern California Gas, Cole of California, Strega Liqueurs, and the Fleur Corporation). He sells his photographs and digital art at art festivals and fine art galleries, and his work has been featured three times in *Design Graphics Magazine* and twice in *Computer Graphics World*.

Ken's photographic career has been paralleled by a long career as a writer. He started by writing two feature films. Most of his writing, however, has been in the form of columns, how-to articles, and technical books on the subject of computer graphics. He has written over 300 columns and articles (many of which have featured his photographs) for such national trade magazines as *Publish*, *DV Magazine*, *MacWorld*, *Computer Graphics World*, *PC World*, and *InfoWorld*. He has also been a contributing editor and columnist for *Computer Currents* and *MicroTimes*.

In addition, Ken is the principal author of 20 computer books, the majority of which focus on various versions on Photoshop and digital photography. Ken is the author of both the first and second editions of *The Digital Photography Bible* (Hungry Minds) as well as *Digital Photography, 99 Easy Tips to Make You Look Like a Pro* (Osborne), and *Cliff's Notes on Taking and Sharing Digital Photographs*. His Photoshop books include *Photoshop Elements 2.0 Complete* (Osborne), *The Photoshop 7 Virtual Classroom* (with live-motion lessons on the CD-ROM), *Master Visually Photoshop 6.0*, *Master Visually Photoshop 5.5*, and *Photoshop 5.5 Get Professional Results*.

Ken has taken his Photoshop and digital photography expertise to an even broader user base by working as a contributing editor for the MSNPhoto web site, authoring user hints for the PhotoWorks online film processing and printing service.

Colophon

Our look is the result of reader comments, our own experimentation, and feedback from distribution channels. Distinctive covers complement our distinctive approach to technical topics, breathing personality and life into potentially dry subjects.

Emily Quill was the production editor and copyeditor for *Digital Photography: Expert Techniques*. Philip Dangler was the proofreader. Melanie Wang and David Futato did the typesetting and page makeup. Reg Aubry and Claire Cloutier provided quality control. Julie Hawks wrote the index.

Emma Colby designed the cover of this book using Photoshop 5.5 and QuarkXPress 4.1. The cover images of fields are from Photos.com. Emma Colby produced the cover layout with QuarkXPress 4.1 using Adobe Syntax and Linotype Birka fonts.

David Futato and Melanie Wang designed and implemented the interior layout using InDesign CS. This book was converted from Microsoft Word to InDesign CS by Andrew Savikas, Joe Wizda, and Julie Hawks. The text and heading fonts are Linotype Birka and Adobe Myriad Condensed; the sidebar font is Adobe Syntax; and the code font is TheSans Mono Condensed from LucasFont. The illustrations and screenshots that appear in the book were produced by Robert Romano and Jessamyn Read using Macromedia Freehand MX and Adobe Photoshop 7.

Need in-depth answers fast?

Access over 2,000 of the newest and best technology books online

Safari Bookshelf is the premier electronic reference library for IT professionals and programmers—a must-have when you need to pinpoint exact answers in an instant.

Access over 2,000 of the top technical reference books by twelve leading publishers including O'Reilly, Addison-Wesley, Peachpit Press, Prentice Hall, and Microsoft Press. Safari provides the technical references and code samples you need to develop quality, timely solutions.

Try it today with a FREE TRIAL
Visit *www.oreilly.com/safari/max/*

For groups of five or more, set up a free, 30-day corporate trial
Contact: *corporate@oreilly.com*

What Safari Subscribers Say:

"The online books make quick research a snap. I usually keep Safari up all day and refer to it whenever I need it."

—Joe Bennett, Sr. Internet Developer

"I love how Safari allows me to access new books each month depending on my needs. The search facility is excellent and the presentation is top notch. It is one heck of an online technical library."

—Eric Winslow, Economist-System, Administrator-Web Master-Programmer

Related Titles Available from O'Reilly

Digital Media

Adobe Photoshop CS One-on-One

Digital Photography Hacks

Digital Photography Pocket Guide, *2nd Edition*

Digital Video Pocket Guide

iPod & iTunes: The Missing Manual, *2nd Edition*

Keep in touch with O'Reilly

1. Download examples from our books

To find example files for a book, go to:

www.oreilly.com/catalog

select the book, and follow the "Examples" link.

2. Register your O'Reilly books

Register your book at *register.oreilly.com*

Why register your books?
Once you've registered your O'Reilly books you can:

- Win O'Reilly books, T-shirts or discount coupons in our monthly drawing.
- Get special offers available only to registered O'Reilly customers.
- Get catalogs announcing new books (US and UK only).
- Get email notification of new editions of the O'Reilly books you own.

3. Join our email lists

Sign up to get topic-specific email announcements of new books and conferences, special offers, and O'Reilly Network technology newsletters at:

elists.oreilly.com

It's easy to customize your free elists subscription so you'll get exactly the O'Reilly news you want.

4. Get the latest news, tips, and tools

www.oreilly.com

- "Top 100 Sites on the Web"—PC Magazine
- CIO Magazine's Web Business 50 Awards

Our web site contains a library of comprehensive product information (including book excerpts and tables of contents), downloadable software, background articles, interviews with technology leaders, links to relevant sites, book cover art, and more.

5. Work for O'Reilly

Check out our web site for current employment opportunities:

jobs.oreilly.com

6. Contact us

O'Reilly & Associates
1005 Gravenstein Hwy North
Sebastopol, CA 95472 USA

TEL: 707-827-7000 or 800-998-9938
 (6am to 5pm PST)

FAX: 707-829-0104

order@oreilly.com
For answers to problems regarding your order or our products. To place a book order online, visit:

www.oreilly.com/order_new

catalog@oreilly.com
To request a copy of our latest catalog.

booktech@oreilly.com
For book content technical questions or corrections.

corporate@oreilly.com
For educational, library, government, and corporate sales.

proposals@oreilly.com
To submit new book proposals to our editors and product managers.

international@oreilly.com
For information about our international distributors or translation queries. For a list of our distributors outside of North America check out:

international.oreilly.com/distributors.html

adoption@oreilly.com
For information about academic use of O'Reilly books, visit:

academic.oreilly.com